Kia Katy

Kia ora e hoa

Journey well!
Kia Kaha!
Walk in your truth!

Arohanui.

Barry.

TUATARA
GUARDIAN OF THE LORE

Tuatara of Ancient Times
Child of the Reptiles
Keeper of the Knowledge
And all that has ever been.

Tuatara of the Third Eye
Gateway to the Universe
Mirror of the known realms
And those between.

Tuatara of the Spirit Trails
Carved in mountain and mind
To mark the pathways to the stars
And all unseen.

Open the Portals of Wisdom
Help us remember the Sacred
And learn to live in peace.

One Heart!
One Family!
One World!

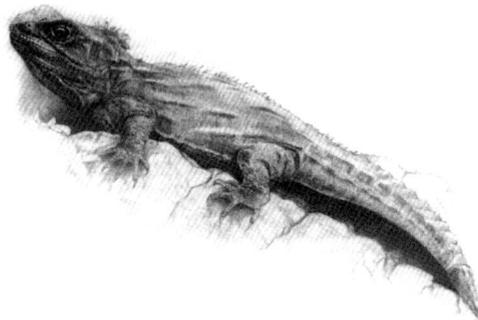

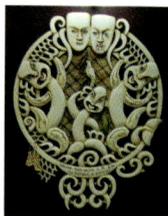

THE COVER

'Takina nga moka o te pae ka korara o parirau.'
'Challenge the margins of time and explore what is beyond.'

*This treasure was designed and carved by children aged eleven and twelve at
Chisnallwood Intermediate School, Christchurch.
It depicts the circle of life and speaks of the kinship of all.*

*At the centre is the child, above it are the grandparents who are the teachers,
and on either side the parents, the guardians.
They are all joined to the web of life, a net of relationships that weave into each
other, and into the wider fabric, the realms of the stone, trees, birds and fish.*

*Hanging on the rim of this circle, that is but one great family, are flax sandals to
carry us along the pathways of life.
They await the trail makers, those born of the questing spirit, those who find
their excitement in walking the margins where truth resides. They speak of all
the journeys that are part of life – the journey of the mind,
the heart and the spirit.*

© 2004 Barry Brailsford

ISBN 0-9583502-8-0

Some eight years on, when his nurse told me his end was near,
I spoke with him for the last time.

'How are you, Andy?'

'Don't take any notice of them, I'm fine!' he replied in a voice that was
determined to raise another issue. 'I don't see you out there!
What are you doing?'

Laughing at his challenge, I replied,
'I'll soon be speaking and writing again.'
He didn't know I was recovering from surgery.

I had written seven books that wove much of the old lore
he shared into my stories.
Yet, in his last moments the old one remembered
only six were published,
that the seventh had yet to appear.

The 'missing book' was written six years ago.
He'd loved that manuscript and was aware
of its journey to the elders in the Far North.
He knew I had been anxious because of the depth of knowledge shared.
So Andy was delighted when other elders said, 'Publish it.
You don't need to change a word.'

Yet, he had shown great patience when I'd set it aside to await its time.
Now, with his last words, the old one gave me the courage to launch that
waka on these tides.

Yes, Andy, this is the seventh
book and you are in it.
And while the words are of
this land and its many peoples,
their message reaches far
beyond these shores,
for the Ancestors taught that
truths founded in Spirit
embrace the beauty of all.

Andrew W.T.K. Taniwha-Pona died on January 29th, 2002.
Many honoured his journey for he always offered friendship,
inspired the seeker and walked with
a gentle reverence for life.

In the Hands and Hearts of the Children

**'Ahakoa he iti, he Pounamu –
I may be small, but I am a treasure.'**

Children, born of many lands,
shaped and carved this tall gateway.
They were but eleven and
twelve years old.

Their chisels cut deep to say...

'The words of the elders
reach into the fire

To rise on the smoke
to the heavens

To ride the winds
and rustle the leaves

To drift across the waves
and meet the waters'

And their hearts say...

'We are of the new day,
the age that says it is time to
find a new way,
and live in peace.'

**When the words of the elders
reach into the fire...**

it is time.

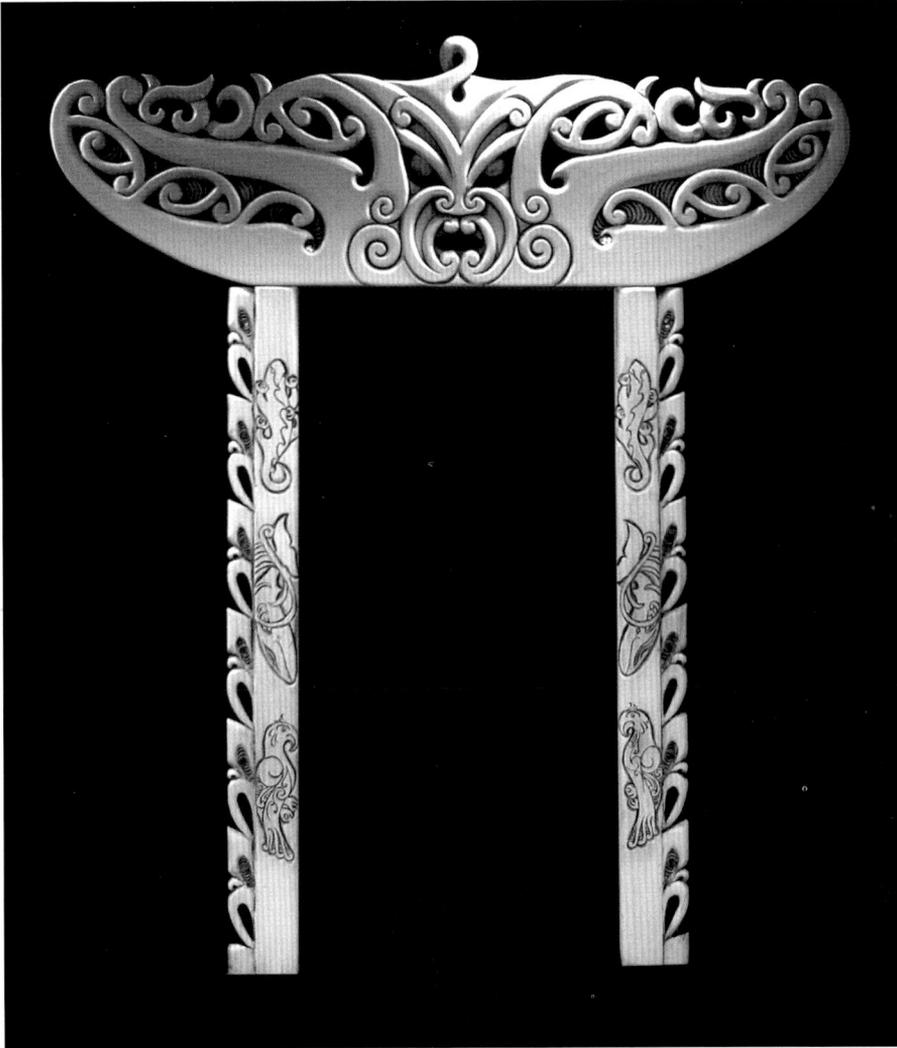

Go through this portal,

and remember as you walk

that our children follow,

do as we do,

learn from all we say,

and expect the best of us

day after day.

Are we ready to be the world

we want to see?

FROM THE ELDERS
OF THE HOUSE

'Tena koutou, tena koutou,
tena koutou katoa.

Nga mihi aroha ki a koutou.

Thrice welcome to the world of the Ancestors, to wisdom once shared by all.

May this be a journey of remembrance, may it call forth the inner knowing
nourished by those who have gone before, may it honour all born of the four winds,
the many colours, and truth that is universal.

Nau mai, nau mai, haere mai,
tena tatou katoa.'

Contents

SONG OF THE OLD TIDES
One Heart! One World!

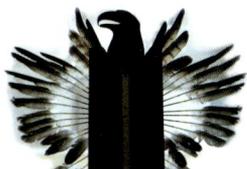

All that has ever been, and all
that will be, is of the Circle —
the unfolding that is Eternal.
And each turning of that Circle is
held within a song, for everything
is born of the sounds sacred.
And each song is held within a
Pouwhenua, a tall, carved post
anchored in the earth to
reach for the sky. And there are
twelve posts in all to guide us
into yesterday and open the way
to tomorrow.

Being of the Circle

FROM THE NATIONS
THE WISDOM OF THE COMPASSIONATE
One Heart! One World!

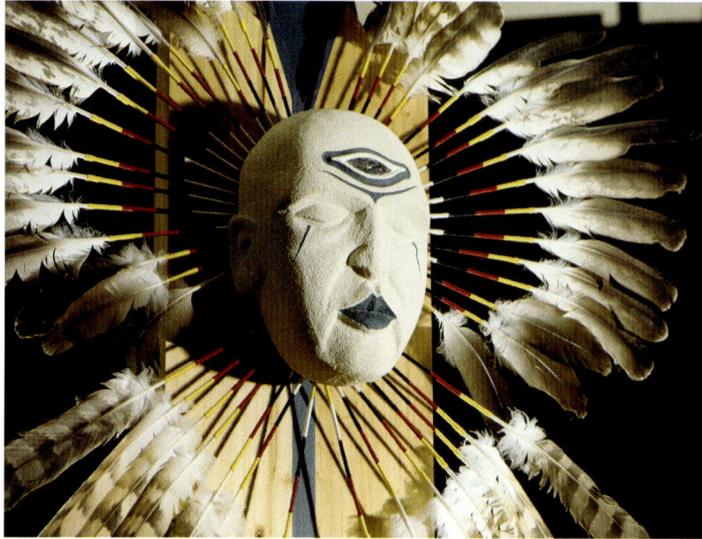

'The Twentieth Century must be seen as a century of warning,
a call of caution to humankind for the necessity of developing a new consciousness
and new ways of living and acting.'
Mikhail Gorbachev, Russia. Nobel Peace Prize 1990

'I am convinced that love is the most durable power in the world.
It is not an expression of impractical idealism, but of practical realism.
Far from being the pious injunction of a Utopian dreamer, love is an absolute
necessity for the survival of our civilization. To return hate for hate does nothing but
intensify the existence of evil in the universe. Someone must have sense enough and
religion enough to cut off the chain of hate and evil.
And this can only be done through love.'
Martin Luther King, Jr. USA. Nobel Peace Prize 1964

'This is my simple religion. There is no need for temples, no need for complicated
philosophy. Our own brain, our own heart is our temple; the philosophy is kindness.'
The Dalai Lama, Tenzin Gyatso, Tibet. Nobel Peace Prize 1989

'Our works of love are works of peace. Let us not use bombs and guns to overcome
the world. Let us use love and compassion. Today if we have no peace, it is because we
have forgotten we belong to each other – that man, that woman, that child is my
brother or my sister. If everyone could see the image of God in his neighbour,
do you think we would still need tanks and generals?'
Mother Teresa, India. Nobel Peace Prize 1979

'I think most of our major challenges are not going to be in the physical field at all. I think they're going to be in the field of human relations, of getting on with each other, of contributing.'
Sir Edmund Hillary, New Zealand. Mountaineer /Humanitarian

'Trust is the basic element for peace. Unless we can trust each other, unless we can be sure that we will receive justice, and that we also have to give justice, we cannot achieve peace.'
Daw Aung Suu Kyi, Burma (Myanmar). Nobel Peace Prize 1991

'We will not learn how to live together in peace by killing each other's children. The bond of our common humanity is stronger than the divisiveness of our fears and prejudices. God gives us the capacity of choice.
We can choose to alleviate suffering. We can choose to work together for peace. We can make these changes – and we must.'
Jimmy Carter, USA. Nobel Peace Prize 2002

'*Ubuntu* is very difficult to render into a Western language. It speaks of the very essence of being human…You share what you have. It is to say "My humanity is caught up, is inextricably bound up, in yours." We belong in a bundle of life.
We say, "A person is a person through other persons."
It is not, "I think therefore I am." It says rather "I am human because I belong. I participate, I share." A person with *ubuntu* is open and available to others, affirming of others, does not feel threatened that others are able and good, for he or she has a proper self-assurance that comes from knowing that he or she belongs in a greater whole and is diminished when others are humiliated or diminished, when others are tortured or oppressed, or treated as if they were less than who they are.'
Archbishop Desmond Tutu, South Africa. Nobel Peace Prize 1984

'Nothing in this life is to be feared. It is only to be understood.'
Marie Curie, Poland. Nobel Prize 1903 & 1911

BRINGING FORTH THE NATIONS' PROMISE

SONG OF THE
SPIRIT OF CREATION

In the Beginning...

was the Nothingness

and into the Nothingness

came the Great Sound

and out of the Great Sound

came Life

and all that is.

Into the Nothingness,
Io Mata Ngaro,
the Unseen One,
seeded the Mana,
the Mauri, and the Maui to
create the Spirit of Life.

And when the Mana
stood tall, the Mauri filled it
with excitement and form and
set it free to soar.

And when the Mauri
ran wild, the Maui moved to
shape it anew and weave the
wonder of design.

And when Io Mata Ngaro
saw the beauty of Life,
the Wairua was gifted to
remind us we are of the
Source born.

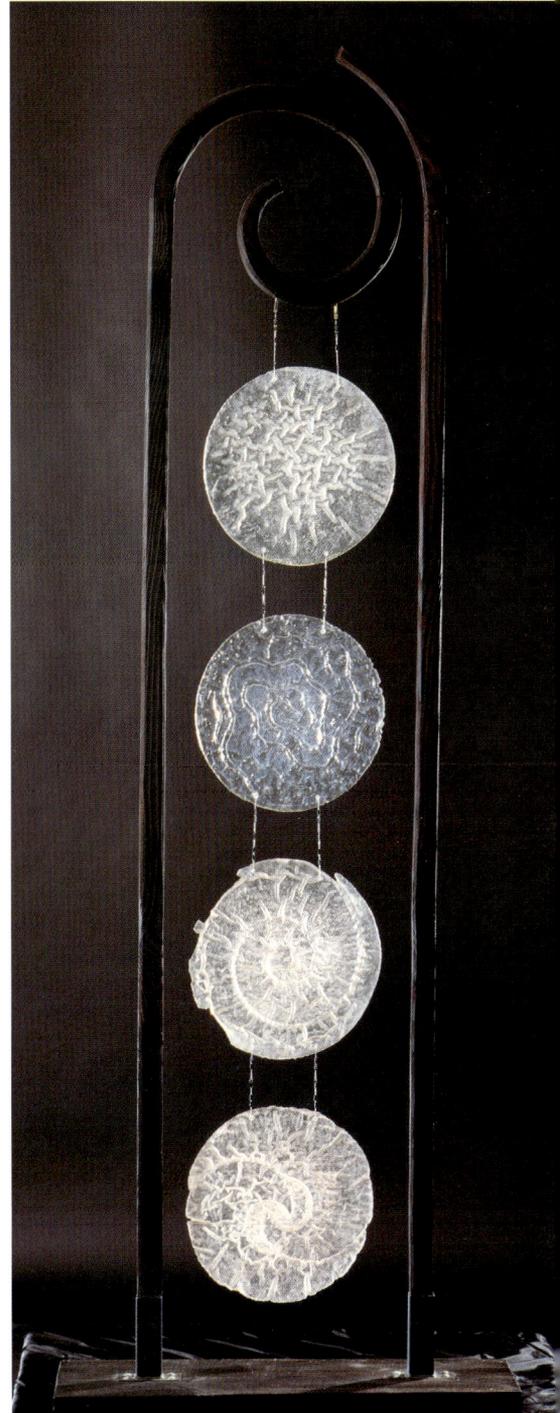

Io Mata Ngaro
The Unseen One

Long, long ago,

the Ancestors walked the

sacred trails into the

Great Mystery,

and met

Io Mata Ngaro,

the Unseen One,

the Source.

'I am Io Nui, the Supreme One, Io Roa,
the Life Everlasting that Knows No Death,
Io Matua, Parent of the Heavens
and their Realms, and Io Taketake,
All Enduring, All Complete,
Immovable.

'I am Io Pukenga, Source of Thought,
Reflection and Memory, Io Wananga,
Source of Knowledge, and Io Matawai,
the Loving and Compassionate One.

'I have many children and they in turn
have many children. May you share with
them the song of life. May you hear their
music, respect their dreams and always
remember that all are kin,
one family warmed by the Sun.

'Walk bravely, for the flame
of hope burns brightly.
And remember,
you journey from Spirit to Spirit.'

I AM

Io Mata Ngaro, the Unseen,
the Creator of All,
the Keeper of the Silent Space,
the Singer of the Song that
Holds the Stars in Place,
and All that has Ever Been
and Ever Will Be.

BEING OF THE CIRCLE

If we lose our story

The haunting call of the conch sounded along the shore and echoed off the cliffs that stood before. The fire circle for the first night was formed.

Grandmother and grandfather, and those who walked to nurture them, slowly drew near. Seated, with help, and short of breath even after such a short beach walk, the old ones seemed too frail to carry the circle through the teachings of this night.

The flickering flames lit the faces of all. Edging closer to each other, the old ones calmly scanned those who gathered to the fire. Noticing how the children snuggled into parents and grandparents for reassurance and warmth, they smiled.

> 'We do it for the children. We ask much of these young ones,' grandmother whispered, 'and of ourselves.'

With these words her fingers sought her Hei Tiki, a wonderful family treasure handed down through many generations. It was a Taonga of great power, a symbol of all they attempted here. She would wear it on their nights around the fire, and it would reflect the flame, the light of today warmed by the light of yesterday.

> 'Ae, we dream of better days… search the trails of memory… hope to bring the children through… yet, we fail them… somehow lose them along the way…' grandfather offered quietly… 'so much lost to the generations… torn from the fabric… scattered by the winds… so few know the story…'

The sadness that cloaked their silence was broken by grandmother's determination to move on, by the strength that comes with the decision to commit beyond mere words.

> 'Some say let it go, let the old knowledge die, but I know the tragedy that therein lies. If we lose our story we lose our dream and if we lose our dream the spirit dies.'

Make the journey

Most came eagerly to this night and others with the slow step of the wary.
Yet, they were here, were gathered — parents with their children, trying to find answers in today's world, trying to hold the family together with fragile cords of hope.

Looking around the circle, grandfather was not surprised to see that some were not Maori, for the marae was now haven to many. All in need were welcome. Some might come but once to this fire, and that was to be expected. However, he hoped others would return night after night, would journey through all twelve

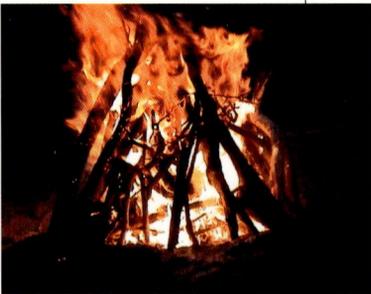

Some say let it go, let the old knowledge die, but I know the tragedy that therein lies. If we lose our story we lose our dream and if we lose our dream the spirit dies.

songs, and greet all twelve Pouwhenua they would create in the mind; the twelve carved posts that held the story. But were any ready for that, was there even one?

The old ones chose this shore as their house of learning, knowing wind and wave and starlit night wove an ageless backdrop to the story. Time stood still in this place and there was solace in the flame, the fire that spoke of ancient journeys made. And they sat within the Moon's brightest trail, the phase that lifted the mind into a special space.

Thus did it begin, with two elders, life companions on the longest of trails, summoning failing strength to honour the good way, to weave old wisdom, the lore of the Ancestors, into the fabric of today.

Stooped by age, creased and lined by the chisels of time, they hoped they had found the grace to smile on all that entered their lives. They knew tears shed for all that was gone did not restore it and anger was no answer to hurt. The way ahead, the hope that brought them to this day was born of the trust reflected in the eyes of their grandchildren. A many-coloured brood who spoke of another age, but their needs were the same; to belong, to be accepted, to have a place no matter what the bloodline or the race. That was of the old way, the secret of tomorrow's world, gifted by the power of yesterday.

Take your courage in your hands

Grandfather rose, with difficulty, from the low bench they shared. Supported by his carved talking stick, he slowly raised his head, squared his shoulders and stood erect to welcome them into the circle.

Hesitating, looking from stranger to stranger and seeing only the occasional familiar face, he wondered if he was truly ready for this journey. Yet, it was too late to step aside, too late to turn his back on the need he saw every day. Together they would find the courage; together they would share the teachings of the old ways.

Grandfather's karakia, the prayer he gave to this night, broke the gathering silence to echo along the shore and open the way to the sacred.

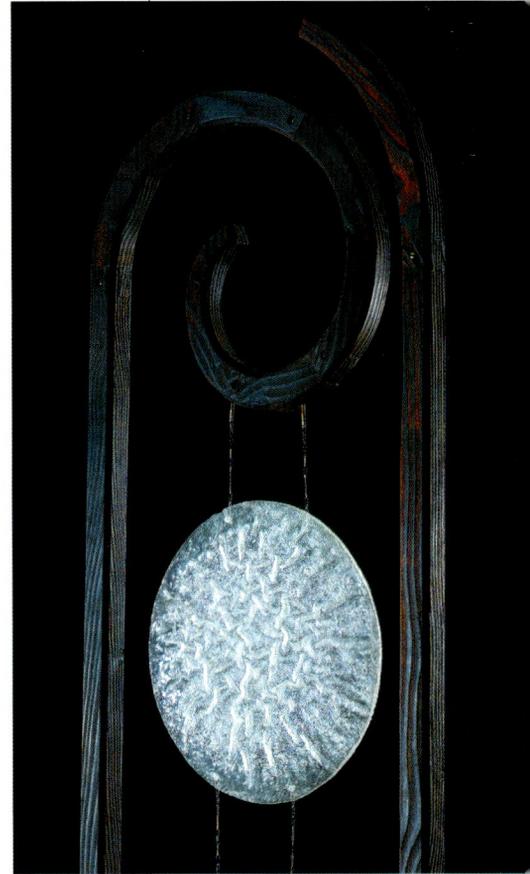

The way ahead,

the hope that brought them

to this day was born of the

trust reflected in the eyes of

their grandchildren.

A many-coloured brood who

spoke of another age,

but their needs were the

same; to belong,

to be accepted,

to have a place no

matter what the

bloodline or the race.

KARAKIA

Na te maramatanga kei te
ngakau o te Atua

Ki a koha te maramatanga ki
te ngakau o te Tangata

Ki a koha te maramatanga
ki te Ao

Ma te maramatanga

Ma te Aroha

Ma te kaha e whakau
te whakaaro nui te Ao

Tihei mauri ora

From the Source,
Within the mind and heart
of Creation,

May light flow
Into the mind and heart
of the People

May it shine
Forth on the World

May light, love and courage
Realise the dream of peace
on Earth

May we choose Life

May light, love and
courage realise the
dream of peace on earth.
May we choose life.

18

Grandfather's powerful words startled everyone, for the strong tone that sent them forth belied his age and filled the night with mystery. Karakia opens the way for the other mind and the other voice.

A shiver of excitement ran the rim of the circle to shift awareness, for that cry was so ancient and true it sped beyond the mind to touch the heart. Few knew the words he spoke, but that mattered not, for their power was born of sound not of meaning. Even babes in arms stirred to receive them.

Grandfather swayed a little, as if pulled forward by an outgoing tide. He was deeply moved by the impact of the words he had gathered from days long gone.

The voice was still there! Ae, the voice of the ancients born, the voice moved by Wairua and shaped by song. He hadn't lost it! The old rhythms and words, the songspeak that is of the spirit voice, were still there.

Lowering himself slowly to the bench with grandmother's help, he felt satisfied. It was done; it had begun. With his talking stick set before and both hands upon its helm, he rested his bowed head upon it as if in sleep. Some might think he drifted off, dozed a little,

Everything is not always as it seems. Assume nothing. Assumptions readily close the door on all that is and might be. The open mind sees beyond the breaking wave to the distant shore. It takes the longer view and sees more.

but those who understood his ways simply smiled.

TE KORE

The Nothingness

Grandmother, who knew she was now the stronger and thus called to carry the heavier load, stood to lead them to the first Pouwhenua, the first tall post carved in the mind to mark the long trail. It honoured the Spirit of Creation.

Remember the Nothingness

'We sit in the warmth of this fire beneath a sparkling cloak of stars and forget they did not always light the dark sky. We marvel at the beauty of the Moon and think it has always been. That is not so.

'In the Beginning there was no light, no stars, no Moon, no Sun, no Earth, no sound and no song. Nothing — but the Nothingness.

'This was the realm called Te Kore, the Void, the place embraced by the Darkness that has no source.'

'Grandmother, were you born in the Nothingness?' asked a small voice.

'No, dear child,' was the old one's gentle response. 'I was born long after the Nothingness ended, but the first Ancestors were born of that time.'

Holding a smooth white stone, grandmother turned it slowly to allow all to see its brightness. Then she spoke quietly into the gathering stillness.

'Stone is the oldest of the Ancestors. It is of the enduring spirit that is of the Beginning of All. It is of the stars that shine above us this night, the cliffs behind us and the distant mountains that shadow the line of the sky.

'We are all of the stone and the stone is of each of us. It is the first ancestor and how stone came to be is a wondrous story, for it came out of the Nothingness.'

Grandmother was excited. She too had found the voice. Her words had flowed as if from another place. The poetry of the past, the songs taught from birth, the chants gifted on, all wove themselves effortlessly into her words. The Wairua moved; she was going to be all right. She went bravely on.

The Nothingness was vast

'In the Beginning there was no stone, only Te Kore, the Nothingness, the one known as the Void.

'Know that everything has children, for that is the lore of the Universe, and all are included, because love is Creation.'

The Nothingness had many children

'The First Child of the Nothingness
was Te Kore Tuatahi

The Second Child of the Nothingness
was Te Kore Tuarua

The next was the Great Nothingness,
Te Kore Nui

The Long Nothingness,
Te Kore Roa

Stone is of the fire born
and is the seed carrier.
Stone is the first ancestor
and how it came into being
is a wondrous story, for it
came out of the Nothingness,
out of the Void that became
the Universe.

The Nothingness of the Seer,
Te Kore Para

The Unpossessing Nothingness,
Te Kore Whiwhia

The Delightful Nothingness,
Te Kore Rawea

The Nothingness Fast Bound,
Te Kore Te Tamaua

And the Nothingness yearned for more,
for its children were all alone.
Io heard its cry and sent the Darkness to cover the Nothingness
and hold it close.'

Te Po

The Darkness

The Darkness is without end

'The Nothingness was embraced by Te Po, the Darkness that
covered all, and the Darkness had many children

The Everlasting Darkness without source,
Te Po Pamamao

The Long Darkness of time beyond time,
Te Po Roa

The Intense Darkness that covers all,
Te Po Tangotango

The Wide Darkness of space beyond space,
Te Po Nui

The Extreme Darkness that shuts out all,
Te Po Kerekere

The Glistening Darkness that absorbs all light,
Te Po Whatiwha

The Peaceful Darkness that embraces,
Te Po Taketake.

The Darkness is of the Everlasting.
The Darkness is the Womb of Creation,
for when a Universe is no more,
when its light finally dies and its time is done,
the Darkness always remains to give rise to another Universe.'

When grandmother ended her journey into the Nothingness, the circle was bound in
silence. The only sounds came from the fire and the shore. Then a young voice broke
the spell of it all.

'How do you remember so much stuff?' asked Ben of just five years.

This thought had formed in older minds, but it was a child who spoke first.
Innocence opens many doors.

'Because it is a song,' answered the old one. 'You know many songs and always
remember the words because you know the tunes.'

'Is that why your voice sounds so different, grandmother?' continued Ben, who had a good ear for music.

'Ae, little one, I'm moving into old tunes, remembering old chants and speaking them in old ways to hold the spirit of what they say.'

The Darkness is the Womb of Creation. When a Universe is no more, when its light finally dies, the Darkness remains to give rise to a new universe.

Na Te Timatanga

The Beginning

We are of the Being and the Becoming

'In the Nothingness all was the same forever. There was no dawning and no sunset for there was no Sun. There was no yesterday, today or tomorrow, no past and no future. The Nothingness was empty of time; it was empty of everything except the Darkness. Such was the depth of the loneliness of the Nothingness.

'Io Mata Ngaro, Creator of All, felt the loneliness of the Nothingness, that was embraced only by the Darkness and its children, and decided to gift to it another child.

'There was mystery in this, for this child, of itself, immediately prompted the birthing of another. When Io gifted Timatanga, the child named "Time", to the Nothingness, Time gave life to the one named "Change".

'Time created the opportunity for things to be. For Time is the seed of life, that golden moment when "Now" has meaning and "Becoming" is possible. With the possibility of "Becoming" we see the birth of Change.

'This brings us to the most wondrous of moments, because Change allowed the birth of Life. And when Io saw Life was so beautiful, Change became a prime law of the Universe.

'Now "this" might become "that", and "today" might be followed by "tomorrow".

'But I move too fast, rush too quickly into Change and go far beyond the mystery that brought us into the Nothingness. It is time to hear about the Great Sound.'

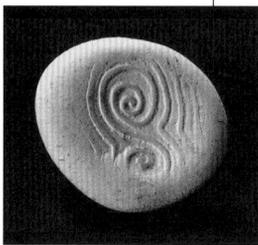

Creation was born of the Great Sound

'The songs gifted through the ages say that in the Beginning was the Nothingness, and into the Nothingness came the Great Sound and out of the Great Sound came all that is.'

'Even the white stone you showed us,' asked Miriam, the first adult to venture a question, 'was that born of the Great Sound?'

'Yes,' replied the old one, 'for it is of the realms of the stars, but understand stone was not the first child to be born after Time and Change.'

'Was that grandfather?' cried young Ben, in amazement. Grandfather responded with a chuckle of delight, for he knew time was a great mystery to the little ones. It was as if all born before them had always been.

'The next children to be created were named Mana, Mauri and Maui. It's time for me to speak of their journey.'

Time created the

opportunity for things to be.

For Time is the seed of life,

that golden moment when

Now has meaning and

Becoming is possible.

With the possibility of

Becoming we see the

birth of Change.

TE MANA
The Essence

Grandfather stood with some difficulty. Stiffness of joint and waning strength made this so, yet his spirit was willing and once standing he did remarkably well. The deeper concern was for his heart, which sometimes broke into a fast, irregular beat that he called "the tom-tom drum". If the rhythm became too frenetic it brought him low. One day it would say, "time to go."

Behold the Essence of Spirit

'When the rainbow sings everything is possible,' began grandfather, who often began his teachings with a little saying.

'Look around you when you lose your way. Too often we go within, go so deep we leave the light behind and stay inside. Look to the rainbow for it is of the child-mind, the spirit that loves to dance.

'When Time and Change were seeded in the Nothingness, Becoming was possible but, until Io sang the Song of Creation, there was no way they could play.

'In the Beginning was the Word, the Great Sound, and out of the Great Sound came life and all that is.

'What a Word that must have been! Think of the dawn chorus of the birds, the sighing of the wind in the trees, the tinkling mountain stream, the roaring waves crashing on the rocky shore, the boom of the volcano erupting, the crack of thunder and know they are all but a whisper within the Great Sound.

'Out of the mystery of the Song that was the Great Sound, was created one known to us as Mana. This child was born of the very essence of Io, a wondrous force gifted to inhabit the realms of Time and Change.'

'Grandfather, did Mana jump all over the place? Was it like lightning shooting across the sky?' asked Ben, who was excited by the wonder of it all.

'Kau! No! Mana just was. Io gifted Mana to the Nothingness to be the timeless spirit, the stillness that stands complete of itself. Mana did not need to move, did not need to burst forth in flame to cross the Void. Just being was enough for Mana and it still is.'

Io gifted Mana to the Nothingness to be the timeless spirit, the stillness that stands complete of itself. Mana did not need to move, did not need to burst forth in flame to cross the Void. Just being was enough for Mana and it still is.

'Do I have Mana?' asked Mark, who was Ben's father. The children were drawing the adults into the stories.

'Ae, we all have Mana. Your Mana was gifted in your mother's womb. No one can take your Mana from you. It is of the Creator, yours alone, the sacred imprint for your journey.'

'This is new to me,' offered Mark, as he carefully placed more wood on the fire. 'I saw Mana as respect and good reputation, things earned, cloaks placed on our shoulders by others. This Mana is different, a gift from Spirit that cannot be taken from us by others, or destroyed by their actions and opinions. This Mana helps me understand the brave men and women who have endured prison and torture to uphold freedom and justice. They carry within an unquenchable flame, their Mana, their spirit of truth.'

'Ae! Kapai! Yes! Good, you understand the power of Mana. But, also remember that which you admire in them is also of you.

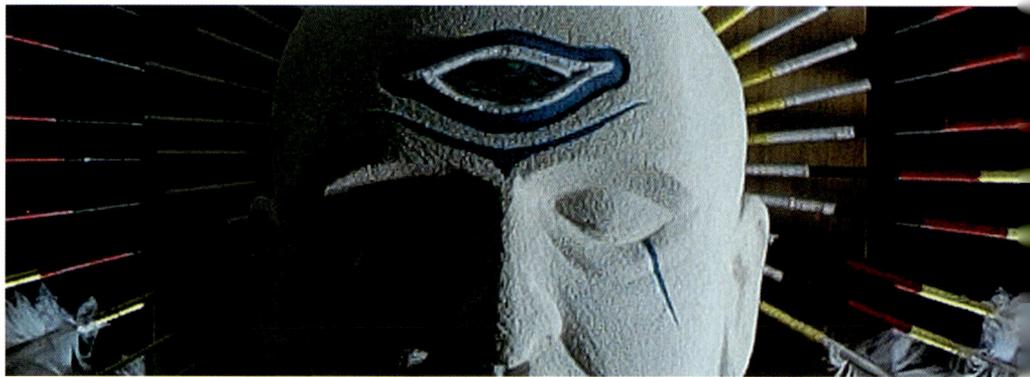

'Whenever we speak our truth, whenever we stand against the tide to hold true to the good, whenever we listen to our heart and act with compassion, whenever we forgive others, whenever we remember the sacredness and power of each word we send into the world, we stand tall in our Mana.

'However, remember the Mana of respect, that would seem to be earned, also has its truth. If you have the courage to be yourself, then you will always be in touch with the Mana of the womb and be respected.

'When the giant Totara Tree falls, its seed carries its life forward. So it is with us, for there is a Mana of the Family that is burnished by the achievements of our Ancestors. That Mana of the blood is handed down from generation to generation. It is born of the deeds of all who hold the name you carry. It is of your birth line, your whakapapa. And it speaks of integrity, of honouring the spirit of the Mana we are gifted for the journey.

'When Io created Mana, it sat still within the Void, a motionless coil of energy waiting to surge across the Universe. It could not move of itself. Until the Creator sang movement into it, Mana remained still.'

TE MAURI
The Excitement

Grandfather was surprised. He felt stronger now, buoyed by the old words that came so easily to him. The tiredness of recent days had fallen away. He was determined to lead the circle on, to hold this space and bring them to the magic of the Mauri.

Behold the wonder of Change

'Now Io called forth the Mauri to make the Mana move, to allow the Mana to surge and flow across the Nothingness.

'When Io created the Mauri, the Universe trembled with excitement because the Mauri is movement, energy in motion, the unfurling wave, the life force that turns and shapes, shifts and remakes all that is. The Mauri is the greatest of all the Children of Change; it is the ultimate vibration.

'All things have Mauri. You have Mauri, the trees have Mauri, lakes and rivers have Mauri, clouds and stones have Mauri. Mauri is the shape of life, and the Mauri gifted to each fragment of existence is different. The Mauri that tells a new leaf how to take the exact shape of the Nikau Palm is different from the Mauri that forms the needle leaf of the tall Totara. The Mauri that creates the clouds and calls forth the colours of the Rainbow is unlike that of any other. The Mauri that gives shape to Stone is unique to each.

'The Mauri is excitement… a restless, dynamic, passionate child. Rushing hither and thither, the Mauri fuels its excitement from opposites… ice and fire, darkness and light, pulse and repulse. Its joy is change without end.

'Io knew the Mauri's exciting nature and the risk of sending the Unpredictable into the Nothingness. Yet without the magic of the Mauri the Nothingness would reign supreme and there would never be a Circle of Life.

'While the Mana was a beautiful creation, a wonderful energy that gifted spirit to all life, it could not bring about the wider dream. It needed the power of the Mauri to move. Yet, the Mauri, if unrestrained, pushed everything to the brink, threatening to destroy all that was beautiful.

'Yet Io moved in trust, allowing Creation to risk all to attain all. Such was the knife edge to be walked on the trails of freedom.'

Although tempted to forge ahead, grandfather beckoned to his helpmate to take up the words. He had already exceeded his expectations, had carried the story forward with the voice of his own grandfather ringing in his ears.

The Mauri is excitement, the Life impulse that shapes each leaf, gives power to the stone and colour to the falling waters. The Mauri is movement, change, passion celebrating the creation of uniqueness again and again.

TE MAUI
The Design

Grandmother stood. She was happy to take up the story and relieved to see the old one had found strength in all he shared. Looking steadfastly at the dancing flames, she saw the opening to the next words.

Behold Design and Balance

Follow the path of the rains gifted from the sea. Follow the torrent down the mountain, over the waterfall, and know they are shaped by the Maui, the wonderful cycle of renewal that carries the waters back to the sea.

'This fire excites and warms, holds back the cold, serves as a friend, yet in another place it might take a life. Ae, it reveals the power of the Mauri as it shifts and shapes each flame and it does the same when it runs wild to consume all that it could claim.

'If you tremble at the thought of the Mauri running free and threatening the balance, remember Io's work was not yet done and shall never be.

'To allow the Mauri, that awesome excitement to exist, while saving the wonder of Creation, Io now sang another child into the Nothingness. It was named the Maui, the key to the continuance of life, for it offers order within the chaos born of the ever-changing Mauri.

'The Maui is insight and design, elegance and flow, rhythm and tide, lore shaped to abide until it has served its time. It is moved by a different wave, for its purpose is to bring order out of chaos, harmony out of disharmony and to hold the balance.

'The Maui is pattern and pulse. Look to the brilliant stars that turn through this night, the Moon that waxes and wanes to mark our journey and the Sun that orders each day and know they move to the Maui. Reflect upon the changing colours of spring, summer, autumn and winter and know you sit within the wonder of the Maui. See the winds gather water from the ocean to send the newly formed clouds to gift rain and snow to the mountains and think of the rivers that carry it back to the sea again. All that is of the Maui, the ever-turning circles of renewal — the spirals of existence.

'Understand the way of it. Io, with wisdom beyond our understanding, saw the Creative Spirit, the one that sits close to Chaos, had to be born before order. Thus was the Mauri set free to quest and seek, to move and grow, to shift and shape without restraint. Freedom was the gift that opened all to change.

'Then the Maui was placed in the Universe to give shape to freedom and allow the Universe to know balance and harmony, to experience the supreme understanding, to bring all into the Circle of Life.

'Thus, in the Creation of Creation, natural laws emerged for the purpose of the survival of all that is, even the survival of survival itself. There is no ultimate end; everything is of the Beginning without End, for eternity walks with us every day.'

Grandmother held that moment in her cupped hand. Offered it to the circle around the fire, as if inviting them to conjure up an ageless place, to walk beyond time into an everlasting now.

'Let us take a while to rest, to stretch and roam the shore. Return on the conch's call!' announced the old one as she nodded to Rewi, who was the keeper of the giant shell.

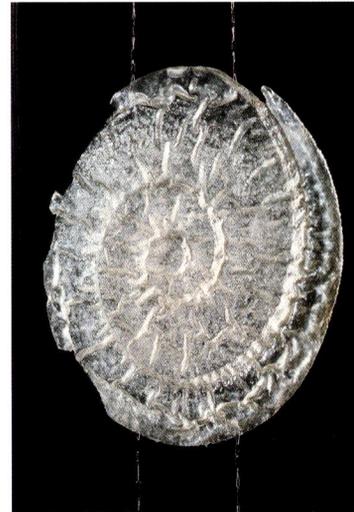

There is great power in a name

Some drifted away, but others came closer to the old ones. As grandmother walked a few paces from the fire, Miriam, young Ben's mother, followed her.

'You have a bright boy in that one,' smiled grandmother.

'Yes, and I love grandfather's little joke. Nicknaming him Smoke is just right. He's always near the fire… colour and light excite him… and he drifts around… comes and goes… you know how it is with five-year-old boys.' Her next words came slowly, and strangely enough they came as no surprise.

'Is grandfather deaf? My husband told him three times that his name was Mark not Spark, but nothing changed. Then my Miriam became Flame.'

Grandmother laughed, she was going to have to explain the old one to the world yet once again. 'He is not deaf. He hears you very well, in fact hears too well at times. No, it's not lack of hearing that brings on this naming thing, it's lack of memory. He simply cannot recall people's names, particularly English ones, they fall out of his mind like drops of rain. So he creates names, bestows them without asking and always remembers them.'

'But why do the new names stick with him?' asked Miriam.

'There is a trick to it,' replied grandmother, 'for he ties the new name to their actions, their gifts and their spirit. He means no disrespect. He sees with eyes that go deep, feels a pulse that is timeless and touches into hidden promise. Over the years many have come to cherish their new name.

'He has named your family for the power you bring to tending the fire. Ask him what he sees in each name. Know that he takes nothing away, but seeks to add colour to spirit.'

'What should I call you?' asked Miriam. 'Despite the colour of my skin, I am more white than Maori, and don't know what to say, for I hear others use Whaea which is aunty or mother, and some use Kuia, which I think means wise woman.'

'Miriam, use what is comfortable… do the same with grandfather who will be called Poua by some, or even Koro… meaning teacher.'

The Maui shifts within the turmoil of the tides to shape their rise and fall to answer a greater call. All touched by elegance and design reveals the power of the Maui.

As she turned to leave, Miriam said, 'I have decided on Kuia and I'm happy for you to call me Flame.'

Watching Flame walk away, grandmother thought, 'Koro has won again… he reaches people in many ways… at least he's never tried to give me a new name… but come that day…'

When grandmother returned to the fire, she felt strong and alert, despite the lateness of the night. Then she realised some around the fire had begun "gifting in return", sending her their awhi across the flames, offering a nurture that sustains. It was like the old days. She had already been given much in response to her words.

The conch sounded. Rewi had heard her silent call. People gathered slowly and the circle settled. With a brief nod, grandmother suggested to grandfather he might like to speak. He replied by taking up the beautifully carved gourd that rested at her feet.

TE WAIRUA
The Joining of the Waters

Moving in the Power of Spirit

Grandfather held the gourd high against the night and poured a sparkling stream of water into the flames. A white cloud erupted, flung ash outward and made the children ask for more. The old one obliged again and again until grandmother caught his eye and signalled "one last time".

'Ha! See that! Where did the water go?'

'It got dried up,' responded a young girl in a firm voice. Grandfather had named her "Mist", the ethereal one. She was often with Smoke, although he was younger.

'Sometimes you even see it rising off the road,' Mist continued, for her agile child-mind had shifted quickly from the fire to the Sun, 'but not always, because it can be invisible when it's getting dried up.'

'Ae! Kapai! Well done. Because water can be visible and invisible, the Ancestors used it to describe the next child Io created to end the loneliness of the Nothingness. Its name is Wairua.

'Io was about to create the stars and set them moving in space and then make the first people. Io wanted to give people the freedom to move and think and become all they wished to be. Yet there was danger in this, for they might wander far away, forget Io and become lost and alone. To avoid this, Io gifted Wairua to the Nothingness.

'When I think of Wairua I remember that "wai" means water, the life giver, and "rua" means two. And I think of the meeting of two waters, the waters of here and now and those of the unseen, the place of the Ancestors.

'I know Wairua joins this moment with all that has been, opens today to yesterday, guides me into tomorrow and enables me to move in the power of Spirit. It helps me step beyond myself, to reach for the stars and, if I wander too far, shows me the way home.

'Remember, Wairua is of the dreaming where time folds over time to bring us into the Eternal. Wairua is the spirit that touches all that has ever been and will ever be, it is of the seen and the unseen.'

Remember, the Wairua holds fast to all that is true. It moves when the waters of this realm join with the realms of the Ancestors. The Wairua defies Time and Space to align all with Spirit.

The Wairua is the Dreaming
where Time folds over Time to
embrace the Eternal.
The Wairua is the Spirit
that joins all that has been with
all that will be.
It is of the Unseen.

The Womb of Darkness

Now grandmother rose to bring these teachings to an end. It was time to close this first circle, time to bring together all they had walked this night, time to help them begin to shape the Pouwhenua, the marker they might carve to carry in their mind. And time to remember that each Pouwhenua created would be unique, for we all see the world in different ways.

'We have spoken long into this night beneath these stars and still not come to the moment of their creation. For all we have shared is of the Song of the Spirit, set within the Womb of Darkness.

'We began with the Nothingness and saw how Io sang Time into the Nothingness to allow for the Becoming.

'Then Io created Mana and Mauri and allowed the child named Change to play. Thus was the way opened to freedom, to powerful energies that might plunge all into the Chaos. Yet Io, with wisdom Eternal, created the Maui to send design and balance into the Chaos to bring forth harmony.

'Then to prepare the way for the making of the stars and the people of the stars, Io created Wairua, the spirit that would join all that existed in the Universe. And Wairua moved to remind us we are forever of Io and that Truth marks the way home — Truth born of the Darkness and the Light.

'And Io saw that it was good, and began to chant the song that gave Birth to Life. But that story is for the stars of another night. It is time to take our rest, to carry to our beds the words shared and to see if they have found a home in the depths of the mind.

'We have walked together to the first marker, the first Pouwhenua and shared much that has been forgotten or put aside. Yet, all that has been revealed is of our old bones, of our story, of the fabric that fashioned our lives. Take from it only what is true for you, only what is worthy of your journey. Take from the kete we have opened only the thoughts that evoke a deeper awareness, an excitement that sings of you.'

Remember, above all else, to yourself be true

Grandfather stood to offer his closing karakia to the last of the night. His words flowed from the warmth of the circle to greet dawn's first light. They spoke of gratitude for the opportunity to share, of the need to support each other, and the strength to go forward and endure.

And there was a particular mention of children for they had found a voice before this fire that opened the way for others of greater years. Innocence dances and seeks no applause, for the young live in the moment and have the confidence to make the unknown voyage.

KARAKIA

The old one carefully gained the seat, and smiled. Stiffened limbs worried him not at all; his concern was always for mind and spirit. As long as the old words flowed he was happy.

Grandmother gently rested her hand over his, and whispered, 'They will return… I hear they want to call you Koro… the teacher… is that okay?'

Grandfather stared into the dancing flames and smiled. She saw contentment in his face; saw a journey well begun, a glimmer of hope for tomorrow and the days to come. 'Ae, Koro's fine… they already name you Kui… the children started that… you are their wise woman… so they got one name right.'

Strong hands helped them to their feet and, for the first time in many years, they stood taller. Dark is the night that knows no end. A new day beckoned.

There was a time when the Earth and Sky were One

In the journey of the Sun,

in the day ending and the

new day begun, we see the

Maui gifting rhythm and tide,

lore shaped to abide until it

has served its time.

SONG OF THE FIRE OF LIFE

Tinana! Tinana! Tinana!

Let matter Be!

Let there be Fire!

Let there be Suns to warm the Universe,

Moons to push back the night,

Planets to hold the birthing Stones and

Comets to light the trails

of Space and Time.

There was a time when smoke from
the ancient birthing fires shut out the Sun,
and Earth and Sky were one - and all
was darkness and life had not begun.

Then the children of Earth and Sky
thrust their parents apart to let in
the light - and allowed the beginning
of life.

Then Io Mata Ngaro sent Tane to
create beautiful birds and tall trees,
and Tangaroa to seed the seas - and life
flourished, but there were no people.

Then Tane searched for the uha
of an earth woman, the feminine essence,
and found it not, so he fashioned her
out of red clay - and named her
Hine Ahu One.

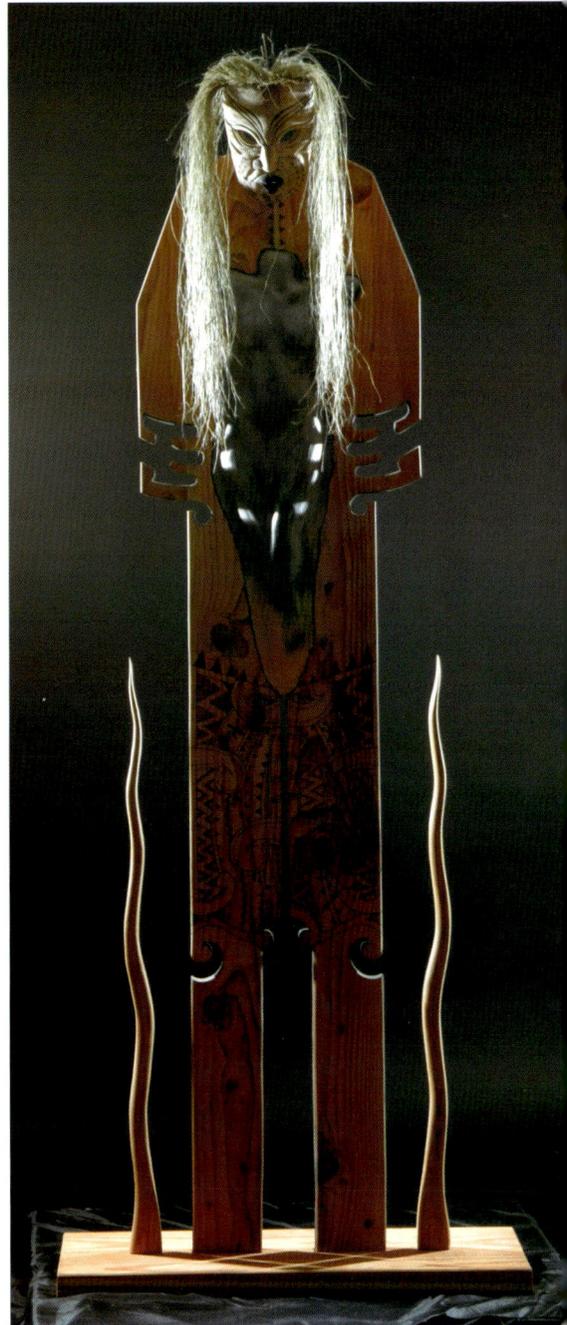

TE AO MARAMA

The World of Light and Life

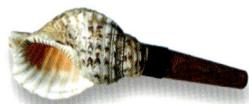

The wind stirred and caressed the fire to bring forth its flame, as the circle formed once more under the darkening sky. They had returned and the numbers were greater than before. Others had answered the call, heard the excitement that ran along the kumara vine and followed it to this shore.

'I've heard whispers,' confided Koro quietly, 'that we journey to the second Pouwhenua tonight to speak of the Fire of Life. How could they know?'

'I may have mentioned on the marae that Koro might share the story of the Creation of the First Woman tonight,' responded grandmother with a chuckle.

'Ae! And you would let me tell that story? You have always claimed that right and that will not change tonight.'

'True! But I used your name to entice the women, and the men will follow to learn the mystery of such attraction,' she answered, nearly losing her balance on her perch as she shook with laughter. The old one had to place a steadying hand on her shoulder.

'So, I get to tell it for the first time?'

'No!' she laughed. 'You have enough to do giving people new names.'

Rested and ready, the old ones sat in silence as the circle shifted and reformed to make room for all. They hoped there was time enough to complete what needed to be done, for the winter of life drew nigh and the days flew by.

Having begun they still questioned their place, questioned the right of age to bring such ancient lore into today, questioned their ability to share the journey lost to so many, but still honoured by some. Yet, for all their questioning, they felt committed, stronger even. If just a few understood and carried the lore forward, it might be enough.

When Rewi sounded the conch, the old one stood, grounded his talking stick to hold his balance, and sent his prayer to greet the Ancestors and embrace the circle of the fire.

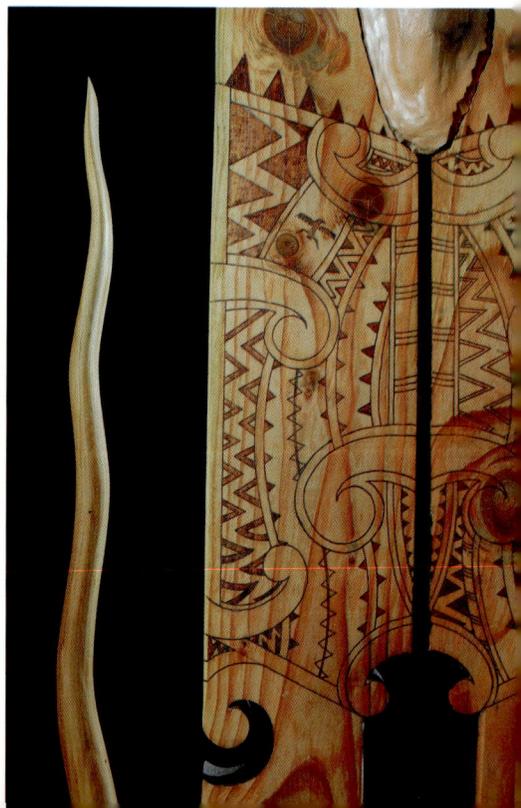

KARAKIA

Once again grandfather's words lifted the circle into a special space. None could describe the feeling that lingered, but all knew a new journey had begun. Thus was the way opened to the second marker, the Pouwhenua that held the imprint of the Fire of Life.

When the old one sat, grandmother broke into a chant that described Io Mata Ngaro creating the stars that led to the seeding of life.

Let Matter Be

'Tinana! Tinana! Tinana!

'Let Matter Be! Let there be Fire!

'Let there be Suns to warm the Universe, Moons to push back the night, Stars to bring beauty to the skies,
Planets to hold the birthing stones, and Comets to dance the long trails of Space and Time.

'Let there be many Great Houses, each a Galaxy of Worlds joined to honour the Dream that is a Song.'

That a woman sang those words seemed very right, for mothers are of the Womb of Life.

The Earth and Sky were One

The old one paused, lifting her eyes to shift their gaze to the stars. There was great learning in silence and stillness.

'Kui, was this when Earth was born?' asked, a woman named "Mountain", not for her size, for she was slender, but for her affinity with stone. She was grandfather's doctor. So she occasionally became "Volcano", not for her glorious Irish red hair, but for her fire when he strayed from the prescribed way.

'Ae! The star scientists say Earth was once a star, a radiant, swirling sphere of nuclear fire,' replied grandmother. 'Then after years beyond counting, that fire dimmed and died to create endless night, a great darkness that cloaked the planet.'

Push back the darkness, bring forth the bright stars that celebrate the light. Creation sings to us whenever we pause to honour the night.

'But, Kui, where was the Sun?' asked Mountain, who was being drawn deeper and deeper into the mystery of the stars. Her years of study had not included astrophysics. 'I know much of bones, but little about space.'

'The Sun was shining brightly, but its light could not penetrate the dust and smoke that shrouded Earth. Until the first rains came and cleaned the skies, there could be no light, and without light there could be no life.'

'Kui, how long did the Earth wait for the first rains to come?' asked a twelve-year-old boy born of the green, western lands, who found it hard to imagine a world without rain. He would soon receive "Torrent" as his name, for he was born of Fran and Mick. Few saw him as Mist's older brother, because her silent, ethereal way was utterly alien to his rushing, surging spirit. They were very different sides of the same coin.

'Many hundreds and hundreds of millions of years, who truly knows, for it was a long, slow journey out of the darkness,' answered the old one.

Let in the Sun

Grandmother paused, for she knew they travelled into deep waters, where the teachings stretched the mind. Better to keep it as simple as possible. Ae, it was time to teach through a story.

'We have an old story that says there was a time when the Sun did not shine and the Earth and Sky were one. Although it echoes the star scientists' descriptions of the beginnings of our planet, its origins are best seen in later times when massive volcanic eruptions, or huge meteor strikes, created so much dust they blocked the Sun's light.

'Many peoples have stories of massive events that changed the planet. The Mayans speak of the age of the Sun of Waters, the Sun of Earthquake, the Sun of Hurricanes and the Sun of Fire. The Buddhist sacred texts describe epochs marked by Suns that relate to water, fire and wind. All appear to have stories of the Deluge, the Great Flood.'

'Kui, please tell us about the arrival of the light and the creation of the First Woman'

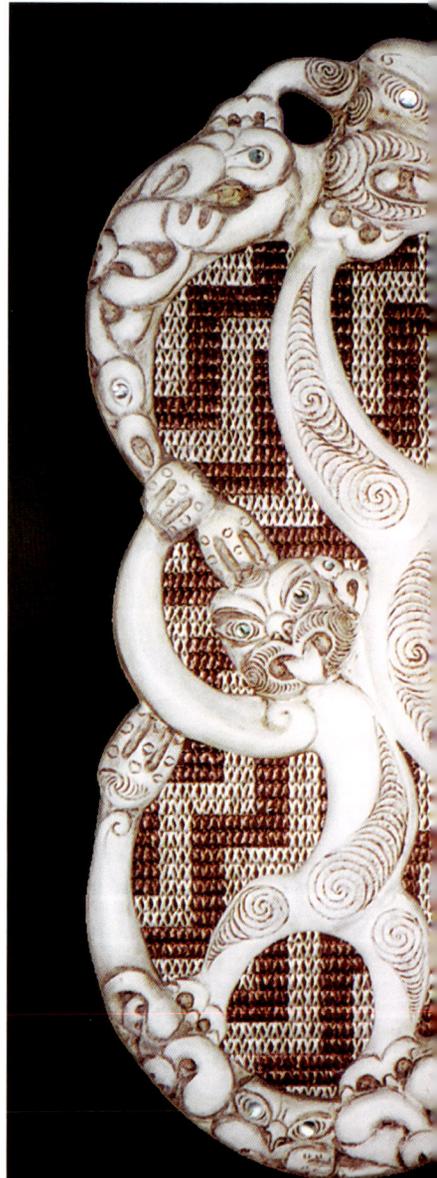

pleaded a teenager in a quiet, Tongan voice. She had attached herself so closely to Rewi, the conch blower and was so determined to learn to sound the giant shell, that grandfather had named her "Echo". She was a music student with a fine singing voice and a natural skill with the drum. Yet, she held back and was so shy in her talent she might just give up. Standing alone, being out there, was too much to bear. To hear her voice across the circle was a surprise and a joy. Perhaps Rewi was behind that.

'Many of you know those stories well,' responded the old one with a smile, 'and because a good story only gets better with the telling, I'm happy to repeat them.

'Long, long ago, when the stars were very young, Ranginui, the Sky Father, loved Papatuanuku, the Earth Mother, so much he held her so close he shut out the light of the Sun.

'Their seven children lived in a deep darkness broken only by shifting shadows that moved at the edge of their sight. Then came the day when Ranginui turned ever so slightly, to reveal to Tane Mahuta a small ray of light. And Tane said to his brothers —

> "There is a world beyond this darkness that is colourful and bright. Let us push our parents apart to let in the light."

'Only Tawhiri Matea, the keeper of the winds, disagreed and would not help when the others tried to separate their Father and Mother.

'Rongo-marae-roa, the Peace Maker, and Haumeatiketike, the Keeper of Fruits beneath the soils, were so gentle in their efforts they merely tickled their parents and made them laugh.

'Then Tangaroa, Guardian of the Waters, sent surging tides between and, although he washed the land clean, he failed to sweep Ranginui aside.

'Now Ruaumoko, Creator of Earthquakes, sent shock after shock through the darkness to shatter mountains standing tall, but moved not his parents at all.

'Angered by these futile efforts, Tumatauenga, the Maker of War, struck again and again, and spilt his Mother's blood upon the soil.

> "Enough!" cried Tane Mahuta. "You achieve nothing with such savage thrusts."

'Squirming around until his back was on his Mother's breasts, Tane gathered his knees to his chest, planted his feet over his Father's heart and using all his strength began to slowly cleave them apart.

Tane gathered his knees to his chest, planted his feet over his Father's heart and with the help of his brothers thrust Earth and Sky apart.

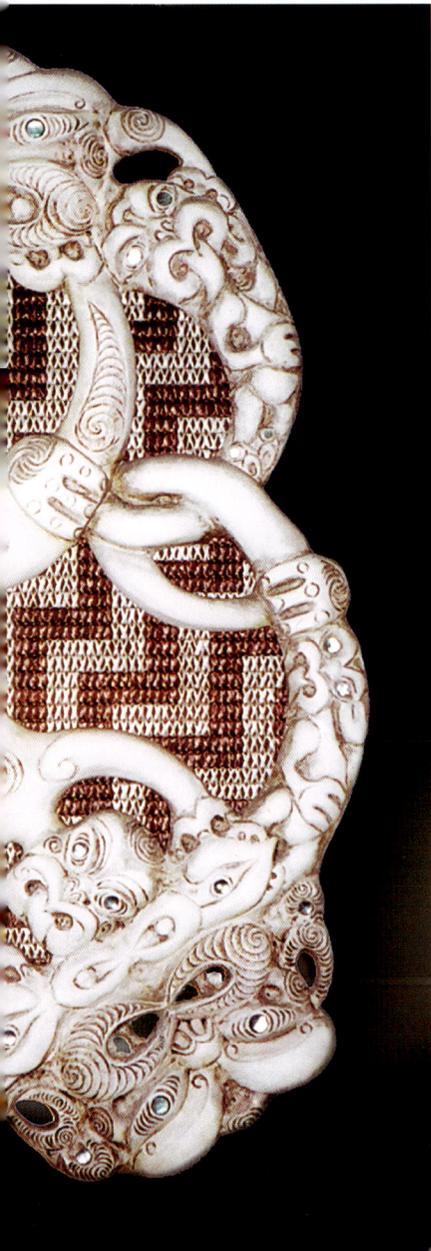

'None know how long Tane pushed. Some even suggest one moon fell from the skies before he gained passage for the first ray of light. We do know that ray struck the sharp edge of a rampart of rock and split into many parts to end the darkness. Some say that site marks the beginning of Earth Time.

'Tane's last mighty thrust cast Ranginui, his Father, into the heavens to create the brilliant blue of the sky. And the light of the Sun reached everywhere to foster life.

'Ranginui, with undiminished love, remembers all that was and is no more, and weeps to make the gentle rain. Papatuanuku, still yearning for the caress of her lover, leaves her tears as dew upon the grass.

'Their love for their children remains; there is no blame. While some say it is sad that the children had to set their parents aside to find the world of light, others say the child's journey is both towards and away from its parents.

'Doesn't the wisdom of old tell us we raise the child but to let it go? And in the letting go, don't we free the child to a space that allows us to still walk hand-in-hand? A place where each know the light that helps them grow. If this is true, may it ever be so.'

Grandmother paused, smiled, nodded to the circle and sat. Those close to her saw she needed to rest and were not surprised to hear her say…

'Walk the shore. Find a place apart from others. Look to the growing light of the Moon. Be alone, each and every one, be with the stars, the ocean and the stones and remember you are of them and more.

'When the conch calls return!'

The Sun penetrated the gloom to create Earth Time, the new dawn, the turning of the seasons and the promise of life.

TIHEI MAURI ORA
The Breath of Life

All is born of Change

The sound of the great conch travelled along the shore. The circle gathered and settled. A piece of wood tossed on the fire by Flame sent a shower of sparks drifting into the darkness. A wave whispered its message and a gentle breeze carried it off forevermore.

Grandmother rose from the bench and stood very still, waiting, knowing someone was finding the courage to ask a question. She smiled to herself when a youngster broke the silence. It was Mist's twin brother who happily answered to "Rain". So many were surrendering their given name.

'Kui, is the land sinking into the sea?' was Rain's anxious query.

'Not today and not tomorrow,' she responded gently. 'Why do you ask?'

'It was in a book. The pictures showed the land sinking. It looked real scary!'

'Ae! What you saw is true. The land did sink under the sea and then it rose again. Where we sit tonight was once the ocean bed. Remember all that happened long ago. Even before Koro was a boy like you.'

Joining in the laughter, she stooped and took a stone from the kete at her feet. Crossing the circle she placed it in Rain's hands.

Every stone has its

story and so do we.

'Look closely at this broken stone and you will begin to unravel one of the mysteries of the planet. It was gathered from a mountain, high above the sea, but has sea shells and fish bones trapped within it. The stone you hold was once part of the ocean floor. The stones remember they are of the beginning and the shells remember they are of the sea.'

Unravel the Mystery

See in Tane's finely
tattooed thighs, the curling
waves of the Old Tides
contending with the land,
and the rivers carving
through the mountains.
In their endless quest for
balance, the meeting of
two forces produces a third.
That is also our way, for the
male essence finds completion
in the seed tides of the
woman, and the woman
knows completion in
the birthing of a child.

Pausing, grandmother reached into her kete again, took out a large conical shell and handed it to Mist, the other twin. 'What do you hear when you place it to your ear?'

'Kui, I hear the sea!' was Mist's excited reply. 'I hear the roar of the sea!'

The shell now moved rapidly from ear to ear. All held it close to hear the song of the sea echo from its inner spiral.

'You are right. The sea is powerful, and its power has purpose. Some say the sea is jealous, that it was once the consort of Papatuanuku, the Earth Mother, that its waters covered her, possessing her completely.

'But, nothing lasts forever. So there came a time when Ranginui became her lover and the Earth and Sky were one. And later still, when the great rains came and the Sun appeared, Papatuanuku heaved her shoulders out of the ocean and let the waters run as rivers to reach the tides. Thus did the land rise above the waves to be shaped anew, through countless turnings of time.

'Now the sea, in its anger born of rejection, attacks the land again and again. Its relentless waves pound the beaches and its storm tides ravage the headlands. The struggle never ceases, for even on the calmest days the waters tease the sands along the strand.

'The land accepts the challenge, accepts the lore of change and sees within the struggle a balance, for what is taken is gifted back in another age. There are times when the land reclaims all that was lost as it remakes the shore.

'The stones reveal that story. They remember the fish whose bones have turned to stone and the seabed rising to become tall mountains.'

'But, how can that be, Kui?' asked Rain, who still firmly gripped the white stone. 'How can this stone remember?'

'I love your question. It makes me realise that I may not have an answer. Let's think about this together, let's see if we can understand the meaning of the old words.'

'It's simple, Kui,' suggested Huia, the thirteen-year-old girl daughter of Silver and Rata, who came to the fire as wood gatherers.

'When Mum goes shopping she makes a list, that's how she remembers. Well, doesn't the white

stone have a list in it? You know, the fish bones, and bird bones and other stuff that tells its story. That's how the stone remembers.'

Instant applause came from the circle around the fire. And laughter too, for the girl's answer rang true.

'Thank you. That's a wonderful answer, Huia. How quickly your young mind outstripped mine. If we see the stone as the carrier of a list, that's how it remembers. When stone scientists read that list, they unravel the story of the stone and see its long journey through time. It sometimes speaks of the simple life-forms that first emerged in our world, of the rise and fall of the dinosaurs and the arrival of humankind. Such is the remembering of the white stone.

'Other stones tell a different story. Some hold in thrall the ancient forests that sank beneath the waters millions of years ago and became bright, black coal. Others speak of immense heat and pressure, of the forces that fashioned wondrous diamonds or the warm lustre of gold. Even the story of the unfolding of the Universe is written in stone.'

Honour the Ancestors before the Ancestors

Grandmother retrieved the white stone and held it high for all to see. Then she raised beside it a beautiful Pounamu, known to some as greenstone.

'Remember how I called stone the first Ancestor? Stone contained the building blocks of life and allowed the emergence of cells, and over countless millions of years plants, fish, birds, land creatures and humans.'

'But my parents were not stone, Kui,' cried Huia, who wanted to understand this mystery.

'That is true,' she responded, 'neither were their parents or their grandparents, or any remembered Ancestors. Yet, I still say stone is the first ancestor and to understand that we need to go back to the birthing of the stars, to the Beginning that we know as Creation.

'Remember that in the Beginning was the Nothingness and into the Nothingness came the Great Sound, and we say that was the Word and out of the Word came life and all that is. That is how the teachers of the old knowledge described the unfathomable mystery of Creation.

'Today the star scientists tell us the Universe began with a sound that ignited millions upon millions of nuclear fires that became suns, the bright stars of the night. Those that cooled became planets, firmaments with a stony crust that encased a molten core. Others became moons, companions circling forever within an ordained orbit.

'Within the stone that is the crust of our planet, Io placed the building blocks of life, all the elements necessary for the creation of life. Everything that grows and moves, brings forth seed to produce its own likeness, owes its beginnings

Tendrils of life, vulnerable shoots of hope, reached for the light. Thus did the plants grow and the great forests flourish to clothe the land.

to stone. Stone is indeed, our first ancestor,' ended grandmother.

'Kui, is that why the mountains are called Ancestors?' asked a new voice from across the fire.

'Ae!' she responded with a chuckle. 'The great mysteries often have simple answers. The mountains are the Tupuna, the Stone People standing tall, our first Ancestors.'

We are the sum of all that has been

Grandmother paused, recalling something that sat on the edge of memory.

When you touch stone you join again with your first Ancestor.

'Long ago, when I was but a young girl, the elders of the day, the teachers who sowed the seeds we harvest now, gave me these words…

"Remember all the lines of life go back to the Word, to the Fire and to the Stone.

"Understand time is the Seed of Life and change is the Birth of Life.

"I was fire and became a stone… a stone and became a plant… a plant and became a fish… a fish and became a bird… a bird and became a mammal… a mammal and became a human… a human and became dust… dust and became a stone.

"In each of these things, I was no more, or less, than the others."

'We are the sum of all that has ever been. Everything is of the Being and the Becoming, of the Circle of Life.'

We are children of the stars

The old ones knew they had far to travel this night, back to the birth of humankind, to Hawaiki, the greatest of mysteries. Grandmother gathered her strength to carry the journey forward. She wished to spare grandfather, who was born but three months before her, and needed to take as much of the load as she could. While she had carried their seven children and thrived in their nurture, he had carried his people, had answered the call of the marae.

They had honoured their iwi, had weathered the storms of life and been ravaged by the simple passage of time. Yet, she was now the stronger, for nothing had savaged her heart.

'Where is your Hawaiki?' asked grandmother, as she stretched her arms wide as if to embrace the world.

'Samoa… Tonga… Holland… Aotearoa… Ireland,' cried those who knew that Hawaiki meant their homeland.

'Wonderful, you know the sea trail of your people. But where is the first Hawaiki, the first homeland?'

A deep silence gathered to the circle. Those of greater years, who carried the answer, made no response, for young minds gained much when they sat comfortably within silence.

When grandmother slowly raised her hand above her head to point to the night, she immediately got a question.

'Kui, is it hidden in the stars?' asked Smoke in a tentative voice.

'Ae! The Ancestors tell us we are born of the stars and that has been the story of much of this night. We are children of the stars, for this planet was once a fiery star. Yet, the old lore says more, says we return to them when we die. Ae, return to the first Hawaiki from whence our spirit arrived.

'Tuatara marks the trail of our journey back to the stars, for the ancient one of the third eye opens the way to the deepest knowledge and the realms between.

'When our stories speak of the return to the stars, it is not just the return of the spirit in death, it is the return of the old lore that speaks as clearly today as

Everything was ready, waiting for the arrival of light. Time blessed the union of water, rock and Sun, and the story of the Tree People, the Bird People and the Whale People had begun.

We speak of
separation
of Earth and Sky,
yet is there
greater learning
in seeing them
joined by light?

it did in ancient times. When we open our eyes to the vastness of space and time, when we go back to the Word, the Fire and the Stone, we begin to know the wonder of the human journey.'

'But where did people come from, Kui?' asked Mist. 'Where did the first people come from?'

TE TANGATA
The Human Kind

Find the Uha of Woman

'The creation of life is filled with great mystery. Humans like to think they are first in everything, but in truth we are latecomers on the planet. Fish, birds, dinosaurs, reptiles and trees were here long before us.

'The old story tells us we are born of the land itself, of the earth and that we all descend from one woman.

'When Io asked Tane to create life on Earth, Tane knew he had to find the uha, or feminine essence, and mate with it. So to bring forth birds he embraced Kahu Parauri, daughter of the stars, a being of flight. From this mating came a magical world of colourful birds that filled the day with endless song. In the same way, he seeded the trees to provide berries to feed them.

'However, when he came to the creation of ira tangata, of human life, Tane searched everywhere for the uha of an earth-born woman, but that female essence was nowhere to be found. It was said to be — "te kitea, te rawea, te whiwhia" — unseen, unsuitable, unacquired.

'In his disappointment Tane cried to the heavens, "The uha of woman is not here. Yet, it is time for the human kind to walk this world. Io of the Twelfth Heaven, help me!" '

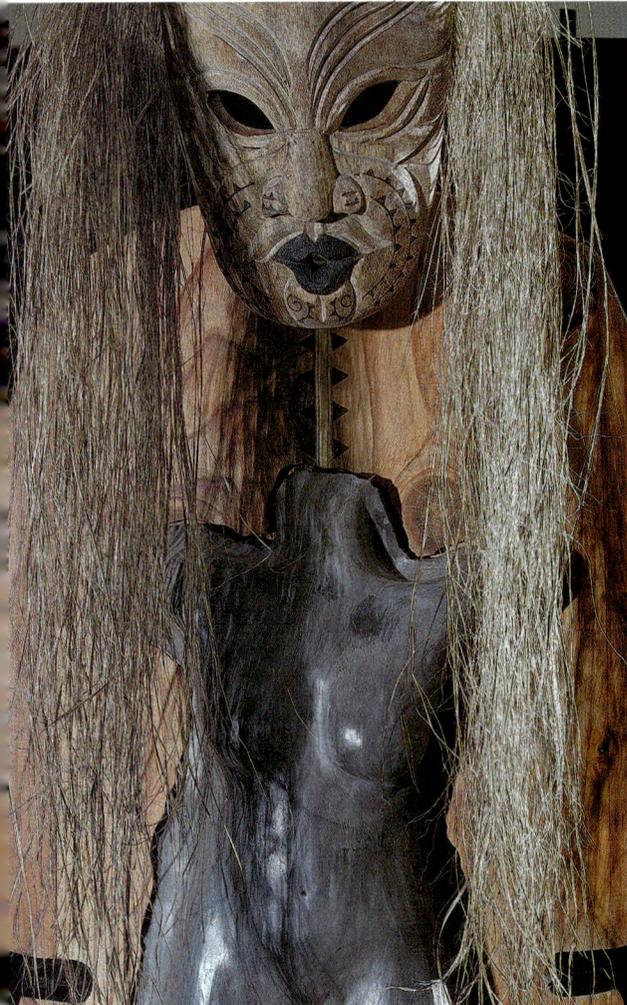

Tane tried to find the essence of an Earth Woman to create the human kind.

Mould the red clay

'Hearing Tane's anguished cry from afar, Io said,

"Trust your hands and follow your heart and bring the beauty of woman out of the red earth."

'Tane plunged his strong hands into the hard, red clay of Kokowai and wrenched it away. Then softening it with water, the nectar of life, he shaped it, with loving hands and a kind heart, into a woman of remarkable beauty. However, despite her perfection, she was empty of life, so Tane said…

"Io of the Twelfth Heaven, please quicken this woman to life."

'In that instant, Rehua, Keeper of Knowledge, flew from the stars with a basket of gifts and said to Tane…

"I place in this woman her Mana, the indestructible essence that is born of the Spirit of Io. And the Mauri that has the power to move the Mana that this woman holds close.

"In the Mana and the Mauri may her uniqueness pass from mother to child down the corridors of time.

"I also gift the Wairua, the spirit that joins all with Io, and the red courage that is blood.

"Finally, Tane, know that this woman is to be your wife. It is for you to gift to her the breath of life."

'Tane looked upon the beauty of the woman who lay so still before him. He saw within her the power that is of the uha, the feminine, and the loving, nurturing heart that but awaited the life spark.

'Reaching out, as if to gather fire from the Sun, he gifted to her the manawa ora, the breath of light. And the Earth Maiden quickened and stirred and embraced life.

'When she opened her eyes it was to smile upon Tane, her father, who named her Hine Ahu One, and loved her and took her as wife. And she was not afraid for she was made in his image.'

Ask the posts and the rafters

The Unseen One moved through Tane to fashion Life with invisible hands. It is impossible to capture and hold light.

'The Sun turned through the heavens and Hine Ahu One became heavy with child and gave birth to Hine Ti Tama, the Dawn Maiden, who was the First Daughter of Time.

'Hine Ti Tama grew into a woman of great beauty. Her eyes sparkled like fire-flame and her long flowing hair shimmered with the colours of the rainbow. And this daughter of Tane also bore his children and was filled with the joy of life until she asked her mother Hine Ahu One…

"Where is the grandfather who will teach my children?
Who is my father?"

'And Hine Ahu One replied…

"Ask the posts, the rafters and battens of this house, ask it of the trees, the birds, the insects and the light that makes the day. They are also of the one who is your father."

'Now Hine Ti Tama knew Tane was both her father and her husband. She stood before him and announced she was leaving to dwell in the Underworld and chanted the prayer that set her free.

'Her parting words were…

"Fare thee well, Tane. I take a new name, for I go to that shadowed place through which all pass on their journey back to the stars. Henceforth I am Hine Nui Te Po, the Guardian of the Dead."

'Thus did Hine Ti Tama leave to protect the spirit of her children as they journeyed through the Underworld, the realm where Whiro stalked the darkness to destroy the descendants of Tane.

'Hine Nui Te Po honours that call to this very day, for we are all of the ancient lines that are ira tangata. All descend from Hine Ti Tama, the First Daughter of Time. And we are guided by Hine Nui Te Po, as we travel the wondrous trails that carry us home to the stars.'

It had been a long, wonderful night. The stars began to fade into dawn's growing light. Their Koro's closing karakia greeted the return of the Sun, one journey was done and another begun.

KARAKIA

The circle remained silent and unbroken for a long time after the prayer. Embraced by a stillness born of the moment, and heightened by the whispering wind and the hushing waves, they reflected on this night.

Helping each other to their feet, the old ones sought their rest.

'So much shared, yet so much still to bring anew to this age,' said grandmother. 'Is there time enough? Can the journey still be made?'

'We but sow the seed,' he responded, 'and the seed carries the dream of what is yet to be.'

'Ae, that is so, Koro.'

They smiled as they caught their first glimpse of the newborn Sun. They had journeyed well to meet the Pouwhenua that reflected the Fire of Life.

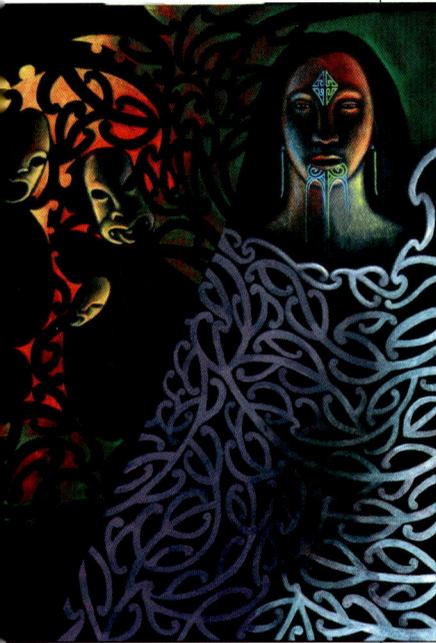

Hine Te Tama, the First Daughter of Time, went into the Underworld to keep Tane's children safe as they departed this life. She became Hine Nui Te Po, the Guardian of the Dead.

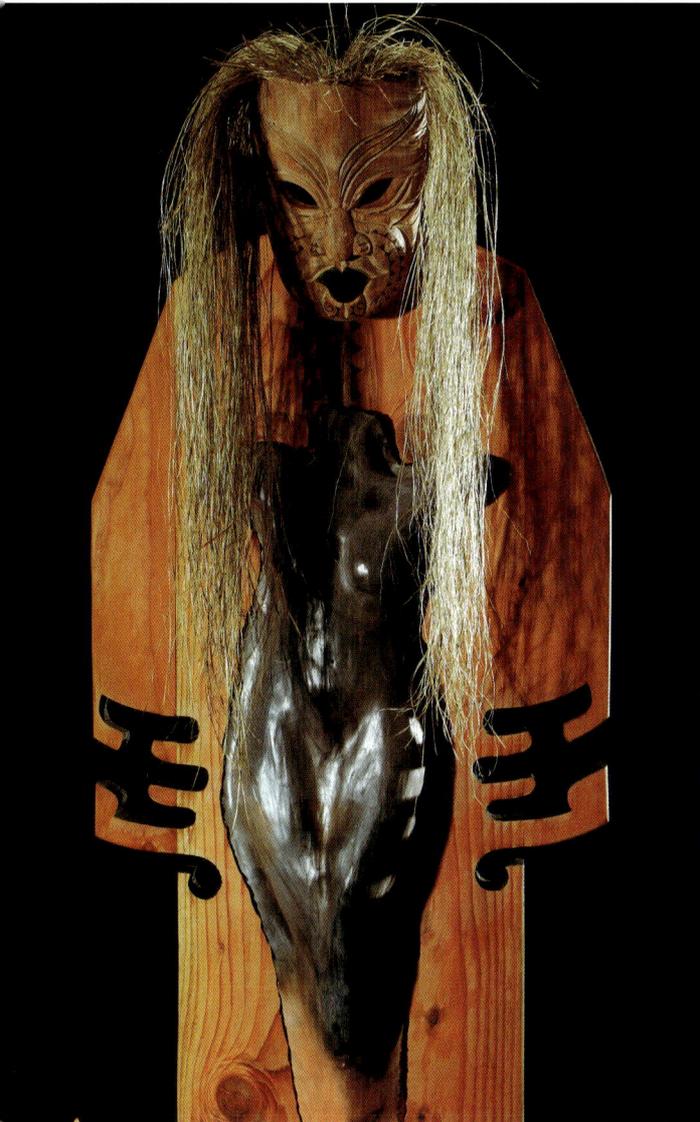

The Fire of Life

was a gift from the Sun.

Tane used its warming

light to bring forth trees,

insects and birds,

and when that work

was done he created

the human kind.

Such is the power

of the Flame.

Knowledge fires the mind

SONG OF THE ANCIENT LORE

Rehua,

the Star of Knowledge,

offered hope to all.

Yet, knowledge

is a two-edged blade,

for it has the power

to create in good ways

or destroy.

Tane took the first Earth Woman as wife
and their children became as numerous as
the sands upon the shore.

And Tane saw his people needed to honour
spirit with warm hearts and powerful minds.
So he rode a great arrow to the distant stars and
came to Rehua, the House of Knowledge,
and was gifted Three Baskets of a good kind.

Tane placed them with those of gentle mind,
with Wisdom Keepers who would keep the
sacred pure, respect the Eternal Tides and raise
stones on high to remember we are born of
Earth and Sky.

When Whiro, Tane's jealous brother, demanded
access to all the Baskets and was denied,
he rode the red cloak of anger across the
vastness of space to seize from Rehua
the terrible Knowledge of War.

That upset the balance and challenged the people
to learn compassion as they journeyed through
this world.

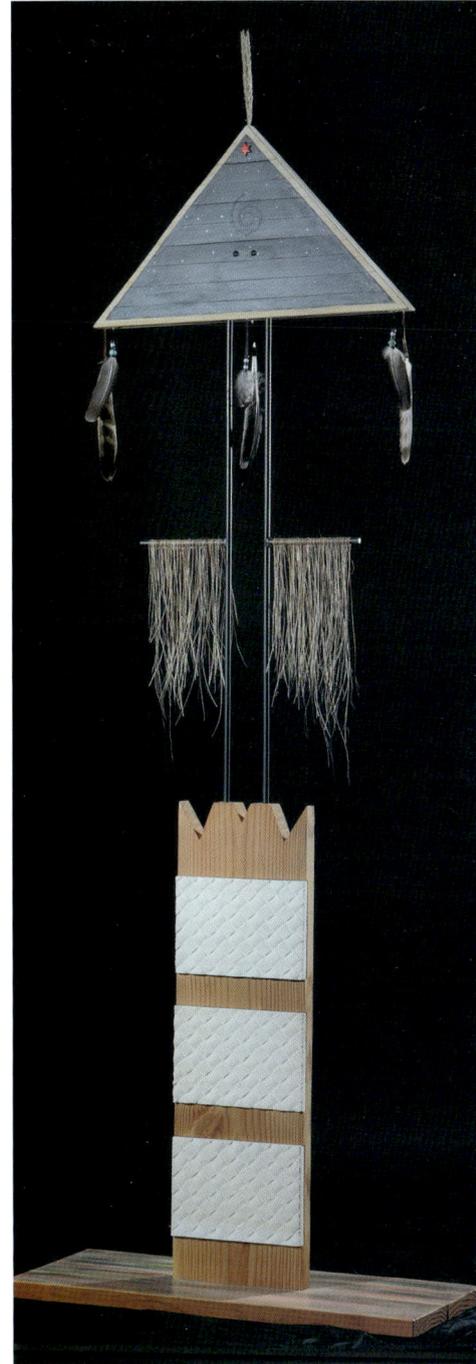

TE MATAURANGA
The Knowledge

Once again they gathered to the circle of the fire. It was cooler tonight, for earlier in the day rain had swept across the Sun and thunder had come. The air had an edge of freshness and was alive with the smell of the lightning's touch. Those who tended the flame, by day and night, had kept it alive despite the storm and would do so until the journey was done, for that was the old way.

The conch sounded faintly in the distance. Rewi and Echo were further down the beach getting in some practice in the failing light. Echo still sought her song within the curving shell.

'They are even more relaxed tonight,' observed grandfather.

'Ae, and they buzz with interest, Koro. They think you will speak of the Wananga, that you will share old lore long hidden in that House of Learning. I told them the rumours were true. Did I do right?' she asked as she struggled with her laughter.

'Let us see what the stars say?' responded the old one with a smile. 'You may confirm, but I may deny. That's the way with rumours.'

The word on the marae was threaded with a growing excitement. The circle held; its centre, the crucial core that gave it shape, was stronger. Silver, Rata and their daughter, Huia, gathered firewood for Spark, Flame and little Smoke. Mountain was true to her name, strong, aware of all that happened about her and seeing beyond the horizon. Mist and her twin, Rain, were already close to Smoke and reaching out to Sean who was soon to be renamed Scree. And old Rusty had come for the first time and promised to return. For such a friend to make the effort, despite his illness, was a great commitment.

The old ones might soon reveal their pain and allow others to do the same. Trust was such a fragile child.

'Could the old knowledge truly heal? Could it fly beyond the barriers of age to give direction and light a new flame? Could it reach the fair and the dark, the blue-eyed and the brown, the country girl and the city boy? Was it able to help them feel accepted, to feel they all had a place in this land and this age?'

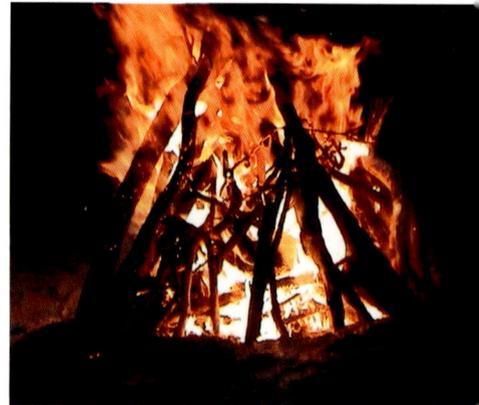

Fire awakens knowledge, quickens our vision to help us dream again, and lights the way when we are lost. It calls us home.

Such were the thoughts of the old ones as they made the journey within to gather their strength to lead the circle to the third Pouwhenua, the tall post in the mind created to honour the Ancient Lore.

A large piece of wood tossed on the fire sent a shower of sparks drifting into the darkness. A wave whispered its message as it met the stones along the shore. Then the conch sounded from close by and all settled.

Grandfather stood with gentle assistance and sent his karakia into the circle to open the way for grandmother to begin.

KARAKIA

And the Wairua moved and they came again to the old voice that lifts the mind. They trusted their journey, felt more and more that it was of this time, felt that the courage they needed would be found in the mystery of each night.

Honour the Three Baskets

'We have honoured the place of the Word, the Fire and the Stone in our journey', said grandmother. 'We have heard the story of the creation of the First Woman out of the red clay and the birthing of her child, Hine Ti Tama, the Dawn Maiden, the First Daughter of Time. We know the gifts Rehua brought from the stars to ensure humankind was beautifully formed in body and spirit, but we have yet to see how Rehua gifted to us the magic of the seeker's mind and the wisdom that guided our Ancestors down the rivers of time.

'When the light first came into our world, all was newness, excitement and confusion. The Mana and the Mauri moved with huge energy to create life in so many forms that the Maui struggled to bring order. Some stars even strayed from their allotted orbits and the children of Hine Ahu One, the First Woman, were prisoners of the needs of the moment. The people lacked knowledge and understanding.

'Rehua, the Keeper of Knowledge, saw the travails of the people, saw them living in ignorance and saw them taking little notice of how today's acts harm tomorrow's world. So he reached across the vastness of the stars to offer these kind words…

"Tane Mahuta, it is time to bring to your people another kind of light, fly the heavens and come to my side."

'With great courage Tane climbed a giant kauri tree and rode an arrow to the House of Rehua.

"Greetings Tane, you have flown the stars to help your people gain insight and learn to fly their minds. Before you are the Three Kete of Knowledge, the greatest treasures I can offer the human kind.

The sacred knowledge
is born of the stars,
of tides that carry us
through the Universe
and of minds that
span the realms between.

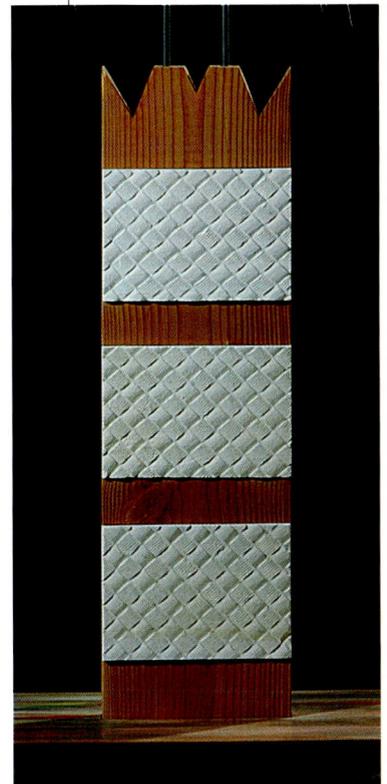

57

"They contain ancient star lore and teach that how you walk the trails of life, how you journey, is more important than arriving."

'Tane knew that only those who followed the ways of humility, gentleness and peace could be entrusted with this knowledge.'

The tides of envy ride high

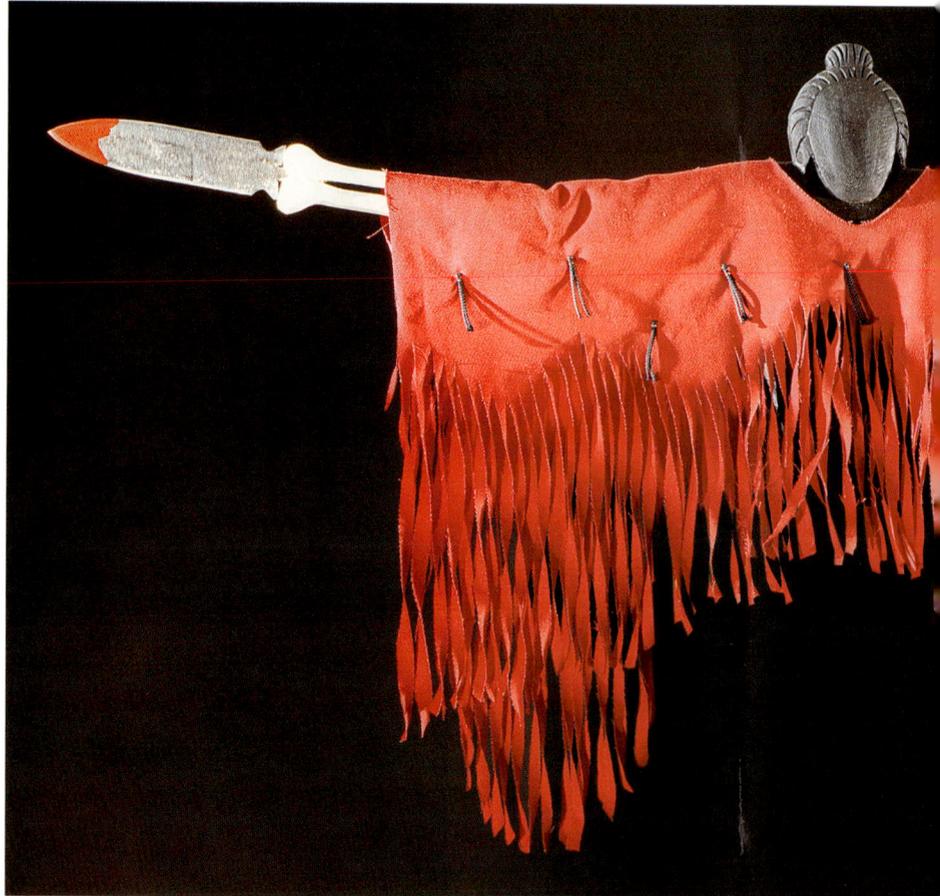

Fear rules the heart of those who deal in pain. Fear tears the soul apart and lets our wells of compassion leak away.

'When Whiro, Tane's brother, demanded the Knowledge, Tane saw Whiro's eyes were filled with envy and the need to take. So he quietly told Whiro he could have all the baskets if he put his anger aside and walked in the gentle way.

'Whiro refused, harnessed his rage and flew the heavens to seize from Rehua the Basket that held the terrible Knowledge of War.

'There was great sadness in this, for Whiro's anger trapped him in a world where all was out of balance. Although a man in stature, he was still a child driven by fears born of strange and dangerous tides. He used knowledge without understanding and twisted it to serve the path of pain.

'Thus did he turn brother against brother and kin against kin, until blood was spilt in anger upon the Earth that is our Mother.

'Yet, Tane and the people still loved Whiro, even though he bound the world in pain. Whiro's actions challenged their courage, their understanding and their love every day. Yet, they discovered that when they met his rage with compassion they grew stronger in spirit and the good way.

'Thus began the Age of Matauranga, the Time of Knowledge.'

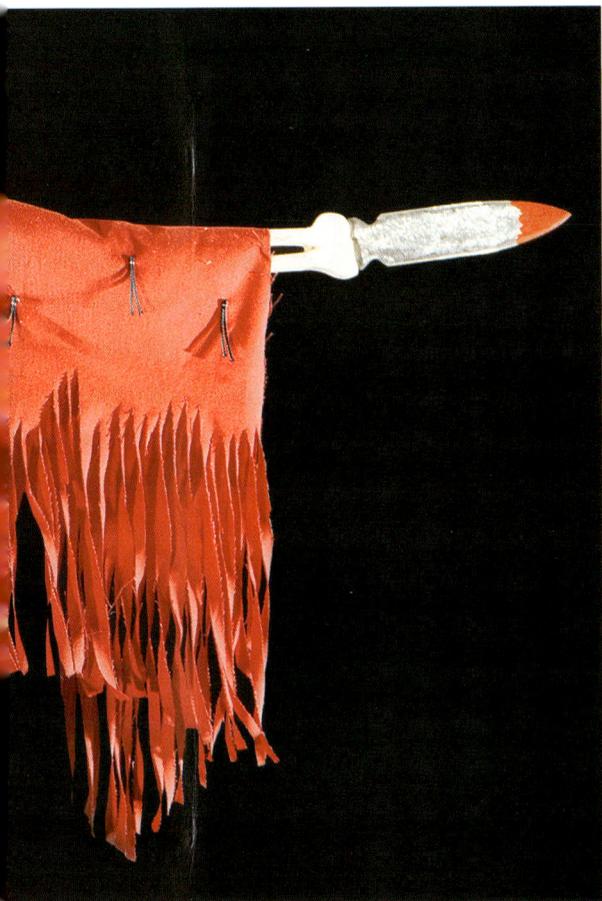

Grandmother rested now. Bringing the name of Whiro to the fire brought sharply to mind her two soldier boys lost to terrible wars on distant shores. A young life does not fade with the passing of time; it does not lose its colours. Children are not meant to pass away before their mothers.

Yet her spirit was strong, because hope was the promise of the Three Baskets, hope nurtured by all who by the good abide. It is written in the Knowledge, in the tides of the open mind. She decided to release them from the fire for a while.

'We have carried the Three Baskets of Knowledge to this place across the great divide of space. Think on that, warm yourself by the fire or walk the shore.

'When the conch calls you back to the circle, grandfather will lead you into the world of Wananga.'

Whiro's eyes were filled with envy and the need to take. He gathered about himself the red cloak of anger, flew to the outer reaches of space and returned with the terrible knowledge of war.

TE WANANGA
The Learning

Grandfather felt reassured by the number who came to sit around the fire. Perhaps it was not too late to pass the old things on.

'Why have we waited so long… because we thought they were not ready… because we were not ready… that's closer to it… wanting to hide… saving our last days to fish the reef… all of that and more… but we got caught… carried here on an incoming tide…'

Catching the old one's quiet words, grandmother replied, 'Ae, we got caught and its time for you to ride the next wave.'

Knowledge was kept in a different way

Grandfather slowly stood to carry the teaching forward. Expectation mounted as the old one prepared to speak. Rumour held true; he would take them into the Lore of the Wananga, the House of Learning.

'The Word is everything. Remember how Io sent the Word into the Nothingness to bring forth all that is and create the Universe.

'Now the word flies so fast around the planet it is hard to keep up with it. There are few secrets, for the net that joins the people of the planet reveals all. The knowledge thus shared is like a river running in the flood tide to breach old banks and reach new oceans.

'There is good in this and a darkness too, for some gather knowledge to follow the ways of Whiro that cause pain. Others in their ignorance move with knowledge too powerful for them to safely contain.

'Our Ancestors shared knowledge in a different way. They divided it into two realms, one open to everyone and another open to few.'

'That doesn't seem fair, Koro!' cried Huia.

'I agree, it does seem to exclude the many and serve the few. But that was not the way of it. In reality the few were called to serve the many. It was a another age, an era when the challenges of life were met in a different way.'

We kept the ancient streams of knowledge as pure as the waters of the mountain lakes. To muddy the waters was to lose our way in the clouded mind.

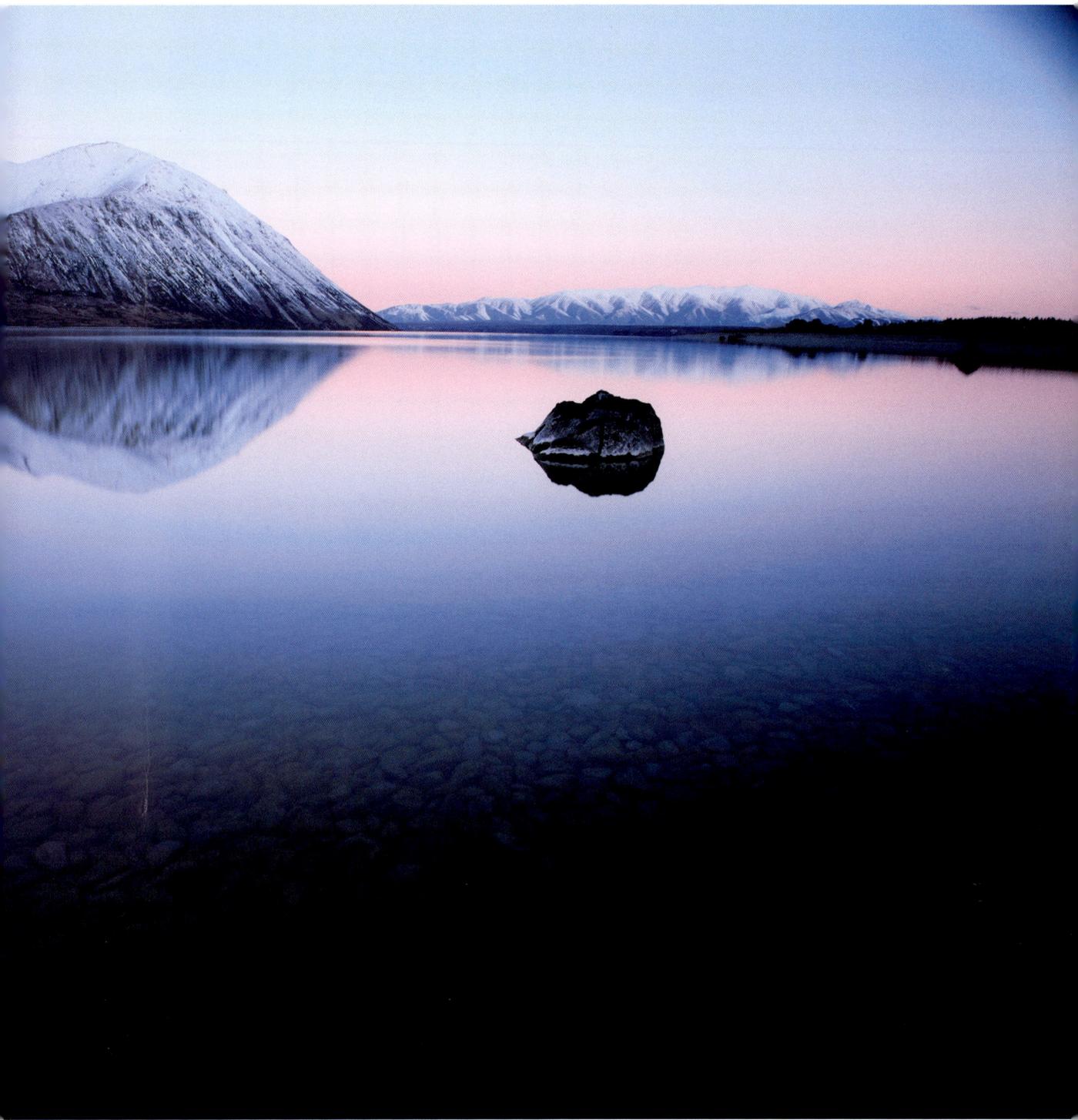

Keep the Word pure

'There were no books in that time, no texts to make sure the facts were kept straight, no means by which everyone had the opportunity to learn what they wanted and to get it right.

'There were no tide tables printed in a newspaper to help you know exactly when the seas would fall and rise. There were no daily weather forecasts available to all, no long-range predictions in magazines to help the gardeners decide which crops would do well that year and tell the sailors if it was safe to voyage back to the homelands.

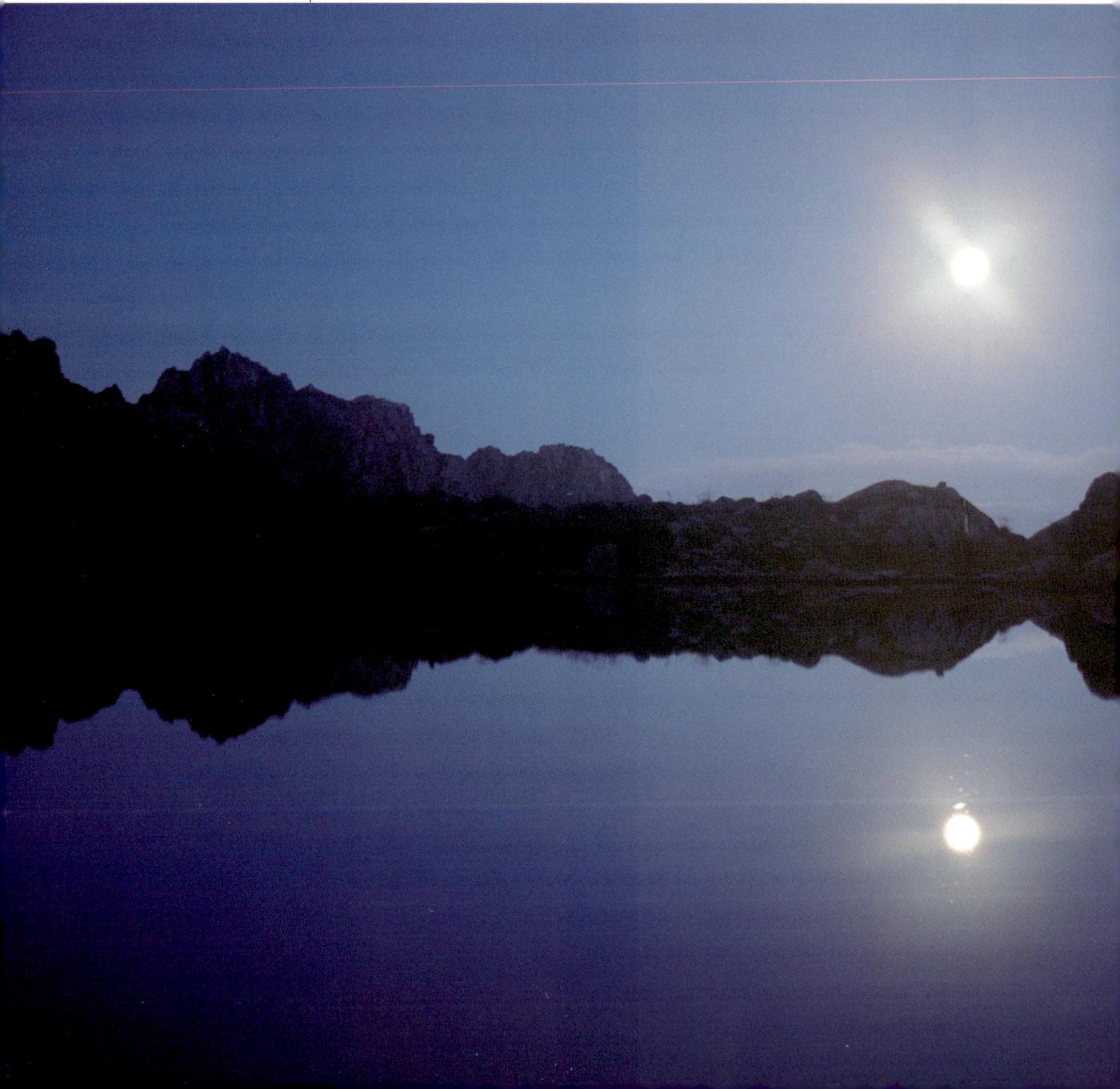

'Yet, knowing those things was essential to survival. Get the fishing tides wrong and you might drown, plant kumara in a warm, damp year and it would die of mould. Voyage back to the homelands when a hurricane gathers to swoop down and your waka might never arrive and never be found.

'When all knowledge was held in song, when it was of the spoken word, it was vital to entrust it to those of exceptional mind and judgment.

'Only those with a good mind and gentle heart are called to sit with the higher learning housed within the Wananga. We know them as Tohunga, the wisdom keepers who carry the old lore and honour the sacred. And they are more, for while they stand tall in their knowledge, which we say is of the upper jaw, they are but the servants of the people; men and women born to serve the nation, not themselves.'

'Where did the teachings of the Wananga come from, Koro? Are they all from the Three Baskets of Knowledge or do some come from another place?' asked Rata.

Aoraki is more than a mountain

'There is a story that suggests the Wananga was brought to this land by Aoraki and his brothers.

'Some say this story is of the time of the ancient ones, the first Ancestors, but others say it belongs to those who came later, for they also had the right to place their word in the land.

'When we stand beneath Aoraki, the tallest mountain, it reminds us of a legend that speaks of remarkable Ancestors.

'Long, long ago when there were other stars in the sky, Aoraki, the son of the Sky Father, asked his three brothers to help him build a great waka out of clouds and fly to Earth to visit Papatuanuku and their Earth cousins.

'When the work was done Aoraki chanted an ancient karakia of awesome power to send their waka across the tides of space. His words held true and he swiftly flew the winds of time to pass safely across the face of the Moon, through the rings of fire to land on Earth.

Aoraki sent his karakia into the depths of space and sent his waka in its wake. It swept across the bright Moon, past towering mountain peaks, and called the waka to a village on a shore where the Old Tides meet.

63

People rejoiced when Aoraki and his brothers opened the way to the magic of the Rainbow Mind.

'Papatuanuku welcomed them with a gentle, warm embrace when their waka landed after its long voyage through space.

'However, the people, who had seen this waka plunge out of the sky, had fled far and wide. When they eventually reappeared they grew bold and gave the visitors a warm welcome.

'Thus did all gather in the night to share lore unrivalled by anything known before. Aoraki, the first brother to rise, sang to Matariki, the great star cluster that guided the Ancestors of old, and when he finished the stars danced in the sky.

'Then Rarakirua sang to Mere Pounamu, the star of the healing stone, and drew cheers of joy when her colours changed from a brilliant green to a beautiful rainbow hue and back again.

'Now Rarakiroa sang to summon torrential rains to beat upon the roof, terrible winds, and lightning to strike the forest and devour the trees with flame. When the song ended it all seemed a thing of dreams, for it was dry outside and there was no sign of fire. The people realised they had journeyed into the hidden trails of the mind.

'Rakirua then called their waka to rest above their heads and as it shimmered in the light of the fire, he sang of his Father's love for the Earth Mother.

'With tears of joy the people sang to honour the magic of the moment, for their cousins, the star children, had come to share their knowledge.'

Carry the Lore for others

'Thus did the people, in the days that followed, learn of the passage of the stars, how to read the seasons still to come, the rhythms of the Moon that turned within the tides of the ocean and the tides of the mind.

'This deep wisdom was placed in the Whare Wananga, the House of Learning, where it might be forever safe. And Aoraki cautioned those who walked with the new lore to remember they carried it to serve others.

'It was a joyous day when Aoraki and his brothers sat within their waka to chart the journey home, for much had been learned.

'Sending a karakia to the stars to open a path to the stars, Aoraki launched the fiery waka into the blue of the sky and it rose high, Then, to the shock of all, it suddenly tumbled and crashed far from the shore.

'Those watching in despair lifted their heads in hope when the four brothers emerged to drag themselves onto the waka's shattered side. Yet, the watchers did not rejoice for long, for even at a distance they could see none would survive.

'Then words of ancient power echoed across the waves to fill the people with awe. Before their eyes Aoraki and his brothers were turned to stone.

'We see them in the south; our four tallest mountain peaks reaching ever skyward, in the sunshine and the rain, yearning to be with Ranginui, the Father, once again.

'Some say the karakia Aoraki used to carry them home was chanted incorrectly. But others think our Father in the Sky gave them back to us to be our kaitiaki, to protect us and remind us to respect the sacred lore of the Whare Wananga.

'When you stand beneath Aoraki and his brothers, when you feel small as you gaze upon their soaring heights, remember we are all of the stars, all children of the Universe, one beneath the Sky. We are all descended from ancient tides.'

Aoraki is an Ancestor, a star rider, a knowledge seeker and lore bringer, who paid a great price for all he shared.

TE MARAMATANGA
The Understanding

Grandfather felt drawn to continue. This surprised him, for he had decided earlier he would say little this night, thinking it better to let his companion weave the stories. Yet, here he was, pushing himself to stand again and speak of the darkness and the light.

Something magical moved here, and it was not just a thing of age. Even the children, who were sometimes lost in the words, were excited and sustained.

The true darkness has no source

'When the hawk flies high, the teacher stretches the mind,' said grandfather. 'It is time to explore worlds hidden in ancient lore.

'Awake in the darkness of the night and all is cloaked from sight. Yet light one candle and that single flame reveals the magic of a world once hidden. Light penetrates and illuminates the mystery that is life.

'The darkness is indestructible for it has no source. Although it retreats before the light it returns the instant there is no flame. It is of the eternal seed tides, the Womb of the Universe.'

'Koro, when you speak of the everlasting darkness, I feel lost... really afraid... it's so... alien... so... mindless... it evokes a sense of evil...' confessed Silver.

'Ae! The darkness has a bad name, but an undeserved one,' sighed grandfather, 'it has been made to take the blame for many human failings. We love to excuse the inexcusable, the evil we do, by blaming it on something else. It's so easy to say evil is of the darkness, but that is not true.

'Remember we are conceived within the darkness of a mother's womb and birthed to the light. The darkness is, and we are, and how we relate to the darkness is of our mind. It is easy to confuse the darkness that is the Womb of Creation with the darkness of the soul, the shadow that obscures the inner light.'

Falcon flight, so swift and sure, and fast enough to deceive the eye, challenges the mind.

66

Beware of the darkness of the mind

'Remember Whiro, the angry one who seized the basket of war. He chose to live in the underworld, because he could not live in the light.'

'Little Brother, why did Whiro want to walk the way of violence and pain? Why did he choose to deal in death rather than life?' asked Rusty, who was a year older than grandfather. He supported his old friends by asking questions that brought the teachings squarely into this time. Pretending ignorance, putting the issue there, was the essence of this elder's style. He wanted to encourage youth to be bolder.

'As ever, your questions cut swiftly to the truth,' laughed grandfather.

'The old lore says Whiro remains forever incomplete, prey to emotions born of angry tides that thrive on ignorance, blinded to spirit by the arrogant mind, and doubt, the first child of fear. Ae! Fear rules his heart, casts long shadows that shut out the wonder of the light.

'What Whiro is, Whiro wants to be. Remember that Tane offered him the Three Baskets filled with light, offered everything for a good life, and he refused. He was not prepared to put his anger aside. It ran so deep and with such fierce heat that it consumed the will to learn and grow, and be complete. His anger became his shield against the light.'

We grow in the light of understanding

'The light is the loom, the weaver of the colours that bring us into completeness. Light is of the harmony, the supreme understanding. The light of understanding is Maramatanga, the mother of many children, the greatest of whom is love. Love is creation, the ultimate gift of Io. Love is the continuance of life, the survival of the species. Without love there is no life.

'Love has many children. Some say the first child of love is trust. Others make no distinctions and speak of nurture and caring, of kindness and gentleness, of sharing and healing, of protecting and giving.

'The flame of love provides the means to grow into all we are capable of becoming. It brings us back to the Mana, the truth of our being, and the Mauri, the creative energy that moves within us, and calls upon the Maui to help us find harmony. Love is of the understanding, the dreamtime that reaches into the widest of worlds.

'Within the understanding we remember that all are kin. That stone is the ancestor of all, that Tane created the trees, the birds and the people. That each and every family is joined one to the other, that separation is illusion.

Some say Tane and Whiro are really one, that they reside in everyone. Our Tane follows the good and seeks the Sun. Our Whiro feeds anger and loses its way. We choose the path to follow. We set the course of each day.

'This understanding brings us into the Circle of Life that is of Io, and holds our place in it.

'All is connected, the light and the darkness, the stars and the mind, the future and the past, the whales and the people, the rainbow and the dream, and the being and the becoming. That is the understanding born of the light.

'When we forget this, we turn our backs on Maramatanga and we create disharmony within the many realms. We blow out the candle and let Whiro and the children of ignorance ravage the wonders of creation.

'Io set in motion the light of the Sun and the Moon to remind us of his love by day and by night.

'Io knew that by giving us the freedom to fly our minds and follow our hearts, creation was placed at risk. The trails of love and the pathways of hate were both opened to us. We could build or destroy, heal or wound, live in hope or fear. Yet, within that circle of life, natural laws emerged for the purpose of the survival of all that is, even survival itself.'

'Koro, haven't you spoken of this survival lore before?' asked Rata, who was very good at keeping the score.

'Ae,' laughed the old one, 'but we return to go deeper. It's where the path leads tomorrow.

'This brings us to the turning of the stars, the long trails of the Moon, the great path of the Sun and the mysteries of the natural law. And to the Maui, the force that seeks to move all into balance.'

Grandfather sat, remaining very still, he looked intently at the fire. From time to time those who tended it had quietly placed wood to feed the flames. He knew there was much to lose if the light failed to reach into the darkness. It was hard to stand at the end of a long life and keep the dream alive.

Then he looked into the faces of those who waited expectantly in the silence that gathered. He was drawn again to the children, their brown faces, fair faces, the dark-eyed and the blue-eyed, those with black hair that shone like ebony and others with red or flaxen tresses that reflected the colours of the flame. Hope flared again. All were joined within the circle. They had travelled to the Pouwhenua that stood tall to honour the Lore that was of the stars born. They had been there together.

'Koro, are you going to tell us a Maui story? Will it be about him capturing the Sun?' asked Mist.

'Perhaps,' was grandfather's jovial response, 'but first we must rest, for this night is done. When we return we sail to ancient waters to meet the Whale that was this land. Then, if you are still awake, there will be a Maui story, but it may not be about the Sun, for in my mind I see a Fish.'

'Is it a chocolate one?' cried Scree, who was just coming awake.
His mother hugged him closer and whispered. 'Koro is speaking about a story, the fish you want will have to wait.'

When their laughter fell away, grandfather stood to close this teaching.
The words of his karakia came easily, for he was warmed by something that went beyond the fire.

KARAKIA

The old ones sat for a while. There was no need to hurry, for their helpers were busy. It was good to have time to reflect. Silver sat across from them, sat in silence as she thought of the last three nights. Koro and Kuia filled her mind… the calm that surrounded them… the gentleness… a presence that invited trust… they seemed to have no idea of how deeply they touched others… so much power in their words… there was much to look at in her life.

'I think we did okay,' said grandfather, with a grin that added more lines to his chiselled face.

'Do you really?' replied grandmother with her soft smile. 'At least you confirmed the rumours I started on the marae. Ae, we did okay,' she concluded with a straight face, which she held for but a moment.

Their burst of laughter drew the remnant to them. But the old ones smiled and refused to share. Some things take decades to blend and grow into their fullness; like a fine wine.

We are of the endless becoming

We speak of separation,
of the need to connect again,
for we see ourselves set apart.
Yet, that is an illusion.
Every turning of the Moon
touches our internal tides,
our very breath is a gift from
the trees, and every sip of
water gathers to sustain the
life stream that is our blood.
We are creatures fuelled by
a network of connecting light.

SONG OF THE
WATERS AND THE LAND

Ancient memory

speaks of the Deluge,

the greatest of storms.

For the winds blew

as never before,

the rains fell to cover all,

and the ocean rose

to drown the shore.

Few survived to greet

the dawn.

Everything is of the Becoming,
the realm of Change that honours the Spirit
of the Unseen - everything is of the Dream.

This land was once a Whale that guarded
the waters where the Old Tides meet,
then the ice shields melted and the ocean
rose and the Whale plunged deep.

Then the Ancestors sailed into the Deluge,
the greatest Storm known to time,
and the Waka of the Gods was hit on
every side and barely survived.

Then the Unseen one sent mercy
on the Winds and turned the Waka and
its crew to Stone and the mountains held
their spirit and their names.

Then the Sun returned and Io sent the
Sting Ray to help the Waka
meet the challenge of the Old Tides,
for this land was bound into
the Ring of Fire.

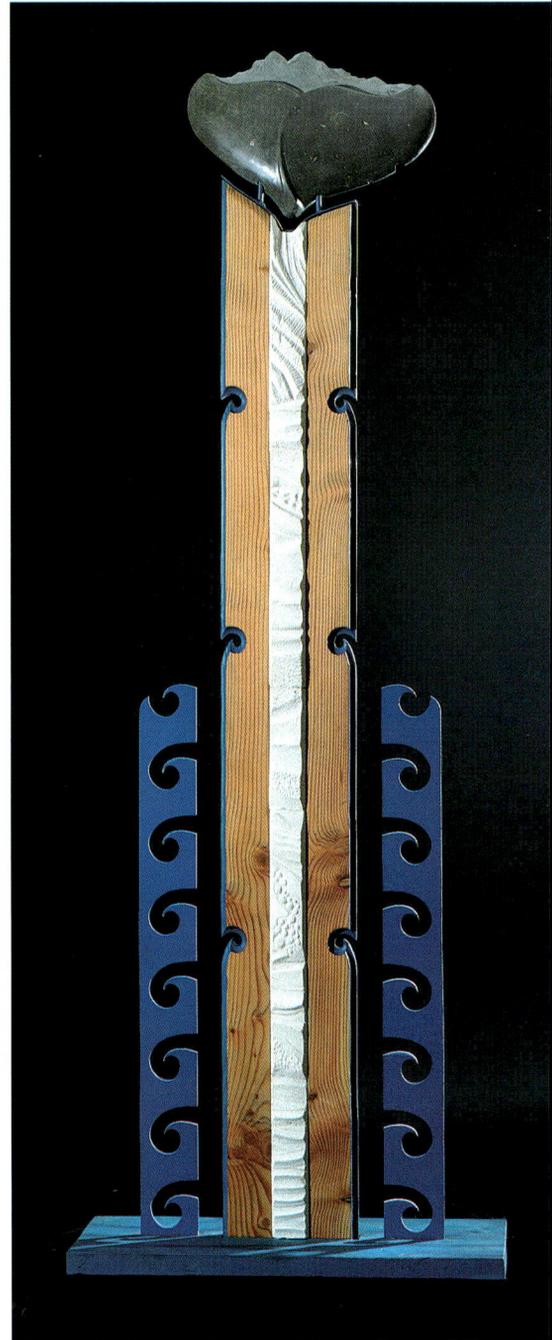

THE BECOMING
HINE MOANA

The Waters of Life

The cry of the conch called to them again. The circle was slow to form tonight. Some found the broken days and long dark nights a stretch, for they were still locked into old habits of time that bound the mind.

> 'Yesterday seems an age away,' grandmother whispered to the old one, as they sat before the fire. 'Time has little meaning in this place. I love its freedom and forget the world beyond this circle. But deep down I know that's just an escape.'

> 'We can't just turn aside,' responded grandfather, with a smile. 'Somehow, the old things have to bring meaning to the new and make sense in the world of today.'

> 'Ae. I'm ready to lead this circle to the fourth Pouwhenua, the carved post that holds the song of the Waka,' said his companion. 'It is all about change but I am going to call that the "becoming".'

Grandfather's prayer to the circle that night spoke to the star nations, the water nations, the tree nations, the fish nations, the fire nations, the stone nations and all the other nations. He asked the Ancestors to bless the journey of this night.

KARAKIA

Grandmother felt the power of his words rebound from the cliffs that stood close by. Reaching into that power she gathered her strength.

Be open to change

> 'We are all works in progress. We all need time to grow, so we are all of the becoming,' began grandmother.

> 'How easy it is to forget that life is change, that change is the excitement that drives everything. How easy to see others fixed in time and space, to forget the infant needs years to learn and develop. How easy to find fault with our young as they cross the threshold into adult life, how easy to misinterpret their confusion as they try to find

Everything exists within change - our lives, which are but a moment in creation's time, and the rocks and rivers that reshape again and again over a vast geological age.

their way. How quick we are to judge, to say "you never do this" and "you always do that," and leave no room for movement or change.'

'I agree, Kui. As you know I have often been very critical of others and made my views known,' confided Mountain. 'At last I begin to understand your attitude… you do not despair… when others fall short you do not lose your way… you still walk that gentle path that makes room for the "becoming" part of us…

'And I remember you saying that change is part of all the journeys, be it from the womb to the grave… or the earthquake's thrust and the volcano's fire… the river shaping… the cave intruding… the rock smoothing… the mountain building… for everything exists within change.'

'Thank you, Mountain. You bring colour to the "becoming" where everything changes, but remains forever the same.'

See Io in Everything

Grandmother reached into the depths of her kete. There she hoped to find the words to carry them through the tides that opened to the fourth Pouwhenua. It spoke of the waters of life, of how a land that was once a Whale became a Waka and a Fish.

'We put great faith in all that we see and touch, all that can be measured and described, and tend to think that what we see is all that is real. Yet the Ancestors tell us the unseen holds the true power.

'Some say there is no spirit in stone, no spirit in trees, no spirit in fire, no spirit in birds, or fish, or the other creatures of the world. They even tell us there is no spirit in people and deny an afterlife.

'Again I repeat the oldest of understandings carried forward by those who have gone before us — "the unseen came before the seen and shall always be".'

'Kui, it's hard to see the world your way,' said a quiet voice. 'My parents came from Holland and I grew up in a "seeing is believing" world. My mates would give me a hard time if I told them there was spirit in stone, water and birds, or anything beyond a beer.'

After a brief moment of laughter, silence gathered around the circle. Grandmother did not try to answer Hans immediately. She appreciated the way Hans and his partner, Day Star were always close by. Mountain had asked them to be ready to help if grandfather needed to stand, or to provide a rug if a cool wind gathered. Their support had now gone far beyond that.

Grandmother welcomed their presence, for they were bright and gentle, and kind in ways that allowed both of them plenty of space. She remembered grandfather had named Day Star for her warmth. It was his word for the Sun. Rumour had it that he favoured "Quasar", the light that goes beyond a star, for her child who was due in a few months, but only if grandmother confirmed it was a boy. The little one was giving Day Star such a wild time, she said she preferred "Storm".

The old one continued to hold the silence. The circle accepted this, understanding her better now, knowing she was leading them in ways that helped them grow. Another voice came to the fore.

'Hans's right, Kui,' confided Day Star. 'Most people resist the idea of spirit in things. My friends would laugh at me too, and I'm Maori and so are they. But the unseen was my Poua's world and even though he died a few years ago, I still hear his voice.'

Day Star paused, felt a shiver run up her spine; it was time to listen with a different kind of mind. After a moment she offered more.

'Kui, when you speak of the spirit of the stone, are you asking us to think about the Creation? If so, Io sent a sound into the Nothingness to begin it all.'

'Ae,' said grandmother, responding with a smile.

Creation brought forth the stars that became the planets, and our planet formed into mountains and islands set within the great oceans. And they gave birth to the forests and grasslands, and the spirit of life flourished with great abundance.

The awakening day brings in the
Sun's first rays to greet the waters.
Everything created honours spirit,
and the essence of spirit is change,
the becoming that expresses
the Eternal.

'I remember my Poua's words… "Io put spirit in all that might be heated, burned or frozen"… the unseen wasn't an issue with him… it was so real.'

'Day Star, your grandfather carries us back to the beginning of the Universe, to the seeding that gave birth to the Mana, the Mauri and the Maui. And to the creation of the stars and the planets, and within our planet the oceans, the islands, the valleys, the mountains, the rivers, the lakes, the clouds, the rainbows and the abundance that is life. All honour spirit, for all are created from spirit. And all honour change, for the essence of spirit is change, the "becoming" that is of the eternal.'

All are born of the Old Tides

'In the long, long ago, when there were different stars in the heavens, all the land was covered by the great ocean and Hine Moana was its guardian.

'Then the land beneath the waters began to move, to shift and rise until it broke the surface of the widest of oceans to acknowledge the light of the Sun. And the waters were divided and one ocean became two.

The land heaved and broke free of the waters to create beautiful islands bounded on both sides by the Old Tides.

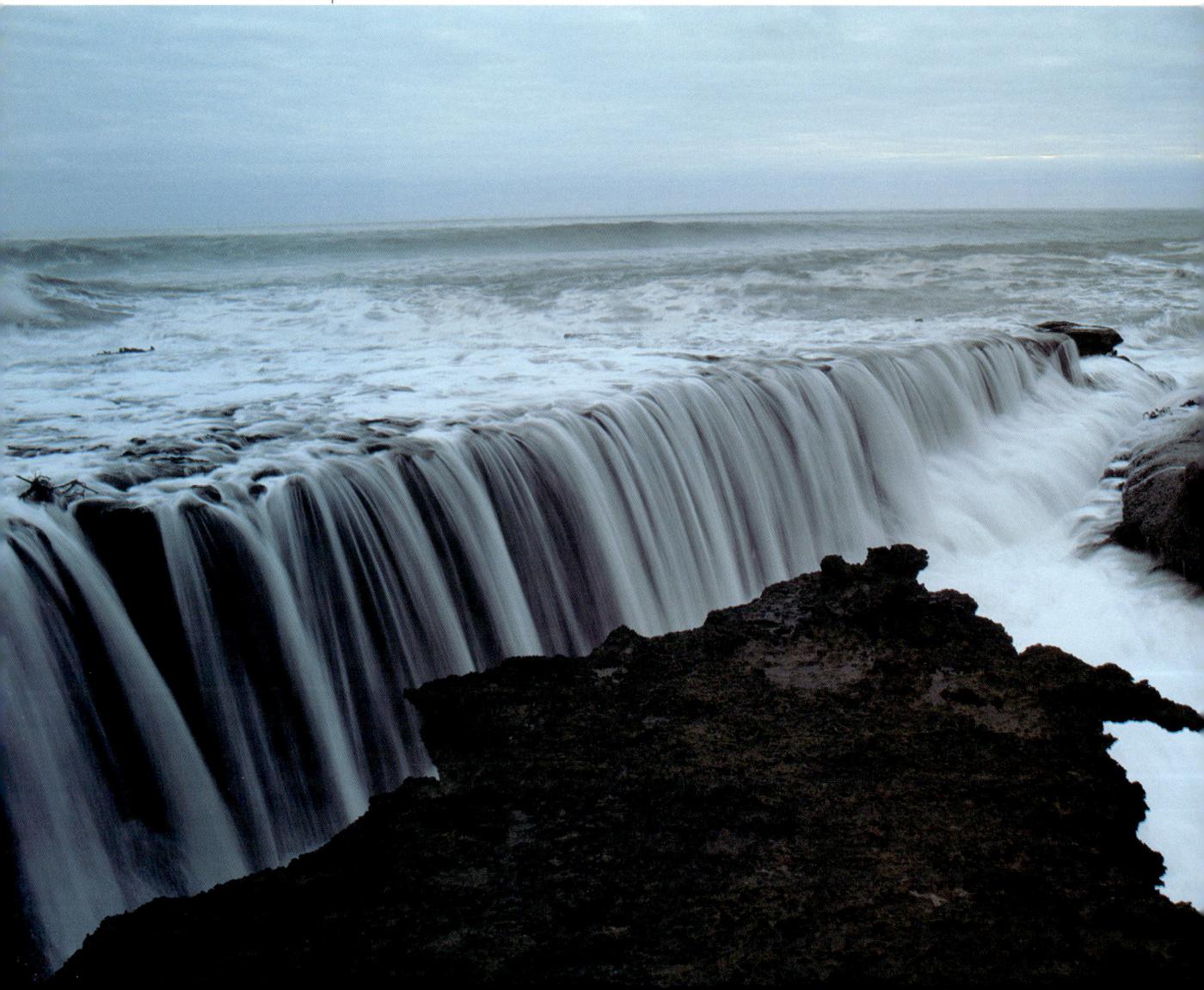

'Today we divide the waters into many oceans but the Ancestors knew but two. The first was Tai Rehua, the Pacific Ocean that held the sacred waters of the gods, and the second was Tai Rehia, being all the remaining waters joined as one. That was the way of the old lore because everything was of the balance, male and female, night and day, fire and water.

'These two great oceans are called the Old Tides and where they meet they become the Seeding Tides of the Earth Mother.

'Imagine that meeting place, think of the power unleashed where the Old Tides join, see the Mana gathered to that moment, the excitement of the Mauri that runs wild within the waters to reach out to many shores.

'And there is more, because we are part of that gathered power, that exhilarating energy discovered by the Ancestors that turns within a circle that is Eternal. Where the Old Tides meet, are the Islands of the Double Sea; this land, this Aotearoa.'

Out of the Waters came Life

'Into this wave-tossed world, Hine Moana invited Tangaroa, the keeper of the tides to bring life into the waters of the world…

"Call Tinirau, your young son, to your side, for he still feels the pulse of the Moon, the ebb and flow that gentled him within the darkness of the womb.

"Ask him to go within his rainbow mind, the place where creation but rests until it finds its time, to seed the spirit of the water children we will call fish.

"Tell him to make many beautiful kinds and I will provide for them in the oceans, the rivers and the lakes that embrace the rains that fall on the mountains."

'Into the birth place of fish, Tinirau called the Mana of Fish to give them life and summoned the Mauri of Fish, to ensure they were created in many kinds and moved well within the tides. And they came forth in all the colours of the rainbow to honour the spirit of light.

'Tangaroa looked on the work of his son, marvelling at the fish he gave to the world of Hine Moana and knew they needed guardians, each and every one. So he asked Kiwa and Kaukau to help him watch over the creatures of the waters.

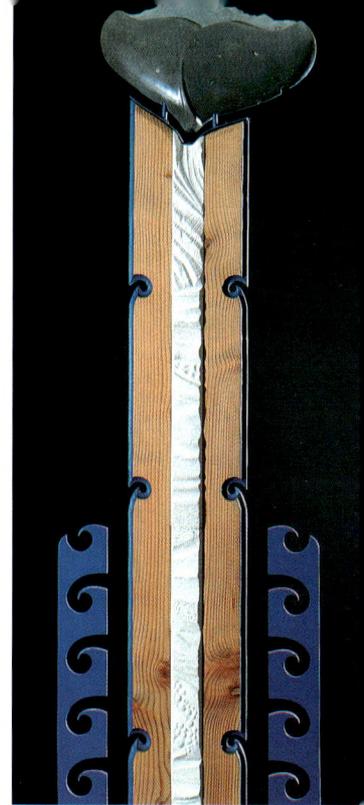

The Old Tide born of the Pacific waters holds the Mana of the Sacred, the Everlasting, and the Old Tide created by all the other waters carries the Mana of All that Remains when spirit returns to the stars. Only Whale, Sting Ray and the Waka of the Gods have the Mana to hold their place within the awesome creative power generated by the meeting of the Old Tides.

'When you see fish jump and see their colours shine, remember there was a time when very little lived within the waters, and celebrate life. Honour Hine Moana and Tangaroa, who watch over the tides to provide the abundance we enjoy.

'And long may it abide.'

Grandmother found solace in the quietness that followed her teachings and said to Hans they would like a short rest, a drink of water and a blanket against the chilling wind at their back. All took advantage of this break. Left alone for a time, the old ones shared things that were part of the night.

'They listen with open minds.'

'And you have gathered strength from this walk into the mystery of the Old Tides,' said grandfather as he gently took her hand. 'Although they may not know it, they reach across the fire in remarkable ways.

'And there is more,' continued the old one, 'Some catch glimpses of the journey, begin to understand that how we do things, how we take the next step is the most important thing of all.'

'But that's hard to teach,' whispered grandmother, 'Life today is so filled with the need to succeed, the need to achieve targets and many believe the end justifies the means.'

'Ae,' nodded grandfather, 'we all push against the tide until we realise the journey is the destination. How we walk the journey is more important than arriving. If the way of it isn't right the outcome will be skewed.'

They finished their brief discussion because water and blankets arrived with Hans and Day Star. In a few moments it would be time for grandfather to begin.

Tinirau created fish in all their colours and wonderful forms, and Tane sowed kelp in the tides and reeds in the clear waters to provide.

80

PAPATUANUKU
The Land that is the Mother

Grandfather gathered his strength and stood to carry the teachings forward. He wanted to show that the land itself was imbued with the power of the unseen. He decided to begin with the spirit of the Whale.

This Land was once a Whale

'When the stones speak it is wise to listen,' began grandfather in his accustomed way. No one knew if his sayings were ancient or new, but all loved to hear them.

'The oldest songs remind us that in the days of the Ancestors of long ago, when this land first emerged from the waters it was shaped like a Whale. That was perfect because Whale is the strongest of Tangaroa's children and holds the memory of the old trails of life. And its songs are of the land and the waters, for it has been of both.

'In asking Whale to gift its powerful spirit to these Islands of the Double Sea, Tangaroa honoured Whale's ability to contend with the tumult created at the meeting of the Old Tides.

'Whale served Tangaroa well, endured for years beyond counting, survived the Great Coldness that spawned immense glaciers, huge icebergs and froze the southern oceans. Then when the seasons of the Sun were restored, the Great Thaw forced Whale to dive beneath the rising waters that engulfed all.

When the Sun set free the frozen waters to end the Great Ice Age, the seas rose and changed the shape of every shore. Lands that once stood high above the waves were seen no more.

'Today, only the children of Whale remain on the surface. They appear in the profile of proud headlands that push into the waves, in ridges that fringe the valleys of the hinterlands and in the shape of smaller islands.

'Yet these children assure us the spirit of Whale is ever present in the deeps, for Whale is our kaitiaki, the keeper of the story, the protector of the people and the guide of the navigator on the long tides.'

Whale departed but left her children in the shape of the headlands to remind us the spirit of what has been remains in the waters and the lands.

Te Waka Aotea Roa o Nga Atua

The Waka of the Gods

Ride the Old Tides

'When Whale left the surface of the waters to hold the dark depths, others were sent to ride the tides of light.

'They are our two main islands, the Waka of the Gods, which is the southern one, and the giant Sting Ray that is the north.'

'Tell us the story of the Waka of the Gods and tell us about the Fish,' cried Mist who spoke for many. 'Please, Koro!'

'If there is time, but first we need to remember that the keeper of the tides is Tangaroa and that our homeland is bound within his realm. Tangaroa is everything to those who voyage far from shore.'

Tangaroa waits within the Long Tides

'Those who sent their waka on the long tides, the rivers that span the oceans, placed themselves in the hands of Tangaroa and trusted he would provide. When the Ancestors launched their dreams upon the waves they carried no water, no dried foods, no yam or taro or potato to eat.

'They sailed without fear knowing Tangaroa would provide fish to feed them. If the rains failed to come to slake their thirst, there were juices enough in thin slices of raw fish won from the tide.

'Guided by ancient chants that opened to the stars, they set out for distant lands knowing they might not arrive. For who knew when Tawhiri Matea, the Keeper of the Winds, would raise the waves high and sink the waka? And who knew when the long tides might not run true?

'Yet, for those called to crew the waka, to give their lives to the waters was brave and beautiful, for the welcoming arms of Tangaroa opened wide if the waka sunk beneath the tides.

'I share this understanding to honour the courage of those who found their joy in the challenge of the waves. That brings us to the story of the greatest waka to ever sail the waters of the Double Sea, and its place within the land that we can see.'

We remember the Deluge

'Many peoples made their home within the Islands of the Double Sea and all were welcome and found peace. However, their ties to distant homelands remained strong, and led to the building of a waka so beautiful it was named the Waka of the Gods. It sailed to honour the many homelands to ensure all the families might be as one. This wondrous Waka voyaged for many generations and while it always made safe landfall, none knew what waited beyond the horizon.

'Then came a day distant in time, but held forever in song, when that brave Waka was struck by the Deluge, the greatest storm to ever sweep the ocean. Huge, treacherous waves climbed the darkening skies to assault the vessel, which writhed within that fearsome tide.

Huge waves climbed the darkening skies to assault the vessel.

'Desperately the crew hauled in the sail and strengthened the bindings that joined Aotea Mairangi and Aotea Roa, the twin hulls. And all the time mountainous seas crashed over the washboards. Doom gathered as the tohunga chanted a karakia to summon their guardian Taniwha to bail out the heaving waters. But that plea went forth too late!

'With a cry of agony Aotea Mairangi hit a jagged reef that tore its timbers apart. As that hull sank, the commander bravely cut the bindings that made them one, to let Aotea Roa break free.

'With no time to mourn the loss of companions drowned in the churning waves, the crew of Aotea Roa battled the Deluge day after day until they wearied unto death.

'Finally, when their pain was too great, Io, the Keeper of All, offered the hand of compassion and turned the Waka and the crew to stone.'

When the Deluge swept all aside, sinking Aotea Mairangi and shattering Aotea Roa, Io, the Unseen, turned the surviving Waka into a beautiful island.

Honour the Waka that is an Island

'Aotea Roa is our southern island and the crew are its tall mountains, the Ancestors, who reveal themselves to the world each day. Be there in the right light at the perfect moment and you will see them in their pain. Some lean on the shoulders of weary companions, others throw their heads back or collapse in exhaustion. Few reveal their faces, yet those that do show that they are brave. Only the navigator stands erect, for he holds the great steering oar.

'Those who perished when Aotea Mairangi slipped beneath the tides are also honoured. Their names have been sung into the snow-covered peaks that proudly wear the korowai huka, the white cloak of remembrance.

'Know that in times past, the bones of our departed were taken into the depths of the mountains to be gifted to the stone. There they rest forever in the arms of the Ancestors. Old voices still call from those high and sacred places and old dreams still linger there to guide us into tomorrow.

'Greet the Ancestors when you walk the trails above the forest and come to the fields of snow. Remember their story as you journey across their strong shoulders. Honour them for their courage in the Storm and listen to their song, it is of days long gone, but not forgotten.'

When the story ended grandfather sat in silence. He was thinking of old bones, of the men and women who gave their lives to Tangaroa and were honoured in stone. It was so long ago and, although remembered today as but a story, he knew each name and each mountain peak that still held it bravely.

Bringing himself back to this time, he stared for a moment into the flames. There was more to share, for all within the circle were hushed and gathered close.

Honour the Mystery that resides

Although it had been a long night, grandfather stood erect using his talking stick to hold his balance. Some wanted him to sit to speak, but he felt he reached deeper within when on his feet. It was an old thing, perhaps no longer important, but never-the-less, a kind of comfort.

'I am tempted to end the story of the Waka of the Gods here, but a little voice tells me some of you wish to sail further. So I ask what you seek.'

'Koro, the story of the southern island brings me to tears that I don't understand,' said Fran, who shared Mist's blanket. Mother and daughter had drawn closer in these days together.

'Can you tell us more about that,' coaxed grandfather.

'Well, one moment I am a child who sorrows for the sinking Waka and in the next an adult who is overwhelmed by a sense of mystery. The story as it sits is not enough.'

'Why?' asked the old one.

'It speaks only of the past; it says nothing of today. It can be dismissed as just another myth, a fairy story. You do not share this time simply to entertain. The nights are too long for that and the cost to both of you too much.'

'Go deeper then, probe the mystery and tell us what you see.'

'I see the courage of Ancestors who risked all… see our mountains in a different way… sense that the waka is a metaphor… sense something deeper… I know I fall short… it has to have greater meaning for my life today… that's been your purpose… that's your way.'

Grandfather received these words in silence. The fire had become but a glow. It needed new flame to push back the darkness and the cool of the night. Wood gifted to the embers sent sparks of joy drifting on the wind. When the first flames struck, the old one spoke.

Sweep through the mists of time, set free the mystical mind to see the mountains as Ancestors with white cloaks adorned.

Great Compassion
 moved on the Tides
when Io turned
the courageous
crew of Aotea Roa
to stone.

'How true! Much has been left unsaid. Fran, you help me open ancient doors.

'Think of a waka as more than a vessel that carries you from one place to another on the tides. See it as the Ancestors saw it. See it as their protector, their guardian, their sustainer, their hope, as the keeper of their dreams, and you begin to catch a glimmer of the place of the waka in their lives.

'The waka was everything. Its thin wooden hull was all that stood between them and death in the storm. In that hull they put their trust. In the tall sternpost, the taurapa, they carved the map of the great rivers they rode across the ocean and the stars that called them forth. In the prow, the tauihu, they carved the chart that guided them around the coast to final landfall. And along the washboards, they carved the karakia, the prayers needed to shift the Mana of the Waka from the stern to the prow and back again, when the voyage asked that of them.

Carry the sternpost of the waka through the land. Tie it high upon a mountain far beyond the reach of the tides to hold the Mana of the long voyage from the homeland. Make this journey to open the way for your children. Use the spirit of the waka to help them grow tall in this new land.

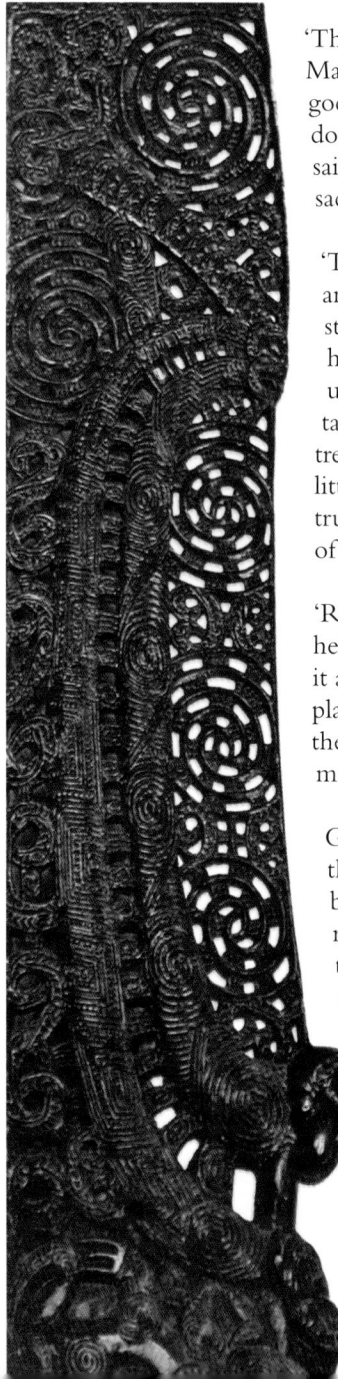

'The great sail that harnessed the winds of Tawhiri Matea was tapu, for it reached into the realm of the gods to carry them forward. When their journey was done, when the waka arrived in a new homeland, the sail was gathered in for the last time and moved to a sacred place and honoured forevermore.

'Then the carved sternpost was cut free of the hull and brought ashore. And when the Moon shone strongly in the night, that carved treasure was lifted high and carried by twelve through the new land until they came at last, after many days, to a mountain tall. Then climbing its slopes they reached the last tree, where everything gave way to alpine grasses and little more, and they bound the taurapa to its strong trunk. Thus did they mark their territory at one end of the arc of the Sun, but all was not done.

'Returning to their waka they cut the bindings that held its carved prow in place, lifted it high and carried it along the shore until after many days they found the place where it might be secured to look forever on the breaking waves. And thus they completed the marking of their land within the arc of the Sun.'

Grandfather sat now, for he was very tired and lacked the strength to reveal more. The circle held fast, bound by thoughts that found new worlds to embrace, reluctant to leave but mindful of what they asked of the old ones when it was so late. Sensing their need, grandmother slowly stood to take her companion's place.

'You have taken up the paddle that sweeps the ordinary aside and begin to move swiftly to the pull of a very ancient tide. We have said enough. But let us see what you have discovered beyond the horizon of time.'

'Koro, I am stunned by the picture you have created,' confided Fran, who still sheltered Mist with a blanket. 'I see the sternpost being carried to the mountain… the prow to a distant shore… I marvel at the huge minds the Ancestors walked into this land… creating from the most sacred parts of their waka… another waka that ensured the spirit that carried them safely to their new home embraced their tribal territory… forever.

'And I see even more… the waka they placed in the land… offered food, shelter and protection… ensured the spirit that brought them to this shore still served… carried them forward… this comforts me… brings me closer to the Ancestors… allows this land to live in me in a new way.

'Yet, for all that, the deeper question remains. How do we bring the Waka of the Gods into the world you are opening to us?'

'You do this already and you do it well,' responded grandmother with a smile. 'You use your paddle to explore new horizons and enter old waters hidden far too long. You have begun to unravel one of the great mysteries, and in doing so brought great joy to these old bones. Your willingness to leave the comfort of the familiar and venture into the unknown, helps all of us put our fears aside. We wondered if our journey could be part of yours, if it was time to share in this way. Your courage in the quest brings us with greater trust to a new day.

'So we come again to Aotea Roa, to the Waka of the Gods, which now reveals itself in a different way. All that matters in life is held within a waka. The power born of that grows stronger still when you know your tribal waka rests within an even larger waka and that waka is a great island, the amazing Waka of the Gods.'

'And does the power of what you share end there, Kui?' asked Fran, whose face shone with a broad smile. 'I wonder about the Waka of the Gods. Does it hold an even greater mystery? What happens if I see it as the Waka of Io, the Unseen One, as a Waka of Creation? And why does such a Waka reside at the meeting of the Old Tides?'

'Who knows where that journey goes?' replied grandmother with a rewarding smile.

It took some time for the circle to take this in. A simple story had been lifted into a powerful place. It offered so much. The world of the Ancestors seemed closer, for their courage and insight touched heart and mind. Their journeys were reaching beyond time.

See the Waka in the Land

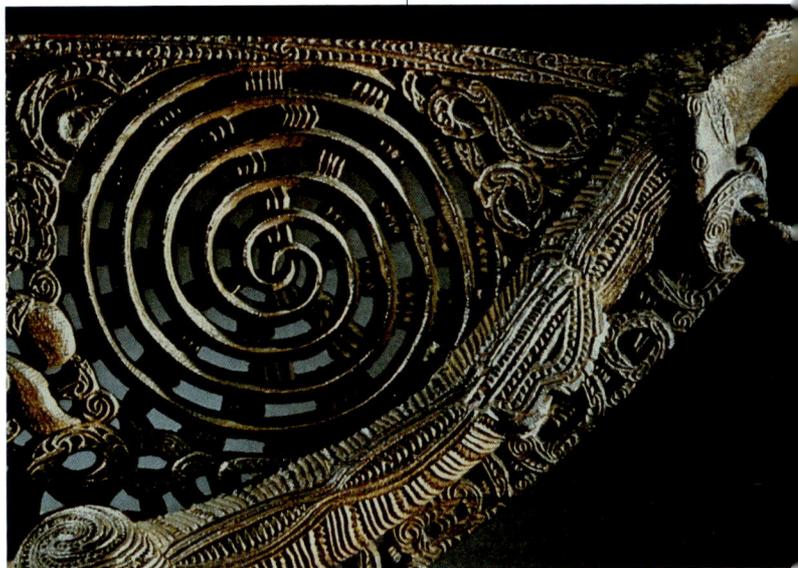

Lift on high the carved prow of the waka that made the great journey and set it on the shore above the waves to honour the distant horizons. May it shape the hopes and dreams of those who follow. May it inspire the mind to step beyond the moment to envisage the shape of worlds still to come.

Grandfather felt moved to rise. Rested, and inspired by the shift within the circle, he wanted to share more.

'Some have journeyed here from Murihiku, from the far south. To you I entrust these words.

'Remember that while the prow of the Waka of the Gods is constantly swept by the cold waters of the polar seas, it still holds true to the anchor that we know as Rakiura, an island set within the harshest of tides. And is still guided by Matua Tonga, the star cluster of the Southern Cross.

'Understand that the many lakes in the south, the beautiful Wakatipua, O Anaka, O Hauiti, Te Pukaki and Te Kapo, are created by the waves that splash over the washboards of the Waka. And know that the great rivers, the Mataura, Matau and Waitaki, that flow from the great lakes serve us well, for they constantly bail the waters out of the hull.

'For those who are of the plains we know as Nga Pakihi Whaka Teka Teka o Waitaha, that are now named Canterbury, we say look to the mountains when the northwest winds blow and you will see the curving underside of the Waka's sail set within the clouds.

'The Waka still holds true to the old trails, to the spirit it carried on the Old Tides so long ago. And it offers nurture within its vast hull as it carries into tomorrow the dream it lifted high so long ago — honour your homelands, each and every one, and remember we are of one family, for the journey begun is not yet done.'

After grandfather sat, grandmother sent the white stone around the circle and with it an amulet, a beautiful fishhook carved in whalebone. Thus did the spirit of stone and the spirit of whale gather as one.

And a small voice cried, 'Please tell us the story of the Fish, Koro.'

'Ae, Rain. So now you take up your twin's case. Tell her, when she wakes, that we soon come to Maui, but look about you and see that this night is done. Come again at the setting of the Sun. Gather then to sail with Maui.'

Grandfather's closing karakia thanked the Ancestors for journeys made and learning shared.

Remember, the land was once a Whale, then a Waka that rode the Old Tides with a companion Sting Ray. Honour their journey, hold it close, for they do not forget all that happened long ago and remain true to their purpose.

KARAKIA

When the silence that followed ended, the old one gave Scree a paper bag and said but one word – 'share'. The youngster grinned and ran off.

Then the old ones drew their blankets closer, linked arms and slowly made their way to the shore to greet the new day.

'Scree is a popular lad this morning,' laughed grandmother. 'Fish for breakfast is fine, but not with mothers if it's chocolate.'

The children were indeed having a good time. And so were the others who had erected a food tent just out of sight.

'Look at the rise and fall of the tide, the endless sweep of the waves. Within that flow great truths abide, we inherit more than we will ever know.'

'It's too much to hold in these old minds, but we still try,' chuckled grandmother.

Hold the Mana of the Waka high to meet the Fierce Tides

Huge seas, sweeping out of Antarctica crash over the Prow of the Waka, threatening to sink it in the Tides. Yet, all is well, for in that place the Mana of the Waka resides.

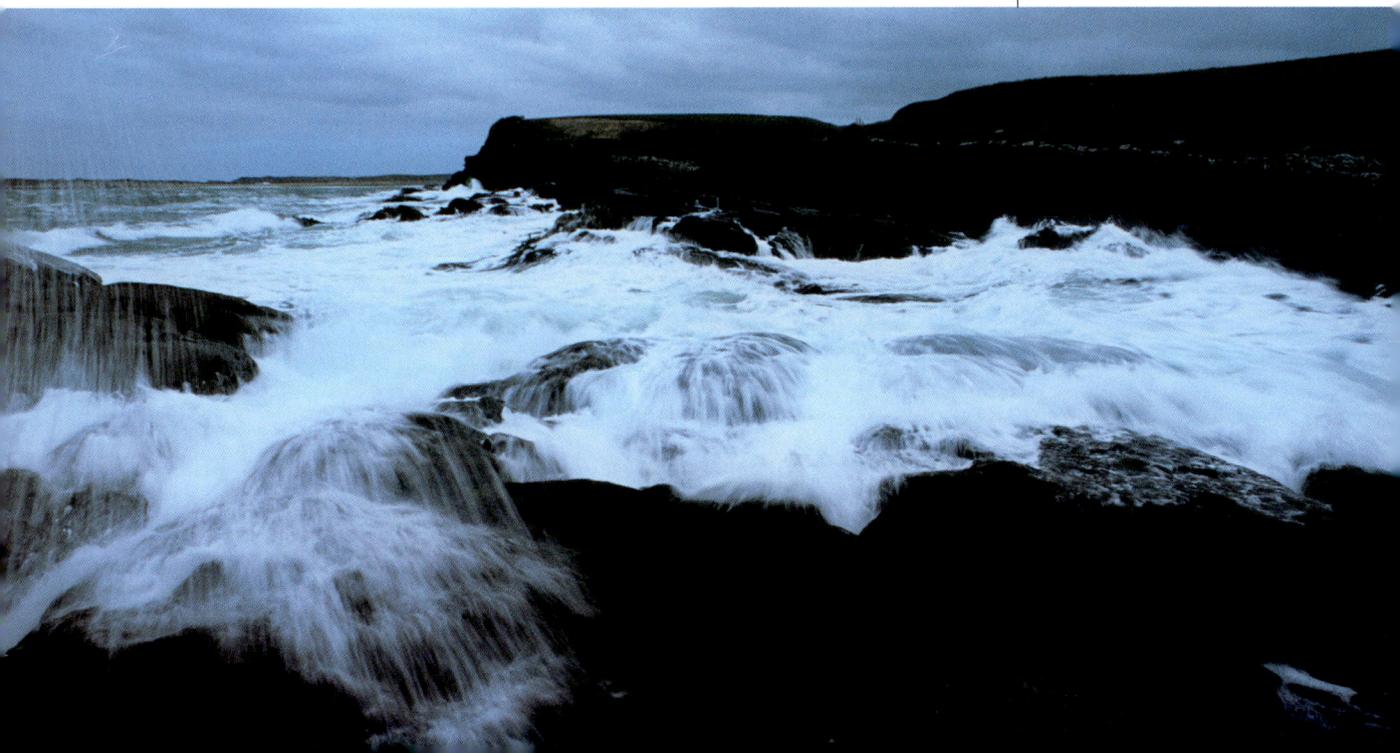

SONG OF THE
SACRED PROMISE

Huge were the minds that saw beyond

the crashing waves to other places

and other times, and powerful the dreams

they took to the Old Tides.

Mighty were the deeds they achieved

for the families of the human kind.

Maui carried to our shores the Promise
of the Rainbow Mind, the Fire that
pushes the Shadows back to reveal
new worlds.

Fire guided Maui to build a House that
welcomed all who promised to care for
the Mother and the Peace Child.

Fire called Maui to bring the Mana
of the Waka of the Gods from the Prow
to catch the Fish by its wondrous power.

Fire gave Maui the sacred words that
reached the Stars to join the Fish and
the Waka in the twisting tides.

Fire helped Maui sail home, but was
extinguished when his waka sank,
and he was lost beneath the waves.

Ngahui and Poutini rekindled the flame
and sailed to honour the Promise
Maui made.

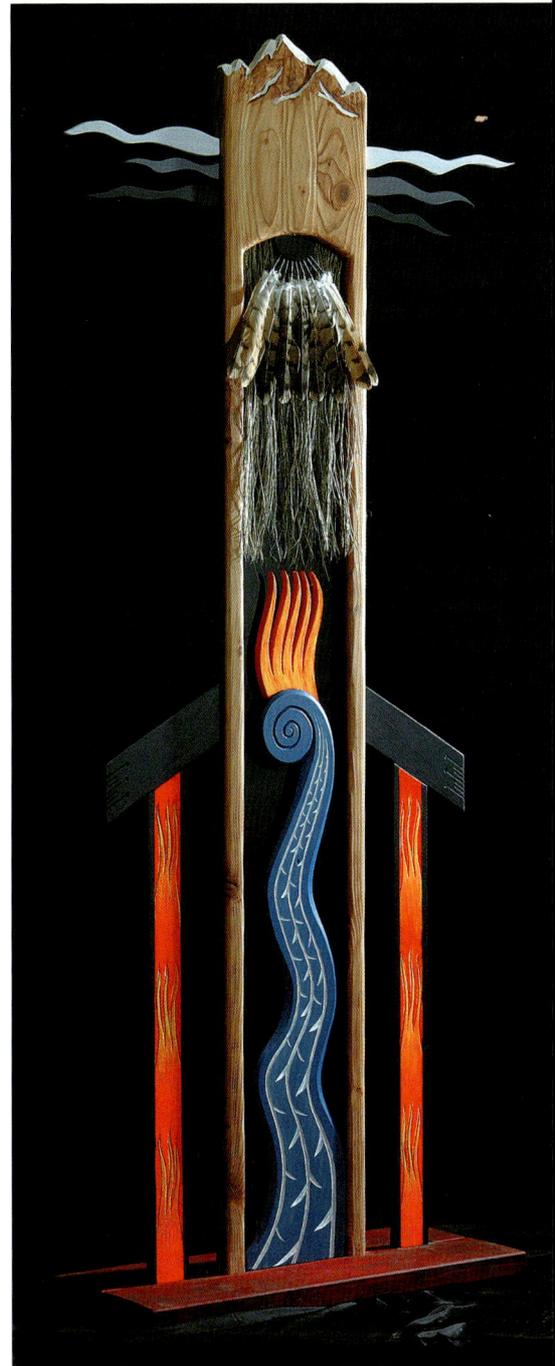

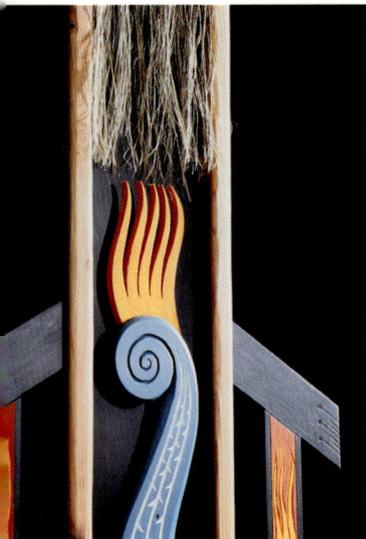

TE TANGATA WHENUA
The People of the Land

They came early, the old ones, came to see the Sun go to its rest beyond the waves and have a few quiet moments to reflect. They honoured the silence for a long time then spoke of the trails that opened to this night.

> 'They do not know that Maui lived,' began grandmother. 'I asked around… they only see him as a trickster… a storybook character… to be put aside… left in those torn pages to die.'

> 'That's not surprising… we abandoned Maui in the nursery… hid the truth… we failed Maui.'

> 'And that's not all… other Ancestors have become shadow people… mere myths with no place in our story.'

> 'So we come to an exciting time,' chuckled grandfather. 'Tonight you bring the Ancestors to this fire and lead us to the fifth Pouwhenua that honours the flame that carries a promise and a name.'

Little Kea arrived clutching a long bundle to her chest. She sat beside the old ones and ever so carefully unwound a long cloth to reveal a beautifully carved waka, a gift from her Poua. She placed it in grandfather's hands.

> 'It's a beauty, Kea, made with much love. Ae, and you care for it so well. It will take you far beyond this night, dear child!'

Then the conch sounded with a haunting, quavering note that was different. Echo was giving her first public performance. Rewi smiled broadly and nodded when grandmother caught his eye and clapped in silence.

Grandfather acknowledged Echo with a smile as he stood to answer the call. He looked stronger as he sent his karakia to meet the power of the dancing flames. It was that kind of night, the time to shift aside the mystery that hid the heroes of the ancient days far from sight.

KARAKIA

The words he offered seemed to bounce off the cliffs as on no other night. And the ocean's whisper sounded just like voices. Some might think the Ancestors gathered on this tide.

Grandmother followed her companion's opening karakia by standing with outstretched hand to point to the setting Sun.

Maui fills the mind of the child

'Look at that fierce ball of fire and tell me the story that it brings to mind?'

'The way Maui captured the Sun, Kui,' cried Torrent. 'He made a great net and held it tight.'

'Wonderful! You are absolutely right. Now look at our fire and tell me which story you find.'

'How Maui was naughty and stole the Fire Children and dropped them in the water,' announced Scree who was growing in confidence and not to be outdone.

We come to the past to see it in a new light, to understand it through other eyes.

'Right again. You do know your Maui.'

'How Maui fished up the North Island, Kui,' exclaimed Mist, with her yearning for that story.

'How he tried to return to the womb and was defeated by the fantail's laughter,' offered Mountain.

'So we know at least four Maui stories,' said grandmother. Then quietly running her eyes around the circle to draw all them in, she asked, 'Do… you… think… those… stories… are… true?'

'No!' responded Torrent, as others nodded in agreement. 'No! But they are fun!'

'And what would you say if I said they were true?' asked grandmother. 'Might that be even better?'

Grandfather glanced at his companion, nodded his encouragement and chuckled when he saw a certain glint of determination in her eyes. It was going to be an interesting night.

Lift Maui out of the pages

'What if Maui was a real person, someone who actually sailed these waters and walked this land? What if I told you I could name Maui's mother and father, and his grandmother and great grandmother and their families?'

'How could you know all that, Kui?' asked Flame. Such detail teased her enquiring mind.

'It is recorded in song, held in the ancient schools of learning. It is bound into the ancient chants that honour the generations that carry us back to the beginning of our tribes. It is woven into the sacred kete of knowledge that we open for you this night. We have not done this before, it is a challenge to all, but we feel it is time.

'This brings us to the first Maui story. Who remembers it?'

Grandfather's face was lit by an even bigger smile. He loved the thrust of her mind as she slowly edged the circle into stronger and stronger tides.

'Kui, it's about how baby Maui was given to the ocean by his mother,' said Torrent, 'and was in a cradle of seaweed… and survived… how he was washed ashore and discovered by his grandfather and grandmother… and was with them until he grew up… '

'Thank you!' said grandmother with a wide smile.

'We never question this story because it belongs to a make-believe-world where all things are possible. Yet, if we look closer we might ask if a mother would really put her new baby in the sea? And if she did how could it be cradled in seaweed and survive? And is it likely that its grandparents just happen to walk by at the right time?

'Tonight I speak of old knowledge held in sacred kete and go deep within to open ancient doors. We know Maui was a premature baby, a little one born well before his time, that's why his mother gathered from the sea a broad strip of bull kelp, sliced it open and lined it with her hair to make a warm nest for her tiny child. Then she gently massaged his body with oil, fed and sang to him of the Ancestors and long journeys begun.

'Knowing this, we can see the Maui story with different eyes. When he was placed in the kelp pouch, he was in the "cradle of seaweed" that was "given to the sea". That didn't mean he was placed in the waves, it just meant he was given to the spirit of them.'

The abundance of the ocean feeds not only the body but also the mind. Kelp saved little Maui and still serves us well.

'Kui, why does the story need to say Maui's mother gave him to the sea?' asked Torrent.

'To remind us that our Ancestors put their trust in the ocean, that Tangaroa, the keeper of the tides, was central to their lives,' replied grandmother. 'Maui's mother was of the Star Nations, the great navigators who put their trust in the long tides.

'All that she was led her to entrust her ailing son to a kelp cradle. If he lived it would be because of Tangaroa and all that the Keeper of the Tides provides. If he died his brief journey in time was surrounded by the best she could bring to his side.

'We know Maui lived, and became a great navigator who challenged the long tides. His charts were used again and again in later times.'

Before all else, protect the child

The confident assertions grandmother placed in the circle, her certainty surrounding Maui, her attempts to add new dimensions to the Maui story, drew the circle out.

'Kui, my grandfather taught me that Maui's long name was "Tikitiki a Taranga", which means, "Maui of the Topknot". That suggests he was named for his mother's hair, for the severed topknot that kept him warm. That supports what you say.'

'Thank you! In the end it's up to each of us to decide in our own way. However, I do ask myself why the young mother didn't make a nest of soft feathers, or finely beaten flax, or something else?'

'She had to use her hair, Kui,' urged Echo, in a voice filled with conviction. 'She sacrificed her hair for two reasons; to give him warmth and to protect him within the sacred. In Tonga we say the hair crowns the place that opens to Spirit, to Io Mata Ngaro, who you often call the Unseen One.'

'Many things are hidden in this story,' concluded the old one. 'Let's keep that in mind when we come to other Maui stories.'

Grandmother paused, for while nearly all in the circle seemed open to the direction she was taking, two stood out. They quietly whispered back and forth, hesitating, lacking the courage to share their thoughts.

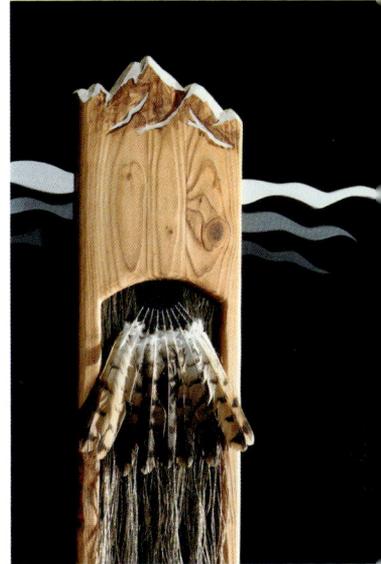

If the sea fills your life,

if each wave is a pulse,

and every twist of the tides

evokes memory, the voice

within that sings to you is

ancient and true. You are

called by family. Ae, called by

the Navigators who fly their

minds to distant horizons

and touch the stars.

Honour the power of the Word

Reaching into her flax basket, grandmother took out a long wing feather gifted by kahu, the hawk. She swept it through the air with a grace surprising in one of so many years and used its flight to emphasise each command that followed.

'Never… fear… to… ask… the… question!
'Fly… your… mind… to… free… the… spirit!'

The whispering youths took courage from her words. Their voices tripped over each other in response to her urging. They smiled as she made a final flourish of the feather as if to scoop their questions from the air.

'Kui, if this Maui was a real person, how come he carries the name of the Maui that Io sent into the Nothingness?' asked Anaru.

'I love your question. Your mind leaps far beyond these flames.'

The old one paused. She was excited by the trail opened by these teenage boys. Ae, she even brought to mind one of Koro's sayings… "When the hawk flies the teacher stretches the mind"… Ae, her mind and theirs.

'Anaru, there is power in a name. Remember that the "Word" ignited Creation, seeded the Mana in the Nothingness, and excited it with the Mauri. And as you say, Io then sent the Maui into the Nothingness to save everything when the Mauri ran wild.

'That Maui is of our minds and the mind of the Universe. It helps us see the rhythms in life, the patterns and the great circles. It is in us, and of us, but it is not a person.'

'But Kui, why was such a powerful name given to Maui Tikitiki a Taranga? My elders are very careful in the naming of a child. They never give a name that is too heavy for the young one to bear,' offered Anaru.

'That's true… so that means the Maui name is special and never given lightly,' replied grandmother. 'I believe the Maui name was gifted to very few. When I go to Hawaii and other homelands in the Pacific, I hear other stories about Maui. And these sometimes describe voyages well outside Maui Tikitiki a Taranga's time. So there were a number of Ancestors who carried that name, different men, who I believe, were in many ways the same.'

'How can that be, grandmother?' enquired Spark, who had covered Smoke in a blanket and managed to get him to sleep. Enthused by the message of the feather, he was encouraged to speak.

'Those gifted the name Maui were born of seeker stars, were brave children who would grow to lead their people to new lands and in good ways. They were trail makers, rare children gifted to their age to bring design out of growing need and confusion. They embodied the Maui that Io sent into the Nothingness. They were the Maui standing tall within humankind. They were its spirit expressed by action, the force that gave meaning to change.

There are no limits to the power of the soaring mind.

'Maui Tikitiki a Taranga was much more than the trickster described in the stories; he was a change-maker, a trailblazer, a great explorer sent to meet the challenge of the Old Tides.'

Maui was born of the meeting of blood

'Much was expected of Maui Tikitiki a Taranga when he grew to manhood, for he was of the blood of valiant Ancestors. He was the great grandson of Hotu Matua and Kiwa, who by their union brought together those of dark skin who worked the soils and those of fair skin, who voyaged far with the knowledge of the waters and the stars.

'Hotu Matua's family line ran back to the shores of Africa. She left there seventy-six generations ago leading a fleet that quested ever eastwards to find the Birthing Cord of the Earth Mother. Among her people, who were tall and dark, were many wonderful gardeners. When she came at last to the shores of Waitangi Ki Roto, now named Easter Island, she knew her search was over.

'Kiwa, the great navigator who sailed from South America to chart the islands of the Pacific Ocean, also made Easter Island his home, for it was well placed within the winds and long tides. Fair of skin and blond-haired, this blue-eyed trail maker was of the people who followed the wisdom of the star trails across the oceans wide.

'Their marriage opened the way for Hotu Matua to honour the dream that carried her so far. She bore Kiwa many sons and sent them in the four directions to explore the vast Pacific. They sailed in her Mana, not their own, and added so many new islands to the charts that Hotu Matua had to put her old name aside and take the title of Te Kupenga o Te Ao, the Net of the World.

'When Te Kupenga o Te Ao, Maui's great grandmother sent him west in his great double-hulled waka to find, once again, the Islands of the Double Sea, she knew much was asked of him. To leave the shores of Waitangi Ki Roto and sail the stars to the restless waters at the meeting of the Old Tides, was a huge challenge to place before the youngest son of five. Yet, she saw in him the Wairua of the Ancestors standing tall and a mind that overcame difficulties, one and all.'

Those who challenge the distant horizons and revel in the call of new tides, are the Trail Makers, the StarWalkers who honour the ancient lines.

Go gently into the Land and the Waters

'When Maui reached the islands of the Double Sea, he led a party up a great river that flowed from the snow-covered peaks of the southern mountains, and came at last to the Birth Place of the Gods. It was in the centre of the Waka of the Gods, the sacred place where the Ancestors held the stones that honoured the journey, and where they kept their most ancient lore.

'Breaking through the mountain rim, he stood on sacred ground where soaring towers of stone reached for the sky. Shaped by water and wind, this Nest, this Kohanga, spoke to Maui of the creation of life in all its forms, of a Universe painted in the stars and, above all else, of the nurturing spirit of Papatuanuku, the Earth Mother.

'How did he know of its existence, this place so remote and so sacred? How came he there with such confidence and with such a deep sense of achievement? Was he the first to walk these awesome stone halls, the first to know the power of these lands encircled by those mountain walls? I think not. Others had gone before,' confided grandmother.

'It was here, amidst these remarkable tors, that Maui asked Papatuanuku for permission to live on the Islands of the Double Sea. And he came with two promises.

'The first promise was that his people would care for the land.'

'What did that mean, Kui?' asked Anaru.

'That they would not burn or ravage the land, that they would only fell a tree if the forest agreed, that they would ask before hunting a bird or gathering shellfish. That they would honour the land in the harvest, and remember to thank Papatuanuku for each gift she bestowed. When hunting the creatures of the deep, they would show their respect for Tangaroa by giving the first fish caught back to the ocean. And would follow the lore that demanded they know how their actions might harm the lives of children born seven generations hence.'

'So the promise was to be kept for just seven generations?' asked Tamatea who loved the forest and all that was of the wild.

'No! Every generation after Maui was committed to thinking seven generations ahead. He promised we would care for the land down the trails of time until time itself ends.

'His second promise was to bring the Peace Child to this land. However, let us leave that within the mystery until it is ready to unfold.'

Maui and the Mana of the Waka of the Gods

Maui sailed from Waitangi Ki Roto to the Waimakariri River and walked it to Te Kohanga, the Birth Place of the Gods. There he promised Papatuanuku that his people, and all who followed, would care for the land forever.

Then he rode the long tide south to Murihiku where he gathered the Mana of the Waka of the Gods from the Prow and sailed with it to Whakarerea in the Stern. Then he sailed home to Waitangi Ki Roto for he had been gone too long.

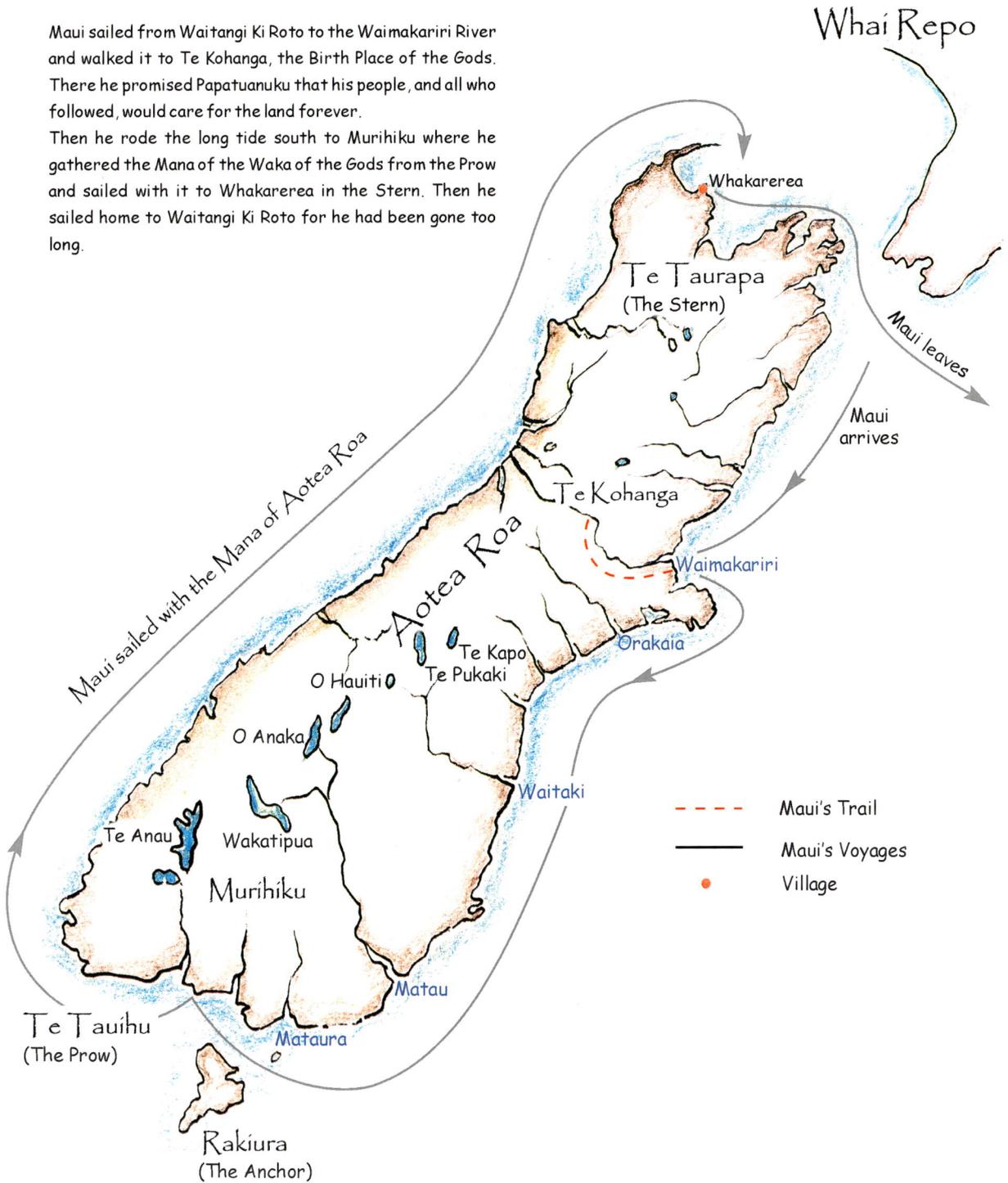

Whai Repo

Whakarerea

Maui leaves

Te Taurapa
(The Stern)

Maui arrives

Te Kohanga

Waimakariri

Maui sailed with the Mana of Aotea Roa

Aotea Roa

Orakaia

Te Kapo
Te Pukaki

O Hauiti

Waitaki

O Anaka

Te Anau

Wakatipua

Murihiku

Matau

Te Tauihu
(The Prow)

Mataura

Rakiura
(The Anchor)

- - - - Maui's Trail

———— Maui's Voyages

● Village

Trust the deeper tides

Grandmother paused to allow her words to settle into the circle. She wondered if she had said enough about the first promise. She looked across at her old companion and knew he understood her hesitation. 'Go deeper. Don't leave them in the shallow waters,' he whispered.

'When Maui said, "We will care for the land," he meant all that I have shared and much more. What I have held back makes me a little frightened.'

'Why are you afraid, grandmother?' asked Torrent, who found it difficult to imagine the old ones fearing anything.

'I'm afraid I will not make this other aspect of caring for the land real to you. That in sharing something brave men and women gave their lives to honour, I will fall short. That in the end you will not understand, through no fault of your own.'

'But, Kui, you have taken us so far already,' confided Mountain, who was just a voice in the shadows.

'Yes, and you have made that possible. You have reached out to help us,' replied grandmother. 'And trust tells me to hold nothing back. So, let us venture together into deeper waters.'

Accept the Spirit of the Land

'Maui knew that his promise to harvest the land with respect and gratitude was not enough. He saw the birds eat of the forest's ripe berries, carry their seed within and sow them where the wind had felled a forest giant, or the land had slipped aside to strip it bare. He watched tiny insects flying from flower to flower to gather their sweetness, and leave with each bloom the pollen that gave life to the seed. He knew earthworms devoured rotting matter and turned it into good soil. The lore of life was the lore of renewal. Everything that took gave in return, but that was not always the way of man.

'Maui understood that words of gratitude fell badly short, for the land cried out for so much more. Papatuanuku wanted people to remember they were part of her, to feel her needs and share her joys. She wanted them to see her uniqueness, experience the power of place and walk in its spirit. She needed commitment, understanding, acceptance and action.'

'Why was the land asking for those things?' asked Tamatea, who was so alive to these words his voice wavered.

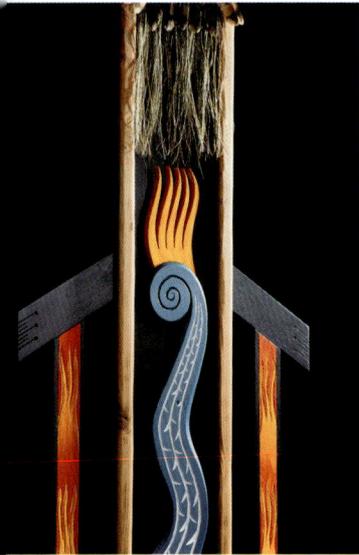

Maui built a house in this land, a house to hold the dream of peace and honour the trails he opened for all who might follow. We inherit that house, the dream and the promise.

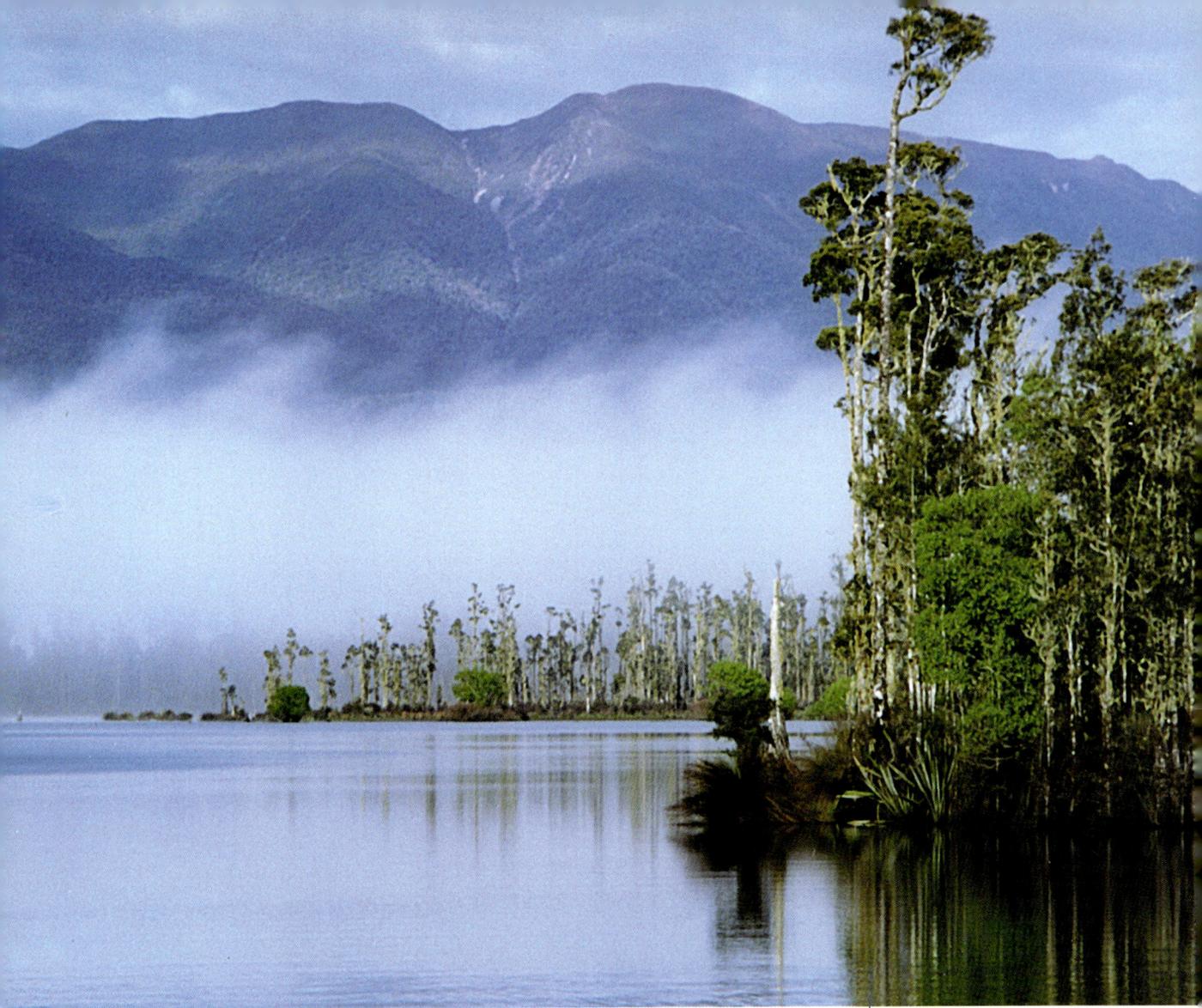

'A simple truth is woven into life. Only when we acknowledge the spirit of the land we move in, see the uniqueness of its Mana and Mauri, can we truly live happily within it. If we fail to listen to its spirit, deny all that is special, we are diminished and the land suffers with us.'

Let the land speak to you, let its voice reach deep within and let it claim you. That is your right, that is the way of wisdom and insight.

'The creatures of the desert do not try to change the desert. They accept its lack of water, the burning heat, the sparseness of the vegetation and the endless shifting sands. They embrace the spirit of the desert and thrive because of it, for they too become special to that place. The desert is not harsh, it is simply different, an ideal home for those who are attuned to it.

'The creatures of the Islands of the Double Sea do not challenge the spirit that abides within them and nor should we. Our true journey is to understand, acknowledge and accept the spirit of this place, not to overcome it, not to

conquer it in some aggressive way. Only when we move in harmony with that spirit, can we fulfil Maui's promise to care for the land.'

Remember, we are of the Old Tides

Grandmother realised she had been carried along by a floodtide of passion. Her words came from somewhere else, were gifted out of Wairua with a power born of many Ancestors. Letting go of fear she had invited courage in. Her excitement was interrupted by grandfather's urgent words.

'Tell them what that means? You are so close to the heart that beats for all. Continue just as bravely.'

Now she knew great joy. The way into the mystery was clearer now. She saw further than ever before.

'How I love this Maui,' she cried, to her own surprise.

'He left his mark on every shore and now he leaves his footprints on my mind. I see his journey unfolding, sense its dangers and feel his commitment. This huge mind walked with wondrous spirit to open timeless doors. And others followed him and we may too, for the journey welcomes all. Ae, all who call this land their home.

'Brave Maui, the son of brave Ancestors, dedicated his life to honouring the spirit of these islands and the spirit of the Old Tides that surround these shores. That was his "caring" and it was filled with danger, for much was asked of those who wished to protect that wondrous spirit.'

'What danger,' asked Torrent in his excitement, 'were warriors coming to invade and destroy?'

'No! The danger was of place not people. The Ancestors knew these islands pulsed with such a creative spirit they might not survive. That was the exhilaration born of the meeting of the Old Tides, the wonderful power released by the Mauri when it sends waves of change into all. Yet, the Mauri spawns paradox at every turn, great strength and innovation birthing vulnerability at the same time. Into this excitement, Maui took the promise inherent in his own name to bring design and harmony out of chaos.'

'How did he hope to do that, Kui?' asked Tamatea.

'By anchoring our islands in powerful realms to bring everything into balance. As his first promise unfolds you will see that Maui was mighty of mind and spirit. And, perhaps you will understand that this promise has no end, for it is ours to share.'

Carry the Mana of the Waka of the Gods from the Prow to the Stern, and in its power 'catch' the Fish and hold it safe within the turmoil of the Old Tides. See the Mana in the stone, and all between. Honour the Mana in everything for it is of the Unseen.

When grandmother finished, she turned and offered a smile to the old one. They had voyaged into deep waters that touched many shores. There was no limit to the trails that open when we trust spirit.

Move in the Power of the Mana

Having shared the promises of Maui, grandmother knew they were but empty vessels until they were honoured by action. By their deeds we would know them. Only then would they speak to us today. With all this shifting through her mind, the old one lifted her head high.

'Maui left the mountains and sailed south to Murihiku, to begin the work of honouring his promise to care for the land. He came to this shore to gather up the Mana of the Waka of the Gods. Placed in the carved prow of the Waka, it guided all through the tempestuous waters of the cold southern ocean.'

'What is the Mana of the Waka, grandmother?' asked Kea, who still clutched her little waka. She named it Aotea Roa as soon as she heard the story of the Ancestors turned to stone. Now she might find other stories to carry within it, for she began to see her waka was more than a thing of wood. It might carry her dreams and hopes to other shores.

'The Mana is of the unseen, the indestructible, everlasting spirit. Remember, the unseen came before the seen and shall always be; it is of the "in between", the space that always has its own place. So the Mana of the southern island, that we know as the Waka of the Gods, is the spirit of that island, something unique, something that is quite different from the spirit of the northern island.'

'Was the Mana placed in a stone, or carved in wood so that Maui could carry it north?' continued Kea.

'None of the stories tell us, but I like to think the Mana of the Waka was placed in both… in stone because stone never forgets… in wood because the tree gives its life for the hull… but the Mana is a mystery… it lets our minds roam.

'Whatever its shape or form, Maui bound the Mana in ancient prayers and sailed north to Whakarerea, the headland that juts into the blue waters we know as Golden Bay. It's hard to imagine the power of the Mana, to even begin to understand what it held, for it is of realms of pure spirit. Yet, Maui realised if he added its power to a place of power, he might bring balance into the turmoil created by the meeting of the Old Tides. He came to that place to fish.'

'Is it time for the story of Maui and the Fish?' asked Mist. It had been a long wait. Grandfather had promised it would come, so she had somehow stayed awake, even though it was very late.

Sharpen the Jawbone and Blood it

Seeing the little one was not to be denied and that it was a fitting time, grandfather shrugged off his blanket and stood to speak.

'Remember this night, little one. Remember that determination has its rewards. Your plea brings me to my feet.

'Long, long ago when Maui and his four brothers reached these islands he anchored offshore, saying...

"It is time to fish, to find our strength in the bounty of the sea."

'But when he reached for the kete that held the lines and hooks his brothers stayed his hand.

"You are the youngest, yet our grandmother gave you command of the waka. We honour that when we tend the great sail, for that is of her Mana. But, when we fish we take the lines brother to brother and they go first to the oldest and then to the next in years until we come, at last to you. And if there are none left that is your loss."

'Thus denied a line, Maui reached beneath his cloak and withdrew his grandmother's sacred jawbone and, after blessing it, honed it into a hook with a grindstone. Then, lashing it to a spare rope, he smeared it with blood struck from his nose and lowered it into the tide.

'It immediately attracted a Fish so huge the whole ocean stirred as it circled the sharpened bone. Then it seized Maui's hook with so much power it threatened to drag the waka down.

'Yet, Maui was not to be outdone. Knowing this catch was beyond his strength he called on the Ancestors for help, saying...

"My grandmother's jawbone has bitten deep. A creature of awesome size threatens to sink us in the roiling tide. Give me the strength to stand and hold."

'It was a long and mighty struggle. In the end it is not clear if Maui caught the fish or the fish caught Maui. Sometime during that night the Great Fish named Whai Repo, the Sting Ray, rose beneath the waka to lift it high above the waves.

'Dawn's light revealed an amazing sight. Maui's waka rested on a Fish so huge it filled the world as far as the eye could see.

'Some say the tall sternpost of Maui's waka stands forever on Hikurangi, the first mountain to greet the new day, to remind us the land rose out of the ocean.'

The story says Maui's magical 'hook' was made from his grandmother's 'jawbone', but perhaps beneath the surface of those waters another answer lies.

'Koro, was the northern island once a Sting Ray?' asked Torrent.

'Well it rose out of the ocean and it has the Sting Ray shape, for the mapmakers show it that way. But in the end who can say?' replied the old one.

'Did he really make a hook out of his grandmother's jawbone?' asked old Rusty.

'That's the way the story has always been told. So, it means his grandmother's jawbone was very important. I wonder why?' was the reply.

'I think the jawbone stands for more than a hook. I think it tells us something else about Maui,' responded Flame.

'Koro, when you spoke of the old houses of learning and those who were asked to carry sacred knowledge, you said it was of the "jaw",' offered Anaru, who was grounded in the old ways. 'I think much of what Maui did was learned from his grandmother, from the wisdom of her "jaw". When it says Maui used her jaw as a hook, it could simply mean he used her knowledge to guide him.'

There is a mountain tied to this story of the Fish of Maui, a mountain that stands tall to greet the first light of dawn. It is Hikurangi, the sacred mountain in the east, the place where Maui's waka came to rest.

'Your insight brings light to this night,' cried Koro with a deep laugh. 'Never underestimate the power of a grandmother.'

With these last words he smiled and added, 'If you still wonder whether Maui was a myth or a man, remember, there are many ways to store the treasures of the past. We have to unravel them, discover them again, and weave them into today and share them with our children who will then in turn find their own way.'

With the story finished grandfather sat. He had answered the little one's plea, and had given his companion a chance to gather her breath. Now he lowered his head, rested his forehead on hands clasped over his stick, and seemed to sleep.

Make the Fish safe

When grandmother stood, she knew the old one would not miss a word. In closing his eyes he opened his mind to realms that are sometimes hard to find. It was time to move again with the Maui, the explorer who walked this island's sands.

107

'When Maui's vessel reached the waters of Golden Bay with the Mana of the Waka of the Gods, he felt its power surge as he neared the land. Anchoring the double-hulled vessel within the curve of the bay, the crew passed the Mana from hand to hand until it rested above the wave-washed shore.

'Securing the Mana to look out on the sea, Maui laid at his feet a great coil of fishing line. With a sure hand he carefully drifted that line on the outgoing tide and watched closely as it was carried north. He sought dangerous prey on this fateful day.'

Maui intoned the words that made the Fish safe, bound it to the stars and to the Stern of the Waka of the Gods with Karakia. Thus did he honour the Promise.

'He will catch nothing!' asserted Huia, who learned how to fish with Rata, her father. 'He has gone at the wrong time... fish feed on the incoming tide.'

'Ae, you are right. But then so was Maui, for the Fish he sought was of another kind. When the float that carried his line was far from sight, he jerked it taut and thus "caught" the distant northern island, the one we call the Sting Ray. And it has remained "caught" unto this day.'

'Why did Maui do that?' asked Hans. 'Why did he go to so much trouble?'

'Because he had promised to care for the land,' replied grandmother. 'By "catching the Fish" he established his right to hold the Mana of the northern island in place and see that it was looked after in every way. Remember the northern island was a very volatile place, for it was home to the volcanic fires. If the "Whale" had sunk beneath the waters, might not the "Sting Ray" do the same?'

Bind two as one

'In the dark of that night Maui sang a karakia to bind the two great islands as one. Standing in the power of the Mana of the Waka, he acknowledged the earth tides that gathered so strongly at Whakarerea and joined them to a bright star overhead. Then he sent his mind across the waters to touch another star and bound it to the Fish. And he joined star to star and thus tied Waka and Fish together, forever.

'From that day hence the Fish would never face the Old Tides alone. And the Waka would gather strength from the presence of the Fish. Later, Maui's great achievement was honoured by those who knew its power; they named the northern island, Te Ika a Maui, the Fish of Maui, and the southern one, Te Waka a Maui, the Canoe of Maui, and the smaller island in the deep waters at the Prow, Te Puka a Maui, the Anchor of Maui. And they still carry those names today.'

'Kui, the sacred lore you share brings new life to the story of Maui fishing up the North Island,' said Hirini, Mountain's husband, who had come for the first time. 'I now see this land with different eyes... feel closer to it... committed to caring...'

'Ae, and such caring calls for vigilance, as Maui discovered in his time. When he sailed home to Easter Island, he said to his brothers, who stayed behind, "Do not cut the Fish." But they did so, claimed the land, cut it up, argued over it and harmed the Fish. In children's stories, that's how the elders explain why the volcanoes erupt to shower the land with ash. It's the Sting Ray writhing in pain... Ae, cutting the fish was the brothers' shame.'

Maui rekindled the flame

The brothers defied Maui and cut the Fish and it writhed in pain and the land broke open and gave way to flame.

'Maui stayed so long in this land his crew faced death because they could no longer make fire to counter winter's cold blade.'

'Why?' asked old Rusty, who knew the story well. 'They knew how to make fire.'

'Maui was to blame!' cried Torrent, who really lived his Maui stories. 'Maui put out all the fires in the village… and the snow came… and avalanches I think… and the chiefs got angry and made Maui go to Mahuika… the Keeper of Fire… to plead for a fire-child… and it gets worse because Maui threw the first fire-child into the water… and the second, and third… and Mahuika grew angry and attacked Maui with giant fingers of flame… as he ran into the forest his grandmother heard his cries and turned him into a hawk… and although Mahuika burned his tail feathers he still escaped…'

'Ae! That's a great story, but is there more?'

'Yes! Kui… the gods sent heavy rain to save Maui… that was a mistake… it began to kill the fire children… but five brave trees sheltered them… I can't remember their names.'

'Wonderful!' said the old one. 'The kind trees that gave shelter were totara, mahoe, pukatea, kaikomako and patete. They still carry a fire child within and it still leaps forth to offer us a flame.

'Let's see if we can go deeper into this little story. Maui's crew made fire by ploughing a pointed stick along a deep groove in soft wood. However, Maui stayed so long they ran out of fire ploughs. The story tells us that when it says, "Maui put out all the fires in the village".

'However, Maui found a solution. He knew Mahuika, the keeper of the fire children, was so powerful she would be present in every land. Somewhere in the forest there would be trees that sheltered the children of the flame. So Maui pursued them in a very careful way, because it was a sacred act to create fire.

'Of course in the children's story Maui is described as a trickster, a foolish youth who has much to learn. So there are lessons in the way this tale unfolds.

'When Mahuika pursues Maui with fire, it is his grandmother who uses her power to turn him into a hawk. This reminds us we are never alone, that the Ancestors are always with us.

'When we see the dark scorch marks left by Mahuika's fiery hand on the hawk's tail, we are warned that it is dangerous to play with fire or mock her in any way.

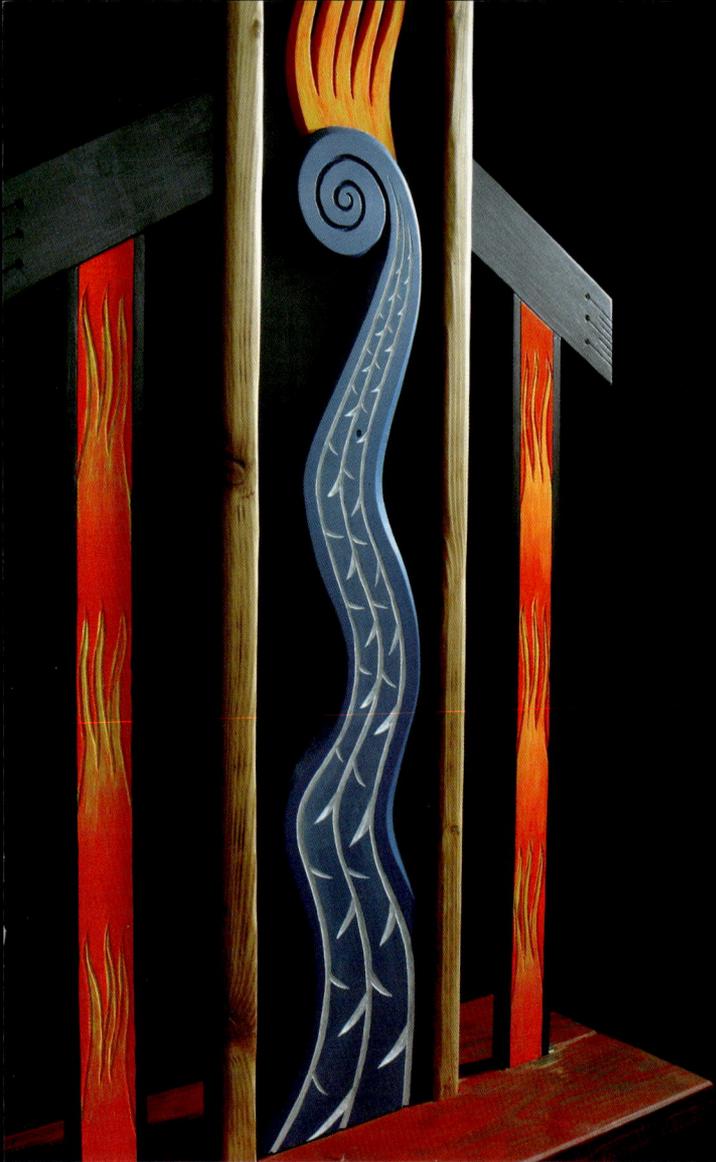

Bring fire to water, and water to fire, and you release powers that can devour. Respect both, for each has its need and its purpose.

'And finally the story tells us which trees hold fire. Maui was the fire-maker not the fire-taker. His journey made it possible for those who followed to survive the frost and snows that visit our land.'

Challenge the waves

'When Maui turned his waka for home the tides held true and the winds blew from a favourable quarter so they came swiftly to Waitangi Ki Roto. It was a time of great rejoicing, for much had been accomplished.

'Maui was welcomed into the great house to sing the story of his journey and the stars he sailed by. In this way they were placed in the memory of those who would later voyage to the Double Sea. Maui planned to return to those waters as soon as the long tides ran strongly and the stars pointed the way. There was much still to be done, for the Mana of the Waka of the Gods could not stay where he had left it at Whakarerea.'

'Why, Kui? Why did Maui need to shift the Mana again?' asked Torrent, who was having a great time.

'Moving it was part of his dream for this land, part of his promise. He knew in ways that are hard for us to understand, that he had to lift the Mana high and carry it down the centre of the island, through the mountains until it was bound again to the Prow of the Waka of the Gods.

'Only then would the land open to the light that is tomorrow. Only then would the Waka have the strength to withstand the giant waves rolling out of the wild, southern seas.

'Thus did courage and need send Maui to the long tides again to answer the call of the Mana bound to a distant shore. And he bravely sailed forth into a bright, new dawn and was seen no more.'

'Was Maui lost? Did he drown?' cried Torrent in an anguished voice.

Grandmother paused. She seemed lost for words. The circle's response, the deep sense of loss, meant Maui had returned to stand beside this shore. They had leapt beyond the myth to the man, opened their hearts to the one who had done so much to bring the promise of the good to this land.

'I hear your sadness. It echoes mine. I shudder when I see the waka sinking beneath the waves, taking Maui and his valiant crew to an ocean grave.

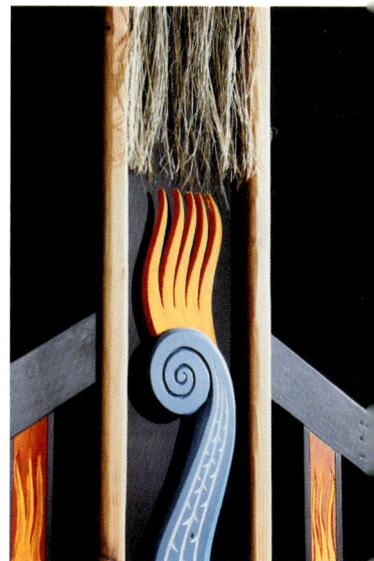

Burned deep are the lessons of the past, burned to mark and shape the world of today. Remember, if we lose our story we lose our dream, and if we lose our dream the spirit dies.

The Mokai still stand tall in the land where Maui was born, but his bones are gone to the ocean tides and there abide.

'That same deep sense of loss touched others in earlier times. So it's not surprising that some stories say that Maui still stands by the great steering oar to sail the Old Tides.'

'Does he really? What do you think, grandmother?' asked Kea, before Torrent could find his voice.

'I think great wisdom is hidden in the mind of the newborn child, that the spirit of the stone remembers things long gone, that the music of the stars touches our lives, and that those who carry the mark of Maui are ahead of their time. Does Maui still stand beside his steering oar? I like to think he does, and will, for as long as we hold that in our minds. Ae, who truly knows what abides?

'Yet, one thing cannot be denied. The work that Maui had begun would not end with his passing. Others would rise to the challenge of carrying the Mana back to the Prow where it belonged.'

'But grandmother, what about his promise to hold us safe within the Old Tides? Was tying the Fish to the Waka enough?' asked Rata, who liked to see the task begun, become the task done.

'And Maui promised to bring the Peace Child,' asserted Flame, who dearly wished to hear that part of the story.

Grandmother smiled. They were so eager with their questions, so aware of all that she had shared that she felt many gains had been made. This was indeed a night to remember.

Everyone is a garden

'I hear your questions, and immediately leap to reveal the little one you have missed so much. The Peace Child was always at Maui's side but preferred to hide until its moment had come. This shy one conceals its fruit until the time of harvest, for the Peace Child is the Kumara.'

'Do you mean the Kumara that we eat?' asked old Rusty, who enjoyed his garden and loved to see his old friends digging deep. 'Describing it as a Child of Peace intrigues me.'

The Peace Child is born to grow, to honour the Mother, and sustain all who celebrate the wonder of life.

'That idea goes back to how our Ancestors saw the world. Remember everything has a family; stone, trees, birds and all we see. And every family is joined to every other family by the web of creation that is of Io. So everything is of Io, of the One.

'Family embraces everything, reminds us everything is related, is of the seed of time, of children and growing, and the many realms of change. And this goes further, for even feelings as different as love and hate have a family and even send their children into the world.'

'Kui, who are the children of love?' asked Flame, who was a seeker.

'You know them well, for they surround you every day. They are named compassion, kindness, sympathy, concern, understanding, caring and humanity. And I pause in wonder when I say the word "humanity", for to see the name that stands for our own kind also standing for love reminds us of our journey. That of itself defines our commitment to family.'

'Who are the children of hate?' was Flame's next request.

'They also stand close, but are often denied or hidden in the shadows of the mind. Hate has many offspring and some are named: spite, malice, cruelty, wrath, rage, anger, fury, resentment, and jealousy.'

'How does this help us understand the Peace Child, Kui?'

'Perhaps that is best explained with a story. It comes from our North American Indian brothers and sisters who also love to teach with stories. That sits well with this night for I know their children gather here.

'A grandfather was explaining to his little grandson how he feels when someone deliberately hurts one of his family.

> "I feel as if I have two wolves fighting in my heart. One seeking vengeance, just wanting to maim and destroy. The other filled with compassion and seeking to heal."

> "Which wolf will win, grandfather?"

> "The one that I feed, little one, the one that I feed."

'We carry in our mind, the way we see the world, be it of love or hate, and that image decides our fate, directs our journey day by day.

'Some say, "We are what we eat," and mean the food we take in decides our body shape, our energy and even our mood. But I say there is even more at stake, that the spirit in which things are done holds greater power. How food is grown, harvested and prepared is important. If done in a good way, it sustains us in body and in spirit.

'So that brings us to Kumara, the Peace Child, the food that reminds us the "how" of things is important, that everything and everyone is a garden, that what we bring to that garden decides the harvest.'

We entrust the Peace child to the women, ask them to hold it close. A mother is the womb of tomorrow, the keeper of the gentle way. We call the fathers to hold in place the circle that keeps the family in a caring embrace.

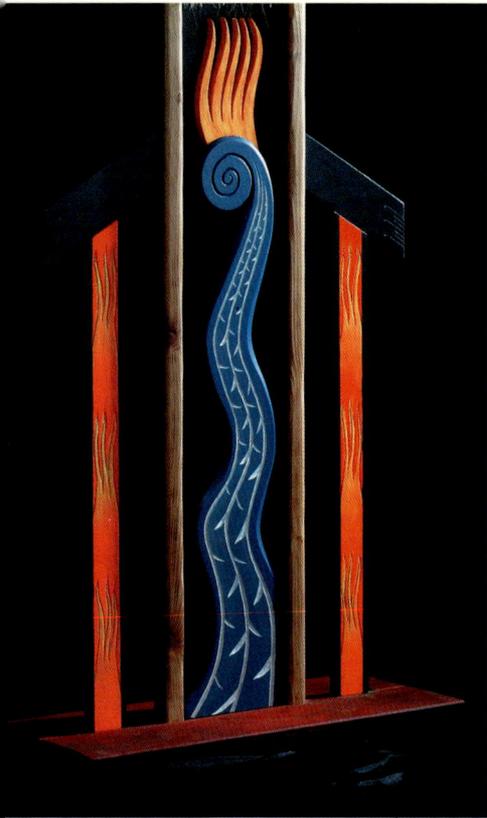

Maui promised to build a

house founded in peace,

a house that respected the

Mother and Father and

welcomed all who wished to

call it home.

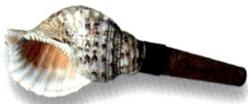

Nurture the Peace Child

'Kumara sustains in everyway. It holds in place the essence of the journey, holds the good way.

'It was carried over the ocean, bound beneath the breasts of the women on the waka. They nurtured it as they would any child, honouring all it stood for, all it meant in life. And they understood Kumara was a vulnerable child, for it died quickly when grasped by the cold hand of the dawn frost. Peace is also vulnerable, a child who asks much of us if it is to grow strong and survive.

'Only women were called to work the gardens, to tend the Kumara and bring forth the harvest. Only the women who carried colours attuned to the seed of the earth, and the gentleness of the caring mother, passed through the garden gates. And only when they were at peace with themselves, and those around them, were they asked to handle the vines and nurture them. Anger had no place in the garden.

'Maui knew the Peace Child's presence was important for the land and the people. Those who came to settle the turbulent domain of the Old Tides touched into the sacred every day. At this crux, this creative pivot on the pathway of change, the People of Peace could hold the balance in a true way. Thus did Maui set momentous things in place, understandings and commitments that reached back to the homeland, and the many homelands beyond that homeland and countless homelands beyond those again.

'When the Earth Mother accepted Maui's promises, she expected them to be honoured in every way. That's why she sealed their agreement with a sign, a shimmering white rainbow that curved majestically across the darkening sky. It was created of all the colours joined, woven into one band of light to honour the Word, the Song of Io.

'On seeing this sign, Maui understood that this agreement went far beyond our sense of time. Those who followed him in later days took up the challenge and renewed the promise and remained true until their ways fell to the warriors' blade, and they no longer held sway.'

POUNAMU

Greenstone

Sail with the Stone People

Glancing around the gathered circle, grandmother was filled with a warm glow that was not of the fire. She saw many were beginning to reach across the chasms of time, were stepping beyond the divide and making space for the Ancestors. They were finding themselves anew. It was wonderful to think that seeds planted here might into tall trees grow.

'While Maui's loss was mourned by all, there came a time when the call went forth for another waka to challenge the Old Tides. Maui's crew had been drawn from the two bloodlines that joined… the tall dark-skinned people, the Maoriori, on his father's side, and his mother's fair-skinned, Urukehu people, who were great navigators. Yet, it was a third people, another nation that took up the dream that must abide.

'We speak now of the people of Ngahue, who were of olive skin and marked by a double fold over the eyes. Their ancient trail led back to Asia and they voyaged far and wide seeking stone, for they lived for its spirit. There was one stone they sought above all others and had not found in the Pacific. Did it whisper to them in Maui's songs, was it hiding in the waters of the Old Tides?'

'This is all very strange, Kui. Who can hear a stone whisper?' asked Silver.

'And why was that particular stone so important to them?' enquired Day Star before the old one could answer.

'As we journey we are going to meet many different peoples and some will call to you strongly, because you are of them. I speak of the Bird People, the Fire People, the Tree People, the Water People, the Whale People and others. Grandfather will show you their houses later and you will know in your heart where you belong.

'However, at this time I want you to meet the Stone People, for they are the Kiritea of Ngahue's line, and of the blood of Poutini, his youthful follower and friend. They honour stone in all they do, for their walk with stone is not a passing thing, it is their life. They attune to its cry in the womb tides of the mother and carry that ever closer until it becomes the song of their being.

'Some time ago grandfather told us we were all Stone People in the beginning. With that in mind let us return to the Kiritea, the Stone People of Ngahue. They walked with the spirit of stone, and like all stone seekers yearned to hold and shape many different types of stone. Those stones came with many names, but the one they sought above all others is known in their distant homeland as jade. It had eluded them when they searched the many islands of the vast Pacific.'

They walked with the spirit of stone and the one they sought above all others we know as Pounamu, greenstone or jade. Some might see it as the Philosopher's Stone, for it was worthy of the quest. Others know it for its power to heal and carry the message of peace.

A quiet cough from grandfather caught grandmother's attention. His eyes sent her an urgent signal. She was to rest. He would now carry this waka forward. Silently she thanked him for his kind intervention. They shared much that went beyond words. He offered his karakia.

When grandfather ended his prayer, grandmother handed him his beautiful Pounamu. He cradled it in both hands, greeted it as one would an old friend and finished by saying, 'Thank you for your journey.' Tears flowed down his lined cheeks, fell upon that Pounamu and were gently rubbed across its surface to enhance its colours. In that moment the old one remembered the dark days when blood was spilt upon the Stone.

It was too soon to bring that sorrow to this circle, but if the tides ran true he might find the courage to reveal that pain.

Know the Spirit of the Stone

Before he spoke, grandfather sent his Pounamu to begin a journey around the circle.

> 'When the snows come down it is a blessing on the land and the people,' intoned the old man.

This was another of those "when" sayings that he dropped into the day. Sometimes their meaning was clear and sometimes insight came days later. Some even remembered them, and saw more, in later years.

> 'The snow cuts us deep when it cloaks all and reminds us Maui achieved much when he found the flame. Without fire there would be no warmth in the dark winter night. And it takes us back to the Ancestors standing tall, the peaks that accept that white shawl. Those Tupuna battled valiantly to defy the Deluge, the world's greatest storm. And last of all snow speaks of time beyond time, of the days that knew no Sun, of the stone that endured when Earth and Sky were one.

> 'When you handle Pounamu you join a journey that goes back millions of years, time counted by the shifting of the stars and measured by the heat of the magma fires. It is thus for many kinds of stone.

> 'In the beginning, fierce fires deep within Papatuanuku sifted and sorted the many children of the mineral realm to make different kinds of stone.

> 'Each stone had its own Mana, its inner spirit that was of Creation and moved to its own Mauri, the uniqueness that set it apart from other stone. Each knew the moment to move from its solid form to liquid, in the heat of the magma fires and when to change back again. While one stone responded swiftly to the touch of fire and ran easily with it, others were reluctant to shift and shape to the song of the flame. Each had its path and knew it well.

> 'Pounamu's story begins deep within the Mother, in a womb of fire that created crystals that formed wondrous fans of light.

> 'All this happened long ago when the planet was shrouded with mists and covered with water. Then the land emerged to become the Whale, one long island within the waters of the Old Tides.

Every stone has its own Mana, its inner spirit born of Creation and is shaped by its own Mauri, a uniqueness that sets it apart from other stones.

116

'As the Whale aged it moved and changed shape. A great slab of the western shore began a slow but steady push north. This was not easy, for as it moved the surface faulted and split the land.'

'Did that cause earthquakes, Koro?' asked Torrent, who was into Earth Science.

'Ae! Massive earthquakes that tore everything apart, earthquakes that utterly changed the land as mountain moved across the face of mountain. Crushed between these colossal forces the Pounamu crystals, birthed of the inner fire, were shaped anew. Now those fans of light wove and intertwined until they gathered, unto themselves, the power to enfold the spirit flowing through these islands at the meeting of the Old Tides; the love we know as Aroha. That is the way of a birthing; light gifting new life. That is the way of the Mother.'

'Tell us more about Aroha, Koro?' asked Day Star, who felt her young one stir within.

'You ask much of me.' he responded, ' Aroha is about love, and is described by action not by words. Let us leave that until we come to the story of the women who nursed the Peace Child. Let us wait until we can set its gentle spirit alongside the Pounamu. Let us hold that story until Rongo-marae-roa is honoured on the Peace Trail of the Stone. Let grandmother take you there, later,' chuckled the old one. 'Meanwhile, let's share a story about Pounamu.'

When crystals birthed in the magna fires were caught within the great fault planes that split the mountains in two, they folded into each other to become incredibly strong.

Seek your wives in the far off places

'Tama Ki Te Rangi awoke to find his three wives had disappeared. Dark mystery moved over the land. Quickly calling his helpers to him, he launched his waka on the tides to search the long shoreline for those he had loved and lost.

'Great was his journey and greater still his pain, when he discovered his first wife bound within the beautiful greenstone of Piopiotahi. His tears of anguish fell upon that stone, reached within it to touch the face of one he held close and there they remain unto this day. Ae, that's why we call that Pounamu, Tangiwai, the Stone of Tears.

'Questing north, Tama came to the Arahura River and paused, because sad voices sang in its rushing waters. Gathering to himself great strength, he paddled far from the shore until his way was blocked by a tall waterfall. And all the while the muffled voices of the lost sang their songs, but he found them not.

'He had arrived too late to save them. Their canoe had overturned days before and they had also been turned to stone. But it was not just any stone, for their names are held within two special kinds of Pounamu. When you look into the dark greenness of Kawakawa, remember her real name is Hine Kawakawa, wife of the great Tama Ki Te Ra. And when you see the beauty of Kahurangi, remember she is his Hine Kahurangi. Much is hidden in a name.'

'Grandfather, is that the end of the story?' asked Kea.

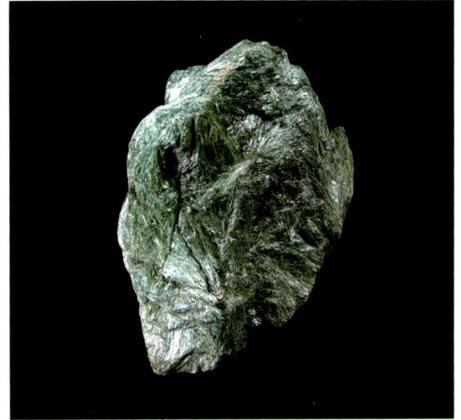

'No, little one. Tama continued on foot until he came to Mount Kaniere and rested while Tumuaki, his helper, prepared a meal of roasted birds. Ae, and in the cooking Tumuaki broke a tapu and was turned into the mountain that bears his name.'

'From beginning to end that's a very sad story, grandfather,' said Mountain.

'Yes, but while it's sad it's also memorable. And we learn the name of three Pounamu, and two mountains and are reminded that Tama explored all the coasts of the southern island and greeted all its mighty rivers. This journey into fantasy sows seeds of truth that but await a greater time of learning.'

'Can we have another greenstone story?' asked Kea. 'One that isn't so sad.'

'Yes, but I'm not sure you will like it. It's about many stones attacking a fish.'

'Let's hear it,' cried Torrent, who knew most of Koro's stories contained hidden messages. He loved discovering them.

Cut and grind to shape the line

'Ngahue, the great navigator and carver of stone, had a favourate fish, and he named it Poutini. It was so strong and so confident in the ocean that he rode it from Hawaiki to Aotearoa where the mountains were cloaked in snow.

'Marveling at all he saw, Ngahue walked the coasts of the lands in the north, then asked Poutini to carry him to a small offshore island. Discovering it was formed from volcanic fire, he gathered shards of Tuhua, a stone that looks like black broken glass. However, on climbing on his fish once more, Ngahue was instantly tossed into the tides when the angry stone plunged its sharp points into Poutini's side. Dropping all they fled that dangerous isle.

'Perhaps stones speak to stones, who knows. Anyway, wherever Ngahue asked Poutini to go, his fish was attacked by stones. Hine Tua Hoanga, the keeper of the grinding stone, sent her stone kind to cut Poutini on every side. Then Waiapu, a stone used in shaping adzes, and Mataa, a flint with the power to cut deep, took up the attack.

'Finally, Ngahue fled to the west coast of the southern island, where he hid Poutini in the bed of the Arahura River. There his wondrous fish was turned to stone, to the one we know as Pounamu. The story ends with Ngahue tearing a piece off the side of this stone fish and carrying it back to Hawaiki where he made it into sharp adzes and built huge waka that carried him across the widest of oceans on the longest of tides.'

The old name for the Arahura River is Nga Wai o Marmari, the Waters of the Green Boned Fish. Many of the old stories describe Pounamu as a fish. Is that because the stone seems alive as it flashes its colour with the current?

118

'That's another sad story,' announced Kea.

'But it tells us something special,' responded Torrent. 'It tells us which stones have the power to cut Pounamu, a very hard material. It's a "how to story". I love that.'

'Let's return now to the real story,' suggested grandfather. 'Let's voyage with Ngahue and Poutini to these shores.'

NGAHUE and POUTINI: The Quest for the Stone of Stones

Te Aka Aka O Poutini
Mawhera
Pa Roa
Waima Whaka Hira Hira
Arahura
Taramakau
Nga Wai O Mamari
Hokitika

• Village

≈ River

Ngahue and Poutini followed Maui's chants, and the stars he set within them, to come to the waters of the Stone of Stones. And they saw the spirit in the Pounamu and carved the stone to bring it forth.

Seek the Stone of Stones in the rivers and along the shore. Look for the colours of Mamari, the green-boned fish, and catch it quickly before it hides far from sight. Go in the rain and the lowest of tides.

Seek the Stone of Stones

'The song of Pounamu was so strong and its spirit so warm, it reached across the widest of oceans to touch those whose ways were of the stone. So it was Ngahue, who was nearing the end of his days, and young Poutini who launched their great double-hulled waka to answer its call. And they came at last to the Islands of the Double Sea and a wild western shore.

'Guided to landfall by Aoraki, the great mountain forever cloaked in snow, their waka was swept north on the coastal current to a welcoming shore. Walking the sands at the water's edge they were overwhelmed with joy when they saw at last the stone they sought.

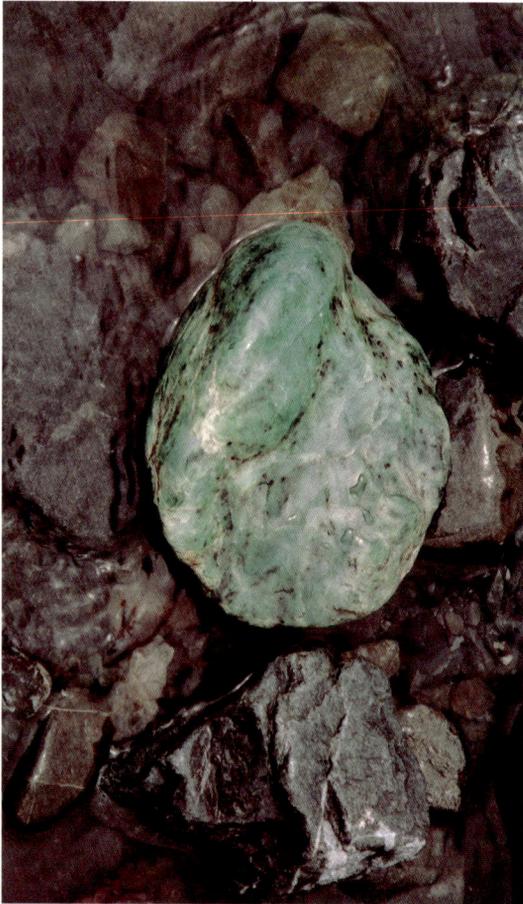

'Its song was of the Fires born of Creation, of the Magma that gave birth to stone, and of the sacred waters of the Old Tides. Its beauty reflected the colours of the snow-fed rivers, the verdant forest, the dawn skies and the brightest stars of the night. Its hardness spoke of the journey into the inner realms, the spirit that learns to endure. Its healing was of the love that knows no end.'

Serve the Stone

'Ngahue and Poutini named the first Pounamu river they explored, Nga Wai o Mamari, the Waters of the Green Boned Fish, because this Stone looked like Mamari, the fish, as it shifted within its flow. Today we know that river as the Arahura.

'Later they walked up the Hokitika and Taramakau rivers to their source within the fastness of the mountains. And as they journeyed, they opened the stone trails that would later serve the people in the days to come.

'They moved in a good way, with respect for this Stone of Stones, the stone of Aroha. When they learned to cut into its hardness and carve the depths of it, they only worked the Stone in ways that honoured its Wairua, the Spirit that was its power.

'Some say it is the hand of the carver that cuts the image into the Stone, that what is created is of that moment, of the committed mind, and there is beauty in that for the mind is elegant, and the hand that carves is, of itself, a thing of fire.

'Others say the carver brings out of the Stone an image that is already within it, that the Wairua which moves there carries from the depths of time and space, a gift that is of Spirit. Some even say that while they carve the Stone, the Stone carves them.

'When Ngahue and Poutini sailed home to Waitangi Ki Roto to share the joy of their discovery, the old one knew he would go forth no more. Age sat heavily upon his bones. His last sailing days had come. Poutini alone would guide the people back to the waters of the Stone.'

Once again the darkened sky gave way to dawn. The old ones had crossed aeons of time in the turning of one night. How good it was to share the sacred lore, and how wonderful to see hope flare. Some of the seeds sown here might still take root in fertile soils, for the soft autumn light often holds the promise of a spring that is warm.

When grandfather finished, he gathered up his Pounamu. He smiled at its touch, for it still carried the heat of the hands that had moved it around the circle. He found great comfort in that. He might still find the courage to share the pain of the past and bring it to the spirit of the healing Stone. His closing prayer sought forgiveness.

KARAKIA

With the circle closed the old ones took some time apart to share. This need was respected so they remained undisturbed.

'I think Maui stepped out of the pages tonight,' chuckled grandfather.

'I feel it too, but remind myself there is still much to do. Ae, but the wind blows in a good direction. We are favoured by time and tide.'

'And we are never alone,' he offered, as he took out his favourite Pounamu. 'And you still have to tell them about the Spirit of Aroha. Remember I left that to you.'

'Ae, that's true, but perhaps it will turn and bite the one who set it aside tonight. Do you seek a new bride?' she laughed as he gathered her close with his best arm.

The group gathered around the old ones as they left the fire. They had journeyed together to the fifth Pouwhenua standing tall. No words were spoken, for their need was simply to walk together.

Then little Kea arrived with all her sparkle and joy to capture grandfather's other arm. And Hans and Day Star walked alongside. Hope beckoned on this incoming tide.

The Promise is nothing unless matched by deeds.

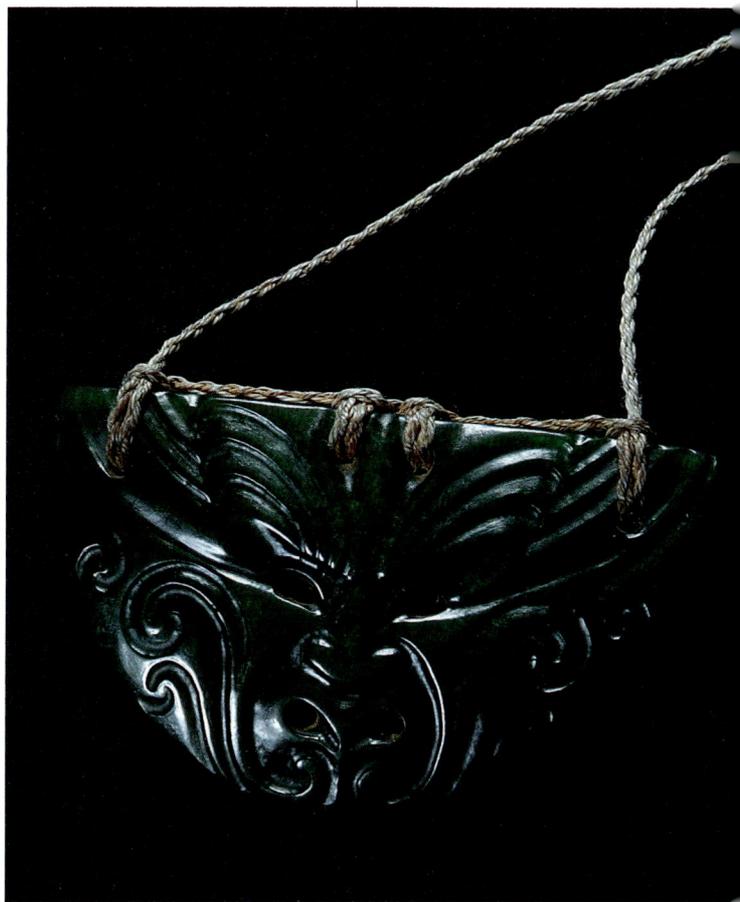

Bend your mind to the stone and it defies you, bring your spirit to the stone and it hears you, listen to the stone and it leads you. Bring forth its Wairua, honour the shape carried within.

SONG OF THE TRAIL MAKERS

Raise Tuahu on high

to bind stone to star.

Raise Tuahu on high

to join star with star.

Go deep into the mind

to find the space

between that opens

to Spirit.

Maui gifted the Sacred Promise to this Land,
the Promise to care for the Mother and nurture
the Peace Child, but he drowned in the tides
before he could complete that Dream.

Then Ra Kai Hau Tu sent his waka
to the waves, and raised a Tuahu in the old
homeland to anchor the Line of Life.
And he sailed home to Hokianga
to do the same.

Seven Tuahu were placed by Ra Kai Hau Tu,
or erected in his name, for the Mana
moved to his chants, and the stars were joined
to the mountains and rivers with his Karakia.

Those valiant deeds call forth other names -
Marotini, Te Waari, Taipo, Rakaihaitu,
Tira, and all who served, unto death,
to honour the Promise and the Dream.

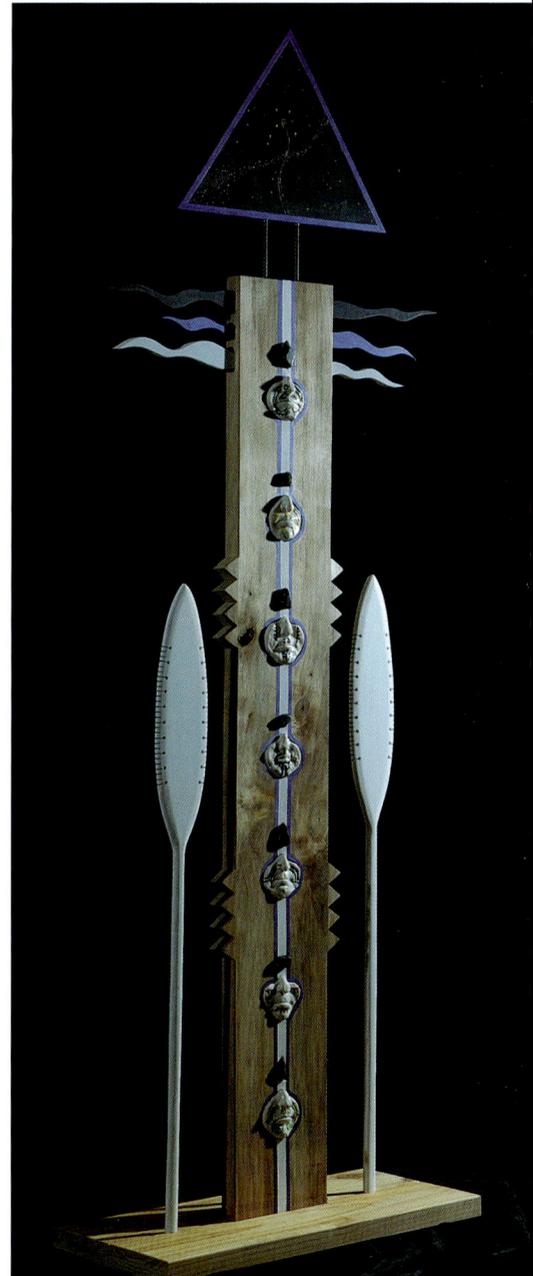

TE ARA WHANUI O MAUI
The Long Trail of Maui

Another trail opened in the sky as grandmother settled at the fire to watch the fading glow of the setting Sun. She nodded to Echo, who walked with her natural Tongan grace to quietly take up the great conch. Then Echo moved closer to the cliffs, wanting to see what sounds might rebound from the towering stone, when she summoned the circle.

The call went out and grandmother quietly applauded. The stone faces had added something special. Echo smiled in her shy way, lifted her head high and gave the conch back to Rewi, who gifted to this student more than she might ever know.

After welcoming some who were new to this fire and thanking Echo for the summons, grandfather opened the circle with his karakia. It asked for inner guidance.

KARAKIA

Then the old one sat with Hans's help and accepted the blanket that was placed over his shoulders to cover his back. It was time for grandmother to carry the dream forward. And while she spoke he would sit quietly with his Pounamu, the stone he had already shared with the circle.

While she waited for those who gathered to settle, Grandmother whispered, 'Soon I take them back to the loss of Maui… the death of the brave one… the Mana abandoned… the waiting for one to come… the long journeys through the mountains… the days when courage stood tall to complete Maui's story…'

Grandfather's gnarled hand reached across to touch her own. His voice was stronger now and so were his words.

> 'I hear your thoughts. Hold nothing back; they are ready to hear the promises the Ancestors carried into this land. And some will carry them for the children and they in turn will hand them on to their children. The old words rise from ancient tides that still weave their magic into our lives. Move on to the next Pouwhenua carved so long ago in the mind to honour the stories of this fire.

> 'Go with the Wairua,' he continued. 'It brought us to this night. It moves with that gathering tide and should not be denied. Trust the Wairua and it will carry us to the sixth Pouwhenua which holds the Mana of the Brave.'

Honour the Promises of Maui

Perhaps too much was ventured here, but who knew when seeds fell which might grow. And for certain, to plant no seed meant no crop at all, only tangled weeds that clutter the mind and bind the soul. Grandmother took her courage in her hands, trusting they would understand.

'Do you remember Maui's two promises, the ones some say stand unto this very day?' asked grandmother.

'To care for the land forever, and to bring the Peace Child, Kui,' answered Torrent confidently.

'And what was left undone?'

'The Mana was in the wrong place and the Peace Child still had to come,' he responded immediately.

It began in the homeland and ends in the homeland. Ra Kai Hau Tu sailed to gather the threads lost by Maui and weave again the patterns of the Dream.

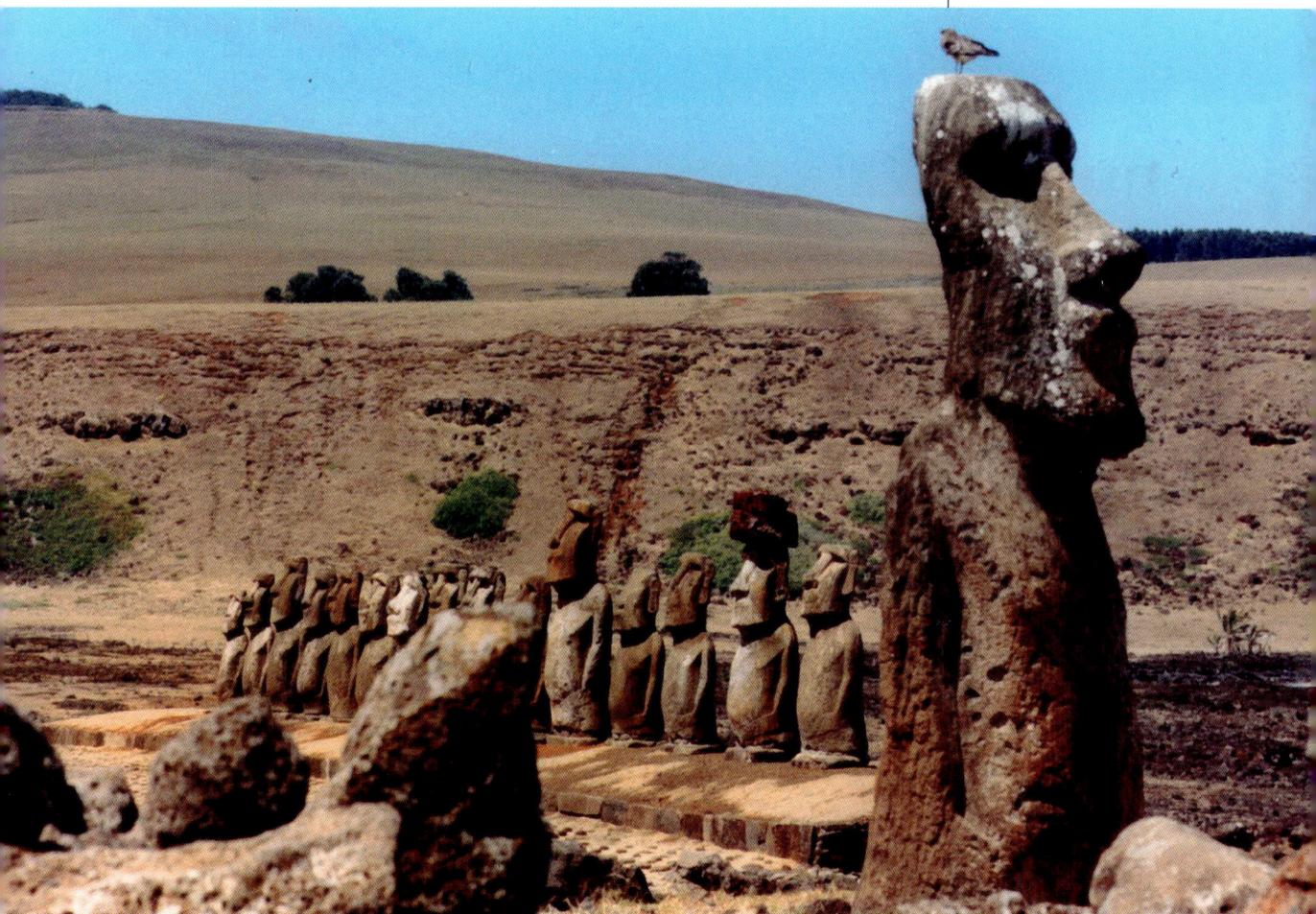

'After Maui was lost to the waves, the Mana stayed in the Stern of the Waka for several generations. Yet, the elders were unconcerned, for they knew the day would come when the Mana would call a brave spirit to its side. Time held no sway over the power it arrayed. The Mana moved to a different tide.

'There was great rejoicing when a boy child was born on the slopes of Tokatoka, for he carried the colours of Maui.

125

'Watched by day and watched by night, seen in the dreamtime of yesterday and tomorrow by elders who held the sacred, this little one, named Ra Kai Hau Tu, grew wise in the power of his name.

'Accepting the gift of 'Ra', the Central Sun, he gathered warmth deep inside and discovered compassion, the fire that nurtures. And the elders smiled to see such gentleness and healing in one so young.

'Many seasons passed as the little one grew into a strong young man, and went to the long tides as the "Kai Hau Tu", the Wind Eater. He was a Star Walker, a Navigator, born to the trails of the night that span the widest oceans. Seeing all, yet needing to search the depths of this "Maui", this dream-maker born anew, the elders challenged Ra Kai Hau Tu on the trails of spirit, tested his resolve and found that his colours ran true.

'No one was surprised when Ra Kai Hau Tu dreamed of holding the Mana of the Waka of the Gods aloft and when the call went forth, many gathered to his side to build a huge double-hulled waka. Yet, some were confused, for when it was launched he sailed to Waitangi Ki Roto, their distant homeland, instead of Whakarerea where the Mana stood.'

Make fast the Line of Life

Remember, the Line of Life is an arc of promise that celebrates the wonder of light gifting life to the planet.

126

The Ancestors raised the Mokai to look to the distant horizon, to watch over the Navigators, those born to honour the power of the ocean and move with respect for every wave.

RA KAI HAU TU : Voyages to anchor the Line of Life and place the Tuahu

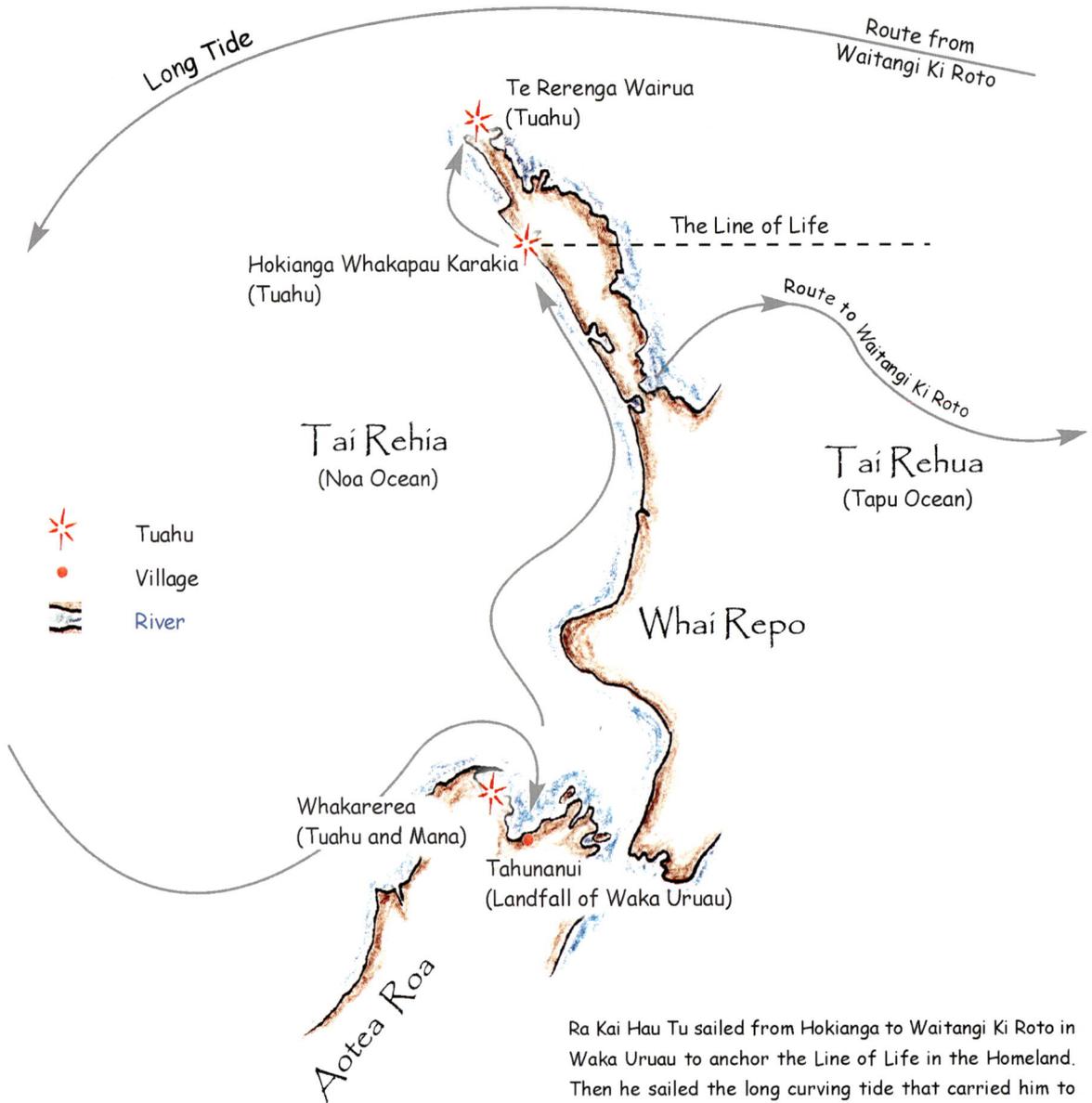

Long Tide

Route from
Waitangi Ki Roto

Te Rerenga Wairua
(Tuahu)

The Line of Life

Hokianga Whakapau Karakia
(Tuahu)

Route to Waitangi Ki Roto

Tai Rehia
(Noa Ocean)

Tai Rehua
(Tapu Ocean)

Tuahu

Village

River

Whai Repo

Whakarerea
(Tuahu and Mana)

Tahunanui
(Landfall of Waka Uruau)

Aotea Roa

Ra Kai Hau Tu sailed from Hokianga to Waitangi Ki Roto in Waka Uruau to anchor the Line of Life in the Homeland. Then he sailed the long curving tide that carried him to Tahunanui.

From Whakarerea he rode the long tide to Hokianga where he anchored the Line of Life in the Southern Cross and journeyed to Te Rerenga Wairua to raise a Tuahu to join the 'Place where the Spirits Leap' to the stars.

Then he returned to Whakarerea to place the Tuahu that joined the Stern of the Waka to the Southern Cross. And when all this was done he prepared to carry the Mana of the Waka of the Gods to the Prow in the south.

'Kui, why didn't Ra Kai Hau Tu go straight to Golden Bay to move the Mana? Sailing to Easter Island seems a bit strange?' suggested Mountain, who had returned every night, although that wasn't her original intention. Scree's increasing involvement with the old ones was one reason and Hirini's sudden interest was another. She was caught up in something that went beyond her need to keep a doctoring eye on grandfather. An occasional visit would have served that.

'Ae, I suspect some saw it that way, even in his day. But there was good reason for that long voyage,' replied the old one, 'important things to be done before he could move the Mana. Ra Kai Hau Tu needed to pick up the threads lost by Maui and weave them anew. That meant sailing to Waitangi Ki Roto.'

'What threads, Kui?' asked Flame as she placed another log on the fire.

'Threads of light that join the land to the stars; threads of mind and spirit that the Ancestors projected into the vastness of space to join Papatuanuku to the Father of the Sky and the Children of the Stars.'

'How is that done, Kui?' asked Day Star, who was excited by the idea of the Ancestors joining the land and the stars.

'With words sacred, and mind pure, and a spirit strong enough to bring the stone and the star into your hand. While there is great mystery in this, it is of the simplest lore that tells us all is one, and that good intent brings forth the power that honours all beneath the Sun.

'When Ra Kai Hau Tu reached Waitangi Ki Roto, he gathered to one place stones gifted from afar, stones that carried the songs of distant homelands and ancient tides. Raising them high, he sent sacred words across the realms of space to greet Matua Tonga, the star cluster that is the Southern Cross. And with those words he bound stone to star to create the First Tuahu, the sacred marker that anchored one end of the Line of Life.'

'What is this Line of Light, Kui?' asked Scree, who hadn't heard it quite right.

'Little one, it is named the Line of Life, but in the wisdom of innocence your question becomes our answer, for the Line of Life is all about light. Ra Kai Hau Tu sited the First Tuahu to welcome the first light of the new day, the Second was to be placed as far west as he could sail and still be within the Double Sea. There he would anchor the Line of Life again to create a sacred place where we might honour the departing Sun. The line between the rising Sun and the setting Sun is the Line of Life, an arc of promise that celebrates the wonder of light gifting life.

'Leaving Waitangi Ki Roto, Ra Kai Hau Tu sailed along the Line of Life to the Islands of the Double Sea and came to Tahunanui. Here he cut the bindings that bound the two hulls of his waka. Then giant totara trees were felled and new hulls carved to balance the old hulls, and where one waka had landed he now offered two waka to the tides. They were Waka Uruau and Waka Araiteuru, and they carried those brave names through many generations.

'Ra Kai Hau Tu sailed Uruau to Whakarerea, where he made his village with the intent of caring for the Mana of the Waka of the Gods, for he was not yet free to carry it back to the Prow. First he had to sail to Hokianga Whakapau Karakia in the far north to complete his promise to anchor the Line of Life where it honoured the setting Sun. Waka Uruau brought him swiftly to that distant headland where he raised the Second Tuahu with sacred words that joined it to the Southern Cross. We are born of the Stars.

'Thus did Ra Kai Hau Tu restore the threads of light that were lost when Maui's waka sank beneath the tides. From that day distance held no sway, for the people could now see a star by night and know they reached across the ocean's great divide to join with family. All this was born of Maui's mind and Ra Kai Hau Tu's courage and determination.

'The people rejoiced, for once again the Maui of Io was weaving balance into the excitement and turmoil of the Old Tides. And although Maui was gone, his dreams lived on in the promises to Papatuanuku that they gathered to honour.'

Sail the Waka of Dreams into the Old Tides

Grandmother paused to settle her thoughts. She realised she had only touched the surface of Ra Kai Hau Tu's voyage to the homeland. Yet, it was important to add each strand with care if she wished to plait a strong rope that reached securely back in time.

With the Line of Life secured she wondered if she might now twist another strand in. Glancing at grandfather, she saw the smile that lit his face and knew his mind had tracked hers all the way. 'Yes, it is time,' he seemed to say, 'I trust your judgment. It can be no other way.'

'When I spoke of Ra Kai Hau Tu's journey, I described everything in his name, for he carried the mana of the voyage. Yet he did not move that double-hulled waka alone, did not paddle or tend the great sail. One hundred and seventy-five made up the crew that left the Hokianga and many of them remained on Waitangi Ki Roto. Some to die there, for age called them to the time to return to the place that held their afterbirth. Others remained to meet with the old families and teachers, and would return on a later vessel.

'The new crew of one hundred and seventy-five had equal numbers of men and women, each with a paddle and the skill to toil. And there were no children or passengers, for all were chosen to carry the Peace Child and the Dream into tomorrow.'

We are born of the stars and return to the stars. This is the journey. And Te Rerenga Wairua is the Leaping Place of the Soul, the sacred headland where all that is remembers the Eternal.

130

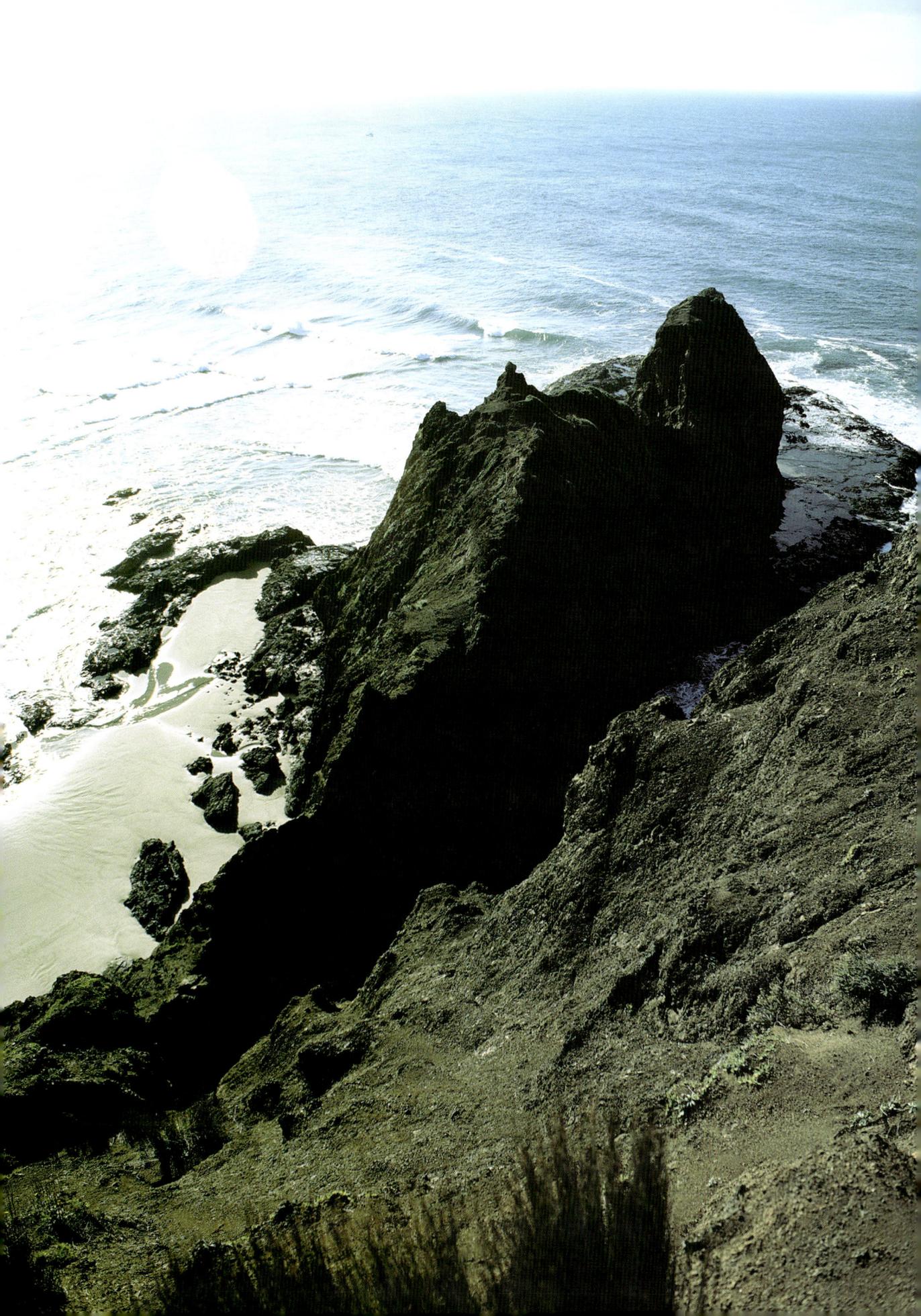

We are born of the stars,
part of the wider realms
and all between.
Life is connection.
Remember, we travel the stars
and feed on the Sun and Moon.
The Ancestors walked
with courage and huge minds
to anchor the spirit of
mountain peaks to the spirit of
the stars, and called on their
pulsing light to enhance Life.
That was the gift they sent
forward in time to serve
those who followed.
That was the promise
they honoured.

'So they went to get the Kumara, Kui. Did that also mean they brought the gardeners?' asked Flame.

'Ae, that is true. The Maoriori, a tall dark people and the greatest of gardeners, came to nurture the Peace Child. Yet, they were but part of the crew, for the Kiritea, the Stone People, came to honour Pounamu, the Stone of Peace and the Urukehu came to open the water trails that give life and help Ra Kai Hau Tu carry the Mana.

'This was no ordinary gathering of people. Each was chosen for their strength and gentleness of mind, their courage and insight, the sacred lore entrusted to them and their commitment to the dream that sailed with Maui. They were all keepers of the promise to care for the Islands of the Double Sea. They carried with them the Dream of a New Nation, a gathering of peoples walking in ways that nurtured the land and each other. The Nation that is Waitaha.'

Go to where the Souls Leap

'How easy it is when I trust the Wairua,' said grandmother. 'And how strong the plait when each strand is honoured. We travel far and we go deep, but we do it together. And we come again to Ra Kai Hau Tu and the creation of more Tuahu.

'Once again those close to Ra Kai Hau Tu were taken by surprise. With the Line of Light anchored in the Hokianga, their minds turned to the Mana of the Waka that was still in the wrong place. But their leader worked to weave a greater design. The order that went forth took them further north, to the sacred headland we know as the "Leaping Place of the Souls", to raise a Third Tuahu.'

'Kui, where is the Leaping Place?' asked Flame. She could see a journey opening to her. She would go to the Far North.

'In the old lore it is Te Rerenga Wairua and today it is Cape Reinga. But whatever name we use the trail it opens is clear, for this is where the spirit that we are leaves the land for the cleansing waters of the ocean and then soars to the stars.'

'Why did he want to place a Tuahu there, Kui?' asked Tamatea, who was at last gaining the confidence to seek, to know and to be heard.

'To honour the spirit trail back to the stars, the path travelled by all our Ancestors, and to keep the promise made by Maui. This Tuahu joined the tail of the Sting Ray, that dangerous barbed spear that holds death, to the Southern Cross.'

'But why do that, Kui?' enquired Tamatea. He wanted to be sure of the story.

'To remind us that the spirit trail is the true trail, that death has no sting, that our journey is bound forever in the stars. Furthermore, the Third Tuahu offers direction to the Sting Ray within the power of the Old Tides, for the Southern Cross is the great constant in the night. When we are lost, its light is our guide.'

Seek the stars
that hold the true course,
find Matua Tonga,
the Southern Cross,
whenever you are lost.
It has the power to guide
you home, for it is joined
forever to the lands of the
people of Aotearoa.

134

'Kui, can you tell me why the Old Tides are so powerful. I live by the sea, yet know so little,' confessed Fran.

'Living in these islands where the Old Tides meet is a wondrous thing. Here the waters of the ancient and the new collide, the divine that is truth eternal, and the ever changing that yearns to shape everything anew. Remember that Io did not bind Creation, did not found it in a fixed way, for that meant nothing could learn and grow. Instead Io set change in motion, sent the excitement of the Mauri into the Nothingness and made the Mana of Io move, and thus allowed the unpredictable. Change carries enormous power into the Old Tides to create and remake.

The Old Tides meet in turmoil and excitement to create within these waters a power that is unique.

'There was great wisdom in the placing of Tuahu that brought balance to the meeting of the Old Tides. The intent of the Ancestors was good in every way.'

'Were the Tuahu at Hokianga and Te Rerenga Wairua enough?' continued Fran.

'No!' replied grandmother, 'Maui's promise was to raise Tuahu where the powerful rivers of life, that flow from the meeting of the Old Tides, cross and join as they course through the land. Three more Tuahu would be needed to complete his dream.'

Stand in the River of Life

'Ra Kai Hau Tu now sailed south to Whakarerea to prepare to journey with the Mana of the Waka of the Gods. At last thought some, for they hadn't grasped the immense scope of the Navigator's design.'

'What about the other Tuahu?' asked Rata, for he loved to see everything tidy and complete.

The power gathered here reaches far beyond this shore for it is bound into the great net of life that embraces the whole planet.

'We come to them as we move with Ra Kai Hau Tu. The next is where he makes landfall in Golden Bay, another awaits him in the southern mountains and the third is placed beyond his grave.

'When Ra Kai Hau Tu came at last to the hallowed shore of Whakarerea he quietly walked its golden sands to make space for the Ancestors who had gone before. Their insight had led them to this wonderful "river of life" created by the meeting of the Old Tides. It flowed through this sacred place, and Ra Kai Hau Tu knew he was called to raise the Fourth Tuahu within the power of its embrace.

'When that was truly done he honoured Maui with words so powerful the spirit of the departed one seemed to gather to that shore. Then, thanking the land for its strength to endure, he laid the name Te Waka a Maui, the Canoe of Maui, as a cloak over the Waka of the Gods. And those with eyes that penetrate the mists of time, saw a waka lost to unknown tides rise high to ride the waves once more. And those who see the land differently still recognise the Master Navigator standing tall to guide us through the fiercest storms of all.'

RA KAI HAU TU : Carrying the Mana from the Stern and raising the Tuahu

At Whakarerea, Ra Kai Hau Tu gathered the Mana and carried it south on the Long Trail of Maui to join the mountains and rivers to the stars.
At Te Kohanga he raised a Tuahu to anchor the Birth Place of the Gods in the Southern Cross. His trail south ended at the Orakaia River, for old age beset him and he was carried to Pa Roa, to enjoy his last days.
Ra Kai Hau Tu bought great honour to the dream of Maui and to the promise to serve the land.

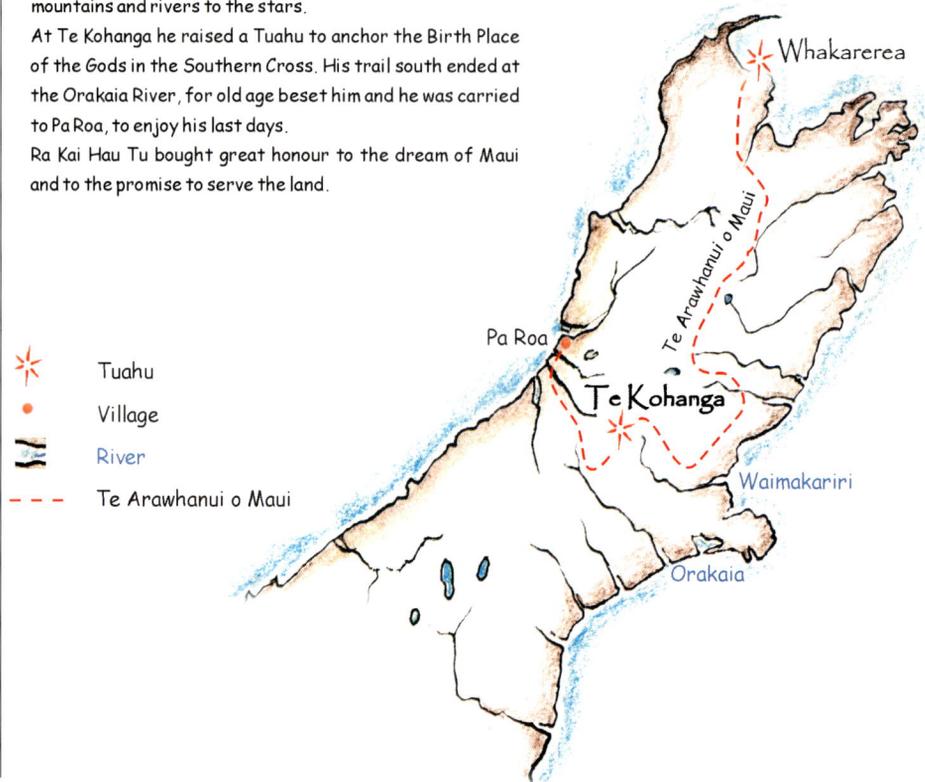

✳ Tuahu
● Village
〰 River
– – – Te Arawhanui o Maui

Whakarerea

Te Arawhanui o Maui

Pa Roa

Te Kohanga

Waimakariri

Orakaia

Live the Trail

'Ra Kai Hau Tu met his people in the light of the new dawn. With his waka safely hauled ashore and its timbers freshly oiled, he called on those destined to leave the ocean's cry to help him lift the Mana of the Waka high. Then he named the path that opened to them, "Te Ara Whanui a Maui", the Long Trail of Maui. Then Ra Kai Hau Tu prayed that they would walk this trail in a good way. And he smiled when a double rainbow appeared to light the day.

'While it was no easy journey down the mountain backbone of the island, it was a gentle one. Nothing was forced, nothing was hurried and nothing was left undone. This journey would be made once, forever and for every one.

'As they carried the Mana, they gathered to it the magic of the land and the mystery of the stars that shone upon them. Every mountain peak was asked to hold the name of one of the crew lost in the Deluge that struck the Waka of the Gods. And when that was done, the mountain was joined to the stars in song.

'Great was the journey. Children were born on that long trail and grew tall, and the Mana shone more brightly as it was carried south. For not only was the spirit of the mountains sung into it, but also the spirit of the waters. Ra Kai Hau Tu tracked each river to its source, found its birthing stone and joined it to the stars. And when that was done he tested its rippling waters and placed its virtues in a song.

'When the story of each peak, river and lake within reach of their camp was recorded they dismantled their round houses and moved on. Carrying the long poles of their shelters, they moved on to the next valley that would be their home.

The old songs tell of Ra Kai Hau Tu's long journey through the land, of the passing of the seasons and the passing of the years. Children were born on that trail, birthed beneath the snow-covered mountains, beside the rippling waters and on the tussock grasslands fringed with beech forests. And the Mana moved and the rocky peaks were joined with the stars.

'Season after season their children lived that trail of snowy peaks, rushing rivers, golden grasslands and dark green forests. Of the distant ocean and its shores they knew nothing. Yet it was there, where the rivers met the ocean, that another party closed the circle to complete the work of Ra Kai Hau Tu.

'That group travelled in the name of Tama Ki Te Rangi, the new-born son of Ra Kai Hau Tu. They walked the eastern shores to honour the waters that filled the bays and crashed against the headlands. Everything they did mirrored the work of Ra Kai Hau Tu, for when they touched the waters at the mouth of the great rivers they were the same waters held high by their leader in the distant mountains. And their words were bound in song to the same stars.

'Thus did the Mana move until it came to the wondrous alpine basin where Maui stood so long ago to make his agreement with Papatuanuku, the understanding that allowed his people to be of this land. Known as Te Kohanga, the Nest, it is the Birth Place of the Gods.

'Here, Ra Kai Hau Tu rested, for age now silvered his hair and sapped the strength of his legs. Then, when the Bright Moon shone on the mountains, he raised the Fifth Tuahu. When his karakia once again reached the Southern Cross that turned forever in the sky, he thought he heard the land sigh. And he smiled upon the mountains that nurtured him and remembered all achieved by Maui and thanked his people for their journey.'

Do not push the river

'The seasons turned and the Mana cried out to move. Now Ra Kai Hau Tu carried it to the mighty Orakaia River, to the turbulent waters at the narrow gorge where it broke free of the mountains. He sent his strongest trail makers to challenge its power, but when they were thrown back by wave and wind he knew the way ahead was closed to him.

'It was a journey well begun, and his part was not yet done. Calling for three large pieces of Pounamu he gifted them to the rushing waters of the gorge, to ease the way of those who would one day take up the Mana and carry it on.

'Several generations passed before Te Waari, great grandson of Ra Kai Hau Tu's blood, took up the Mana and carried it over the "Pounamu Bridge" left by his courageous ancestor. Leaving the raging waters of Orakaia behind, he carried the dream south into the lands made beautiful by the waters of Te Kapo, Te Pukaki, O Hauiti, and O Anaka. Then he came to the shores of Wakatipua and saw his life drawing to a close, and released his spirit to fly to Te Rerenga Wairua that it might travel back to the stars.

CARRYING THE MANA OF TE WAKA O MAUI

Te Waari uplifted the Mana and carried it over the Orakaia River and into the southern lakes. On Te Waari's death his son, Taipo, carried it forward but failed to reach the ocean. Rakaihaitu gathered the Mana and carried it to Hokitika and moved it down the coast until he came to Ore Puke, where it sat once more in the Prow. Then he sailed into the coldest of waters to Maunga Huka and raised the last Tuahu. When he voyaged on to Waitangi Ki Roto to tell the elders the dream of the Tuahu was set in place for all, his Waka was lost forever in the tides.

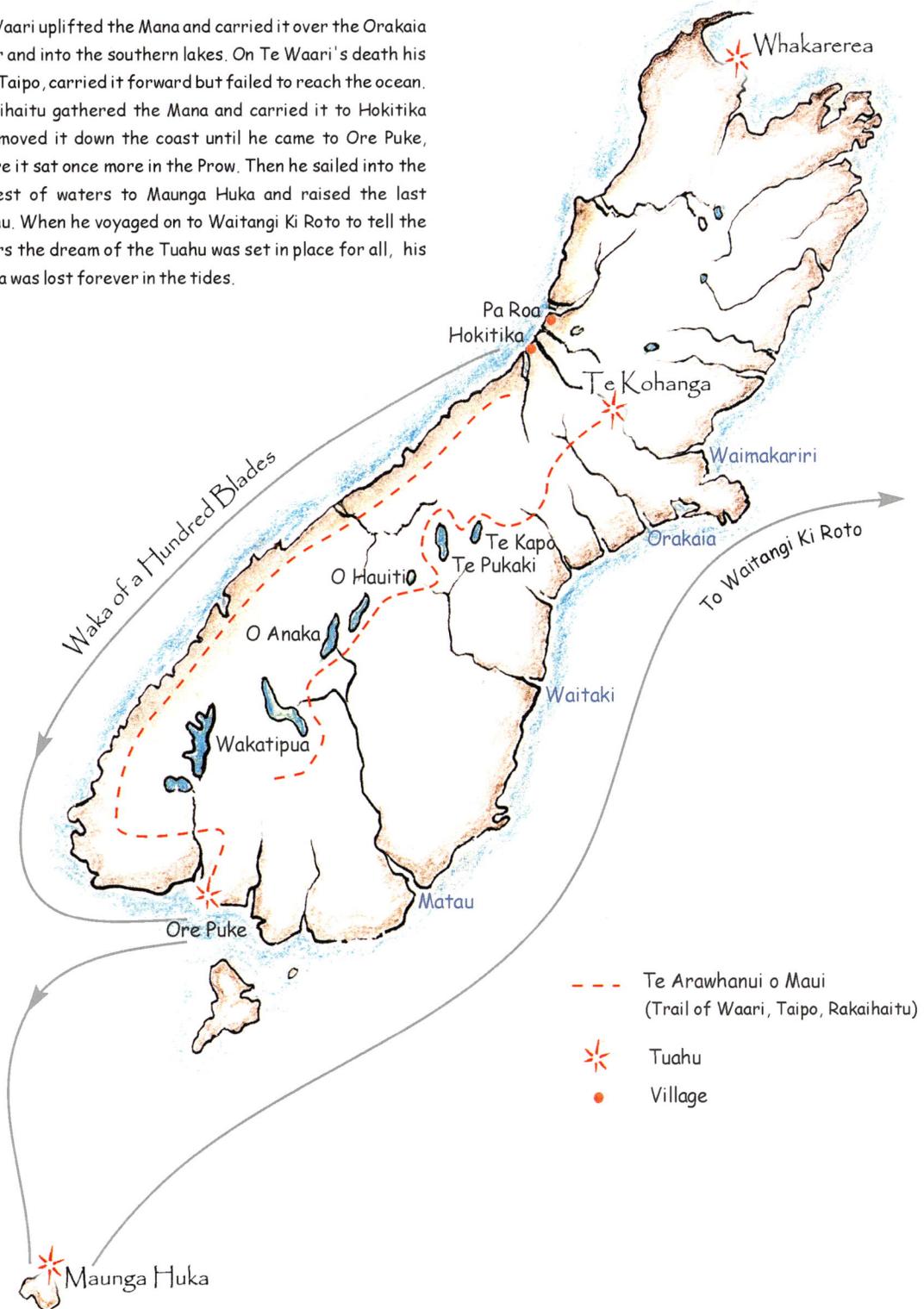

Whakarerea

Pa Roa
Hokitika

Te Kohanga

Waimakariri

Waka of a Hundred Blades

Te Kapo
Te Pukaki

Orakaia

To Waitangi Ki Roto

O Hauiti

O Anaka

Waitaki

Wakatipua

Matau

Ore Puke

- - - Te Arawhanui o Maui
(Trail of Waari, Taipo, Rakaihaitu)

✳ Tuahu

● Village

Maunga Huka

139

Honour the power of the
mountains, be humble beside
the still waters, let the spirit
of the land reach within to
greet you. Mountains mirrored
over water bring us into
another tide on another side.

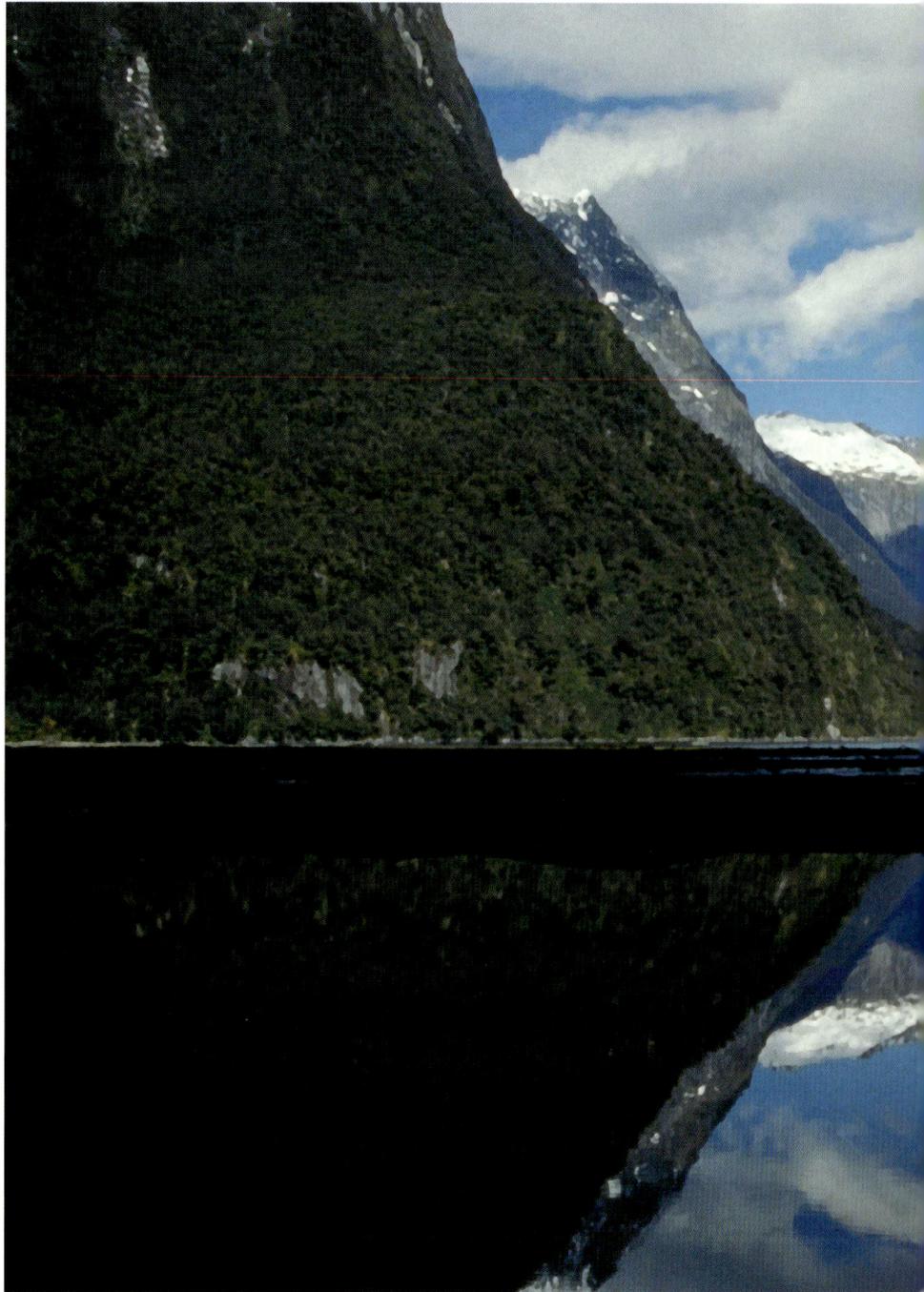

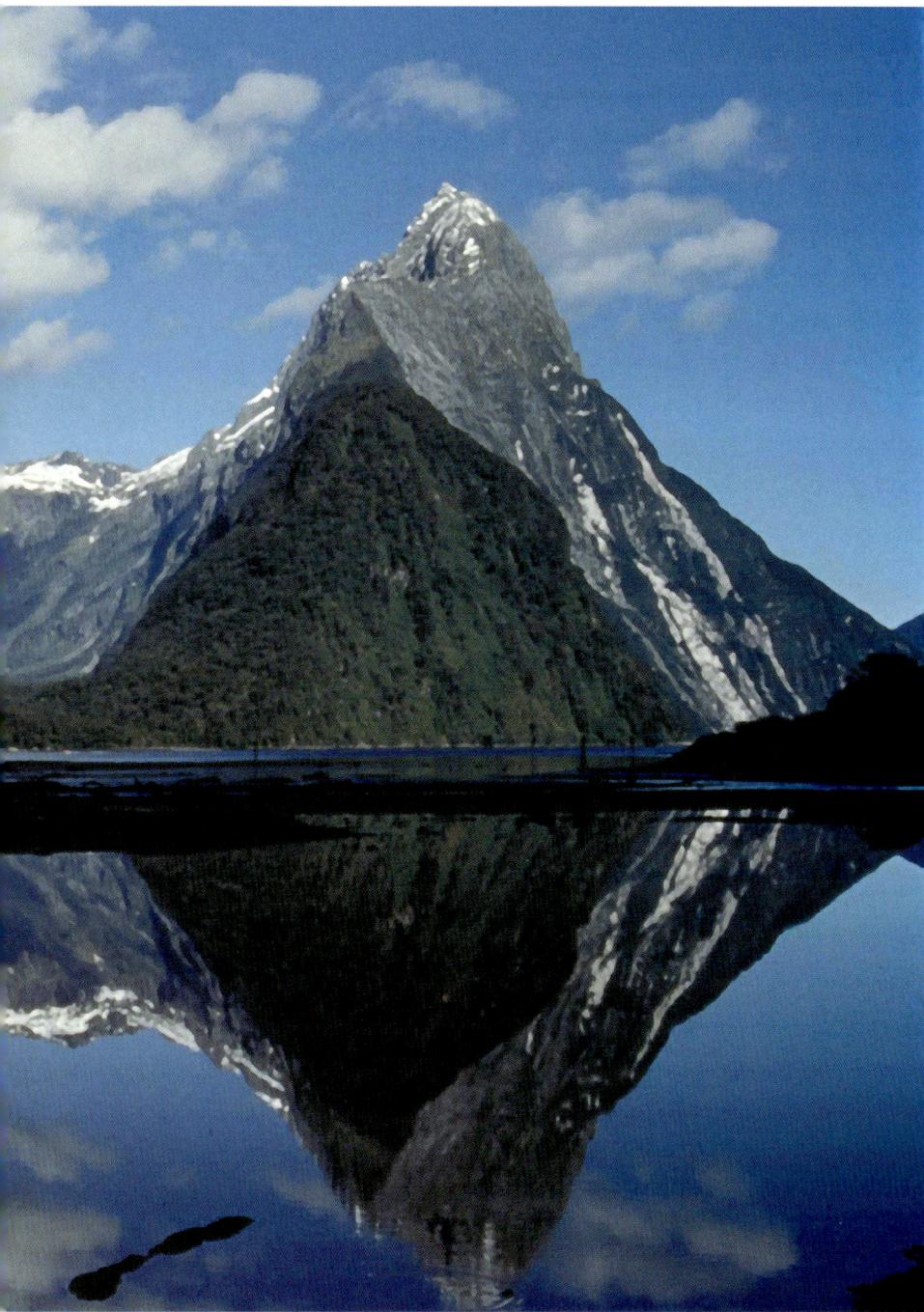

'Now Taipo, son of Te Waari, stepped forward to carry the Mana. He walked bravely, for the Moon turned strongly in the night. Then, many seasons later, he faltered when storm clouds gathered to bar the way and the birds of the trail hid far from sight. Dark were the signs.

'Yet Taipo, knowing the ocean was close by, pushed through until one of his party died and the Mana fell from his grasp. And there it lay awaiting the one who would lift it up again.'

Listen to the Mana

'Years passed then Rakaihaitu, a young man of courage and keen mind, born of the Ra Kai Hau Tu line, heard the call to move the Mana. But he chose to open a trail that honoured it in a different way. Realising that the Mana had only been to the waters that ran to greet the rising Sun, he dedicated his life to carrying it to the shore that said farewell to the light at the end of the day.

'This took him to Hokitika where he constructed the "Waka of a Hundred Blades" and gathered a brave crew.'

'Kui, why does it have that name?' enquired Mick, born of that western shore. He was excited by this story that took him so close to home.

'Because each blade was really a paddle, so that tells us this was a powerful waka. Ninety-six were used by the crew, two blades were joined as one to make the great steering oar, and two were carried to honour a great journey made and one journey still to come.

'Sending the waka to the tides Rakaihaitu walked south with the Mana, knowing his crew would rendezvous at the mouth of each river. This journey was like no other for they carried great Taonga… the paddle used by Ra Kai Hau Tu and the old one's bones. In the power of these treasures Rakaihaitu carried the Mana to a lake and with words of remembrance, left the paddle on its headland to honour his ancestor.

'When they came at last to the majestic fiords of the south the land party was sorely tested. Yet, with the Waka of a Hundred Blades close at hand, they were able to honour each river where it reached the shore and each mountain standing tall and sing them into the stars. After years of endeavour they broke through to the southern shores, set the Mana down at Ore Puke and raised the Sixth Tuahu.

'The Mana had returned to the Prow of the Waka of the Gods to keep it safe in the huge tides that swept in from Antarctica. The circle begun by Maui was now the circle joined.'

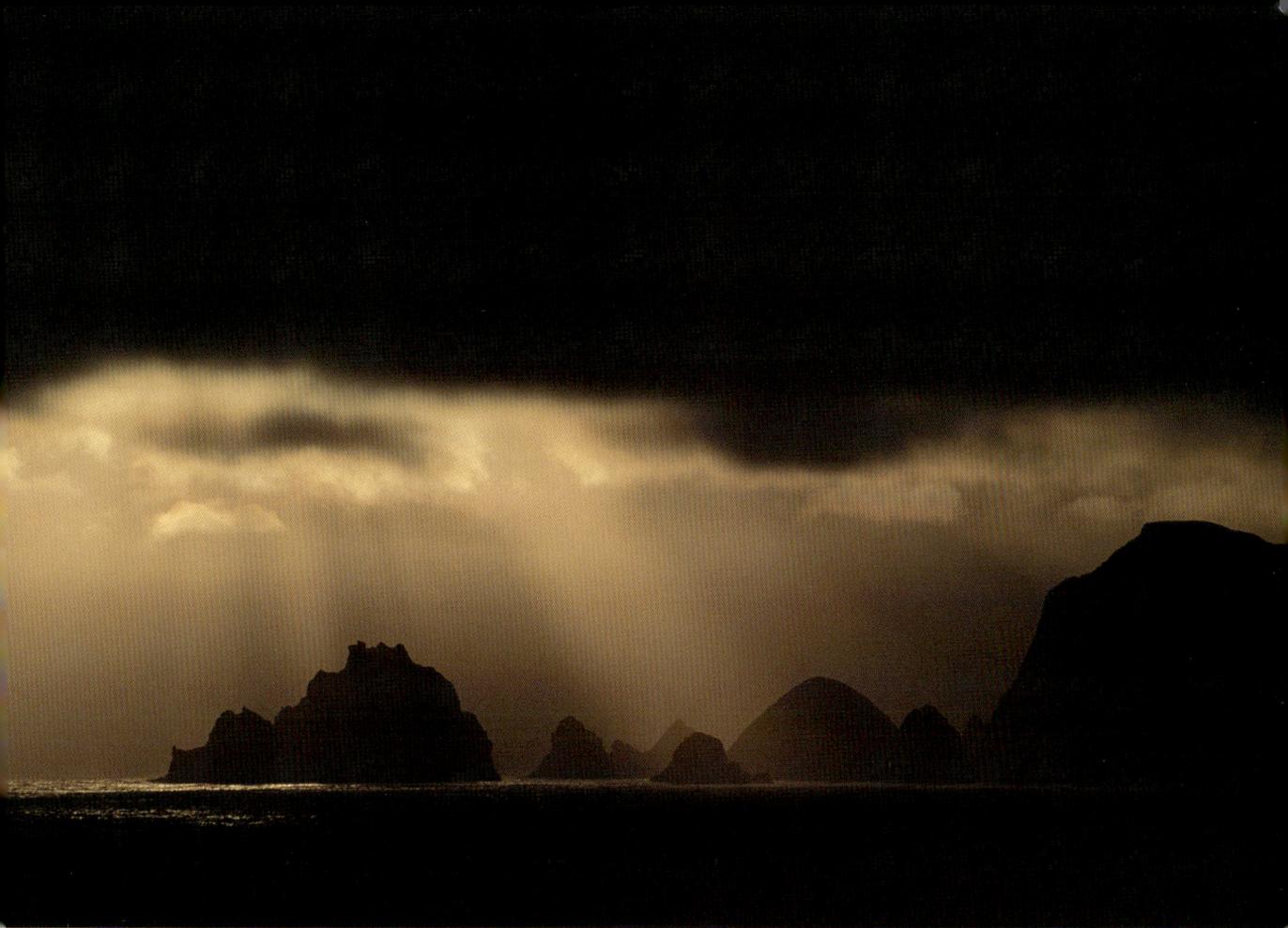

Courage is in the Cold Sea

'Standing in a great circle at Ore Puke, Rakaihaitu walked to the fire that held its centre and turned his back on it. Those who knew his ways understood his action had much to say. They were not surprised when he said that their waka was destined to leave shores comforted by the flame, to sail into the southern waters where ice and snow held sway. Then, raising his eyes to the Southern Cross, he assured them the oldest of songs and the brightest of lights would guide them all the way.

'Few can imagine the cold and the pain that assaulted them every day. Yet they accepted it, embraced its power and used it, for to reject the Mana of this cold domain was to die with shame. And they won through to the island of their seeking and came ashore on Maunga Huka, and honoured its name for it was truly of the waters of the great ice mountains that drifted in the tides.'

'Are they icebergs, Kui?' asked Torrent.

'Ae, that is so. But have you guessed what this is all about? Do you know why they sailed into these dangerous waters?'

'To raise the last Tuahu,' cried Mist and Scree together. They were not to be outdone.

'Ae, that is so,' responded the old one with a warm smile. 'I thought I might have lost you on the way. Ae, that's where Rakaihaitu joined an island, set within fierce tides, to the Southern Cross and with that karakia added another star to the balance.

Leave the land, sail south and prepare to meet the harsh wind that makes the ocean freeze. There is no other way if the last Tuahu is to be placed.

143

'Some say the power of that Tuahu softens the impact of the wild waves, born of the distant ice mountains, as they crash ashore. They hear its calming voice within the roar of those ancient tides. And they know the Mana in the Prow protects the south from the Storm of Storms that might sink Te Waka a Maui in the tides.'

Close the circle in the meeting of the bones

'When Rakaihaitu left those southern waters he sailed up the east coast to leave the song of his voyage with the fishing fleet. Then, after a brief farewell, set his shoulder to the great steering oar and came to a course that brought the setting Sun to his back and opened the way to Waitangi Ki Roto. All this was ordained by ancient lore for having honoured the call, he knew he must return to that ancient homeland to complete the circle that had its beginnings on those treasured shores.

Waka venturing into the blue waters of the south are challenged by the terrible storm winds born of the Ice Mountains.

'Brave was the crew and strong the one who leads them, yet none knows what awaits on a distant tide or when Tangaroa might call them to his side. The Waka of a Hundred Blades never reached Waitangi Ki Roto. It was lost forever in waters wide where mystery moves within the depths and its own promises keeps.

'How strange that Rakaihaitu's death mirrored that of Maui? How fitting, in a way, that the bones of the one who completed Maui's work now rested with him in Tai Rehua, the sacred ocean now named the Pacific or Peaceful One.

'And there is more. Before the Waka of a Hundred Blades left its home waters Rakaihaitu had completed Ra Kai Hau Tu's dying wish of generations before, by gifting his bones to Tai Rehia, the Ocean of the People, now named the Sea of Tasman.

'And even then that part of the story is not done, for those waters awaited the arrival of another favourite son.'

144

RONGO-MARAE-ROA

The Peace Maker

Nurture the Peace Child

'With the Line of Life anchored on Waitangi Ki Roto and the headland at Hokianga, and the Mana in the Prow of the Waka at Ore Puke, and the Islands of the Double Sea bound forever to the Southern Cross by the Tuahu, the Ancestors had bravely answered the call to honour the promise made to Papatuanuku.

'Yet even more had been done. While the Mana was being carried back to the Prow, the gardeners were planting the Kumara that the women nursed throughout the voyage to this land. The Peace Child was first raised in the southern island for it was there, in the sunniest of bays, that the elders saw it reach full harvest in the shortest of days. Remember, Kumara was a frost tender child. It might die in the grasp of one harsh night.

'At Wairau, close to the shore where Waka Araiteuru made landfall, the gardening people found favour in the soil and the way the Sun filled the day. There generation after generation toiled to give this wondrous child a good life.

Marotini held the Peace Child in her arms and honoured the pledge that Maui made to grow the gentle one where the land knows the winter snows. How bravely that challenge was met down the generations.

'When the Wairau gardens were flourishing those who honoured the needs of Kumara followed the trail opened by Ra Kai Hau Tu and came at last to Te Kohanga, the Birth Place of the Gods, deep within the mountains. Led by Marotini, a woman entrusted with lore gathered in countless generations of tending the soil, they journeyed in trust to honour trust. Standing before the same stone tors where Maui had promised to care for the land, Marotini committed her people to growing the Peace Child in the place that honoured the sacred.

'This asked more than most will ever know, for great was the challenge to nurture Kumara in alpine heights where snow sometimes came in the season of the High Sun. Yet, with great skill and wisdom, the gardeners succeeded and continued to harvest for many generations until their last days had come.

'Remember these words well. They did not bring the Peace Child into those mountains because soil and Sun offered easy gardening. They went into that alpine basin to fulfil the promise made by Maui. While some might think there were gardens enough, others were determined to place the Peace Child where their commitment began. And there was virtue in that, for they learned much from the land and gifted much back.

'With the promise of the Peace Child embracing more and more of the land, it is time to once again take up the story of the Peace Stone, the cherished Pounamu discovered by Ngahue and Poutini.'

Poutini carries the promise of the Stone

Grandmother sat for a time. They had travelled a long way this night. She thought of words already shared, of how last evening they had voyaged with the Stone People to the Pounamu, of how they had heard Ngahue say that he could sail no more. Now their journey was with Poutini alone. It was his voice that called her to the story. Rested now, and eager to share, she found the words once more.

'It was Poutini who gathered a crew of brave men and women, and followed the songs of the old master until the stars guided them once again to Aoraki and the home of Pounamu.

'Poutini built his village on the northern estuary of the Mawhera River and named it, Te Aka Aka o Poutini, the Anchorage of Poutini. There he lived in the fullness of his days creating wonderful taonga in the Stone, teaching those born to carve how to sit with it and listen to its song and how to see the shape that waited to be brought forth.

'He served the Stone well, walked the rivers of its birthing, mapped the stone trails, counted each day on that coast as a blessing and met his death in twisting tides that gathered to grasp his waka.

'We remember Poutini with great joy, honour a life that truly served the people, thank him for his wonderful ways with the Stone, and name the waters of that western shore Te Tai Poutini, the Tides of Poutini. Which is fitting for they claimed his bones.

'All that Poutini achieved abides, for his life embraced the healing Stone, and his spirit went to the Waters and it still whispers along a wild shore that moves beyond the sands of time. Such is the power of Aroha.'

Grandfather smiled when he heard her end with the word Aroha. He marvelled at the way his old companion wove each thread into a greater design.

His strength was in the sprint not the long haul, or it was before age crept so quietly into his life. Was he really eighty-four; part of him still seemed but a boy!

Embrace the Tides of Aroha

'Grandfather set before me, in the hearing of all, the task of explaining Aroha. I could say "thank you" to him for this opportunity, but that would be impossible in Maori, for in our language there is no such word,' said grandmother with a laugh.

The circle sensed she was in a playful mood. They began to understand that lightness and laughter were strong threads that joined these old ones. While age and wisdom gave them great presence, a keen humour, born of humility, added the warmest colours to their cloaks. Each time the circle gathered they saw more. And each revelation was a mirror into the way two people might love and grow, if they were open with each other.

'As I cannot thank grandfather, I am tempted to hand this "Aroha thing" back to him, but that would be unfair, for he would probably lead us all astray.'

Now grandfather joined in her laughter, for he loved to hear her recite his little failings. There was Aroha in that too.

'Perhaps understanding why there is no "thank you" in Maori is a good place to begin to share the Spirit of Aroha. In the old ways a kindness is always repaid by a kindness. If someone does something special for you, then you do something special in return. If someone gives you a beautiful stone you give a stone for that stone, or something else you value.

'Today, when we say — "actions speak louder than words" — we come to the heart of Aroha, to one of the greatest gifts Io gave to the Islands of the Double Sea.

'Io did not leave the Spirit of Aroha drifting in the tides of space, but gave it a place. As Pounamu was created and shaped within the great mountain faults, the Spirit of Aroha was woven into its core to be carried there forevermore. And because it was birthed deep within the Mother we know as Earth, Io bestowed on women the guardianship of the Stone. And Io called on men to walk with them in the strength of the Father who cares.

Io did not leave the Spirit of Aroha drifting in the tides of space, but gave it a place. It was woven into Pounamu's core, gifted within the mountains to serve forever more.

147

'When we come to Aroha, we see it takes many forms. Aroha is the love that a parent feels for its child, the nurturing love that carries the babe through those magical years of change, the caring love that embraces both its joy and its pain. And when that journey seems done, when the child becomes the parent of another little one, that Aroha grows to make room for a grandparent.

'So that nurturing, parenting love never ends, no matter how independent the grown one may become. It is an umbrella of caring that abides until our last breath is lost to the eternal tides. It is a way of being that is expressed again and again in actions, not mere words.

'This Aroha that finds its strength in family and friends, spills into the world when we allow the heart to step ahead of the mind. The Ancestors knew that as a way of life.'

Walk the Stone

'When the river gifts Pounamu to the seeker, it offers the Spirit of Aroha in the expectation that it will be nurtured and gifted on. There is hope in its touch, for Aroha mirrors our pain and our joy, and helps us seek direction. And in opening the mind, Aroha brings us back to Spirit.

'Pounamu is of the moving mountains born of turmoil and travail that allowed it to experience change, know healing and pass that on. Poutini saw it as the Journeying Stone, dreamed of his people carrying it through all the land, but drowned before he could achieve all he planned. His death closed that Stone Trail to the Nation and many generations passed before it opened again.

'It was Te Waari who opened the "Pounamu Bridge," who went back to the songs of Ngahue and Poutini and found within them the perfect trail upon which to carry the Stone. It followed the Arahura River and to those fast waters he called Rongo-marae-roa, the Spirit of the Peace Maker, and asked the women of the Nation to hold the Mana of that Trail. It became known as Te Huarahi o Rongo-marae-roa, the Trail of the Peace Maker. And it was a very difficult journey.'

'I don't understand, Kui. Why carry heavy stone over the mountains when they could so easily ship it on their double-hulled waka?' asked Tamatea, who spent his weekends walking the hills. Anaru was buying a pack and would soon be by his side. Youth enjoys a challenge.

'Ae, some of the stone did travel by waka, but only after it had been carried on the Trail of Peace to the high pass that opens to the east.'

'This gets worse, Kui. You mean they carried stone up this trail and back again, and then put it on the waka?' Anaru was amazed.

'Ae, they sometimes did that, and they had their reasons. Their thinking went far beyond the hard physical effort of carrying the Pounamu to a small lake cradled in the cusp of a mountain pass. That journey was made to honour the Stone. They walked it for Spirit.'

We walk the trail and the trail walks us

'Carrying heavy Pounamu deep into the mountains to honour its spirit was a far cry from the way many see the Stone today. It was one thing to speak of your respect for the Stone, to offer words and a very different thing to lift it high and carry it through rivers, up steep trails, through the snow and over the rocky ramparts of the mountains.'

'How was that journey done, Kui?' asked Tamatea, who realised he was committed to walking the Old Trail.

'Te Waari put the way of it in place. He asked men to walk the trail with women because women were the guardians of the Stone and held the Mana of the Old Trail. The parties were to be twelve, the ancient star number for journeys. That twelve learned to be as one, for the power of the strong must be shared with the old, the young, and the weak. And those who walked strongly in some things found they were weak in others and came to humility in that learning.'

Carry the Pounamu to the purest of waters, to the melt waters of the snow that gather in the lake at the pass. Let it rest within during the turning of the Sun, then send it forth in the fullness of its Mana.'

'Was that all that Te Waari asked of them, Kui?' continued Tamatea, as his mind searched for those who might walk the Trail with him. Anaru was one, but where would he find the others? This old lore asked much of him for he revelled in solitude. Yet, if the journey was to be done, he wanted to do it in ways that respected the Ancestors.

'Te Waari taught that other stone found on the Old Trail be left where it lay. Only Pounamu was honoured on this journey, only the Stone of Stones was carried. That was their one task, the sanctified, sacred task that brought them to this Old Trail. There was no secondary or additional task, for the Ancestors understood that to do two things at once dishonoured all. The lore of holding to one task is the key to walking in the sacred.'

'But we are always doing two and three things at once, Kui!' cried Fran, who was often overcome by the demands of her three children.

'I know, dear. I have been there too, but when I look back on those days, I see how I lost so much by forgetting the old ways. Let's explore that later. Meanwhile let us prepare this youth for the Old Trail he yearns to walk,' responded the old one with a chuckle.

TIRA: TE HUARAHI O RONGO MARAE ROA
The Peace Trail

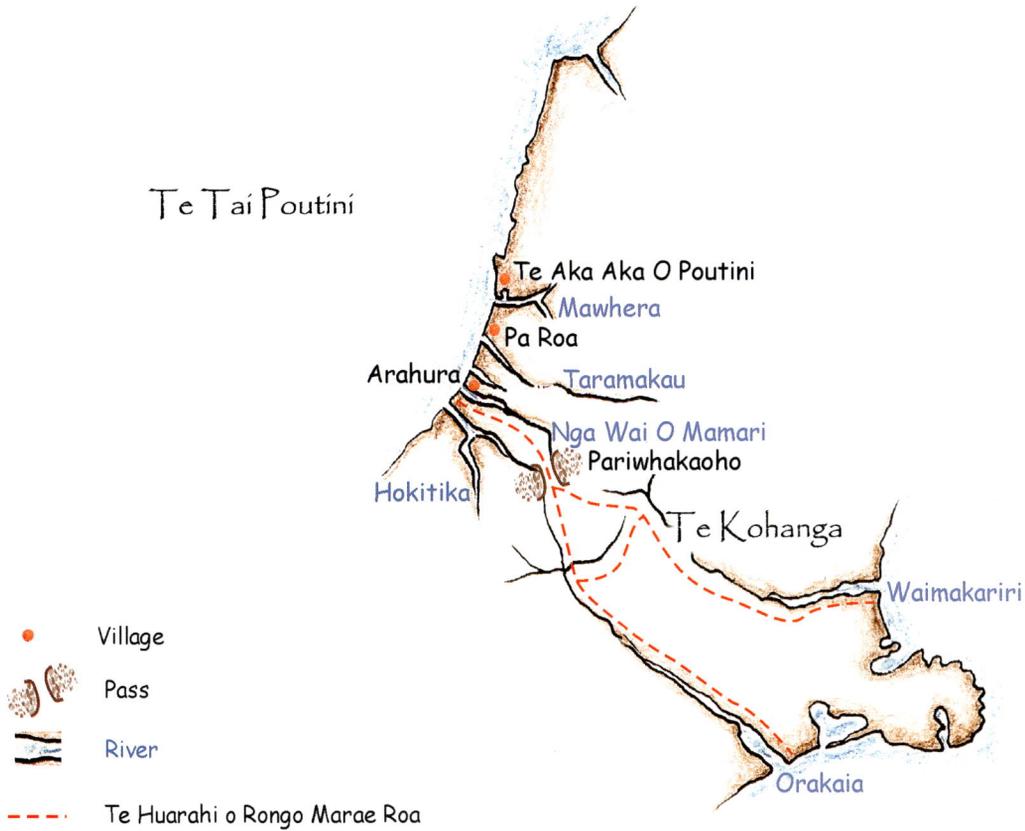

Te Tai Poutini

Te Aka Aka O Poutini

Mawhera

Pa Roa

Arahura

Taramakau

Nga Wai O Mamari

Pariwhakaoho

Hokitika

Te Kohanga

Waimakariri

Orakaia

• Village

Pass

River

– – – Te Huarahi o Rongo Marae Roa

Tira was called to bring the dream of the Peace Trail to completion. He gathered the Stone People, the Water People and the Star Walkers to serve the Stone Carriers. And the Pounamu moved to heal the land, the waters and the people and to serve many nations far beyond these shores.

Grandmother paused and listened to the night. Once again old voices echoed across the mountain divide, defying the realms of time to reach the hearts of the stone carriers. Thus does yesterday meet today. The trail calls and those who hear its song answer. Her eyes swept around the circle as she came to her next words.

'If you would walk this Peace Trail, remember respect opens the way to each day. Meet the rising Sun, the dawn of light, by forming a circle to pray in your own way to offer your gratitude. Remember you journey in spirit, for while your feet mark one trail in the snow, your mind and heart traverse another.

'Look for the Bird People. Hear their songs and know you do not walk alone, for they are the kaitiaki who support you on this Trail. You walk with the Hawks, and they are with you all the way. Kahu, the Sky Hawk, glides over the peaks to see all that was, and is, and might yet come. Kea, the Ground Hawk, comes close to share its laughter and its play, and walk with you for part of the day. Ruru, the Night Hawk, swoops by in silent flight to oversee the darkness. Its distant call assures you that to sleep is safe while this friend is awake.

'Riro Riro, the little Grey Warbler, is another bird who helps us on this Trail. Listen at dawn for its piping call, for the old lore says, if the Warbler is silent do not walk the trail that day.'

'How will I know Riro Riro's song?' asked Tamatea, who felt the teachings made him part of himself, and closer to the rivers, something much greater than the forests and the peaks.

'If the Old Trail calls, you may be led to some who still walk it in the old way. On the other hand, you may join with others who acknowledge the old and bring in the new by moving outside the twelve and shaping the journey to serve today. Whatever the party that gathers to carry the Stone remember to respect the Ancestors of the Trail, respect the land, respect the journey and in that respect you will continue to honour the true way.'

'But what of Riro Riro, Kui?' repeated Tamatea.

'If the Old Trail calls you so will that little bird. It will make itself heard. Trust the way.'

Honour the Bird People on the trails of life, for they hold the space between where Earth and Sky meet as one.

In the Mana of the tokotoko, the carved talking stick, we speak from the heart to share our journey.

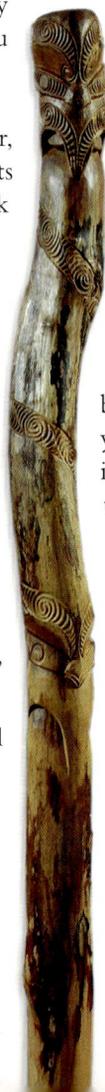

Pass the talking stick around the fire

Grandmother wondered if she had shared enough. Although her journey over the Old Trail was made long ago it seemed like yesterday; some things remain ever close. Her teachers always concluded her preparation by reminding her that you really learn the lore of the Trail on the Trail, that action gives meaning to words, that wisdom gifted to the wind may be merely lost to the wind. However, She decided there was one further thing to place before the flame of this fire.

> 'To truly honour the Stone you carry, remember you are asked to walk as one. The spirit of Pounamu is Aroha, and Aroha reaches across the difficult tides that swirl around people journeying with people to teach us to provide for each other.

> 'Tawhiri Matea, the Keeper of the Winds, may caress us one day and strike harshly on another, but we gather our cloaks close, accept the journey, and move on, for that is the way of the Trail.

The storm winds are of many kinds. Some lash the land while others assault the mind. Hold fast when they bring the trees down, and stronger still when they send their darkness deep inside the mind.

'Yet, there are winds that are not as easy to survive. These are the storm winds that pass through the mind. They are fuelled by pain, by hurt, by anger, by envy and by fear of failure. On the Old Trail we bring those winds to the talking stick as it travels around the circle of our evening fire.

'The lore of the talking stick is very simple. It moves from hand to hand and stops only if someone wishes to speak. That person may talk for as long as they like and as long as they hold the stick, they may share without interruption. When the stick moves on, it goes around the circle and the next to speak has no obligation to follow the theme of the previous speaker. The talking stick asks us to speak from the heart, not the mind. To tell our story, to share something from the past that is of our joy or our pain, to share something important to us in the journey of that day, to share our dreams for tomorrow.

'There is a power in the "talking stick way" that helps us walk with Aroha. It teaches us to listen to each other and to hold a space for those who suffer the turmoil of "the winds that fight within the mind". It allows us to share our story and know we are supported when twelve walk as one.'

Remember the Trail Families

Grandmother knew this night of sharing was almost done. She was tiring now, feeling the weight of old bones that needed to rest and sleep. Yet, the circle drew her on, for the journey to the Pouwhenua of the Trail Makers had created its own excitement. And with that thought a story came to mind and she knew its time had come.

'With the lore of Te Waari in place Tira, the son of Paparoa and Huaaki, was called to organise the Families of the Old Trail. They were created to serve its needs and were drawn from the Stone People who became the Stone Carriers, the Star Walkers who trained the Trail Guides and the Trail Guardians who kept the Trails open, built night shelters and provided food stations along the way.

'Only the Trail Families walked the Old Trail. It was their domain, their place of challenge and their responsibility, until recent days when all that changed to open the way to everyone.'

'Do you have an Old Trail story, Kui?' pleaded Anarua, who was now determined to walk with Tamatea. An ancient knowing stirred, awakened something that could only find its voice in the mountains.

'You have touched into my mind, seen the story before it emerges from the mists of time,' answered the old one with a smile. 'Ae, you shall have a story. It honours the Mana of the women of the Old Trail and brings us bravely to the end of this night.

'Raureka is the name of the young woman who takes us to the Old Trail tonight. She was born of the Star Walkers who navigate the oceans wide and cross the mountains high. From birth her life was dedicated to those who walk with Pounamu and she was trained over many years, and many mountain crossings, to guide the Stone Carriers through the wilderness.

Trail guides move through the mountains to open the way. If it closes on them they must go back or stay. Raureka waited bravely day after day until the snows came and took her life away.

154

'Sometimes the elders sent Raureka to the passes to meet a group arriving from the east to bring them safely to the waters of the western shore. At other times she guided the parties of twelve from the villages of Hokitika, Arahura and Pa Roa to the Great Divide, where the waters decide their path back to the ocean. There she gave them into the hands of another who led them safely through the eastern trails.

'Storms created for her the greatest hazards in the mountains. They brought heavy snows to the heights and sweeping rains that gave birth to the flood tides that made the rivers impossible to cross. Nothing moved when winter's cold hand closed the trails, for it was a dangerous journey made only in the warmer seasons.

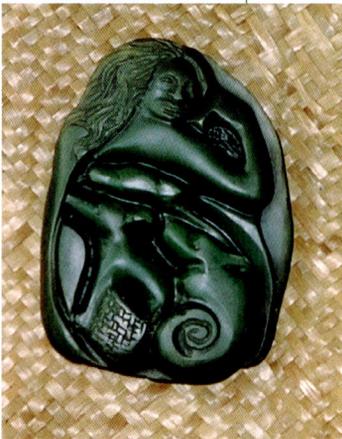

Raureka went to her death long ago. Yet some who walk that pass say they have seen her face in the mist, and heard her dogs barking in the night.

'The day came when Raureka was sent to await a party from the east. Arriving on the given day and on the right Moon, she camped on the pass beside the lake with her dogs. Looking to the place of the rising Sun each day, sweeping the long valley below with keen eyes that were anxious to see those she would guide home, her concern grew as the wind spoke of the coming snows.

'Dawn followed dawn. Raureka's food was gone and the Moon had moved on. No one would challenge her decision if she turned for home. Yet, her heart would not let her go. She had to be here to hold the party safe if they came. So she pulled her cloak close, gathered her dogs to her side and hunkered down to await those who might simply be delayed.

'The snows fell heavily that night. Dawn revealed the mountains standing tall and strong, wearing their beautiful korowai huka, their shining white cloaks. Nothing moved in the land, nothing at all.

'In the springtime, when the bright yellow flowers of the kowhai opened the trails again, the people found Raureka. She still looked to the east, to the rising Sun, with her faithful dogs beside her. And those who gathered to honour her bones, wept for a heart that rang so true, and a spirit that walked the highest trails of life.

'Some say Raureka still travels the Old Trail to guide those who walk in peace. They hear the bark of her dogs echo through the valleys in the dark of the night.

'I have heard their sharp cry, and felt the spirit of Raureka move across the mountain peaks, have known her joy, for there is no sadness in her journey. It is of the sacred, of the Spirit that is Eternal.'

The old one gently touched her cheek to wipe away her tears. Then she turned to accept grandfather's special Stone, for he had offered it without a word. And she quietly gifted her tears to that Pounamu, and felt the Ancestors gather to share the memory of courage and love. The Stone was warm to the touch, warm with the Spirit of Aroha.

'Thus was Pounamu moved over the Old Trail and to the waka that carried it

to the people of this land, and to those who waited on distant shores in homelands far beyond the horizon.

'And as the Stone journeyed over the waters and the land, it healed the waters and the land, and as it passed from hand to hand, it healed hand to hand, for that is the way of Aroha.'

When grandmother handed the Pounamu back to the old one, he cradled it in his gnarled hands and whispered the closing karakia over it. And all heard his words within a stillness broken only by the crackle of the fire and the whisper of the waves.

KARAKIA

All seemed reluctant to leave the completeness of the circle, to leave the dreams of long ago and walk back into today. Yet, we are of the now and that is our power, if we have the mind and heart to walk the dreams of yesterday into tomorrow.

The old ones felt the growing strength of the circle and in it found their own. Rising together they said, 'Peace be with you,' and walked off hand in hand. And Hans and Day Star stayed close.

Bring forth the Promise

When the old couple came to a log far above the tide, they sat to rest awhile. Hans and Day Star joined them, for they shared a deep bond that comes from caring. Memories, awakened by the journey of this night, brought the old ones to a moment of reflection.

Grandmother knew why her old companion in life was so quiet; it was always like this when he let his spirit cross the borders of time to feel the pain of things long gone. Part of her wished he wouldn't do it. Part of her knew that was his gift, the power he offered to this age.

So much happened long ago, a great sadness witnessed only by the stars and dusty old bones. Yet, the pain of the past remains, awaits those who know the power of the healing ways.

'So much blood spilt upon the Stone,' said grandfather in a strained voice. 'So much pain hidden deep within old dried bones that find no rest within the caverns of the dark night.'

'You touch something that has been buried so deep few thought it would surface in this age,' responded grandmother with great sadness. Then in a firmer voice she said, 'yet, although we are brought to tears, I feel that Wairua moves here. Once again the Stone shows its healing face. We are of Raureka, of that line, and in her courage we find our own. It has always been. So I am content to summon up the storm and trust it will wash the blood from the Stone.'

'Ae, it is time to look again at old bones,' offered grandfather with a wry smile, 'after all, who will heed our simple words? And if some find them hard to accept, that is of their journey.

'Each generation is called to meet its story,' he continued as he reached across to hold Day Star's hand in his own, 'and we must do the same. Age offers no excuse when challenged by the Ancestors to speak the truth. We have taken this sharing deeper than others might dare. We have gone to the sixth Pouwhenua and walked with the Trail Makers, who are the Keepers of the Promise. Our intent is pure, for all we bring to the fire is of the fire, and all we say of the stone is of the stone, and what we seek for this land, and its many peoples, is to bring forth its promise.'

When the old ones moved on, Hans and Day Star sat for a while, giving them space, aware of their slowness. They could catch up in a moment.

'Why do you cry?' asked Hans.

'I love them so much, I never want them to go,' shared Day Star, in a voice that trembled with feeling.

'They need their rest. These nights ask too much of them,' said Hans as he hugged her closer.

'I meant more than you know,' she whispered to the night.

The Eternal is with us every day

Hold the peace child close

and be open to a

universe of hope.

CHAPTER SEVEN
SONG OF THE ETERNAL TIDES

Through countless aeons of time

our Ancestors answered

the beat of ancient drums -

the pulse of distant stars,

and the rhythm of the Moon and the Sun.

That beat still sounds across

the vastness of space,

still gifts the essence of Life.

There are many songs in the Universe

and many powerful tides

that the heart knows

and the head denies.

We are not set apart.
We are moved by the Tides of the Universe,
shaped by their lore and held fast
by their pull.

We move through space at the behest of
the Sun. It is the Day Star that swings us
through the seasons of light to ignite life.

We are bound to the Moon Tides, to an ebb
and flow that reaches far beyond the rise and
fall of the ocean wide, for it triggers the seed
that flows into the next generation.
This our women know.

We are no greater than the whales
that honour the seasons in their migrations,
or the birds that answer the ancient call
to cross the vast oceans.

We are moved by the Celestial Tides,
swept by the solar winds, and joined to
the turning of the stars by the blue line
of light that makes us who we are.

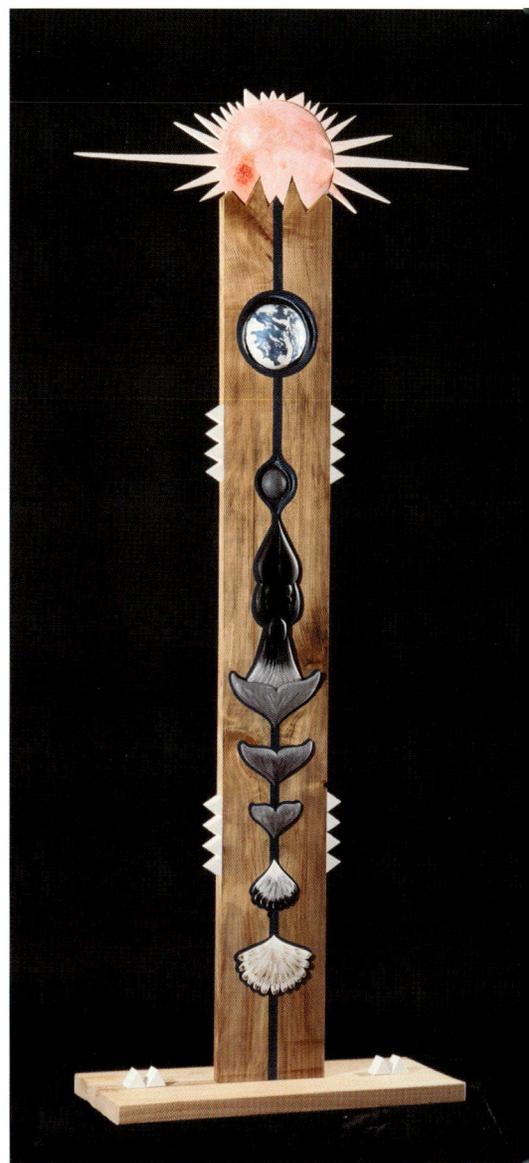

TE MARINONGA

The Harmony

Day gave way to night again and people gathered as before to continue the journey. Some could not return, but that was also of their learning. We do what we must and do it in the end for our children.

Once again the old ones sat before them in the light of the fire that had not been allowed to die. All knew the fire keepers would tend it until this learning ended. It was grandfather who rose to speak, to open the way to the seventh Pouwhenua that moved with the Tides Eternal.

In the silence, grandfather waited upon the prayer that offered itself to this night.

KARAKIA

As the last words of his prayer joined with the land and the ocean, Hans, who stood nearby, stooped low to seize the end of a flaming stick and lift it slowly from the fire.

Honour the Tides of the Universe

Grandfather accepted the burning stick and wiggled it a little to keep the flame alive.

> 'When the last flame dies in its own time we know the circle closes in a good way.'

He etched these words into the night by using the glowing stick to draw a circle.

> 'Long, long ago when the great Fires that gave birth to the Universe were still young, Io, the Unseen One, assigned set trails to all the spinning stars.'

Now he drew curving trails of fire. Then, as his story unfolded, he used that flaming brand like a baton to call forth each dramatic event.

> 'Thus was order created, elegant turnings of day and night, and seasons and tides that were intended to abide.

> 'However, when Mere Pounamu, a rainbow star, swept through space to take her place, her astounding beauty changed all that,' announced grandfather with such a grand flourish of his fiery baton that he tripped over his feet and teetered off balance.

Grandmother laughed, then slowly shook her head in a way that meant, 'behave yourself, you are too old for this'. But the old one was undeterred. This story was one of his favourites.

'In the beginning Mere Pounamu was admired from afar, because all knew that Io of the Twelfth Heaven expected each star to keep to its place. But came the day when the impetuous Red Stars left their assigned trail to cut across her path. And this departure from the way soon became a habit until it began to happen almost every day.'

When Hans handed the old one a second stick from the fire, grandmother smiled for she knew what would soon transpire.

'Then the Blue Stars left their orbit to do the same and they clashed with the Red Stars in ways that threatened to tear the fabric of space. Thus began the Battle of the Stars.'

Now grandfather wove the arcs of flame around each other until they collided in an eruption of spinning sparks.

'Io was saddened to see such disregard and sent this message into the world of stars — "Mere Pounamu is betrothed to Poutini, a bright and steady star. She seeks no other suitors. Depart! Return to your places this very night." — and they obeyed.'

The dramatic moment was over. Grandfather quietly acknowledged the obedience of the stars by returning his burning sticks to Hans who had timed his part so well.

'Mere Pounamu and Poutini had three star children and named them Arahura, Hokitika and Waimea Whaka Hirahira. You can see them in the western sky on a clear night, for they sit above three villages gifted those names in the land that holds the Pounamu.

Mere Pounamu was such a beautiful star that the Red Stars and the Blue Stars left their allotted trails to gather to her side. As neither would move away, they clashed and sent the heavens into disarray.

163

'When you see all the millions and millions of stars turning slowly through space, remember they follow a noble design bound by ancient tides.'

Grandfather sat. He had made his contribution to the drama of this night. He was both excited and tired for it was not easy, at his age, to dance with fire.

Feel the Force within you

'I am pleased to see you have all survived Koro's story of the Battle of the Stars,' began grandmother. As she waited for their laughter to subside she looked at the canopy of stars that graced this night.

'Koro brings us back to the Mauri, the Chaos running wild and dancing with fire. And I am the Maui, that mysterious force that works to restore order and design.'

See the Mauri bring the colours of excitement to the sky, see the storm clouds gather and build, see the winds of change begin to swirl.

This time grandmother had to wait a long time for the laughter to end. Although the circle let it go quite soon, it was grandfather's repeated chuckles that started them off again.

'Kui, can you tell us more about the Maui?' asked Salote, a young Samoan woman who had joined them for the first time. The surf was her home and her wetsuit her most prized possession. But a great sadness cloaked her spirit.

'Ae! Understanding the Maui is a challenge. It is hard to reach with words alone. Let us try to find another way. Imagine being attracted to someone and falling in love. One moment you are in balance, and then love turns your world up-side-down. Life suddenly expands, becomes extraordinary, fills with an excitement that grows and grows to ignite new passions.'

'But that is not the Maui, Kui,' offered Mountain. 'Isn't that the Mauri, that creative excitement, that chaotic state that sends the world swirling?'

'Ae! That is indeed the Mauri,' confirmed the old one. 'The excitement of love, the curving, brilliantly coloured rainbow that illuminates the skies, the herald of the storm born of the winds of change, is a wonderful way to describe the Mauri. It is of the brightness and the tumult, for it shapes us anew, uplifts all, opens new horizons and carries us out to the stars and back to the soul. Being in love takes us into the creative Chaos, a wild energy that seems to change everything.'

'What else brings us to the Chaos, Kui?' asked Silver, who still searched for direction in her life.

'Grief born of loss, the pain of illness, despair and all that carries us into the dark night of the soul. Those things also shift us off balance and spin us into the Chaos.'

'Does the Maui somehow counteract being in love, Kui?' asked Salote, who was determined to catch up, having come so late to this trail.

'No! The Maui doesn't say this love is too much, or this loss is too great to bear, it simply helps us learn to handle it, helps us find a good life within the new way. If we listen to the Maui it helps us grow, allows us to see meaning and purpose in change.'

'Kui… this Maui… is new to me.' offered Salote in a low voice. She was clearly struggling to express her thoughts. ' It brings… hope… to my pain… I lost my child… but trust I will find a life again.' A fleeting smile crossed her weary face. She now knew why she had been called to this fire.

The Maui shapes the Universe

Grandmother felt her words had not yet reached everyone. Mana, Mauri and Maui were beautiful ways of seeing all that moved in the world, but they were still foreign to some.

'Remember we all have Mana, that unique spirit gifted by Io to each of us in turn, the indestructible essence of the soul. No one can touch our Mana or destroy it in any way. And we all have the Mauri within us for it is of everything, shifting and turning and creating again and again, being the spirit of change. And then we come to the Maui that stops the Mauri from taking us too far off balance and brings beautiful things out of change.'

Let the Maui gather to the Mauri to create beauty within change. Let the new take wondrous shapes.

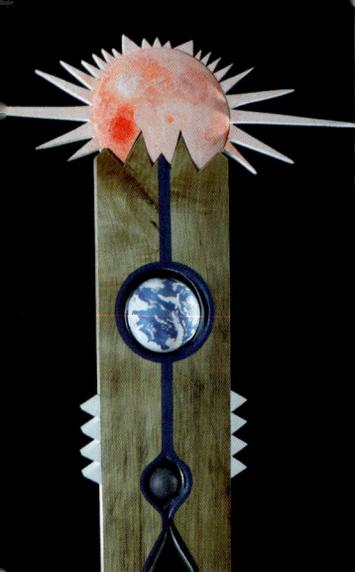

There was no time to play, no time to sit and dream of things long gone and things still to come, when the Sun ran across the heavens. And season sat on top of season.

'The Maui was so important the Ancestors wove its power into stories and gave its name to the heroes of those days who helped the people grow through change.

'Remember that is why we tell the stories of Maui the man, and why he carries that name. Maui the man illustrates again and again the Maui that moves across the wonder of time and space to create wondrous design.

'Maui had the courage to walk the margins of life where the truth resides, to bravely probe unknown waters, to walk without fear into the tapu place where fire hides and discover it in the five trees that host its flame. Maui had the vision to honour the old to bring forth the new, to open trails into new islands and new knowledge for the people. Maui had the wisdom to walk the edge of Chaos to find the new balance. He was the Maui of Io standing tall to serve all.'

'Is that why we have the story of Maui and the Sun?' asked Mist in a strong, clear voice that confidently affirmed she knew her words had a place in this circle.

As grandmother accepted these words, she turned to face the old one beside her. His eyes opened, even though she said not a word. He loved to tell this next story.

'Ae!' grandfather said with a chuckle, 'you have it in one. Mist, do you want to hear the story of Maui snaring the Sun?'

'But this time think if you really need to use fire,' laughed grandmother.

Maui challenged the Sun

When grandfather stood he moved as if to take a flaming brand from the fire. Then he paused, drew back, and sent grandmother an impish smile. There would be no more fire dancing tonight.

'When the Sun moves too fast, look at your life. This is the thought I gift to you this night. Visit it in your own time and in your own way.

'Little Mist leads me into another Maui story, and I love to respond, for such stories carry a wisdom that reaches us at any age.

'In times long gone the Sun suddenly began to run. Instead of moving slowly across the sky in the usual way, it jumped out of the gloom in the east and raced to its rest in the west. People had no time to fish or plant, no time to play with their children, and no time to sit and dream of things long gone and things still to come.

'Even the birds in the tall trees and the fish of the deep waters were unhappy with the Sun. There was too little time to lay their eggs and raise their young. All pleaded for a return to the old ways that gave them longer days, but the Sun heeded them not.

'Knowing the pain of his people, Maui decided to capture the Sun. With the aid of his brothers he secretly plaited lengths of rope and wove them into a magical net. Then, in the depths of the night, they carried it to the summit of Mount Hikurangi, where the land greets dawn's first light.

'Aware that something had changed, the Sun cautiously viewed the awakening day, sending first one glancing ray, then another to lightly caress peak after peak. When all seemed safe, it leapt boldly into the sky to completely banish night.

'On Maui's command the great net unfurled to catch the light and snare the brightness of the Sun. The more it struggled the more the cords entwined to grip closer and bind.

'The people were exultant; some wanted to hold the Sun prisoner forever, but Maui disagreed. He knew everlasting day would be as bad as everlasting night, for he understood we are creatures of the Moon as well as children of the Sun.

'So Maui offered to release the Sun if it promised to return to its old ways. He spoke of the difficulties experienced by all because of short days. The Sun listened and agreed because it now understood that how it journeyed across the sky was more important than simply arriving on the other side.

'When Maui cut the ropes that held the Sun, he wove invisible cords to tie it to the Earth. Look for them at the end of the day when the clouds gather to reveal shafts of light that join Earth and Sky. They remind us we are forever bound as one.'

Maui let the Sun go to ensure we continued to enjoy the wonder of day and night, but he kept it close with invisible threads of light that he checks at dusk when the clouds are right.

Grandfather had the last word in the story of the flame. He took from his pocket a piece of candle that had burnt down to but a small stub. Carefully lighting it from a burning twig offered by Hans, he held it before him in cupped hands.

'This little one came to me from a land so far away it farewells the Sun when our day has barely begun.

'The flame that first gave it life was kindled by the bow that spins the shaft that draws fire out of wood. That flame was taken to light the pipe of peace, and the flame within the pipe was gifted on to give life to another, and thus did that one flame give birth to many sisters and brothers.

'Its tiny wick is ash now, but within that ash is carried the memory of the flame that birthed it, and that flame remembers its birthing flame back through time to the one before it, until we come at last to the original flame. And there the memory is of peace, of the compassion that nurtures the loving flame of the kinship that joins all who know the Sun.

'I leave this little stub upon this stone. When you return to this circle, it awaits your candle and the flame you make to carry the promise ever onward. Whether your hand takes up the flame, or leaves it, is for you to decide. You make your own journey.'

We live by the Circle of the Sun

Grandmother took up the story now and with a happy heart. She loved to see her companion so excited by the way everything was unfolding. Sometimes years dropped away and he seemed but a boy at play. The candle stub was a surprise, for it had not been shared for a long time. She wondered what else her companion of the long years had hidden aside.

If the Sun moves too fast for you, look at your life.

'The story of Maui and the Sun reminds us everything has a time and a season, a special place in the wonder of the Universe, and that the actions of one touches many others. There is no separation.

'All is movement within the world of the stars. Our planet spins along trails held true by the power of others, the turning of countless stars that move with elegance and grace into perfect balance. A miracle of motion created by the Song of Io, the perfect expression of Marinonga, the way of Harmony.

'All that we are is because of the Sun. It is our Day Star, the one so close we are warmed by its nuclear fires and touched by their light. It allows Earth to flourish with life.

'Our Day Star is the pivot of our journey. Its powerful attraction holds our planet in its thrall and we respond to that call, for it keeps our spinning Earth on its assigned trail through the vastness of space.

'We are space travellers. Ae, never doubt that for a moment. Cocooned within our own atmosphere, and protected by its cloak, we ride this planet on an awesome journey. We mark our days by this journey, for every time we make one great circle of the Sun we celebrate our birthday.

'That year-long voyage through boundless space gives us the magic of the seasons. See the changing colours of the land, the vibrant hues of spring. Remember the heat of summer and the grasses that dry to their golden glory. Listen to the wind disturbing the fallen leaves of autumn. Take in the sharp breath of winter, the white of the sparkling snow. In these, our journey with the Sun is marked for all to know.

'Remember, the dark clouds that herald the fierce storm, the towering clouds that speak of lightning and thunder, the sombre clouds that birth the rainbow, the misty clouds that whisper of mystery, are all of the Sun born.

'The great rivers within the ocean, the ones we call the long tides because they span the widest waters, are children of the Sun. Flowing with purpose, these powerful currents follow time-worn trails season after season and century after century until, in the fullness of time, the cold waters of the poles become the warm waters of the tropics. And, in the turning of the Sun, gain the energy to make the journey again until warm waters return to cool at the poles.

'All this is of Te Marinonga, the Harmony created by the power of the Day Star that we know as the Sun. '

Moon and Earth are joined by invisible cords

Grandmother thought of their visit to the Hopi, the people of the high mesas of Arizona. She remembered how they were invited to sit quietly to greet the first light of the Sun. Her mind went back to the chill of that desert dawn, to birdsong that so joyously greeted the return of the light, to the gratitude that welled up to sweep the little irritations of life aside. And how wonderful it had been to sit to farewell the setting Sun.

'Does simplicity so profound have a place in this busy age?' asked grandmother, in words so soft only grandfather knew she had spoken.

The old one nodded and smiled, for they shared many fond memories.

'We have been lucky. We lived the rhythms and tides that the elders wove into our lives. Many who share this fire still sit outside the mystery, know little of the old lore, and have rarely experienced those magical moments that take us beyond time,' responded grandfather just as quietly.

'Then let us plunge into one of the strongest tides,' whispered grandmother. 'No one stands beyond its reach or can resist the pull that it provides.'

With those thoughts firmly in mind, she rose to speak of the power of Te Marama, the Moon.

'When we stand beneath the Moon that gifts its beauty to the night, we remember it reflects the Sun's light. Yet, the Moon is more than a mirror, for it touches deeply into our lives in its own right.

'We think, that apart from its play within the tides, life would go on without the Moon. But that is not true. The star scientists say if we exiled the Moon to outer space Earth would be a harsh, barren, lifeless place.

'Remember, as our home spins through space its angle of alignment to the Sun gives us the gentle change of seasons, the certainty of what is to come. Take away the Moon and that certainty would disappear because Earth and Moon are bound as one as they circle the Sun. The magical cords that hold them close are elegantly fashioned out of gravity's attraction and motion's spinning action. Earth and Moon ride the heavens together and in that remarkable embrace, reach a miraculous balance.

'Without the Moon's pull to keep it steady, Earth would tumble wildly as it rode the trails of space. Over a three-week period, any place on the globe might swing from the fiercest tropical heat to coldest polar extremes. This devastating shift, from hot to cold and back again, would destroy all life as we know it. Trees would explode, fish would die and birds would freeze and fall out of the sky. And storm winds, reaching three hundred kilometres an hour, would frequently sweep across the Planet.

'Moon and Earth, together, create the Harmony that gifts and sustains the miracle of life.'

We are children of the Universe

'Generate! Create! Excite! Ignite!' whispered grandfather. 'Remember how we used word play to memorise the lore of Te Marama. We were very young and found great fun in calling her the Lady of the Night. Yet, even then we felt the surge of power she gifted when her face was bright. Hold nothing back. Help them ride the Tides of the Moon.'

Grandmother smiled in agreement and whispered in return, 'They see more than romance in the Moon, some already ask why we planned these teachings within its brightest cycle. I'll not hold back.'

'We are more than flesh and bone that is independent of the greater Universe. That comforting earth-centred view denies the very essence of all that truly influences our lives. We all carry the mark of the stars and are driven by internal tides moved by the power of the Sun and the pull of the Moon. While our ability to function, our health and our creative achievements appear to be founded here on Earth, they are also moved and shaped by forces far beyond the limits of our little world. This earthbound cocoon, we work so hard to manipulate and control, is part of a greater whole.'

Moon and Earth, together, create the Harmony that gifts and sustains the miracle of life .

'Are you alluding to our birth stars, Kui?' asked a father, who was struggling to make sense of his daughter's passion for astrology. The idea of a star connection made no sense to him.

'Ae, in part, for I did mention that we carry the mark of the stars. So I'll reach into that kete for a moment, and perhaps visit it again later. Yes, our Ancestors saw significance in their birth stars. They believed the light that welcomed us into this realm shaped our future. It was so important they chose their leaders and teachers by their birth stars, not by seniority within family. Remember, Maui was the youngest son.

'Recent studies into the influence of birth stars suggest the Ancestors followed a wisdom that we may learn from today. However, let us now move on to explore the internal tides that bring so much into our lives.'

The Moon sends the Seed Tides

'Sometimes when we stand on the shore, we see the waves gather their strength to embrace the upper reaches of the sands. Then we come again and watch as the waves retreat far from the land. The short tides that rise and fall each day are created by the pull of the Moon.

'Honour the Moon, for she is our closest companion on this journey through space, and the keeper of the passing of the days, the twenty-eight-day cycle that is the true month and the thirteen moons that mark the year-long journey of the Sun.

'Understand that when we go beyond the clock, and the calendar of the mind, there is an older way to join with time. It is of moon-tides, a rhythm of life that wove its colours into every day walked by our Ancestors.

'They knew the rise and fall of the ocean tides, as do we. They saw that ebb and flow in the Moon's glow, and looked deeper still to see its changing light touched our tides too.

The Moon controls the seed tides to complete the cycle of life.

'Ae, we are of the tides. Women feel this in the flow of their seed. Yet, not all realise that the Moon ordains the twenty-eight-days of change that peak in the brightest of nights, to complete the circle of life.

'The ancient seed tides known to women are also present in men. What the Moon provides for one is not denied the other. Yet, that ebb and flow that completes the joining and that creates life no longer comes to mind.'

The Pulse of Time touches body and mind

'Some say the Moon has no place in our lives, that the connection was lost. But, I say what seems lost, is not lost, for while the mind moves on, the body remembers, and the heart knows.

'Over aeons of time, over ages beyond counting, our Ancestors were influenced by the power of the Moon. While they did not seek its gifts, for they were freely given, they lived in harmony with the elegance woven into its turning. They attuned their lives to use the power of its rhythms.

'Every twenty-eight day circle of the Moon consists of two great pulses - a powerful, outward pulse that stretches the mind and the body to excel - a gentle indrawn pulse that brings a time of recovery and reflection, a pause to prepare for the next exciting outward pulse.'

'What can you tell us about the powerful, outward pulse, Kui?' asked Flame, who had been drawn to the Moon's light since she was a child.

'The outward pulse fills the fourteen days of the Bright Moon, being the seven days before and after the Full Moon. It is then that the Moon tides send us huge energy and great strength. If you want to know when the Ancestors took their waka to the long tides and sailed back to the homelands, look to the Bright Moon. If you seek to follow them when they carry Pounamu over the high mountain passes, look to the Bright Moon. If you offer your help in the digging of the canals through the wetlands, look to the Bright Moon. If you wish to join them in Wananga, within the House of Learning, look to the Bright Moon.'

'Why is that Kui? How does the Moon help us to excel in the time of the Bright Moon?' continued Flame. She was eager to understand, for she began to see facets of this rhythm in her life.

The tides of the Moon draw the sap up the tree.

'The waters that span the planet rise and fall to the tides of the Moon. The seeds we plant germinate to the tides of the Moon. The sap in the tree moves upwards to the tides of the Moon. We are no more or no less than them. Most of our body is fluid. We are but a vessel shaped by bone and muscle to carry the waters of life. And those waters respond powerfully to the Moon's tides.

'The Bright Moon lifts us into another realm of body and mind, heightens awareness and builds a momentum that helps us overcome the great challenges in life. The strength that flows at that time is of another mind and that mind walks a space of the vision-filled kind.

173

'The fourteen-day span of the Dark Moon, the seven nights that sit either side of the night that is said to have No Moon, is a quiet time given to rest and reflection, to play, and to planning for the phase of the Bright Moon. Sometimes it is called the time of the lovers, for it offers closeness to those who find joy in each other.'

Explore the secrets of the Moon

'In the old villages, mothers carefully observed their children during the Bright Moon to see how they responded to its pull. Many saw a heightened awareness in their children and significant changes in behaviour.

'Some youngsters wandered far from home at that time, for they were born of the adventurous spirit of the trail-makers. Others drew close to tend the fires, for they were providers and healers. Some asked many questions, probed the frontiers of the mind, became engrossed in the stories hidden in our carvings or yearned to hear the old songs. In them we found our teachers and artists. Others wanted to help in the gardens, a path that was very different from those who were drawn to the hunt on the oceans and in the forests.
Thus were their inner trails revealed by the light of the Moon.

The ancient tides that touched our Ancestors' lives still abide.

'It is time to remember that the old calendar is not born of mathematics and the mind. It is of the lore of the Universe that provides for all life. It is born of ancient tides created by the stars, the Sun and the Moon. It is of the mystery, an ebb and flow that our Ancestors knew well and used with great purpose in their journey. That lore remains undiminished by the passing of time except in the trails of our mind. It but awaits our remembering.'

Stone rides a circle of change

When grandmother sat to rest, she briefly closed her eyes. Her thoughts were of older times, of a different way of life that knew a lore that provided all that might be desired. Now everything shifted and changed almost day-by-day. Yet, change had always been the challenge.

'Remember what our elders taught us,' said grandfather very softly. 'See the lore anew, shape it to serve, remember the truths that truly matter are timeless and of every heart.'

Those old words inspired her next thought. Grandmother smiled to her companion and reached into her kete to bring forth an old friend, a stone that had already travelled the circle.

174

'See the white stone,' she cried, as she held it aloft, 'tell me what you remember of its story.'

'It has shells and bones in it,' recalled Torrent, the earth science enthusiast.

'It was found on the top of a mountain,' added Scree.

'What does that mean?' asked grandmother.

'It has made a long journey from the sea to the mountain,' replied Torrent.

'Do you wish to hear more of its story?' asked grandfather as he rose and placed a hand on his old companion's shoulder. He felt her determination to see them through this night, but knew her need for rest was now greater than his own. It was time for him to take up the teachings.

'This stone was created in the ocean a long time ago. Let us become the journey of this stone,' suggested grandfather.

'Take a deep breath, close your eyes, slip into the deepest ocean you can imagine and plunge down to dark waters that shut out all light. Think of the Sun no more, or of the Moon, and wait. Wait on the floor of that ocean. Wait for sands to drift down from the waters far above and for shells and the bones of fish to gather about you. Wait for more years than there are seconds in your life and then wait some more. And all the while watch as the shells, bones and sands are pushed closer and closer together by the huge weight of material above to become limestone. Stay even longer and see it all touched by fire and changed into hard, enduring marble.

'Now wait through aeons of time for the great plates of the earth to push against each other and buckle. Be strong for they shout as they heave and rise sending huge shocks through the lands and the waters. And be brave, for you are watching the birthing of the tall mountains.

'Riding the power of the up-thrust as stone from the bottom of the ocean reaches for the sky to become the peak that gathers to itself winter's snow and summer's heat. Season follows season in the turning of the Sun and time finds fault in the stone. Fissures open to its inner core. Melt waters penetrate the shield and freeze within its confining walls to split all apart. Thus do heat and cold tear the stone asunder and send it tumbling to the valley floor where the river carries it on the flood tides that eventually reach the ocean shore. By then the stone has been ground to fine sands that are bedded in the sea once more.

'Here shells and bone gather, to await the time when they will be bound in stone and lifted high to be of the tall mountains again.

'Such is the trail of the stone seen by the light of this fire. It is of the circle that makes and recreates all that is in an ever-changing world.'

Grandfather enjoyed this game. He often played it with his grandchildren, telling the

Every stone has its story. Some lock it deep within, while others reveal it slowly. It took millions of years for this stone to create its story, and but moments for experts to read it through.

life story of different stones. Each time they had gone home holding a piece of the stone of the story and they never forgot every twist and turn of its long journey.

Water moves to find itself anew

'Earlier this evening, grandmother spoke of the Day Star, that is central to our lives. Can any child give me this Day Star's name?' asked grandfather.

'It is the Sun and it is Ra,' whispered Smoke, who repeated those words with greater confidence when the old one beamed in surprise.

'Wonderful! I ask for one name and you give me two, and both are beautiful. Thank you!

'Who can tell me where rain comes from?' continued grandfather.

'First the Sun gathers water from the sea and sends it into the sky to form clouds,' said Torrent.

'Good! But tell me, what happens next? What makes the clouds drop their water?'

'I think its because they get colder, but I don't know how that happens,' the youth replied.

'You are right, Torrent. Rain is all about warm air catching a cold.'

Water knows no bounds, never stops trying to find its way through, and sets no limits on its journey back to the ocean from whence it came.

This wry comment led to much laughter. The circle loved the old one's little asides almost as much as he enjoyed creating them.

'Warm air can hold a lot of rainwater, but when it cools it has to give it up again. When the wind pushes clouds against mountains, they are forced to rise and as they climb higher and higher they become so cold they cannot hold their moisture and drop it as rain or snow.

'The rain that falls on the mountains runs into small streams, joins the great rivers and quickly returns to the ocean. Rain trapped in snow awaits the spring thaw to let it go. Rain frozen into glacier ice may take centuries to find its way back to the sea. And rain that penetrates the deepest underground caverns may rest for a thousand years before completing its journey.

'Yet, all yearn to eventually return to the ocean that is their source. Each droplet contains the memory of the circle, the turning and the returning that brings it once more to the source, and a new beginning.'

Whales move with the seasons and the tides

'Hear the birthing cry of the baby whale and know you are in the warm waters of the tropical islands. Paikea, the great humpback whale, comes to its breeding grounds once more and the people on the shore thrill to that knowledge, for the ancient sea trails open again.

'Paikea is a friend of proud lineage; the keeper of the old lore, our guide on the long tides that sweep across the ocean. Paikea was the companion of the double-hulled waka that voyaged far, as comforting as a bright navigation star.

'The whales gather for the birthing and the nurture of the young. They have escorted the pregnant mothers from the cold waters of the Antarctic to these warm bays. They journeyed far without food, for only the newborn, suckled on their mother's milk, will feed here. The others fast until they reach the cold waters again.

'When the young are ready, the wise old one sends forth the bravest of songs to open the way for the journey. And all answer but only the strong will survive the path that opens.

'Again and again, day follows night across the ocean wide as the great whales follow the currents until they come to Aotearoa, the Islands of Double Sea, where the Old Tides meet. And they hear the oldest of songs and thrill to the same echoes that came back from the land long ago.

'Venturing ever south, drawn by the coldest of waters and guided by memory, both ancient and true, they come at last to the feeding grounds that are Antarctica.

'To the young all this is new, a wondrous world of plankton and small fish, the perfect food to carry them through the greatest of circles. For when the winter beckons, they must leave to allow the baby whales, still to come, to be born in waters warmed by the high Sun. And when this is done they return at last to end their fast in these bountiful icy waters.'

Born of the warmest of waters the whales follow ancient trails that bring them to the coldest of waters. Whale wisdom guided the waka from homeland to homeland, for their trails always held true.

177

The Ancestors were the Whale Riders

'Koro, how do the whales remember to travel that great circle? Their migration pattern is amazing. It meets their needs in every way. It's perfect. When I stop to think about their journey, I am reminded that some birds fly from here to Siberia and back again to follow the seasons. And I wonder how it's all done.'

'Whales and birds honour the pull of the Eternal Tides, feel a truth that ebbs and flows, attune to its call and harvest its rewards. They are of the Knowing, a power that drives the body without conscious reference to the mind. And we are of the Knowing and see this in our women, for the trigger that releases the seed tides is not of the mind but the Moon.

'When all is aligned with the Eternal Tides, life is beautiful and we come to the Rainbow Mind, but that story is for another time.'

When grandfather said his karakia, those who gathered were bathed in dawn's first light. All were amazed they had come to the end of another night.

KARAKIA

Which star calls the birds to cross the ocean, on which Moon do they gather, what is the compass that guides them so surely? What secrets do they hold that we may never know?

Thus closed the circle that had joined them to the rhythms of life, to the tides of the day and the night, and taken them to the seventh Pouwhenua that stood taller in the mind.

The old ones stayed when most of the others quietly moved away. They thought of their journey, of their days together in the springtime of the child, of their bright summer days and the colours of their autumn years and the winter cold that gathered near. And, although they did not voice the words, they had wondered if they would ever reach that springtime of hope again. Tonight the days ahead looked very bright.

Then they left the fire, left it to those who would tend it, left the flame until the stars called them forth to meet again. And Hans and Day Star walked with them into the light of this new day.

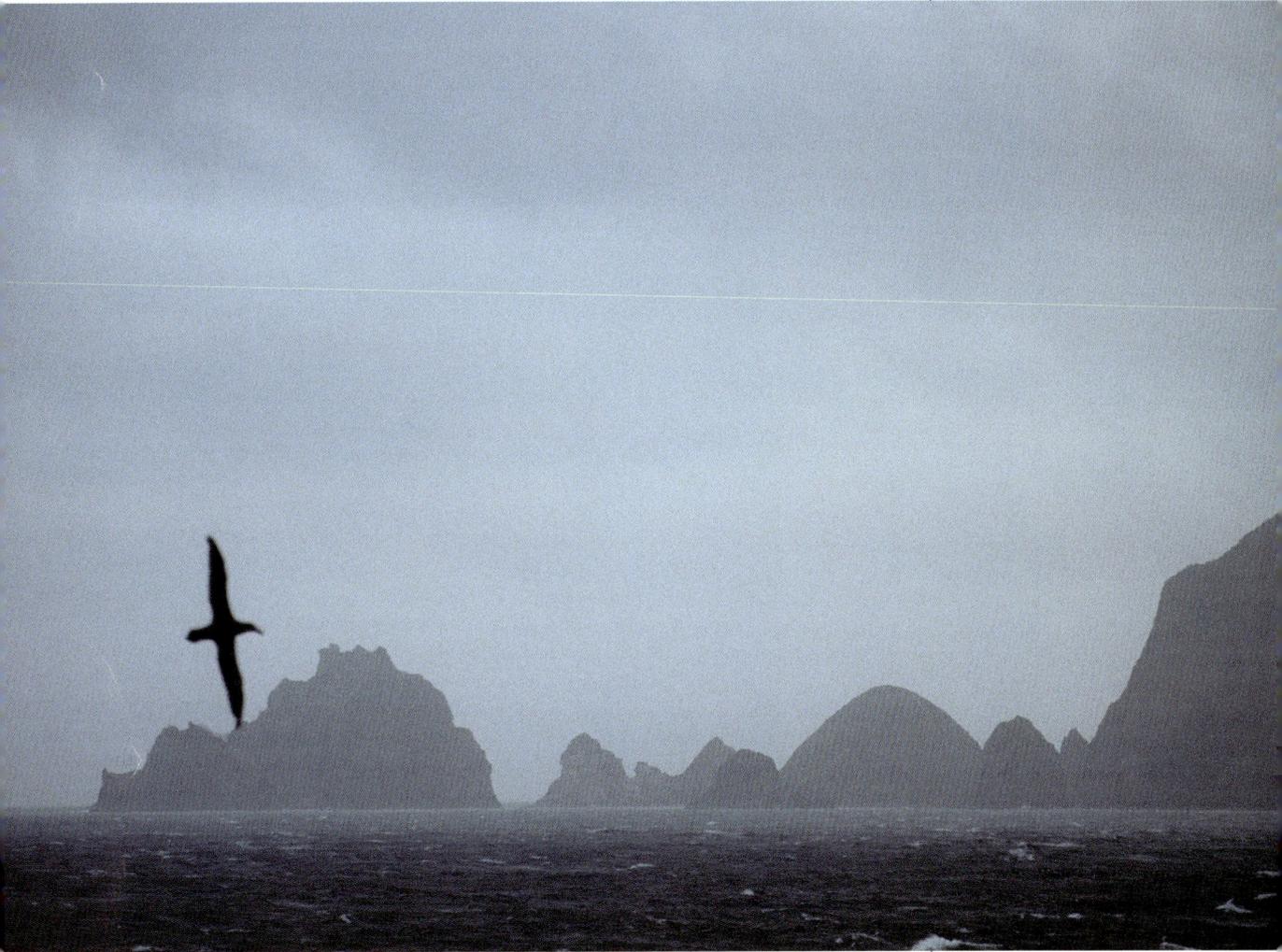

Find the doorway to the Spirit Mind

SONG OF THE RAINBOW MIND

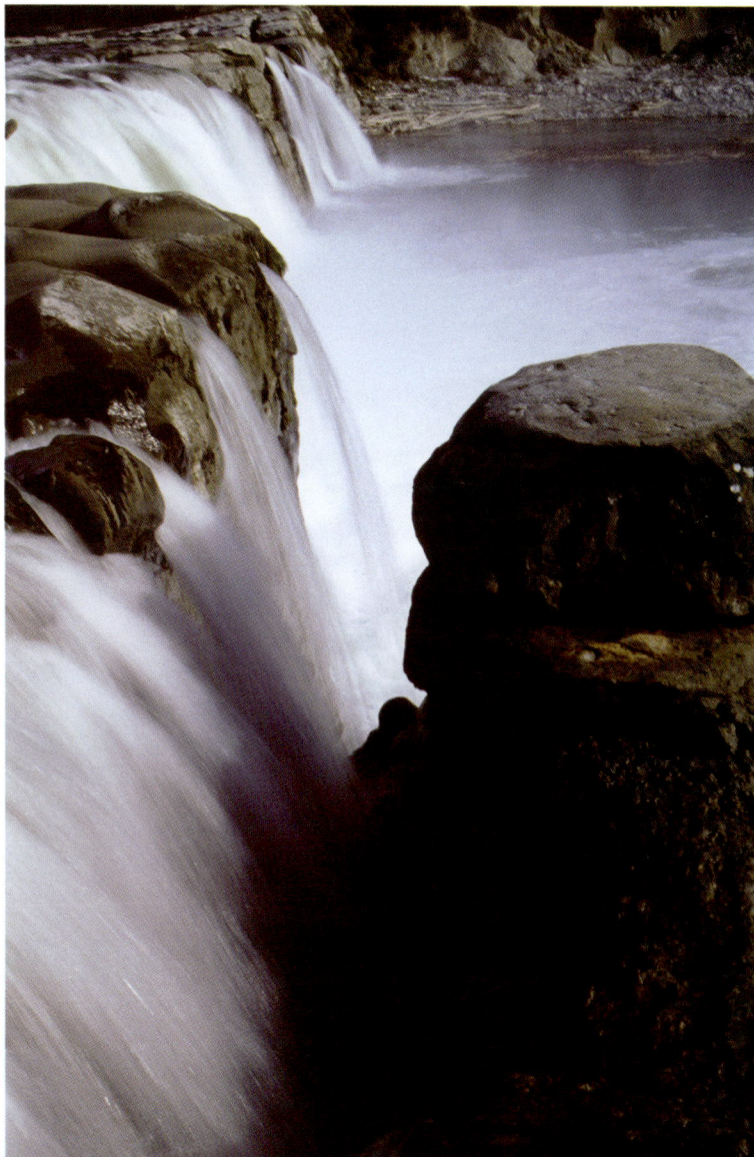

A river flows through our life,

a powerful stream

that joins all with Spirit

if we allow space

for the open mind.

We are of the Dreaming,
the Rainbow Mind that crosses
the frontiers of Space and Time.

Great power resides within paradox;
the letting go that moves more than
we can ever truly know;
the letting go that frees us from
expectation, and learns from every
outcome; the letting go that takes us
beyond judgment and into
compassion; the letting go that
cuts us loose upon the river and
trusts the journey; the letting go that
admits the presence of a guiding
Spirit within the flow.

We are of the power of the Third Eye,
the doorway to the Spirit Mind.

We are of Io Mata Ngaro,
the Unseen One.

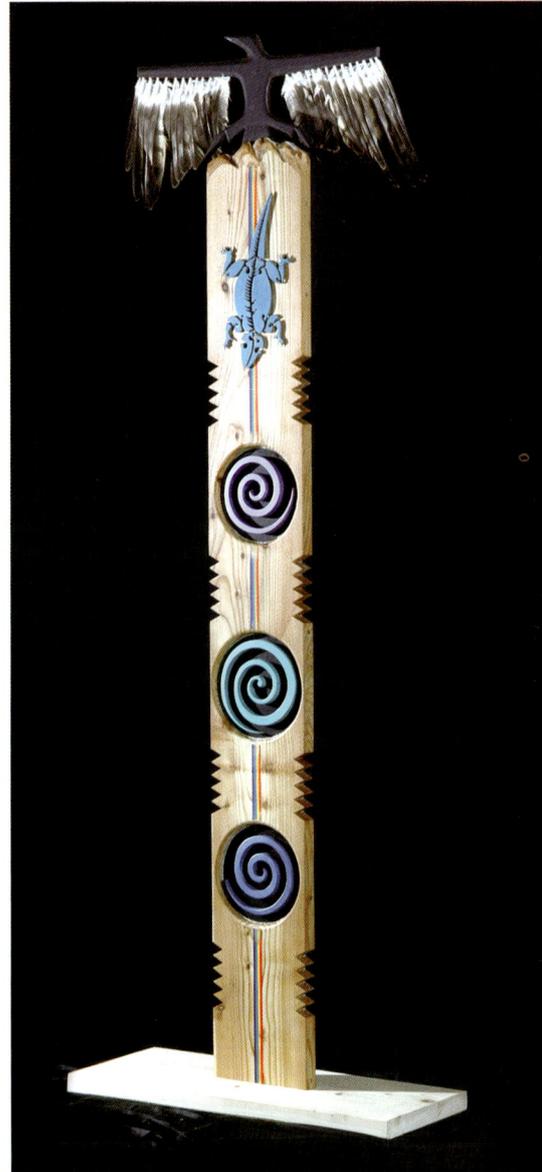

TE MOENGA

The Dreaming

Although it was well before the appointed time, some had already gathered to sit before the fire. Those who hoped to share a private word knew this was their best opportunity to be with grandfather and grandmother alone.

The old ones always arrived early. When asked why this was so they simply said, "We come to empty the mind; if it is full it has no room to grow." Tonight they would open the way to the eighth Pouwhenua, a wondrous image of a world that moves to tides that are deeper than the conscious mind.

The magic is in simple things

Out of the dark of the night, someone approached quietly.

'Kui, might I sit awhile and ask a personal question?' all this said with a laugh that failed to hide uncertainty.

'Of course, dear,' she replied with a smile, as she took the young woman's hand and drew her down beside her. Grandmother remembered she was called Silver around the circle because grandfather had originally named her Silver Pine. Few women find their hair turning silver-grey in their early thirties, yet that was not all that prompted the old one to bestow this name. Silver Pine is a wood that defies age; it endures where others fall away.

Grandmother had waited on this moment, had expected it sooner, but knew young lives were moved by many tides. Linking her arm through Silver's, she whispered, 'Let us share the magic of these dancing flames. Begin.'

'I feel as if I have been lost in a barren desert… much of my life I've felt alone… even though I've been with Rata for sixteen years. Night after night I come here… have put my work aside… other commitments… your words fill my life… yet, reveal its barrenness… I want to be accepted… to love but so much is locked away inside… you and Koro share more than knowledge… offer simple things that mean much… you support each other… have unspoken understandings… how have you grown so close?'

'Truly, I'm not sure I know, but I am happy to share our story. If you find answers in it they are yours, not mine.'

Before grandmother could say more, the conch sounded bringing all to the circle of the fire.

Walk in the world of simple things to know wisdom and peace of heart.

As they made their way, the old one considered Rata's name. She knew grandfather had gifted it to Silver's partner for more than the brilliance of its flower. Rata is a vine that becomes a tree by completely enveloping another.

We never know what the next moment brings

The conch sounded again. Echo's joy could not be bound. The circle fell to silence as grandfather stood to send his prayer to the stars, and all between, to honour the Ancestors and the Great Unseen.

KARAKIA

The old one staggered as he finished. Some smiled at this, for he often swayed as he sought to keep his balance, even exaggerated it a little as if to hide the first loss of stride. This time was different. He sank to his knees and slowly collapsed onto his side.

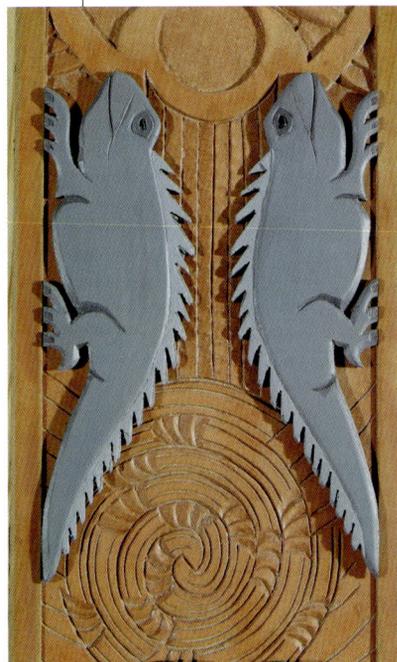

Mountain's strong, knowing hands turned him gently into a recovery position and sought his pulse. Hans arrived with blankets and a pillow, and Day Star with water and the old one's pills.

'He's okay, Kuia… he's conscious…

'Grandfather! Koro… do you hear me… the tom-toms are beating again… twice as fast as you need… what a pulse… 140 to the minute… we'll sit you up soon… give you your pills… get you into the rest tent… okay?'

The old one offered no resistance as willing hands lifted his slight frame gently onto the little bed that had been carried to the fire. In moments he was sheltered in the tent with grandmother at his side. Although sleep beckoned, he said…

'This is not unusual… I promise to rest tonight… these pills make me dizzy… stay till I sleep then speak… give them something… but not Tuatara… hold that space for me…'

Within minutes, Mountain found his pulse was slowing. Not that grandfather cared. He was already slipping into a shallow sleep.

'We have a bed ready for you too, Kuia. Do you wish to rest?'

'No! Mountain. We have been to this place too often to let it swamp our waka. We were prepared for this. We knew it could happen.

'Ask Hans to tell the circle that Koro is doing well. Invite them to sit with him, one-on-one, throughout the night. Tell them I will come and speak in a little while.'

Some follow trails founded in their birth

When grandmother stood before the circle again, she was met by a sombre silence. Grandfather's frailty, the effort it took for him to share, the hidden cost of it was almost too much for all to bear. They had spent many nights together and grown very close.

'I feel your awhi, the support you send across the circle. I assure you grandfather will be stronger tomorrow and speak to us again. Many of you were aware of his heart problem. I have not tried to hide the risk, although he denies it.

'Let's use this to draw closer, to share the things that matter. That's why I want each of us to sit with Koro as he sleeps, why I want to speak, even though it may only be for a short while.

'Earlier this evening, Silver asked me to share my story, which in truth is a grandfather and grandmother story. Before I could begin the conch called us in.

'Sometimes I wonder if our journey was carved in stone long ago, mapped in the womb of time. Looking back it seems, despite many a twist and turn, as if it could not have unfolded any other way.

'Koro and I come from a little village by the sea. We are the same age, went to school together, got into trouble together and shared the same upbringing.

'We were children of the marae, little ones gifted by our parents to our iwi. We didn't know that of course, not as children. Our grandparents took us into their homes soon after our birthing and became everything to us.

'We were raised to be comfortable in at least three worlds. The world of the marae that was the womb of our people, the world of ancient lore that they wove into our day and the world of the new that came from far across the ocean.'

Grandmother paused, sensing a growing agitation in a child. Scree raised his hand.

'Can I be the next one to sit with Koro? He promised to tell me about the blind Taniwha that lives under the land… but I'll make him go to sleep again if he wakes… I really want to see if he's okay,' all this said in a breathless rush.

'Ae, go now… help your mother look after him. And remember,' she said in a cautioning voice, 'there will be no Taniwha stories tonight.'

184

Scree skipped off, and grandmother smiled when Mist silently joined him. There was no asking on her part, for she was of the Water People and water moves where it will, seeking its own way through. This was accepted because Mist always seemed to know how best to handle any moment. She would support Scree, who knew more about grandfather's heart than most because his mother was the old one's doctor.

Seek the knowledge of all worlds

Fly the mind to embrace many worlds.

With Mist's silent departure, grandmother remembered days long gone, the wonderful world of the child.

'We were lively children, even naughty, for we often pushed the boundaries. Living on a shore that cried out for play, we lost ourselves in a place beyond time again and again.

'Looking back I see we were guided with subtle design. The elders conspired to bring us together and shape our lives. I regret none of that, for we were inseparable. And the journey they charted went far beyond the marae.'

Grandmother paused when Mountain returned from the tent. She smiled when told the old one was sleeping under Scree's watchful eye. No mention was made of Mist, for all knew she simply drifted in and out of sight, moving in her own way to her own tune; a child of paradox, so present and so accepted that she became invisible.

Living on a shore filled with excitement was a wonderful place to be a child.

Returning to her story, grandmother hesitated, for it seemed strange to be speaking in the old one's absence.

'When our high school days were over we went to the city, worked for family and studied part-time at university. Seeing new faces every day was both exciting and bewildering. When you leave a world where everyone is known, and greets you, it is strange to move through crowds of people who rarely say, "Hello!"

'But we had our cousins and each other, and discovered the old ones had taught us more than ancient waiata. We sensed the deeper thoughts behind the words of others, read the shift of the body as well as the mind, trusted our inner senses, saw a bigger world and knew our part in it. So we never really lost our way.

'I took a few papers in psychology, just enough to study the great thinkers who delved into the caverns of the mind. I wanted to see how the wisdom seekers in other lands came to the place of visions and the world of dreaming.

'While I followed great minds, revelled in music and devoured novels and plays written in distant lands, Koro sat with heaps of rocks. The world of geology was his portal to heaven. He sat a few papers as well and excelled in ways that must have brought joy to our Ancestors.'

Change is the constant in life

Another returned from the tent. A smile and a nod of the head indicated that all was well. Grandmother took up the last threads of her story.

'When we returned from the city the old ones asked, "What does your future hold?" Some might wonder where to begin to answer that, but we knew exactly what they wished to know. It was written in our upbringing, the need to honour family and relationships above all else.

'I said, before Koro could utter a word, "We want to stay together and raise a family." So we did, and our children loved the bay and we continued our journey into the old ways.

'Looking back I see that our grandparents offered us the best of the old and the best of the new and trusted we would have the heart and mind to bring those together to serve.

'The knowledge that really matters is very simple. It goes far beyond the old lore and the new, for it is about people. We are of one family, one nation and one heart. Ae, the pulse that beats out our story is heard far beyond this time. Let us take it up again after rest.'

The word from the tent was that Koro's "tom-tom" was slowing down. He slept on. With this news shared, Mountain suggested they bring the evening to an end and gather again in the new day.

In grandfather's absence another voice gifted the closing karakia to the night. White Eagle, who had held a silent place in recent days, was called by old Rusty to stand tall to close the circle.

White Eagle was seeing further than ever before, for he yearned to live up to the power of his new name. Only time would tell how much of the past he could reclaim. At forty he knew little of the promise the elders saw in his journey. Perhaps that was the best way.

The sea and its creatures, the caves with their mystery, the spiders with their webs, and the streams with their fish and stones were our teachers.

KARAKIA

As grandmother walked slowly to the tent, Silver linked her arm through hers. They paused before the entrance to look back to the fire.

'Thank you Kuia,' said the young woman. 'I begin to see what others mean when they speak of kindred spirits… I sense new meaning in my journey…

the burning ground was a preparation… it's time to walk my dreams… to take the next step… to trust and see where it leads… I have new friends… they understand… I see more of myself… my needs… Rata's needs… perhaps you are the mirror that clears my sight.'

Grandmother said nothing in response, merely put her arms around Silver and held her close.

'Give Koro my love… rest well my Kuia… thank you for who you are,' whispered the young woman as they parted.

Giving way to Mountain's urging, Grandmother was soon bedded down in the tent. She was exhausted. It had been a strange, revealing night. She had indeed had a fright, for the heart of her companion was ever on her mind. Yet, there was a wonderful sense of completion in telling the circle of their long journey together.

Sleep beckoned. As grandmother gave way to the pull of the ebbing tide, she didn't know two children lay close by. On the ground, at the end of grandfather's bed, lay Scree and Mist, half-hidden and pretending sleep. The mattress they shared had been created of spare blankets from under the bed. Might grandmother awaken to a Taniwha story after all?

Step into the Power of the Higher Mind

The conch sounded again. Everyone had arrived early, all anxious to see how the old one was in this new day. The news was good, Mountain was happy for him to speak. But she was determined to change things in subtle ways.

Grandfather had come to this night with much on his mind and he knew that was the trouble of this time. It was so easy to get lost in the restless mind, the arrogant mind and the absolute mind that tries to dominate its world from a small space.

Yet, he felt stronger despite the little upset of the precious night. He signalled to White Eagle to rise and offer the karakia that would open the way. Rusty had been at it again, quietly moving behind the scene.

KARAKIA

When White Eagle finished, Grandfather slowly stood, glanced at Grandmother and Mountain, smiled and sat. The circle sighed in relief and clapped. He acknowledged the applause with a laugh that signalled he was back and ready to play. However, he would follow orders and sit to speak.

The old one's concern was not for his heart. He felt it had served him well and would see him through. The challenge tonight was the journey to the eighth Pouwhenua that stood tall to reveal the Rainbow Mind. Only Tuatara could help him open the doors into the deeper recesses of that kind.

When he spoke his voice shifted into that special space that gifts words in another way, the space that opens to Wairua, to the spirit that joins all with all. Although they had often heard this "voice", for it was there in both the old ones, it still stirred the hair at the back of the neck and lifted the mind to another place.

'We gather to the light of the flame to share the lore of old that brings forth the sacred name. All spoken here is of Io, the Source of Life and in that name, I call on Tuatara to bring us to the Dreaming that is of the Rainbow Mind.

'Tuatara of Ancient Times

Child of the Reptiles
Keeper of the Knowledge
And all that has ever been.

Tuatara of the Third Eye

Gateway to the Universe
Mirror of the known realms
And those between.

Tuatara of the Spirit Trails

Carved in mountain and mind
To mark the pathways to the stars
And all unseen.

Open the Portals to the Sacred'

Tuatara's ancestral line runs back to the beginnings of creature time. It leads us to the great Houses of Learning and when our journey is done guides us on the Spirit Trail back to the Stars beyond the Sun.

Grandfather held the silence for a long time. To speak of Tuatara was to navigate through difficult tides. He seemed to drift far away, before a child's voice called him back to the fire. Sometimes the little ones see much more than their words convey.

'Why have you called the Tuatara, Poua?' cried Kea, the wide-eyed child who told grandfather that she would call him Poua, in the Maori way, if he would be her third grandfather. He'd accepted that with a broad smile, seeing he had already replaced her Katie with Kea. White Eagle, her uncle, had brought her along on the first day as a one-off, baby-sitting favour, but this seven-year-old couldn't be kept away.

'Poua, will we be all right?' Kea asked when he was slow to reply.

'Be not afraid, Tuatara is our friend. It helps us discover the magic of the third eye,' replied the old one with a smile.

'I think I have seen its third eye, Poua, but I didn't know it was magic,' responded Kea, who was remembering her visit to the reptile house at the zoo. She had been drawn to Tuatara in its stillness, was fascinated by its unblinking gaze and if she hadn't actually seen the third eye she had certainly heard of it.

'Ae, few know about the magic, little one,' he chuckled. 'It's time to see if we can change that, time to walk the magic… even if I have to sit to do it.'

His little joke at the end came with a wry smile that was reflected back to him by his old companion in life.

Tuatara is the gatekeeper

'When the Ancestors came to these shores, they knew that Tuatara was both ancient and wise. And they saw in its power a path to the Dreaming that is of the Rainbow Mind, for this wondrous creature had a third eye.'

'How does it use its third eye, Poua?' asked Kea.

'Tuatara looks to the side with two eyes, and uses a third to reach beyond Space and Time to defy the boundaries that divide. That third eye brings us to the Dreaming that is of the Rainbow Mind.'

'I've heard of the third eye in my studies, Koro,' offered Emma, Flame's teenage daughter, who had arrived late because of her comparative religions course. University had taken precedence until today.

'It's part of the eastern cultures… about linking mind with spirit… we have it too… in the forehead… its one of the charkas… but we haven't got there yet.'

'Ae, your studies serve us well. Yes, it is an Eastern thing and a Maori thing and there is mystery in that. Tuatara and Chinese dragons seem to travel the same trails.'

Truth is paradox within the big mind

'Koro, what is this Dreaming that is of the Rainbow Mind? Is it like the Dreamtime of the Australian Aboriginals?' asked Emma.

'I suspect so,' responded the old one. 'It is of that special place where truth is paradox, because the Dreaming is not about sleep! The Dreaming is not about drifting into a cosy space! The Dreaming is not about fluffy stuff without substance! The Dreaming is about waking up. Ae, the Dreaming is about awareness, no, more than that, it is about the ultimate awareness that we call Te Wai Pounamu. And it is that awareness that brings us to the Rainbow Mind.'

'Koro, I don't wish to divert you from your course, but I have to ask about Te Wai Pounamu. It's our name for the South Island, and accepted by all I have met in the north. Am I wrong to see it that way?' asked Mick.

'You are not wrong, for names change. It happens here almost every night,' grandfather said with a chuckle.

'It's not surprising in this age to see the island that is home to our precious Pounamu, carrying the name of the Stone. By penning it on his charts, Captain Cook sealed its place. Yet, the deeper meaning of Te Wai Pounamu remains. The Ancestors gave it not to the land, but to the purest stream of thought, to the river of the Rainbow Mind that flows into the Dream Time that embraces many worlds and speaks of realms unseen.'

'Koro, are you suggesting we have more than one mind?' asked Flame.

'Your question asks me to tear apart the seamless fabric of the mind. I cannot divide that which unites, so I will explore the many facets of the mind, and hope that along the way you find an answer.'

Te Wai Pounamu is the stream of ultimate awareness - enlightenment - the altered state that brings us to the highest of minds.

Walk beyond the margins into the Knowing

'Does the Dreaming still exist?' asked old Rusty.

'Yes,' replied grandfather with laugh. Rusty was forever of the Dreaming. 'It's part of every life. In some it lies dormant for it cannot be reached by the closed mind.

'I'd like to begin our quest for Dreaming that is of Te Wai Pounamu, by bringing into this circle a power I call the "Knowing".

'This Knowing is of the hidden tides that serve the mind. It is seen in all creatures, be they birds, fish, insects, butterflies, snakes, cats and dogs or even your friends. Let us go to the bird people to learn of the Knowing.

'Hear the birds sing to greet the dawn or farewell the Sun and look behind their songs to the cause. Each call affirms life and place, each says I am and this is where I stand tall. Those songs change in the winter months and again in spring, for then they call to attract a mate. And when they wheel and swoop in the joy of flight, they often pair bond for life. Together they gather twigs and grasses to build a nest and its design is always unique to their kind, and just right, for it is shaped by ancient memory, the Knowing that defies time.

'Some of the songs and rituals of the birds are learned, are gifted from parent to child, but many are not. Instinct is the word used to describe these understandings that are "Known" rather than learned. But I call them the Knowing, for they come from messages written into their lives.'

'Are you saying that some things never need to be learned, Koro?' asked Mountain, who had taken a particular interest in psychology during her medical training and might still follow that path.

'Do you suggest that birds pass information from generation to generation without the need for instruction? Are you taking us back to the Mauri, saying that the uniqueness of a kiwi, its special habits and customs, are simply inherited at birth? That these things are coded in their DNA?'

'Ae,' responded grandfather. 'Bird Scientists have taken eggs from different nests, raised the chicks in isolation and discovered each bird knows how to build the nest of its own kind. Staying true to a family they have never seen, they recreate their parents' nest design from an inner Knowing.'

Grandfather was beginning to question the path he had chosen to walk this night. He wondered if this was the best way to bring them to the Rainbow Mind. As he hesitated, he was pulled back to the challenge by a child's confident cry.

'Koro, my dad took me to see the Godwits on the estuary. He said they go to a warm place in winter,' offered Mist, who always seemed awake despite the time of the night. 'Do they fly to Kaitaia? That's where my gran lives and it's very warm.'

Are there messages already written within, memory gifted from ancient times that serves our need? Look to the inner knowing of the birds and learn.

'Ah, you speak of Kuaka who follows the Sun. Kuaka does fly to Kaitaia, and then some more until it leaves the land far behind and sees only the greatest of oceans stretching north. And it continues flying until it reaches Siberia, on the other side of the earth, where the Sun offers summer's warmth.

'The map for this amazing flight is not taught, for it is gifted in the memory of the egg. It is of the Knowing.'

'Koro, will you tell us a bird story?' asked Scree. He was never far from Mist or Smoke in word or deed.

The old one paused. He wondered why these little ones returned again and again to sit through the long nights. Perhaps they came for the magic of the leaping flames, or took in more than we might think, even in sleep.

'Ae, if it's a story you want little one, then it's a story you shall have,' responded grandfather with a chuckle, 'but the story is grandmother's to tell.'

Grandfather let his head fall forward until it rested on top of his talking stick. It was time for the song of the Shining Cuckoo to be heard, and it was grandmother who carried those words, for they were of the Knowing shared by mothers.

Love the Difference

Grandmother reached for her flax kete as she rose to speak. That was a Wairua thing, a prompting from within that guided her in this moment. Some might say it was of her Knowing, a trust that took her beyond herself to meet a need.

Her hand explored the depths of her kete and brought forth a paua shell that reflected its brilliance back to the dancing flames.

'Pass this treasure on. See its rainbow colours flashing in the light and thank paua for the wonder it offers to this night.'

As the paua shell moved on, grandmother's hand explored her kete once again and lifted from its darkness a dusky, sharp-edged, shining stone that looked like smoky glass.

'This wonderful stone is obsidian, the friend of Ancestors who needed to cut their hair, sever a rope, or incise an amulet shaped in wood or bone. When it reaches you, carefully feel its edge, look into its dark core and understand it too accepts the magic of the flame's light. But unlike paua, that sends the light back with rainbow's power, obsidian takes the light in and holds it close. Its surface darkness is illusion, a sign that it is filled with light that is held tight. This stone is a light holder and has a purpose and a place.

'The Mauri moves to create the wonder of difference. It moves in shells and moves in stone and even moves when it fashions and shapes our bones. We are all different and in that difference, special. That is how Spirit made us.

Difference adds wonder to life. See the rainbow colours shining in the paua shell as it reflects the light. See the darkness of obsidian that takes the light in and holds it close. Both serve the light.

'Difference is the Joy of Spirit that flourishes in the many flowers that fill the world with their brilliance and colour.

'Difference is the Touch of Spirit seen in the breeze rustling the leaves of all the wonderful trees.

'Difference is the Excitement of Spirit that dives deep within the tides to create fish of every hue and shape.

'Difference is the Happiness of Spirit that soars with the birds that bring their songs to greet the dawn.

'And Difference brings us to the story of the Shining Cuckoo and the Grey Warbler.'

Seek the truth that is your way

'In the long, long ago when birds were still discovering how best to make their nests and raise their young, the Shining Cuckoo watched their efforts with dismay. She marvelled at the strength of the Eagle that gathered sticks so big they seemed to stretch beyond the span of its huge wings and the Kingfisher diving into a steep riverbank with head outstretched to smash its beak into the crumbly surface to make its nesting chamber. She watched bird after bird every day, but could not find her nesting way. Then, hearing the bright trill of a happy bird, she saw Riro Riro, the Grey Warbler, flit by and quickly followed to give nesting another try.

'Grey Warbler's nest was so beautiful Cuckoo put the idea of all other nests aside. It hung like a huge raindrop from a branch of the tree. When Grey Warbler departed to feed, Cuckoo flew swiftly to the nest, squeezed through the entrance in its side and laid her egg beside others that would become its sisters and brothers and left.

'Grey Warbler accepted the new egg and when it hatched, nurtured the chick, as would any mother, until it was strong of wing and left.

'Watching all this from afar, Cuckoo realised she was not born to build a nest, or hatch her eggs and raise her chicks. Henceforth, Grey Warbler would be her children's nest mother.

'When the summer days were done, Cuckoo decided to follow the retreating Sun, and flew north over the wide ocean through long nights and bright days, until she came at last to a beautiful tropical island. It was paradise, for winter held no sway in that place of delicious fruits and berries.

'She was very happy and thrived, yet, when the Sun moved south again she knew it was time to return to the homeland that gave her life. And Cuckoo did not go alone, for as she spiralled high, others watched and bent their backs to launch a great waka to follow her on the long tides, for she was their guide.

'When Shining Cuckoo reached these distant southern shores, her song brought cries of joy, for she was the messenger who announced the return of the Sun.

'Cuckoo's children continued to honour the ways of this mother who is like no other. Emerging from Grey Warbler's nest, they grow strong in heart and wing and without instruction of any kind leave our island tides to seek others. Following a map set deep inside they fly north, as their mothers did before, to be welcomed by the people of the warm isles. There they recover their strength and await the call of the tides of home.

'So Cuckoo found her place and so did her children and so will we if we accept that all are different and special in their own way. Celebrating difference lifts us beyond the frontiers of time to wisdom that is of another kind. There is no limit to the journey of the open mind.

'And so it shall be forever more, for the oldest wisdom still abides within the dream that is of the Knowing deep inside,' concluded grandmother.

Do not sacrifice your Knowing to the dominant mind

Now grandfather lifted his head from where it rested on his talking stick and nodded to show he was ready to weave, once more, the sacred threads that shaped this night. They were of many colours, for that is how the old ones open the way to insight.

'We have travelled far with the Bird People and seen the magic of their life. There is little time this night to swim with the Fish People into the fathomless waters of their Knowing.

'If we followed the eels that leave the lakes late in summer to return to the sea of their birthing, we would see the Moon call them to honour the Knowing.

Fly the mind to embrace the Knowing.

'Inanga, the little ones named whitebait, have the same Knowing as the eels, only their journey is from the sea back to the spawning waters of their mothers.

'Beautiful and mysterious are the trails of the Knowing. Listen closely now for some may find the next words difficult. There is Knowing in all that lives, in the birds, the fish, the trees, the whales and the insects, for the Knowing is of Spirit. And the Knowing is of us.

'I marvel at the wonders of modern science. I love its truth for all truth is of the Source. Yet in recent times the Knowing has been lost in the dominant mind, the mind that thinks that the unseen doesn't exist unless it is proved by science.

'Our elders taught us to listen to the Knowing, that voice within that speaks from intuition, from the place of deep insight, from the Dreaming.

'Perhaps the greatest journey we make in life is but three hand spans across – the journey from the head to the heart, for it anchors the mind in Spirit. Then everything is of the sacred.'

'But how do we recognise the Knowing, Koro?' asked Emma, in a quiet voice beyond the flames.

'Begin by recognising it in others. See it in the world around you, in the wondrous ways of the birds, the fish and the whales, in design that speaks of understanding that reaches far beyond the mind.'

196

'But I have no imprinted nesting memory…
no migration map to guide me around the world…
I am not like fish raised in the ocean that return
only to their birth rivers…'

'All you say is true,' responded grandfather, 'you
are not a bird or a fish. Their songs are not your
songs for all are different. Yet, the Knowing they
reveal invites you to look to your own, for they are no
more or less than you.'

Be true to your homeland; listen to its song

'Each creature is of a Knowing that is true to
them. So the journey now is to discover what is
true for you, and it will lead you into the wisdom
of the Rainbow Mind.

'When we go into the dry, desert lands with their
great dunes of drifting sands, we fear for our
survival. The lack of water, the searing heat of the
day and the coolness of the night, constantly
challenge life. Yet, the creatures of that place, those
born to that realm, not only survive, they thrive.
They know no other and seek no other for this
wilderness is of their Knowing and thus perfect in
every way.

'Where we might die, the Desert People, the Little
People of the Kalahari, the Bedouin of the Sahara,
the Aborigine of the Outback and the Hopi of the
Three Mesas of Arizona, have become so attuned
to the wisdom of the sweeping sands and fierce
heat, that they flourish.

'When I asked the Hopi why they chose to live in such a harsh place,
they said they wanted to walk the sharp edge where life depended on being
close to Spirit. So they took their corn into the driest of lands and used
the power of the Knowing to dance to call forth rain and it always came.
The journey of the Desert People honours Spirit, for it remembers
the Knowing.

'The Ice People of the Frozen North, the Inuit of the Taiga and the Sami of
Lapland, also walk the sharp edge. They survive by honouring the Knowing of
lands that experience endless night and endless day, and walk in the power of Spirit.

Beautiful is the life attuned
to the desert sands.
Some find contentment in
the magic of the ice.
Others walk the jungle
with joy.

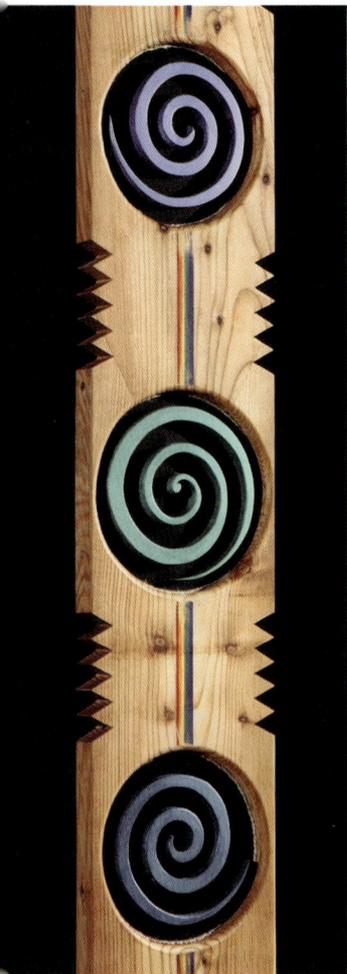

Te Wai Pounamu, the stream

of ultimate awareness is

born of many minds.

We touch into it in many

ways day by day, opening to

the power that lives within.

'The Tree People of the Amazon Forest and of the great jungles of Africa live on the sharp edge where rain, flood, and danger challenge them day-by-day. And they live well when aligned with the Knowing that is of the deep trails of Spirit.

'All these Peoples survive and grow strong because they accept a world that asks much of them and listen to its songs and take to themselves its wisdoms. They do not try to change the desert, or the frozen wilderness of the north, or the great forest. When allowed to live their own way, they are content within the Knowing that is of Spirit.

'Be true to the land that you call home, honour its Spirit and find your joy within it.'

And be true to yourself

'I think we lose sight of the Knowing when we become lost in the wilderness of the mind. When we raise the power of the rational mind above all other powers, we close off the light.

'That might seem strange to you because we always think of the mind growing in the power of the light. Yet, the mind that sees itself as supreme, fulfilled without any other part, is incomplete. It is not open to the voice of the heart and may become a cold thing that shuts out the warmth of the light.

'When we say it is important to journey from the head to the heart, we speak of a joining not a separation. In rediscovering the heart we give power to the mind, open it to realms unseen that are born of Spirit. In that place children find their play.

'Those who trust the power of the awakened mind can reach others by thought alone, across the space of a room or on the other side of the planet, in the same moment. Put your doubts aside for many have done it.

'Some call that telepathy, a mystery to be studied, but to us it is just the old way of touching mind to mind. All can do it if they trust the Knowing.

'The first step is taken when you realise you have communicated with another without speaking. That awakening nurtures powers long dormant, but not lost, and of itself carries you forward.

'Remember you cannot force the mind of another. You cannot touch mind to mind with someone who has a closed mind. Only the welcoming mind will accept a message from another mind.'

There are many facets to the mind

'Some have the gift of the psychic mind, the power to be touched by events that are distant in Space and Time.

'Distance is no barrier to the power of the mind that sees no limits to its range and does not label that gift as strange. In the psychic mind you may experience the death of another, know where a lost one is to be found and have an awareness that receives from afar both sadness and joy.

'The psychic mind is both a cross to bear and a blessing to share. It is wonderful to know, in our pain, that there are those who can reach us with a kind mind.

'Some step beyond the confines of time when they are in the Knowing. Standing on ancient battlegrounds, they feel the terror of the slain, hear their voices and see the events of yesteryear revealed once again. They penetrate the thin veil of time, touch into the eternal to reach a reality that is of another kind. They turn a page into another age.

Fly the mind to find the
Shamanic way.

'Others experience vivid images of events still to come. It may be a flash of insight that reveals an impending disaster, a folding of time over time that defies explanation by the purely rational mind. Many speak of "seeing" what is around the next bend in the road, a "vision" that allows them to move out of harm's way. Others "see" far ahead to warn of dangers or foreshadow good results. And the more we heed that "seeing" the more it reaches out to help.'

'Have you ever experienced that, Koro?' asked White Eagle. The visions that began to fill his life and voices that spoke with great warmth, were electric in their power. His hands yearned to give them form, to gather their mana and bring them to the world. But the "why" and "how" of that was still distant and illusive.

'Everything I share here has been of my journey. I speak of nothing I have not experienced or done,' replied the old one with a smile.

'And what of the heart, Koro, tell us of the Knowing that is of the heart,' continued White Eagle.

'I have spoken of the welcoming mind, and the welcoming mind is the mind joined to the heart. It is the compassionate mind that does not stand apart. However, I can speak no more of the heart, for grandmother stole mine many years ago,' said the old one with a smile.

With those words, grandfather rested his head on his stick again. He saw the wisdom in Mountain's insistence that he sit while speaking, for while he felt the words came with greater ease and power when on his feet, he also knew old bones were at their best at rest.

There is a Rainbow Mind

'Ae, the heart! Koro says I stole his heart, but how can you steal what is freely given?' grandmother said with a laugh.

'Understand that the compassionate heart, the thinking heart, the heart open to the wonders of the mind, is the true heart.

'When head and heart are one, we begin to walk in the power of the Rainbow Mind. Pulse and impulse are the virtues of the heart. The pulse sends the lifeblood through our bodies to move and shape us and fire the mind to ignite the Knowing.

'And the impulse is the spark that lights the way for spirit to move. Impulse is the voice of wonder, of joy and laughter, of kindness and compassion. Impulse is the heart urging us to step beyond and act in a good way. Impulse is trust taking the next step because the heart calls for it.'

'Kui, have you always followed your heart?' asked Silver.

'No! In my early teens I experienced a strange, unsettling time. I felt much was expected of me, yet my body seemed to belong to another, the girl that I was teetered on the edge of the potential mother.

'In that time of uncertainty, I sought rules… needed rules to follow perfectly… to avoid upsetting others… the harder I tried the more I failed… I felt paralysed… confused… lost… could not be myself… then the grandmothers said, "You only need one rule to guide you in life, one rule for everything, and that's to follow your heart".

'Follow your passion, your excitement, and your truth because they are of your heart and the best of you.'

Grandmother looked to her old companion and when he gave a slight nod of his head she sat down. He would lead them into deeper waters and help them find the trails opened by Tuatara.

The Keepers of the Promise are of the Pure Stream

Before the old one could speak, a question that came from the circle helped grandfather see his way forward.

How fitting to bring whale and feather into one, how right to unite sea and sky within the searching mind.

'Who walks with this Rainbow Mind, Koro, who is of Te Wai Pounamu?' asked Mick, who was still excited by the deeper meaning given to his island home.

Sitting in silence, grandfather looked towards his companion. He made no move to answer. Everyone was comfortable with the way the old ones took their time to approach things. Hans and Day Star, who now stayed close, were not surprised when grandmother placed Koro's Pounamu in his hand, added a Kumara from her kete and a great taonga, a feather carved in old whalebone joined to a whale carved in wood, and gently poured water over them. Thus were old friends brought together to help him go deeper into the tides of the Rainbow Mind.

'When the cabbage tree flowers in abundance, wisdom tells us it will be a long dry summer.

'Ae, what we need for the journey comes to our side,' said grandfather. 'Spirit always moves to provide.

'How did the Ancestors achieve so much? How did they create a Nation of many peoples who lived together in peace for a thousand years? What power moved them to such heights?'

Holding his Pounamu towards the fire, he moved it ever so slightly to send back its light.

'Pounamu born of the eternal tides… holds the power… the Aroha that allowed the Ancestors to achieve so much… bound the many peoples together for a thousand years… sustained the keepers of the promise. Pounamu brings us to the Rainbow Mind.'

Then the old one took the Kumara, which still glistened with water, and presented it to the circle.

'Kumara… the Peace Child the Ancestors dedicated to the sacred… the Spirit of Gentleness… that nourished the Nation… the food that bound the people to the land and the land to the people… is the doorway to the Rainbow Mind.'

Now grandfather held aloft the feather carved in whalebone and slowly moved it back and forth.

'I hold before you the feather that joins Earth and Sky, and the whale that plunges to the depths of the waters and call on these guardians to help us open the way to the Rainbow Mind.

'You ask who walks with the Rainbow Mind? You know them when you remember the Ancestors who created the dream that is this land. You know them when you remember the Ancestors who carried the promise to honour the dream.'

Our ancestors discovered they could reach beyond the moment, could escape the past and envisage the future. They learnt to step outside the present mind to another mind that opened into a dreamtime of endless opportunities. They learnt to fly the mind, to come to the ultimate awareness and journey into the mystical mind.

Tohunga, Shaman and Mystic are of one mind

'Intellect alone cannot bring us to the ultimate awareness. That wondrous Rainbow Mind is of a very different kind. It is seen in the Tohunga, the Shaman and the Mystic, who enter it through sound and dance, and induced trance.

'The constant beat of a drum, or the repetition of an ancient chant within the sacred stone structures of Egypt, Europe and the Americas has created, even in the untrained, the shamanic, mystical trance. Such sounds, set within stone halls, send the body into a "waking sleep", an altered state where we appear to doze; yet in truth the mind has never been so aware and so awake.'

'Koro, how does a drum or song do this to us?' asked Eagle Heart.

'I know something about it,' offered Mountain, who was thinking back to lectures that dealt with brain-wave patterns. For the first time she was making huge connections between theory and fact, and ancient powers and modern machines. She had seen the printouts, seen the typical sleep waves change with the arrival of the alpha waves that indicated intense awareness within the brain.

'This is not an imagined state,' continued Mountain, 'the change can be measured in our brain and induced by machines that replicate the alpha wave pattern. Scientists call it an altered state. They can deliberately send people into the shamanic trance and bring them out again.

'I cope with all that, but begin to see things that simply blow me away.'

'Doctor Mountain,' laughed grandfather, who had added her title to her name after his fall, 'you bring great knowledge to this fire. Please share your insights.'

'I see the shamanic mind as the greatest leap forward in the history of humankind… I understand biological evolution… changes to our bodies over aeons of time that have helped us to survive… learning to stand and walk tall… the power we get from opposed finger and thumb… the tool-making that followed… a technological revolution… the working of stone and sharpening bone…

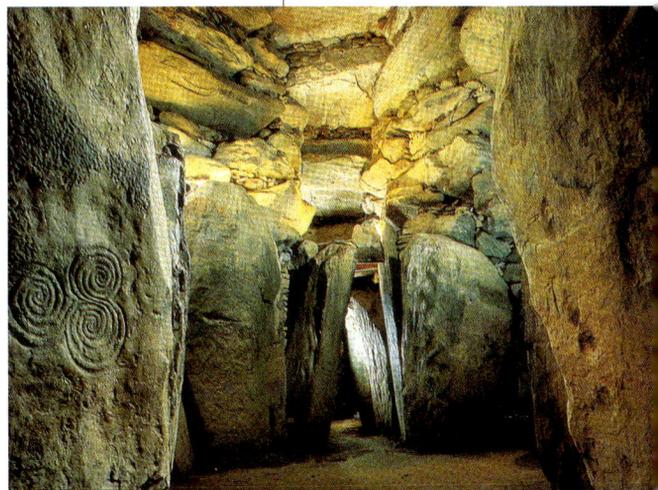

Ancestors in distant lands entered the altered state of the shamanic mind through the rhythm of drums, song trance and sounds created within special stone structures.

203

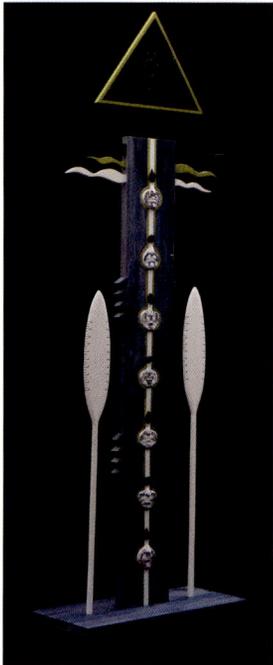

'While those things set us apart, sent us on a special path, the most stunning advance of all hit me for the first time tonight.'

Mountain paused. This was all happening so fast it was hard to find the right words. Her mind had jumped a chasm so wide only part of her had reached the other side.

'Using altered states our Ancestors leapt forward in incredible ways… other creatures remain bound within biological evolution… know only the moment, the now of things… do not imagine… do not design change or go beyond themselves or outside themselves… to shape their lives.

'The altered state freed the mind to make room for the thinker, the visionary, the dream maker, the inventor and the artist… that was social evolution… a whole new way… suddenly I see more… the altered state propelled us beyond the physical… and beyond the social and we made a quantum leap, it allowed us to access Spirit.

'Wow! That is our stage… Spiritual Evolution.'

'Ae, you see it so well, Doctor Mountain,' chuckled the old one. 'Our Ancestors learned to explore the unseen and great men and women dreamed dreams of awesome power. They stepped out of the known and into the unknown and grew in remarkable ways. And we may too.'

They walked the Dream into tomorrow for all who might follow

Grandfather placed his Pounamu, the Kumara tuber and the carved taonga of whale and feather on the ground. They were his guides into the remainder of the night.

'How did the Ancestors achieve so much? How did they create a Nation of many peoples who lived together in peace for a thousand years? What power moved them to such heights? Let me remind you of their story, their dream and the spirit that fired their lives.

'It was Kupenga o Te Ao, the Net of the World, a brave woman who voyaged into the Pacific to find the Birthing Cord of the Planet, who set the Dream in motion. With Kiwa at her side, she saw the children of their lines creating a haven of harmony within the vastness of that ocean.

'Their vision sent Maui to our shores to fashion, with his great mind and heart, the foundations of a new Nation, a union of different peoples who gathered to serve this land in peace.

'Maui came to honour these islands set fast within the meeting of the Old Tides, for he knew it was the cradle for the children of tomorrow. So he asked Papatuanuku, the Mother of this Earth, if he might bring his people to these favoured shores. She agreed and Maui promised that his people, and all who

followed, would care for her forevermore. He took the Mana of the Waka of the Gods from the Prow to Whakarerea in the Stern to tie the northern island to the southern island. Thus was the Fish held safely within the tumult of the Old Tides.

'There was more, for Maui promised to bring the Kumara, known as the Peace Child to this land. And he gifted Fire, the Fire that warms the land and the Fire of the Dream Maker to sustain all. Then he sailed home to Easter Island and told the story of his journey, and gathered to his waka those who would venture forth to honour the Promise once more, but was lost at sea and reached no shore.

'However, the Dream did not die with Maui. Ngahue and Poutini sailed from the homeland to discover in the west the Stone of the Gods that they had so courageously sought. And they named it Poutini, but that name did not hold and it became Pounamu. Humbled by its power, they carried it home to Easter Island and all saw that the Stone healed, for it was imbued with the Spirit of Aroha. They rejoiced for they had found the perfect Stone to stand beside Kumara, the Peace Child promised by Maui.

'And the Mana left by Maui in the Stern of the Waka was not forgotten. Once again, one born to walk the trail founded in the Dreaming, came to the fore. We speak now of Ra Kai Hau Tu, born of ancient lines, but birthed on these shores. This son of surf and tide, of mountain and stone standing tall, of the Star Walkers who found their way to many distant shores, answered the call. Building a great double-hulled waka, he sailed to Easter Island to gather the great minds and hearts needed to complete Maui's vision of a compassionate nation dedicated to these lands and waters.

The vision that carried the ancestors so far from home was born of the great minds that raised the stone on stone.

'And Ra Kai Hau Tu did more. He anchored the Line of Life that circles the planet, on Waitangi Ki Roto and in the Hokianga and then began the great land journeys to raise the Tuahu that joined these islands to the Southern Cross. And he went to Whakarerea to lift the Mana of the Waka of the Gods on high and carry it south to the Prow.

'All this was done to honour the memory of Maui who was the architect of this Dream that bound the waters, the land and the people to the stars, to the Tides Eternal and truth that knew no bounds.

'This chronicle of great deeds born of great minds does not end there. For Marotini and Titi Raukura, women of great vision, carried Kumara into the Birth Place of the Gods to grow the Peace Child in those mountain lands to fulfil the Promise.

'The Dream was not forgotten even though generations passed. For Rakaihaitu, of the blood of Ra Kai Hau Tu, took up the Mana of the Waka and moved it safely to the Prow. Then he sailed the Waka of a Hundred Blades into the coldest of waters to raise the last Tuahu that joined the land to the Southern Cross. And when he sailed for Easter Island to tell the people that the Dream had been carried forward, his waka foundered and went deep.

'Great courage and wonderful vision is the legacy gifted from those times. And it does not end with the passing of such great minds, for Paparoa and Huaaki and their son Tira, not only established the sea gardens of the Nation, but also organised the movement of Pounamu across the mountain passes on the Trail of the Peace Maker.

'It is important to remember that all they brought out of the Dreaming was dedicated to Harmony. The power of the Rainbow Mind was used to care for all. When Pounamu travelled the land trails and the sea trail of these islands, it moved with Aroha to serve. It reflected the light of the Universe, and the love of Io, to the land in need of renewal, to waters diminished in spirit and to the people.

'And when the waka sailed, the Healing Stone was carried to distant shores, for the Dreaming was like the ocean that joined all lands as one in the warmth of the Sun.

'It is time for the Dreaming to bring forth its promise again, for the Rainbow Mind to become our life. It reveals truths about creation that bring insight and renewal. It invokes a supernatural reality. It instils a reverence for life. It allows the land itself to be our teacher. It offers a sanctity that embraces the unity of life. It is the poetry that brings the rational mind to Spirit.

'It is time for the Healing Stone to speak to all. It is time to share the greatest pain that clings to our island strand, time to bring Te Wai Pounamu to the people and the land.

'There are things in our past that cannot be changed, but they can be healed. Bring your promise and your hopes when next we gather to this fire. Be true to yourself and journey well.'

Although the night was not long into its journey, the old ones chose to end this circle early. They knew there was much to be done before they could go forward. Old pain, seeded deep in the land, needed to be lifted away.

Grandfather rose, with help from Hans and Day Star, to close the circle with his prayer. Standing was a small act of independence that brought forth smiles. He was truly on the mend.

KARAKIA

Only grandmother knew the pain the old one carried. It had nothing to do with his heart. It was not of this day or this time, it was a burden from a bygone age. And its weight threatened to crush him. They were going to spend the next day preparing to meet it. They would fast, would remain alone with the Ancestors to find the wisdom and the courage to carry them through the next fire.

Spark, Smoke, Emma and Silver stayed behind to gather wood and tend the flame. Rata was off with Huia; there was talk of fishing after a sleep, but first they had to find the lines.

White Eagle was sketching on his art pad with a bemused look. There were questions to be asked and decisions to be made. As Mountain and little Scree arrived to sit on a log nearby, he quietly covered his design.

Scree was tired beyond sleep, but still had questions that would not keep. Mountain was utterly exhausted too, but knew her mind would not settle. Too much had happened, too many strands of thought still wove their colours through her mind.

Mist was gone, but few knew where and no one was worried by her absence. Later Fran and Mick found her hidden in a sheltered niche beneath the cliffs. It was her favoured place. She was sitting cross-legged, with her eyes closed, using a pebble to beat a rhythm on a flat stone and chanting. She accepted the food offered, agreed to return to the fire soon and assured them she would not be late.

Fran and Mick smiled as they left, for they knew their child and understood there was magic in her play. The chant that followed them along the shore said even more…

'TE WAI POUNAMU IS
THE RAINBOW MIND

TE WAI POUNAMU IS
THE RAINBOW MIND

TE WAI POUNAMU IS
THE RAINBOW MIND'

We are of the Knowing born
of the ancient mind,
the reasoning mind joined
with the spirit mind. We are
of the Becoming that shapes
and turns and grows to find
the truth of our journey.
We are of the circle that
has no end, for the end is
but a new beginning.

Close the circle of pain.
Face the past to heal the
present

SONG OF THE NIGHTS OF CHAOS

Wonderful were the days of peace,

with generation after generation living

in harmony with each other and the land.

Then the waka of death made landfall,

sweeping Aroha aside and unleashing

a red tide that left blood upon the stone.

Some despair, but hope resides in the old ways,

for the Circle turns to herald a new day,

where past pain surfaces to be faced,

honoured and healed.

Old wounds can cut so deep
they pass down the corridors
of time to destroy a
nation's life.

Binding the wounds,
trying to stem the flow with
empty words is not enough.

Hiding the past,
setting aside the hurt by putting it
out of mind, sows seeds of a
dangerous kind.

Kia Kaha! Have courage!
Face the Chaos that we made and
go beyond blame to heal a past
we cannot change.

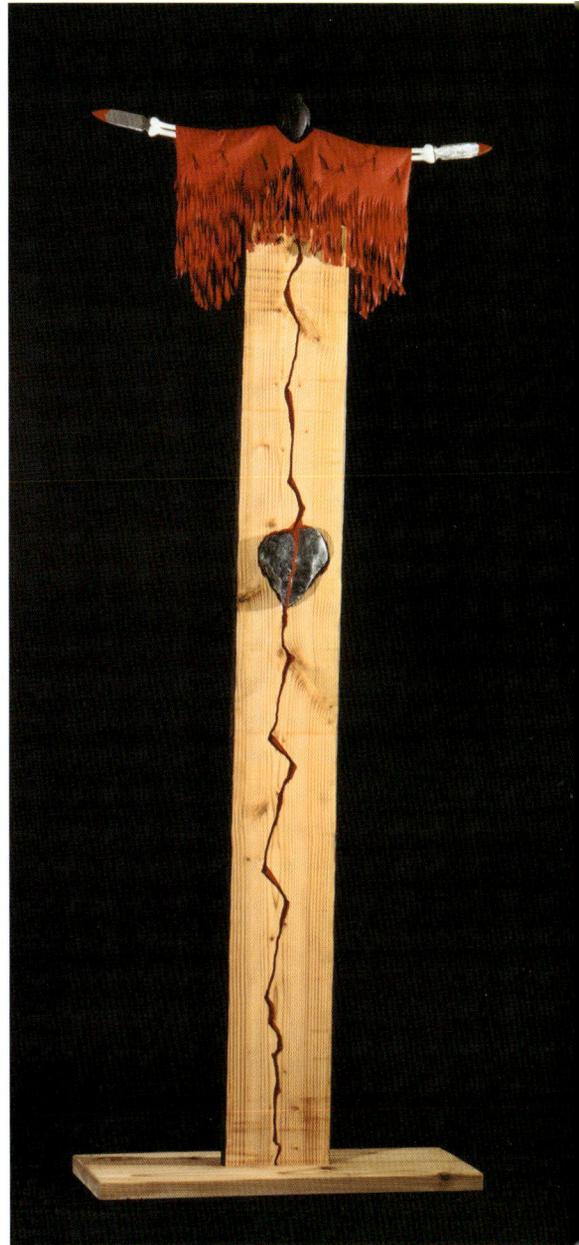

TUMATAUENGA

The War Maker

Once again those who wished to sit within the circle that warmed to the fire, gathered at the setting of the Sun to hear the words of the old ones. News of the path to be walked this night had reached far and the numbers had grown. An air of expectancy touched these shadowed shores. It was said that something hidden too long was to be put right. Old wounds were to be laid bare. A Pouwhenua of pain was to be stripped down to the twist of its grain. And this would be the ninth carved post to mark the journey.

All began as usual with the haunting sound of the conch calling them to the silence and the teachings, and grandfather offering his karakia to meet the covering darkness.

 # KARAKIA

The old one's words touched depths that caused many to shiver, despite a sudden flaring of the fire. And a gust of wind chose that moment to spur the flame as the Wairua moved across the face of blame.

This was followed by a special moment. On grandmother's signal, White Eagle, with help from young Kea, set an old, unravelling basket at her feet. As she chanted a greeting, they drew forth a beautiful Pounamu that shone brightly in the fire's light.

Yesterday unravels, breaks the weave of today, because it carries old pain in a hidden way. Yet, the old flax kete still carries the Pounamu that served the ancestors so long ago. Its healing touch is undiminished despite the blood spilt on the Stone.

Holding a finely carved gourd above the Pounamu, grandmother sent a thin stream of water cascading off its shimmering surface. It had begun — the old Healing Stone was in place.

This night would be different, for they journeyed to cleanse old wounds, cut away dead flesh and put to rest bleached and battered bones. It was grandmother's fervent hope she might, with the help of this circle and all who gathered beyond its flame and beyond that again, lift aside her life companion's pain.

When the elders had taken him apart from her so long ago and asked him to carry the old histories that spoke of the death of the broken generations, the burden seemed too much for one who was then so young.

Age had not lessened that load, but merely added weight. The old one saw its fate and understood, at last, why those who loved him had placed it on his shoulders. He had been chosen to make the journey of the Wounded Healer, to carry the saddest memories of the past into today and carry them alone. There could be no other way, for there is always one who is chosen to carry the Mauri. In that aloneness he had arrived at last at that place where he could end the pain that echoed down the ages, end it once and for all, leave it in the light of these flames.

And if you wonder why it was not done earlier, remember there is always a time in the turning of the Sun when all conspires to close the circle.

Feed not the Fear

When grandmother spoke it was as if she sent her voice out to the stars and carried them with it.

Whiro unleashes a power
that yearns to devour.

> 'Remember how Whiro, Tane's brother, rode the red cloak of anger to the stars to seize from Rehua the Knowledge of War, the darkest basket of all, the one woven by fear. And how he returned to Earth triumphant in this power that seeks to devour.

> 'Some say doubt, the first child of fear, was the seed that Whiro scattered all about on returning from the stars, but others say it was envy, for that is what sent him on his journey. It matters not of course, for doubt and envy both taint the harvest.

> 'While Tane chose all that was good, for he had parted the Parents to bring in the light, Whiro followed the path of hate and pain and chose the darkness for his domain. He roamed the underworld where Tumatauenga, the Maker of War and the Taker of Lives, resides.

> 'Into that dark place he gathered the pain that grew from the abuse of the Word and lies that multiplied in the absence of light and arrogance born of ego running wild and violence seeded in the dominant mind that pushed all else aside.

> 'From time to time we all contribute to that pain. It might do little harm if confined to that darkened place, but Tumatauenga, the Widow Maker, adds it to Tawhiri Matea's anger and the Wind sends it back to us again. It arrives in unexpected ways to assault and maim, having grown tenfold in the shadows where we nurture blame.'

Know where the old hurts hide

> 'Grandmother, is that dark place, hell?' asked Huia, who was fascinated by the idea that there was a place where old pain dwelled.

'Some might give it that name, yet, for me it is not a distant place, but very close. I see it within myself. I have known that darkness. I have walked the dark valley of the soul, been lost within that place of doubt and known a fear that paralysed my will. Hell, if there is any hell, lies within me and is of my own making.'

'But why would you do that, grandmother?' said Huia in dismay. She couldn't envisage the old one making any kind of hell.

'I didn't intend to. None of us do. I suppose the first fears were sown when my child-mind failed to cope with the world of that time. Misunderstandings, harsh words, deep disappointments, loss, frights and imagined moments of abandonment may breed fear in any child. As we grow we learn to see these fears for what they are, remnants of days long gone that have lost their power.

'Yet, some fears may be buried so deep, hidden so far from sight because of the pain they hold, that they never see the light. Those fears can take shapes that cast long shadows across a life.'

'But where do those fears hide?' continued Huia, who had initiated this discussion. She was determined to track hell to its source.

'They hide in a place of mystery where the very best of you resides. They go to your essential core, for there they hope to find assurance and comfort. They go to your greatest power for protection. And that power is of the unseen, an awesome place deep within. There wisdom that reaches far beyond our time, awaits our call. Yet, many do not acknowledge it at all, for it exists beyond awareness, beyond the mind that openly directs, sees and feels; it inhabits the subconscious, or as some say, the unconscious mind.'

There is a firewall in the mind

'When we say, "I know my mind", we tell the world we will not be pushed into something that goes against our will. We cherish our mind for its awareness, for the magic of memory and thought. We think we understand all that it is, but there is more. Behind the conscious mind, which orders our day, is a firewall that protects a special part of the mind that works in a very different way. We call it the unconscious mind because we can't simply demand that it come into play.'

'Kui, is the unconscious mind like a hidden hard drive, with a database that provides information in its own way in its own time?' asked Torrent, who saw the world through computer eyes.

'Ae,' laughed grandmother, 'thank you for joining the world of wise minds with the world of computer science to help me grapple with the immensity of this mysterious part of the mind. Some say our unconscious mind stores in its memory banks every thought, sensation or event that has touched our lives.

'And there is more, for it is the keeper of great wisdom gifted down the ages, universal truths that defy the boundaries of culture, race and time.'

'Grandmother, are universal truths the same as archetypes?' asked Emma, the bright one with great awareness in her eyes.

We call it the Mind Song of the Ages, the seamless fabric of space and time that holds all that has ever been and will ever be.

214

The old one chuckled with delight as she pondered her reply. Should she venture further into the world of the "subconscious" and even the "collective unconscious", or quietly avoid that intriguing side of life?

Hear the Mind Song of the Ages

'Emma, you steer my waka into deep waters with your probing questions and bring me to landfall in the Mind Song of the Ages,' responded grandmother, who had decided the deepest mind trails should not be denied.

'Well do I remember the night when my elders introduced me to the Mind Song, knowledge so profound it utterly changed my life. My world of beginnings and endings was shattered by the suggestion that all that has been, all that is and all that will ever be, is really a seamless fabric that exists beyond time. And into that fabric is woven the Mind Song that holds and remembers all.'

'Grandmother, as I grapple with what you share, I hear this old lore echoing the dynamics of the Universe, the laws I teach in physics,' offered Nova, who, although obviously absorbed in the stories, had kept her silence until now. Earlier, Koro had taken her aside and claimed her for the Sky Nations, and named her Nova for a new star. Born in Aotearoa, of a Chinese mother and a North American Indian father, she had journeyed far with an open mind that made room for all peoples and ideas of many kinds. Mountain was her closest friend and physics, mathematics and history were her passions.

Are there worlds within worlds, and universes within universes, that exist in the same moment? Is there no realm of time, just an eternal now that recreates itself in ways that defy the mind?

215

'The Mind Song brings me to the concept
of parallel Universes,
of different worlds existing
in the same place at the same time,'
said Nova.

'Grandmother, when I think of the sheer elegance of fractals - the mathematical lore that states any small part of a curve that is enlarged, repeats the character of the whole - I see the seamless fabric you describe,' confided this woman of few words. Her excitement flared as she voiced these connections. Forming her thoughts into words and offering them aloud to the circle of the fire, seemed to give them an unexpected power.

'When I add the formula we know as the Mandelbrot Set, which suggests everything changes within constants that accord with design of an everlasting kind, I see the great minds of today affirming the Mind Song. Are we physicists merely catching up at last?'

Truths are carried from the past

Grandmother nodded in recognition of Nova's fine mind that was open to a Universe that defied time. She paused to let the words of the other hold the space, for they were truly worthy of the silence.

When grandmother spoke her words rang with confidence, for she responded to the growing warmth of the circle. They were opening to the power of the Mind Song, offering their hearts to its beat and beginning to see the futility of the long days of retreat. Running away had brought many to this day, to the end of the line that curved back to circles of wisdom born of other times.

Moon and Sun meet to create the golden ring.

'Ae, the physicists are the poets of tomorrow, for they see with eyes that leap beyond the veils that blind. Their quest for truth fashions links between the old and the new,' responded grandmother, as she sent a smile in Nova's direction.

'Now I return to the Mind Song to give thanks for its presence, for it is the cornerstone that anchors my life.'

'Why is that, Kuia?' asked Silver, whose need to build relationships consumed her.

'The Mind Song is my cornerstone because it gathers to itself great and abiding wisdom, lore so compelling it is described as universal truth, for it speaks with one voice to all the nations. In later days, some named these truths in other ways, seeing them as profound models that marked the good way, the great archetypes that might guide our journey.

'Some say those truths, derived from ancestral experience, are not passed from mind to mind in spoken or written form, but seeded into the "collective unconscious", or "tribal memory", at birth. These archetypes are not taught, but inherited through our bloodlines and influence our actions without recourse to the ever alert, ever aware, conscious mind.

'So the Mind Song of the Ages is a source of wisdom and magic. It allows us to walk where the Ancestors walked and be open to the power of the Rainbow Mind. Those who know the ways of contentment and inner peace, have discovered how to bring together the conscious and unconscious mind. But many seem to have lost that power.'

Do not deny the wise one within

Grandmother wondered if she had lost them in the labyrinth of the mind, had attempted too much this night. Her musings were interrupted by a strong voice.

'Why is the power lost, Kui?' this from Mick, who was becoming more and more aware of the Rainbow Mind.

'The firewall that protects the unconscious mind, that provides a special space for higher wisdom, is formed with insight, for while it needs to be strong to protect, it mustn't override the voice within,' said grandmother. 'Sometimes we build the protective wall so tall and thick, that it denies access to the unconscious mind and its reservoir of wisdom.'

'Why would anyone do that, Kuia?' asked Mick.

'To contain and control fear! To hide behind a mighty firewall fears we think have the power to consume us, fears that we imagine could even overwhelm us,' responded the old one with a sigh. 'That is truly tragic, for we not only block the guidance of the "wise one", but provide a place for those fears to grow, distort and multiply. There they sow seeds of doubt, destroy trust, shatter hope and sometimes drive us to fashion our end with our own rope.'

Worlds exist within worlds. Crystals with wondrous shapes are held deep within stone. This cube, shaped to perfection by natural lore, seems to give birth to another. Elegance of design, the awesome expression of the Divine and the Life Force, is discovered every day.

We walk with deep wells of pain, with hurts that still cut deeply, but need no longer remain.

'How do we heal the fear that holds us back, Kuia?' asked Silver.

'By lowering the firewall until we find the balance that allows the "wise-one-within" to be heard.

'By finding the courage to lift our hidden fears out of the shadowed places and face them in the light.

'By seeing those fears for what they truly are and embracing them and letting them go.

'By walking in the humility that allows us to learn from our mistakes.

'By learning to forgive.

'By realising that while we cannot change the past, we can heal it.

'Love offered is repaid in kind. That is the lore of the Universe. We are the keepers of our own story, the architects of our own journey, the makers of the maps that guide our lives.'

'What about the power of evil, Kui? Mindless violence and grave danger fills the news every night. How can I bring my baby into this world at this time?' asked Day Star. She felt ill prepared for this coming child, despite Hans's support and Koro's offer of the name Quasar.

Know where evil hides

Once again the old one sat to rest. It was good to have a moment to absorb the anxiety carried in the question. Then grandfather's chuckle made her turn to catch his whisper.

'When you answer, remember that "evil" spelt backwards becomes "live".'

She smiled as she remembered how often he had lifted her out of pain with laughter. What we lose or gain from anything depends on the end from which we view it. His hand touched hers and he leaned closer to share more words.

'Help them to disarm evil. Help them find its source.'

With those words ringing in her ears, grandmother took up the challenge.

'What is evil?' began the old one. Asking a question was often the best way to find the path to follow.

'Evil is all around us, Kui. It's a dark force that wants to destroy. It's a frightening thing that we cannot control,' offered Tamatea, who revelled in games that pitted the good against the dark forces.

'Ae, it is often described so. However, there may be another side to that dark coin, one that shines brightly to give us hope. Remember how I suggested we are the makers of our own hell, well, I also think we are the creators of evil. And what we create we can unmake.

218

'When we feed the angry mind,
fail to look at the other side,
and send arrows of envy
and hate into the world,
we kill the good inside.
All that we throw at others
returns on a flood tide.
Hurt sent forth
comes back as pain multiplied.
That is evil;
that is what we contend with in life.
It is a product of the hell
we create and allow to abide.

'Can anger become a dark force that obliterates and divides in ways that go beyond our control?' asked grandmother. 'Ae, it can, in all its sadness and pain, when driven by the "gathered fear" of a nation, tribe or family.

'The evil that I speak of takes many forms and carries many names — evil that tortures and maims, evil that rapes and murders, evil that abuses and dominates and the greatest evil of all that brings these together under one name, the evil that is war.

'But I repeat the words that disarm evil — what we create we can unmake if we understand its story.'

Blood spilt demanded
more be taken in return,
and all spiralled into Chaos.

Losing our way

'In the beginning father and son used their great strength of arm to build and serve, for they were the warriors who sheltered and protected the children, the women and the aged.

'Yet, over time the peaceful warrior, who fought only to protect, mutated into the warrior of death; the aggressor who yearned to conquer and dominate. Thus was virtue distorted to serve the War Maker, who fashioned a state that pitted family against family and nation against nation. And blood spilt demanded more be taken in return and everything that was good spiralled into Chaos.

'Remember that the War Maker, the leader who favours aggression, cannot fight the enemy on his own. He needs an army and people willing to pay his way. He needs people who will put wisdom and compassion aside and kill in his name.

'A leader bent upon War manipulates his nation, harnesses envy and hate, jealousy and pain, and fuels fear. He mobilises the unforgiving who nurse their rage, the put-upon who want to dominate, the vulnerable who see danger on every side and the greedy who want it all. They become the shadow keepers, the creators of a darkness gathered into deep wells of anger. They become the arrows of death that fly to the leader's aim.

'Many a misshapen "child" has been conceived in the corruption of power and the exploitation of patriotism and belief. Those children of the dark mind have carried many names down the trails of time. Can you name some of them?' asked grandmother, with a glance at Nova who had a growing reputation as a great reader. Little seemed beyond the reach of her mind.'

The Trails of the War Makers

'Pax Romana… being the Peace of Rome that
brought the death of nations,'
began Nova with an ironic laugh,
'and the Crusades,
Christians winning salvation
by killing Muslim believers…
the Spanish Conquistadors
harvesting souls and gold…
the Slave Traders who tore the heart out of Africa…
the British Merchant Empire that made the
ocean its own lake…
the Colonies that stole the cultures that stood in the way…
the American Dream that opened vast frontiers with the
First Nations' blood…

the Japanese Co-prosperity Sphere that
devastated the peoples of Asia and the Pacific…
the Third Reich,
guardian of the racially pure,
creator of the ultimate solution…
the Soviet Union that wanted to give to all according
to their need… and ended up taking from all,
controlling all with thought police,
bureaucracies and armies…
the Jihad that sees some Muslims distort their own faith to justify
the right to retaliate… the Jews who do the same…
and the Coalition that fights the terror with the old mind that says
the world is ours to save and remake,
because we have the power.'

It was hard to absorb this terrible litany of pain, this tragic recital of inhumanity. Two thousand years of control and organisation where power, not wisdom and compassion, decided the fate of people. Where power decided who prospered and who suffered.

Grandmother nodded her silent thanks to Nova. Then composing herself as best she could, she used the back of her hand to wipe away the tears that tracked down her lined face.

'When we choose to subjugate others, enslave the body and mind in the name of dominion, of empire, of colony, of economic advantage, of religion or race, we are driven by the dark side, a world of our own making.

The challenge is to live our

passion and our joy.

The old one sat beside the

Pounamu that reflected

the light of the flames.

'We have all contributed something to the pool of anger, added to the legacy of pain. Yet, we are learning to empty it out again, to heal the past and go beyond blame.'

We can't change the past, but we can heal it

Grandmother sat now. She was wearied by this journey into the shadowed places of the mind. Yet, that was not all. She knew it was time to bring grandfather to the fore.

The kete laden with the pain of those wounded

in body and spirit,

that he had carried for so long,

was this night to be laid bare.

He alone could speak of that burden,

of the loss and sorrow that remained

and all that might take them beyond the

destructive realms of blame.

When grandfather was helped to his feet he staggered. Voices from around the fire urged him to sit, to speak from his chair, but tonight he could not give way. Tonight he would decide when to stand or when to sit. With his talking stick in hand, he found his balance, and squared his old frame to share words that some would sooner see hidden from the light of the cleansing flame.

'To live! To be truly alive, to know passion, laughter and joy, to dance within, to see beyond our trials, is the challenge grandmother places before us.

'Yet, the burden is too much if we are laden with old sorrows. This I know, for I was asked to carry the pain of the death of nations. In that journey I learned the greater picture is but part of a smaller, that in the end the many comes down to one — to each of us, to you and to me.

'Grandmother said, "What we have made we can unmake." Ae, each of us within this circle, and beyond it to the nation, carries ancient pain, a "gathered pool of suffering" that underlies each waking moment. And that is the secret of our hope, for it takes but each of us in turn, one by one as we find the will, to become the difference that makes the difference. We have the power to unmake and recreate, to drain those ancient pools of their hurt and move humanity forward.

222

'Tonight we bring the pain of the nations into the light. Tonight we walk down a trail of tears into the Nights of Chaos that meant the end of Marinonga, the end of the Harmony that was Aotearoa.'

Koro sent a ripple of concern into the circle when he gently collapsed on to the ground. He was not hurt or even shaken by this fall, for it was by design. He had used his Talking Stick to slowly ease himself down. Those who started to go to his aid were relieved when he sat upright, like a child on a mat, and smiled. He was where he meant to be, beside the Pounamu that sent back the light of the flames. He would stay there until he was done. As he spoke he caressed the Stone.

'My words place no blame.
That is why Pounamu holds this space,
why we bring its Mana and its Mauri to move with
Spirit as we unfold and heal
the distortions in the old shape,
the past that was,
that impinges so powerfully on the present that is.

'Tonight we speak of the end of Marinonga,
the Harmony,
the end of that wonderful time when the spirit of
the people and the spirit of the land were one.

'This Pounamu reflects the light of this fire to
remind us of those days
and to offer the hope that the Peace that was,
will be with us once again.'

'I send this karakia, this prayer gathered from ancient days, to help us honour the true flame.'

KARAKIA

'Let there be life. Those are the words that sit here tonight, a life of peace for all of the human kind.'

Peace once walked the land for all

'In the days of Marinonga, the land knew only Peace. The Nation, the one we call Waitaha, brought many peoples together to share their talents in harmony.

The healing Stone mirrors old pain, embraces it and heals the cause and makes us whole again.

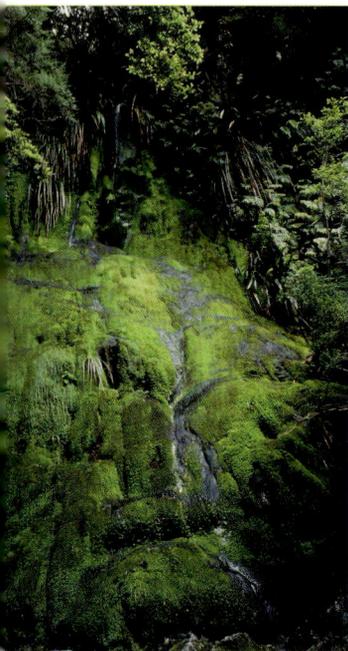

Although we came from many lands, we found harmony in each other, for we were sisters and brothers.

'Some were of the Bird People; others carried the spirit of the Tree People, the Stone People, the Fire People and the Kumara People. There were even the Star People who followed the twinkling markers of the night across the oceans. There were many peoples, and they had many children, and they spread throughout the land to become as numerous as the sands upon the shore.

'The waka of Waitaha, the great double-hulled vessels that sailed the Long Tides to reach across the widest of oceans, voyaged back to the homeland of Waitangi Ki Roto once in every generation to test the courage of their youth upon the waves. And their return voyage took them to other homelands, to weave a greater design that became the key to the Nation that they made. At each destination, they left some of their crew behind, and maintained the balance in the waka by exchanging them for young people from that place. This was the secret of the Nation, its greatest strength, for they knew that strong children meant a healthy people, and strong children grew best from the mixing of the blood.

'All who returned on the waka came because they knew Aotearoa found its joy in the arms of Rongo-marae-roa, the Peace Maker. Generation after generation kept the promises of the Ancestors, and lived the dream that lasted for a thousand years and more. It was a long time of peace, a long time to be at one with each other.'

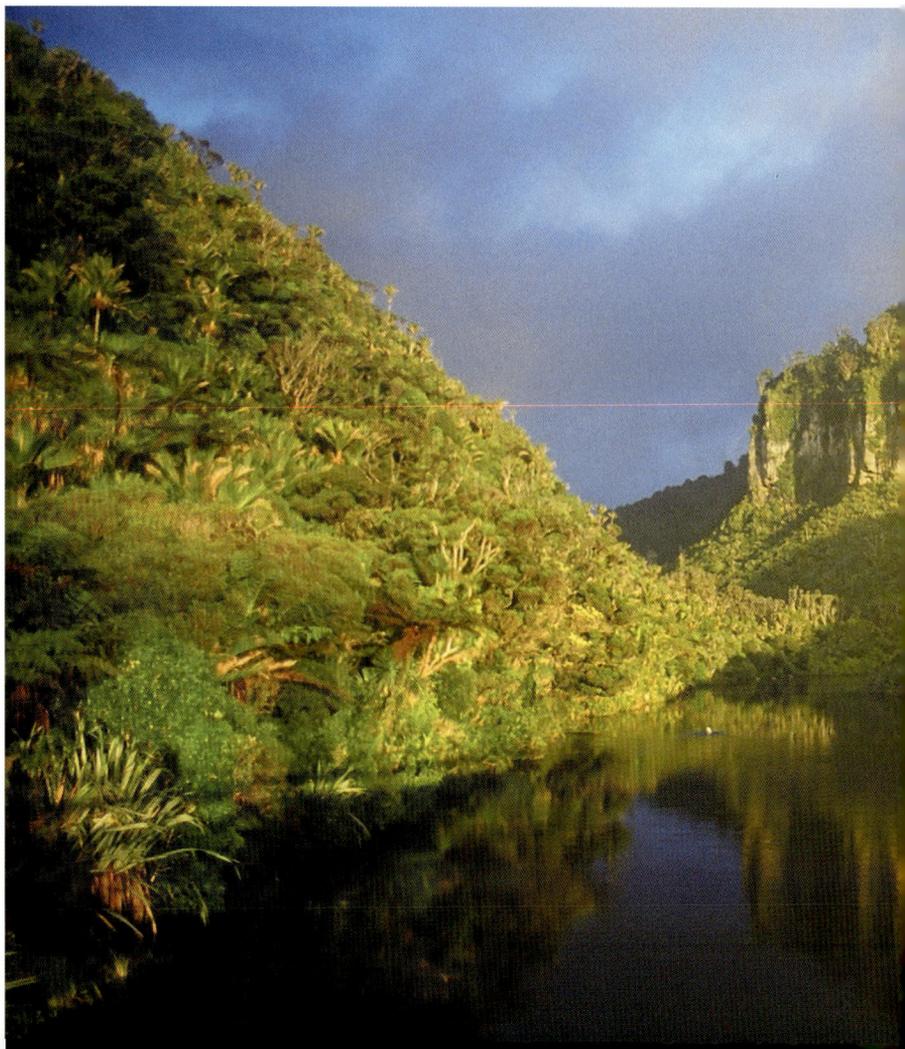

Generation after generation
kept the promises of
the Ancestors. It was a long
time of peace, a long time to
be at one with each other.

'Who knows what happened in the old homelands to thrust the peaceful ways aside and raise the warrior high?

'Who knows what fostered the dark clouds that sent the warriors south on the long tides?

'Those who welcomed the waka to these shores wore cloaks of peace, but were greeted by the cries of war. The creed of death leapt swiftly across the waves and the old ways were soon no more.

'Tumatauenga, the protector who honoured the warrior way, stood very tall that day. And the blood that flowed was of the same source, for those who dealt in death were of the same ancient lines as those who suffered. This was death of the worst kind, death loosed within the family. The pain of it turned the Ancestors in their graves, stirred the bones painted red in the burial caves, found those lost within the tides and screamed, "You do this to your sisters and brothers!"

'And what of Waitaha… they took up no weapons… lifted no hand to defy… gathered in circles… hand in hand… man, woman and child… to receive the fatal blow…'

The old one stopped for a moment. The silence that gathered seemed to shroud the land and still the waves. Tears fell upon the Stone.

'Ae, how they lived meant more to them than how they died.

'They did not depart from the peaceful way, for they knew the death wielders sowed their own death, the death of spirit. To take the life of another was to take your own away.

'That is the pain we bring to this fire, the pain bequeathed by the Long Night of the Patu when iwi from afar spilt the blood of the iwi of this land, upon the land. And the ones who crossed the oceans to deal in death, were of the same iwi that suffered. Ae, as the bones shrieked, they were sisters and brothers.

'And the manner of it strikes to the very core, like a flame searing flesh. For the weapon that brought the Nation to an end was the Patu, the tongue of learning fashioned in Pounamu to honour Peace. It is hard to forget that this taonga, carved in the sacred Stone that carried the Spirit of Aroha, was the chosen instrument of death.'

Grandfather closed his eyes and others were moved to do the same. The images that ran through the flames were so terrible they seared the mind.

'Ae, blood was spilt upon the Stone! And the destruction of the Nation, the end of Waitaha, did not silence the conch that called the warriors to be brave.

'That act of genocide was but the beginning of many Nights of Pain. Those who unleashed the dogs of war found it hard to cage them again. Chaos is not easily tamed.'

When the waka came ashore tribes from afar spilt the blood of the tribes of this land, upon the land. The patu swept them aside forevermore.

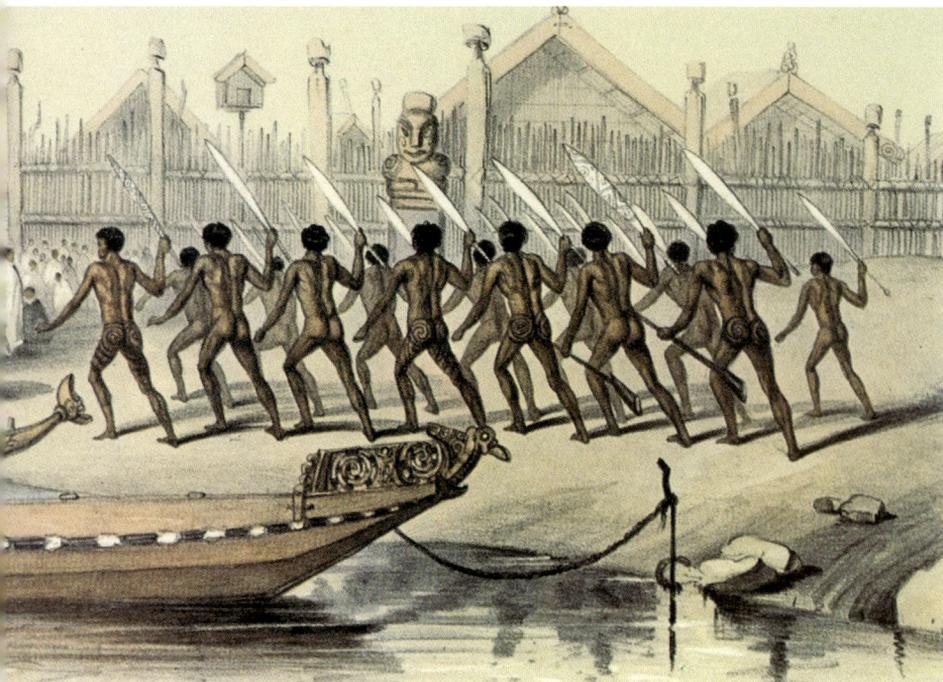

The Long Night of the Taiaha

'Other waka with warriors at the blades, found their way into the southern ocean. Tribes born of different islands, came to feast on the Nation that was broken and when that was done, turned on each other.

'Warfare spread like fire in the fern and reshaped the land as never before. Now the turf was turned for more than the garden. Huge defensive ditches were created and high palisade walls and all kinds of impediments to cloak the makers of war. These fortifications became the centre of life, vital havens in a world committed to strife.

Warfare spread like fire in the fern and reshaped the land as never before.

'If you doubt the extent of these pa, walk the land. See them protecting the bay and standing on the headland, numbering in all some five thousand that are documented. See their tattoo etched into the face of the hill to mark the power of the warriors.

'We remember these times in our literature of the modern kind, as "heroic". We speak of the bravery of the warrior and find virtue in the killing and hold our heads high on the marae.

'Ae, and in that pride we forget the suffering, forget the legacy of pain founded in the code of an eye for an eye, the revenge that we know as utu. We forget that the warrior spirit, the code of courage, founded in the need to protect the family became enmeshed in utu, that endless cycle of pain, bequeathed from generation to generation.

'I do not mean to lay blame with my words, for all that happened was of another time. But I do speak with purpose.
I come to a time of remembering that asks much of us.'

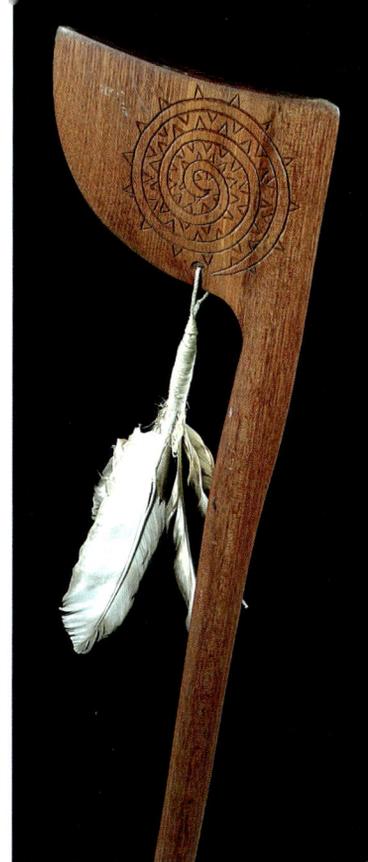

We were swept along
by the need to repay death
with death. We lost many
who were very brave.
It was a cruel price to pay.

The Long Night of Utu

The Traders came and found

favour with the people,

for they offered much

that was new, as well as

the devastating power

of muskets.

'The next vessels to bring turmoil to the islands of the Old Tides carried many sails.

'The Explorers came from many nations, to chart the waters, map the land and take home reports. They came in peace, but set in motion events that changed much and led to conflict.

'The Sealers followed, enticed by quarry rich in fur that had a market on European shores. They stayed until the seals were no more.

'The Whalers came with their harpoons and fleshing knives and huge blubber rendering pots and sought out the Whale People to use their skills to make the harvest. In the beginning the Whale People would not man the boats for any shape of coin, for Whale was their Kaitiaki, the guardian of their people. But later some broke the promise and went aboard and saw not the dangers of this path until the day came when Whale was no more.

'The Traders came and found favour with the people, for they offered much that was new, as well as the devastating power of muskets. This weapon, which killed like no other, completely changed the way of war, for until then death was delivered hand to hand. There were no throwing spears or bows and arrows in the old battles, for custom forbade such missiles. Death at a distance had no place when tradition demanded meeting the challenge face to face.

'Muskets gave huge advantage to iwi who gained them by trading timber, flax, amulets and the dried heads of enemies. The musket tribes moved swiftly

against blood enemies to take revenge for blood debts handed down through time. Utu! Ae, the revenge that never seems to die, now exploded out of the barrel of a gun.

'Thus began the Long Night of Utu
that saw tribe turn on tribe
with terrible destructive power,
to honour inherited purpose.
It was truly the darkest of times,
and lasted far too long.'

Utu, the way of revenge,
the lore of an eye for an eye,
was achieved in a terrible
new way.

'After the Long Night of the Patu, and the Long Night of the Taiaha and the Long Night of Utu the keening cry went through the land to lament the Long Night of the White Death.

'Those who voyaged from afar brought more than trade goods in their holds. In the past Aotearoa was free of the diseases that swept through other lands. Tuberculosis, chicken pox, measles and venereal diseases were not of these shores, so when they arrived their impact was terrible. Even the strongest warriors died of chicken pox and measles.

'The sickness that ran riot through the people, opened the way for the Missionaries who brought a new god. When the children of the Missionaries got measles and threw it off in a few days, but the warrior chief died, the tribes concluded the Christian god protected the white children. So, they placed that god alongside the many gods that filled their day.

'This was easy to do, until the Missionaries discovered this practice and told them they could only worship the new god, that they had to turn aside from all others. Thus was the ancient fabric of belief stretched and torn away.'

The Long Night of the Horse Soldiers

'Then Settlers followed the Traders and came in peace, seeking a better life for their children just as others had when they came so long ago.

The wheel of change swept into the land and carried with it more than any could see or understand.

'Yet, when the European need for land clashed with the Maori need for land, the authorities, established to protect the rights of all by Treaty, called on the terrible power of Tumatauenga. And great vessels came over the oceans bringing the regiments of the British Empire and their cannons and horse soldiers and western ways of making war.

'Thus do we come to the Long Night of the Horse Soldiers, to more loss and pain, to more blood spilt in anger to shame the Spirit of Aotearoa.

'While the Horse Soldiers won their battles and suffered their defeats, for both sides were brave, the number of settlers increased and the number of Maori rapidly dwindled. Bullets and disease were winning the day.

'Lands, which were their life in practice and in spirit, lands bound to them in Treaty were seized and lost. And the tribes knew the bitterness of defeat and justice denied.'

Standing tall, the People survived

'But Maori survived and that is the miracle. Despite the loss of land and the torn fabric of life the people survived. Despite schools that forbade the use of the language, the language survived. Despite laws that outlawed the tohunga, the keepers of the wisdom, the old lore survived until it was threatened in later times.

'Unbeknown to many, it was the Long Night of the Winged Soldiers that dealt the harshest blows to the sacred lore. When the new armies swept across Europe and the Pacific we offered our young warriors in battle, for we saw the need to go abroad to ensure those who sowed violence never reached our shores.

'In forming the Maori Battalion, we committed our Tohunga to stand with our men in the fiercest battles. Our lore keepers were lost in the maelstrom of war. Much that was wise and true was buried on foreign soil.

The regiments came at the behest of the settlers' government and cleared the land of opposition with their muskets.

Diseases unknown in this land killed children and strong warriors with an ease that defied description. Thousands upon thousands died and often handed on the cause in their greatly prized blankets.

233

'We still grieve for the return of their bones and for all lost in that cause.

'The land carries the pain of the past and reveals it in many ways. And people carry the pain of their ancestors, the pain of those who wielded the patu and of those who fell to its blow, the pain of lives shattered by musket and diseases carried from lands unseen, and the pain that grieves for youth left in foreign fields.

'Ae, it is time for the return of the peaceful warriors, those who learn their taiaha skills to discipline the mind, to learn the wisdom of the Ancestors and add courage to compassion. That is the challenge of this age, the challenge that calls forth the truly brave.'

Grandfather had laid bare old bones and revealed hidden pain. A terrible burden might now be lifted away. Together we could acknowledge the past in all its pain and heal it.

Compassion walks with the wounded healer

Grandmother did not stand to take the old one's place. All knew she would, but respected her need to speak quietly with her companion who sat with eyes closed. Her gentle voice was only for him.

'Thank you for carrying that burden… with so much courage… it was not in vain… they hear the pain and will heal all that remains… as we close this dark circle… a bright one opens… that is the old way.'

Then came the silence and the waiting and the gathering of the words grandmother wished to place before the flames.

'So much pain shared on all sides. So much lost to Tumatauenga, to the Chaos that destroys, so much to be faced and admitted, so much to be forgiven, so much to be healed if the balance is to be restored.'

Again there was silence, but this time it was broken by a question that might have been prompted by the need to shift the weight aside.

'Kui, you said earlier that Koro was called to be the wounded healer. Can you share more, or is it too personal?' asked Fran.

Grandfather stirred and to everyone's surprise spoke. Although tired he wanted to try to answer this question, for it had teased his mind and stretched his spirit for a long time.

'The healing spirit is in all of us,' he offered with a rueful smile. 'We all know its power although many deny it. Those who have learned to forgive, see it work its magic every day.

'Is the wounded healer any different? No, that journey is the same. The wounded healer is called to carry the Mauri of the Pain and bring it to resolution at

We offered our young warriors, sent them far beyond these shores to do battle for a just cause. It was a time of sacrifice, a sad time that saw many leave their bones on foreign soil. That was the way of the Second World War.

the right time in a compassionate way. Many have walked that trail. Some pass into history unnoticed, for their path is silent and special in its own way. Others are asked to stand before the world and carry it openly.

'That was the journey of Te Whiti, who stood with such valour to honour the ways of peace at Parihaka, in the face of the guns.

'That was the courage of Te Maiharoa, the Waitaha prophet, who walked his people into the heart of the South Island to place peace in the land and prevailed, despite the power of the mounted constabulary.

That was the path of Gandhi, who broke the power of British dominion in India with passive resistance, and Nelson Mandela who spent twenty-seven years in prison, to bring freedom to his people.

'The Dalai Lama is another who shows us the power of those who carry the Pain and transform it. And to finish, I place before you the Christ, sometimes known as the Redeemer, who took upon himself the Pain and suffered to bring the world to change.

'They all carried the Mauri of the Pain and laid it before the world to open the way for healing.'

The gate can swing two ways
– old hurts can be hidden
and remain, or revealed and
healed to free the future
of pain.

The old one closed his eyes again.
Despite his words he felt he had failed to explain the path
of the wounded healer.
It was born of paradox,
of truths that he had still to fathom.
Yet, at least one thing was clear to him.
While the wounded healer brought truth to the Pain,
others had to complete the change
and do it in a good way.

Truth is at the heart of change

Grandmother stood again. The old one had opened a door to the hope of today and she felt compelled to step through it.

'Bring to mind the Truth Commission in South Africa, the one Archbishop Tutu created to heal the nation. It offers those who perpetrated hideous crimes of torture and abuse under the apartheid system, the opportunity to meet their victims openly. It allows the face of cruelty to meet the face of pain and answer to it in a unique and powerful way. It offers those who lost

their way the opportunity to seek forgiveness and those who suffered, the opportunity to give it. It means every story is heard. And, while that history cannot be changed, it can be healed.'

Grandmother was about to sit when a young voice sent an anxious question across the circle. Although only seven years old she felt confident enough in this setting to seek an answer from the old one, who was now a third grandmother to her.

'Has war come to stay, Kui?' asked Kea. She knew little of war itself, yet, had picked up enough from adult talk to feel its menace.

'No, war is not here to stay, there is a better way. The world begins to see that war is not the answer. You cannot build if you destroy. How things are done always decides what will remain.

'We can be the change that heals, can walk hope into tomorrow's dawn, go beyond blaming and journey together in a good way. Remember that, my little one.'

When grandmother ended all knew it was not a time for further questions. They understood that the answers they sought would be found in the silence, in their own journey, in the Wairua that moved to remind them the power that mattered was of Spirit.

Wash the blood off the Stone

It is time to face the truth of the past and understand that while it cannot be changed, it can be healed.

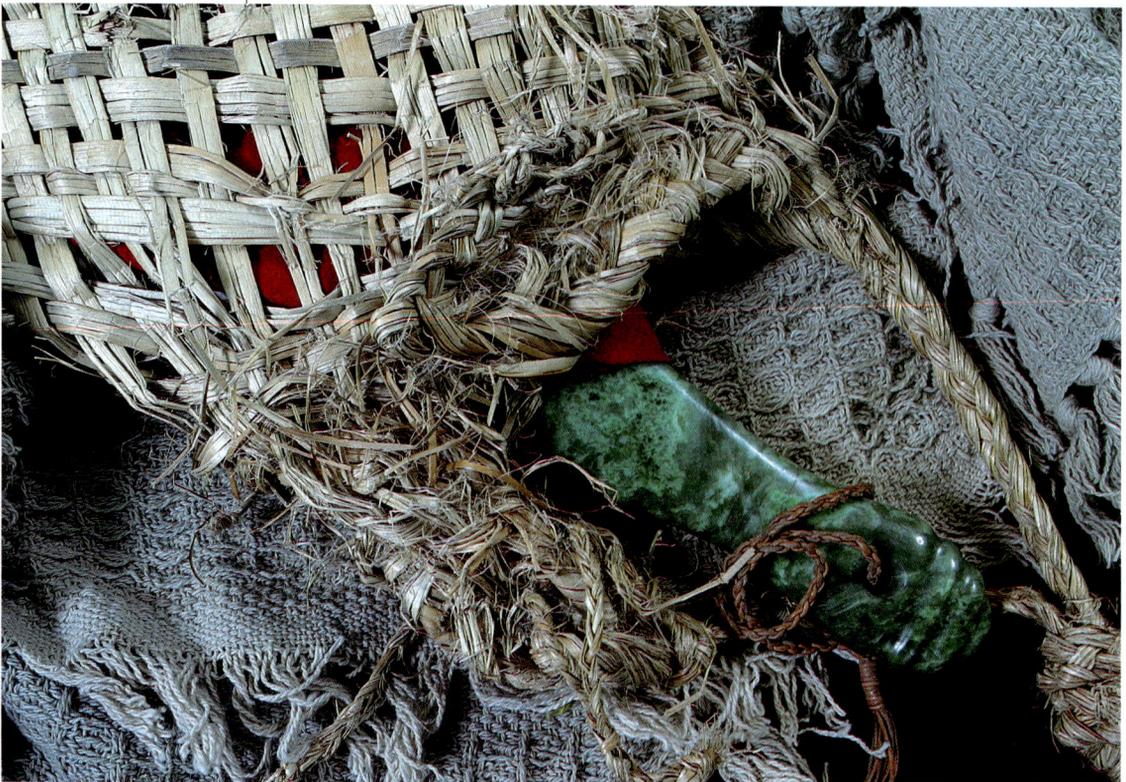

Grandfather reached into his kete and withdrew from it something wound in a red cloth. He removed that covering to reveal a Patu of great antiquity and mana. He balanced it carefully on the Pounamu healing stone. Then he turned to grandmother who sat with a shocked look etched on her face.

It was time to bring humility and compassion to the Mauri of the Pain and wash the blood away. Time to show that while the past cannot be changed it can be healed.

> 'This Taonga, this Patu crafted by the hands of my forebears, has not seen the light of a flame for more than two hundred years. It has been in my keeping since those early days when I was asked to walk the path of the wounded healer. Tonight I see its face for the first time.

> 'Grandmother reels from its pain, feels the hurt in it, so does Mountain and Kea and Flame. Ae, it carries the blood of the slain.

> 'Tonight in this place, with this water gathered from a spring, and simple prayers, we will lift aside this stain. Ae, we have that power now, for we walk as one to achieve this purpose.

> 'Come to this Patu, gather water in your hand, offer your prayer and wash its pain way. All are welcome… no, more than that… I need you… each child… everyone… to join with us to complete this long journey… it will be enough.'

The children came first, came unbidden because they understood in ways that went beyond words. Mist led the way, Scree followed, then came Rain and Smoke. Torrent was joined by Nova, the first adult. Mountain and Hirini found Kea at their side. Fran and Mick hung back waiting for old Rusty to come forward until they realised he would be the last. It took a long time, but everyone made that journey to the Stone that cried out for healing. And so it was that the blood of days long gone was lifted away.

The circle waited for grandfather to say a karakia to gently hold their words. And when it came it was a prayer for strength in humility, for the courage to withhold the blow, for the compassion that heals and the return to the days of harmony.

KARAKIA

When the prayer ended every eye turned to rest upon the Stone, for grandmother knelt beside it to run the last of the water across its polished beauty. Water gathered from the spring, tears gifted by the rain to join with ours to bring healing again. It was done, and done in a good way.

They all left quietly, still recovering from the long litany of pain, yet carrying hope. And while not all understood its source, for some were new to the power of Aroha, all were uplifted.

There is always a moment when we can make a new start. The seed we plant is for our children and their children's children. And that seed honours promises made long ago.

'I find great comfort in this day… relieved of a great burden… the stain has been washed away… the blood has gone from the stone… others step up to tend the flame,' confided grandfather, as his companion of so many years locked her arm in his to gentle him away.

This moment was to be savoured. The end of the long trail beckoned, for the journey was almost done.

Beyond the shadows and the pain is light. Beyond the hurt of yesterday is a new horizon of hope.

Stand in the power of the Unseen

CHAPTER TEN
SONG OF THE SPIRIT GUARDIANS

There are eyes that see further

than ours and serve us well.

There are unseen forces

that move within the tides

of life to nurture and sustain.

There are ancient families,

beyond our families,

that still remain.

*We are the children of ancient lines
that walked in spirit.
We come again to that time,
to the sacred that speaks of truths
that bring strength to our side.*

*We are of the Stone People,
the Fire People, the Star People,
the Water People, the Whale people,
the Bird People and the Tree People.*

*We see the courage and wisdom of
the Ancestors, and stand tall in the
power of the Unseen,
for we are the sum of all
that has ever been.*

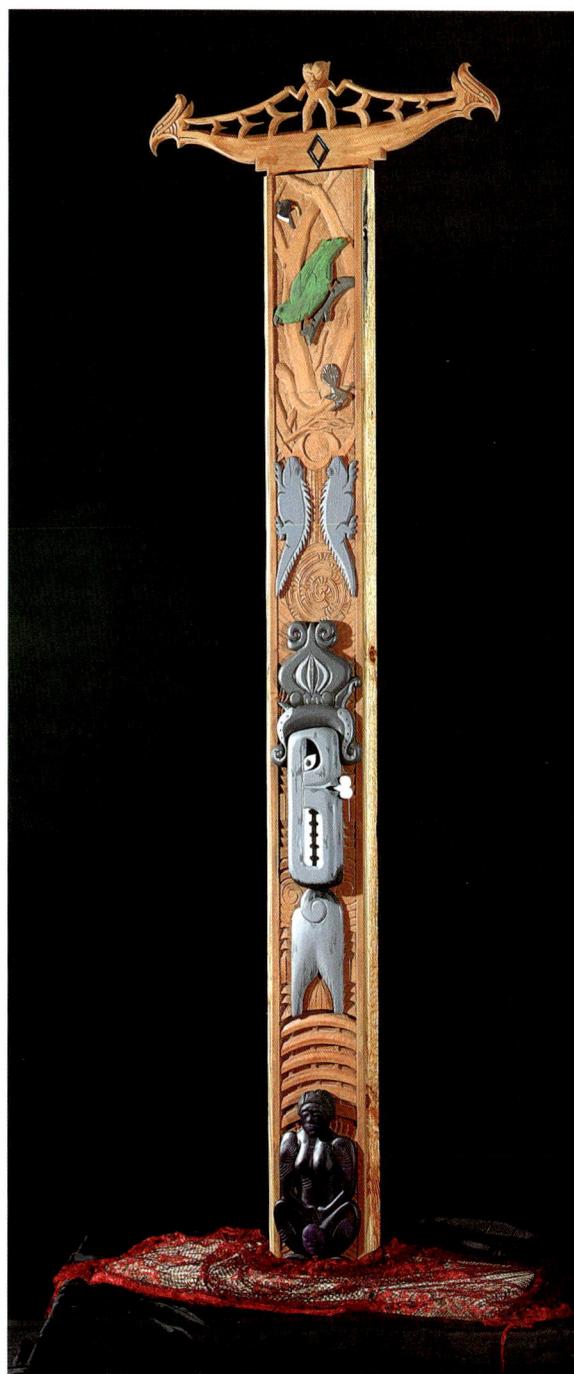

TE ARANGA

The Awakening

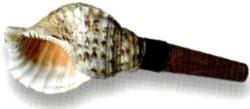

The old ones stood taller now, walked with greater assurance, smiled upon the gathering night and looked forward to all that might be shared. They had left their pain with the last fire's flame. In that leaving they found freedom. Others felt it too, had come to an awakening, to insight that was like the lightning's strike.

Grandfather was so eager to begin, he almost said the karakia before the sounding of the conch. Only grandmother's restraining hand kept him seated until the circle had answered the ancient call and settled.

KARAKIA

Having sent his prayer into the night, grandfather remained standing to gently prod the circle into a lighter space. It was his time to share, to begin the journey to the tenth Pouwhenua that was created in the mind, to honour the kinship of every kind.

Return to the wise mind

'I think birds are wiser than we are. So are ants and eels. I see that every day,' said grandfather with a wry smile.

'Which came first, the brain or the mind?' was the next thought he set before them, and answered before anyone could reply. 'Think of the creation of a child. In the beginning it is merely a thought in the mind of the parents. Then it is conceived and born to the fullness of life. Without the thought there would be no child. The mind is the seed of the child.

'I see the brain as the record keeper, and the mind as the hawk that soars the realms of possibility. Some say the mind can send a thought to circle the planet in a moment. Others know we can speak mind to mind without the need of words, and find pathways into knowledge that defy the power of computers. And yet, of itself, the mind is not as wise as the sparrow, the ant or the eel.

'Our magical minds travel elegant lines of simplicity and labyrinths of complexity, bring us to clarity and confusion, to decision and doubt, to the mountaintops where thoughts fly high, and to the swamplands where they are mired.

'The mind can be our greatest friend and our worst enemy.'

I, me, mine is the cry of the taking mind

Live in harmony,

find the balance

and gain a life.

'When Io set us free to be all we wished to be, that was done without constraint. It was the supreme act of love; freedom without conditions.

'We gather knowledge and constantly strive to reshape the world around, and lose the balance that sustains life. Birds, ants, eels, and all the other creatures, move in harmony with their world and respect its wisdom. Their lives flow to tides that honour the voice of the land, because if they don't align they don't survive.

'But we have learned a different way, to use the world for our advantage and ours alone. We have become the prisoners of the taking-mind. When we take without asking, that is arrogance. When we take more than we need, that is gluttony. When we take and do not give in return, that is self-destructive greed. When we take and have no concern for the consequences, that is stupidity.

'When we take, and take, and see not the end of that taking, that is ignorance. When we lay claim to the planet and see it as our private domain, and then proceed to destroy it — that is insanity.

'Daily we poison its air in the name of progress, pollute its waters in the name of commerce, destroy its soils in the name of production and send countless creatures into oblivion.

'That is the legacy we gift to our children. We wish the very best for them while destroying the planet that is their home. Despite all our achievements, we have forgotten how to live in harmony with our surroundings, forgotten how to honour the natural lore.'

Live in the balance

'The Ancestors followed the way of Wisdom. They saw all life as kin, asked before taking, returned the first fish to the waters, gifted the first fruits back to the earth, honoured the harvest and gave thanks for life given to sustain life. They knew the Earth as the Mother and ravaged her not.

'They greeted the Sun and the Moon, sat within the silence of the stars and found peace in them. We hurry hither and yon and find only the illness of the mind and the troubled heart. And we wonder where it will all end, for the way ahead seems dark.

'People ask, "How can I save the planet?" The answer is that we do not have to save the planet. No matter what we do, the planet will survive and, even if it takes millions of years, will recreate itself.

'The real questions are — How can we save ourselves? How can we survive?

'By returning to the wise mind, by remembering who we are and awakening to the ways of spirit.'

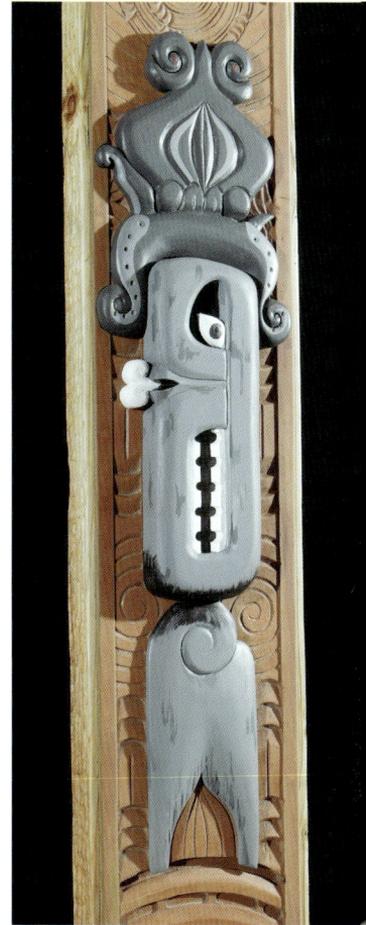

How can we survive? Where do we find the wise mind that sees beyond the moment of profit?

243

Grandfather rested now. Perhaps these opening words would be his only contribution to this night. Yet, who foresaw what might still unfold; kinship knew no limits.

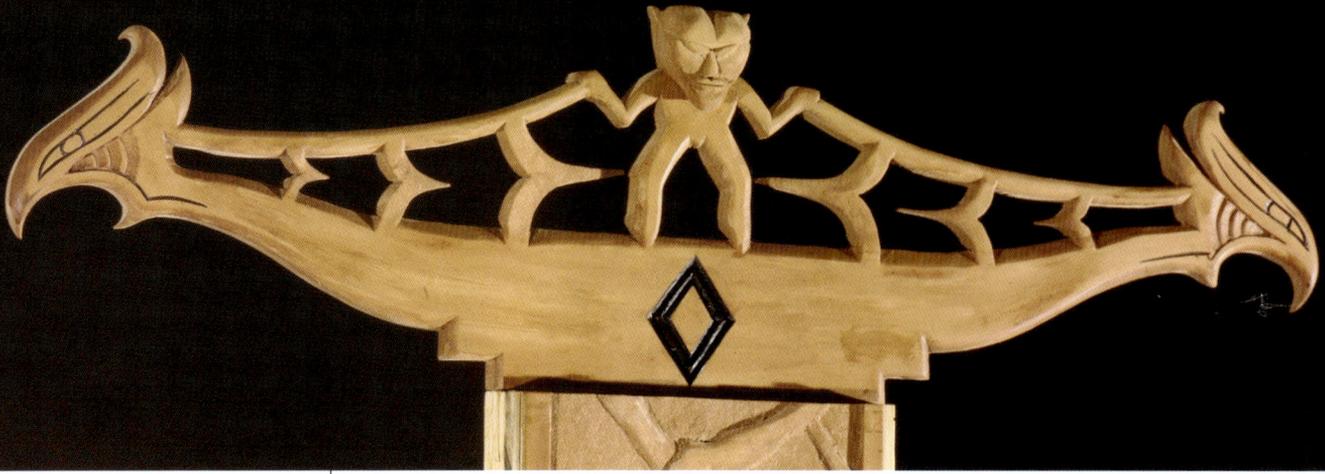

The Ancestors assure us we are never alone, for we carry forward the spirit of the ancient families and are attended by their guardians.

TE KAITIAKI
The Guardians

Find nurture in the land

'We may from time to time feel lost and lonely,' said grandmother with her kindly smile. 'But that need not be so.

'Be very still and listen. Hear the waves meeting the shore. That voice is an ancient one. It speaks of the oceans of Hine Moana and of Tangaroa, the keeper of the creatures of the waters,

'Each realm has a guardian as does each family and each person. We are never alone. And our excitement tells us which realm touches deepest into our lives, which holds the spirit to give us strength, courage and insight.'

'The sky excites me,' exclaimed Mist, 'and the shooting stars in the night and the Moon. Does that mean Ranginui is special in my life?'

'Ae, that's the way of it dear child,' responded grandmother.

'I love walking in the mountains, love the forest and the rivers, love them so much White Eagle calls me his "wilderness girl",' confided Kea. 'Does that mean Papatuanuku is special to me?'

'Ae! It seems we all have our great loves in life; the open skies and the stars, the mountains, the forests, and the wide oceans. Endless loves that are so special we need them to survive.

'There is a story that tells us how we came to choose who might watch over us in life.

'Remember the story of the parting of the Earth and the Sky, and how the arrival of light created a great abundance of life. There were so many fish, birds, trees, insects, snakes, lizards, reptiles, mammals and spiders that their numbers became a problem. Not so much in ordinary times, but certainly when the whole of creation was shaken by the Battle of the Gods.'

Beware of the wind's rage

'When Tane Mahuta forced the Earth and Sky apart to let in the light, he defied the wishes of his brother, Tawhiri Matea, the Keeper of the Winds. Forced to decide where he might abide, Tawhiri Matea was torn between his Mother and his Father, but eventually decided to join his Father and ride the skies. But he made that choice in anger and attacked his brothers with fierce storm winds and thus began the Battle of the Gods.

'Thunder and lightning devoured the night, and terrible winds lashed the mountains, pounded the shore, felled the trees and devastated all. The creatures of the earth hid as best they could and called out in their pain — "Who will protect us?" — and no answer came, because the noise of the battle smothered their words.

Tawhiri Matea's rage struck out at all. None were sheltered from the pain as the guardians fought each other to establish their domains.

'But, one strong voice was determined to be heard. Tuatara, who opens the door to the realms beyond, the three-eyed one who has seen the light of many Suns, used his ancient tongue to penetrate the tumult of the battle with these words — "Protect those who cry out to you! Call them to your side, serve and promise to provide!" Then Tuatara stood very still.

Tuatara chose to stand apart,
to hold the space between
to be able to intervene when
the guardians lost their way.

'Shocked to hear the old one speak with such power, the guardians looked around them, saw life in Chaos, and heeded Tuatara's wise words.

'Creatures, both great and small, were invited to decide which guardian should watch over them. And they did and have remained true. Yet one, and one alone, sought no protector, for Tuatara decided to stand apart.'

'Why did Tuatara choose to have no protector, Kui,' asked Rain. 'Why would it want to be alone?'

'If it stood apart it was free to challenge the guardians if they forgot their promise to serve and provide,' responded grandmother.

Help surrounds us

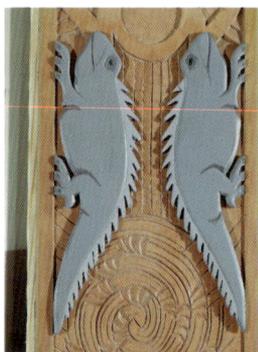

'Who can tell me the names of the children of Ranginui and Papatuanuku, the guardians that move in the World?'

The answers came quickly...'Tane Mahuta is the keeper of the forests and the birds....Tawhiri Matea is of the winds... earthquakes and volcanoes are of Ruaumoko... Tangaroa is of the waters.... Tumatauenga is the protector and the hand of war...Haumietiketike is of the fruits beneath the soils... Rongo-marae-roa is the peacemaker...'

'Wonderful! You have remembered the seven guardians, the kaitiaki, the companions who are part of the world that is our life. But some families have one special companion, a kaitiaki that helps them through the difficult times. Do you know your kaitiaki?'

'I think ours is Ruru,' said Huia, 'because grandmother tells us many things when she hears the owl call in the night.'

'Grandpapa says our family is helped by the Whales,' said Echo from Tonga, the island of the birthing waters of the great Whales.

'We sit with the Kauri tree when we make important decisions,' shared Anaru, who lived near Waipoua Forest.

'Our special animal is the Dolphin,' added Mist. Her effort was challenged by her brother Rain, who said, 'But that's only when we go to the beach. At home dad tells us to watch for the two Hawks. He says they fly over our house each day to keep us safe.'

Families in the past all had their guardians, be they owls, trees, stones, stars, lizards, sharks, seals or dolphins. It has always been so and may be that way again.

247

Huriawa is the wondrous Taniwha who clears the underground rivers in the north and east of the South Island. Her many sons and daughters sweep aside debris carried into the dark tunnels by the flood tides. Without their labours the mountains and hills might subside.

'Pounamu is the one we bring into the gathering of our family,' said Mountain, who had taken up this lovely tradition from Hirini's family.

'My stone is Jade,' offered Nova, who had some Chinese ancestry, 'and Turquoise when I go home to my Sioux Nation.'

'Thank you! It is wonderful to hear of so many kaitiaki,' responded grandmother. 'With such friends, you should never be lonely or lost.'

'But I have no kaitiaki, Kui,' lamented Tamatea, whose long journeys into the mountains alone were part of a deeper quest than the need for solitude. His grandparents had departed this life, gone from him before the old things they carried could be shared.

'If your family has forgotten its kaitiaki, it is possible to remember it again. Discover which realm excites you most. Ask yourself if your spirit cries out to the waters, the forests, the mountains, the stars, the birds, the fish, the stone or some other realm.

'Listen closely and you may find the answer. What has been of you, is still of you. It is your birthright. It is time to call it forth again and stand tall in the power of your kaitiaki.'

Huriawa bails the water from the stern

'Did you know Te Waka a Maui, the southern island, has three special guardians. We call them Taniwha. Remember how the tohunga called on Taniwha to bail water out of the wallowing waka in the midst of the Deluge, and how they came too late to save Aotea Mairangi, which sank beneath the waves?

'Well it seems the three Taniwha that arrived to help Aotea Roa remain with that waka unto this day. Each is responsible for one part of the hull.

'Huriawa looks after the stern, the place where the navigator, who is known as the wind-eater, stands with the great steering oar.

'The lair of Huriawa is deep within the up-welling waters of the Waikoropupu Springs of Golden Bay. The many children of this powerful guardian travel the underground rivers beneath the Aorere Mountains to move the storm waters swiftly back to the ocean.'

'Kuia, is it true that some of those rivers emerge far out in the sea? That fishermen trawling with their boats sometimes encounter great areas of fresh water where it should not be?' asked Nova.

'Ae, your information is correct. The power of Huriawa reaches far beyond the shore.' responded grandmother. 'That is how this Taniwha keeps the Waka riding high.'

When the winter snow weighs heavily

on the shoulders of the Tupuna,

the tall mountains, Tu Te Raki Hau Noa,

the Taniwha of the warm North-West

Wind, melts it in the spring.

Tu Te Raki Hau Noa sweeps away the snow

'Tu Te Raki Hau Noa, is the Taniwha who protects the centre of the waka.

'He cares for the tall mountains that bear the burden of Tawhiri Matea's rage. When the keeper of the winds vented his anger on his brothers, he laid heavy cloaks of snow upon the Ancestors turned to stone, and continued to do so again and again.

'When Ranginui intervened, Tawhiri Matea relented and offered to sweep the peaks of snow from time to time. He keeps that promise unto this day by sending Tu Te Raki Hau Noa, the Taniwha that is the warm northwest wind, to melt the deep snows.

'When the hot norwester blows strongly, those on the eastern shore see the clouds take the shape of the sail of the Waka of Maui. Others call it the norwest arch. We see that billowing sail as the work of the Taniwha, the warm hand that caresses the Ancestors, to melt the burden of the snows.'

Tekapo bails the water from the Prow of the Waka

Tekapo is the third Taniwha of the South Island. He was given great powers but failed to honour his chosen task and had his sight taken from him. As he stumbles through the underground caverns in the south, he causes earthquakes, avalanches and rock falls.

'Tekapo is the third Taniwha. He is the keeper of the Prow that plunges into the huge waves, born of the cold southern ocean, that crash over the splashboards to gather within the hull to create the many lakes in the south.

'Tekapo did not always carry that name. In the earliest of days he was Tu Takapo, a disgruntled Taniwha, and some would say with good cause. So much water came over the Prow, that the rivers could not return it fast enough to keep the waka high in the waves. The heavier the waka became, the deeper it sat and the greater the intake of water. In desperation, Tu Takapo challenged the gods to give him their powers for a day, promising to reshape the land to allow the waters to quickly drain away.

'The gods agreed to grant Tu Takapo their powers from sunrise to sunrise, but added, "If you fail to open the way for the waters in that single day, there will be a price to pay."

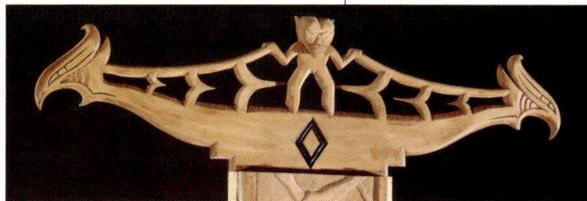

'When Tu Takapo rose to greet the Sun he felt awesome powers move all around him. With one sweep of his hand he cut through rock to free the waters of the first river and quickly moved to release a second and a third. Filled with confidence, he stopped and sat with the beautiful female gods who found favour in this brave guardian of the Waka. Thus did the time pass in pleasure, until the Sun slipped away.

'As darkness descended, the Taniwha resumed his task with great haste, opening more rivers to the ocean to save the Waka. However, as the night deepened, he grew weary and lay down to sleep. Some say the imprint of his body made Lake Wakatipua, and that his heartbeat still echoes through the land and pulses through its waters.

'He awoke to a bitter dawn because the work was not done. Those who came to reclaim their powers, and demand the price of failure, took away his sight and renamed him Tekapo, the blind one.

'Tekapo still wanders the rivers and the underground places to free the land of the storm tides. His blunderings in the world of darkness cause the earthquakes that shake the southern mountains.

'And all the while the blind one remembers what might have been.'

The land claims us

'A long time ago, those who taught me the old lore, said, "All born of this land are of this land". I felt I understood that, because I believed belonging to the land was of the blood. If my mother's line was of this land then, I was also of the spirit of this land.

'Later, the same elders smiled and said, "All who sleep beneath the mountains of this land, are of this land", and that teased my mind.

See the mountains as your ancestors and let them claim you as their son or daughter. We are children of the land, nourished by the Mother who gifts to the womb, the minerals to make our bones, the waters to create our blood, and the air that gives us life.

'In the silence that followed, I remembered the mountains are the tupuna, revered Ancestors turned to stone. And I also recalled that stone itself is the First Ancestor, that without stone we would not be. I saw in that moment, that I did not have to claim the mountains, for they already claimed me. I was their grandchild and as I slept they looked over me.

'Searching deeper I asked, "What of those who come to this land from afar, those who are born of other homelands but now live here?" They chuckled and explained, there was a third law that spoke of the people and the land, a law held very close to the heart, for it stood above all others, "All who call this land home, are of this land."

We are embraced by the land every day, held within the cup of its being and sustained in every way.

'It has taken many years to understand and accept this truth. We don't claim the land, the land claims us. We do not own the land, the land owns us. We are accepted by the land, simply because we are here.'

'How can that be?' exclaimed Echo in an excited voice. When she first arrived from Tonga, she had felt out of place. Even now it was sometimes hard to see this as a new homeland. Yet, suddenly she realised the fire circle and Rewi and the conch had changed all that. She felt different.

'It is very simple,' grandmother replied. 'This is not about the politics of land claims and compensation for past injustices that we wish to see honestly met.

'It is not about race confronting race, about ownership by right of occupation in times past. It is not about the displacement of others on the grounds of cultural dominance or economic power. Many of those matters still await resolution.

'This is about the acceptance that is gifted by the mother and the father. Those who sustain us and nourish us, by their actions speak of acceptance and claim us as their own. The mother I speak of is Papatuanuku, this Earth, and the father, Ranginui of the Stars.

'You are a child of the land. The hand of this land touches every cell in your body, every living moment. That began in the womb tides of your mother. The energy she needed to carry you, and grow you, was fuelled by the food gifted by the Earth Mother.

'Vegetables, fruits, grains, fish and meats burned within your mother's body to give her heat, to spark her brain to think, and fire her heart to beat, and her lungs to breathe.

'And do not forget that her air came from the trees, and the blood flowing through her veins, and into yours by the joining cord, was of rivers and the rains.

We are not set apart, we are connected to all, to the rock on the seashore and the waters that span the planet.

'Those not born of this land are also claimed day-by-day, nourished as the womb child was nourished. We are sustained by the gifts that make their claim. And when our journey beneath the Sun is done, we return to the Earth from which we came.

255

'We are not creatures apart. We are born of the soils and gifted life from their bounty. We are claimed moment-by-moment, for the land is of us and we are of her. That is simply the way.'

Find your Turangawaewae and stand tall

Grandmother realised she had not completed this story. She needed to acknowledge the power of place.

'In our world we have a special word that describes the place where we stand tall, it's called our turangawaewae. I would fail you miserably if I did not tell you of the power of such a place, for it is capable of gifting great strength in times of adversity and joy in times of celebration.'

'What does standing tall mean, Kui?' asked Emma. 'It seems to discriminate against those who are small.'

'Ae, it might be seen that way but I assure you size is no part of it. Standing tall is about pride, about being aware of our Mana, about having faith in our abilities and feeling worthy.'

'Do you mean there is a place for each of us that helps us feel good about ourselves?' asked Huia. Thirteen could be a difficult age for a girl.

'Ae, and you will not find it in a guide book, for only you can discover that place,' replied grandmother.

'But how will I recognise it, Kui?' asked Emma.

'It will call you and embrace you. You will feel so alive in that place you will want to skip and sing. You will feel inspired and uplifted in body and spirit. It will excite you and assure you, and bring all that you are into balance.'

'Wow!' exclaimed Emma, 'I think I have already found it.'

'Then honour that knowing and go to your turangawaewae whenever you need sustenance of any kind. And if you cannot travel, go there in your mind.'

The Old Families claim us

Grandfather now took up the story. He was drawn into the wonder of this exciting world of kinship that grandmother was creating. He wanted to share, to add his token to the learning.

'Do you know each of us has a family beyond the family name we carry?

'Ancestors all over the planet once belonged to a spirit family that nurtured them everyday.

'I speak now of families known as the Tree People, the Fire People, the Whale People, the Bird People, the Star People, the Water People, the Snake People and the Stone People. And there are others I do not mention.'

'How can trees be people, or birds, or fire?' asked Torrent, ever ready to probe with his mind.

The Stone Family is of the Beginning

'I have been to many lands and sat with many elders and shared their wisdom. Again and again they have said — "Stone is the First Ancestor."

'This is not new to you, because we have already heard how the building blocks of life are held within stone. So I merely remind you that without stone you would not be, for without stone there would never have been Ancestors. In that sense, we are all Stone People because we are born of the stone.

'Few remember they are Stone People, but those who do, those who still hear the distant voice of those forebears, find excitement and joy in their closeness to stone, in walking the beach to collect stones, in bringing crystals and other stones into their homes.

'And when they answer that excitement, when they honour the spirit of stone, they begin to truly understand the power of their journey. They bring together something they thought was outside them, with something hidden within. Thus do ancient rivers of remembrance join and flow.'

Your Family is revealed in your excitement

'Those who no longer hear the song of the stone lose nothing, for they now walk to another excitement. Their Ancestors grew so close to the spirit of something else that the cry of the stone became very distant.

'There was no loss in that, for they explored the power of spirit in other realms. Some became Tree People, others Bird People, Whale People, Fire People, Star People, or Water People. Each family in turn understood the wisdom that was of their people.'

All were of the Stone People in the beginning but those who went to live in the forest became the Tree People and others took to the oceans and became Whale People and so on until there were many Peoples.

257

'How do you find your people again?' pleaded Tamatea who was still trying to take all this in. He felt as if he stood at the entrance of a great cavern. It might open to a new world. No, to an old one lost when his grandparents died too soon.

'Your people are revealed in your passion, in the excitement that gives you joy, that releases something powerful and sustaining from deep within. If you are tired and dispirited at the end of a hard day, and are drawn to the garden to sow and weed, and are refreshed by that work, you are of the Tree People.

'If instead that weariness sent you to a river, ostensibly to fish, but really to hear the waters sing, and you return feeling calm and uplifted, you are of the Water People.

'If you find excitement in discovering new places, crossing new horizons, and thrill to the journey, you are of the Star People, the trail makers and navigators of old.

'If you delight in the touch of the snake and feel renewed in its company, you are of the Snake People.

'When you do something that gives back more energy than you put into it, then you are moving with your old people. You are remembering in ways that go far beyond the reach of the mind. You are moving with your spirit family, discovering the truth of who you are and walking with it.

'Our spirit family inspires and uplifts us, reaches into the depths of us, into our ancientness, to help us on the journey that is life. To receive such nurture, to be rejuvenated and restored by the spirit of those who have gone before us, is a precious thing.

'Tamatea, follow your excitement, honour the spirit bequeathed by those who have gone before you, and reclaim your life!'

'Koro, can we be of more than one family?' asked White Eagle. 'I think I am of the stone, but my spirit often lifts with the birds.'

'Yes! You are of the stone, but also have the far seeing artist's eye and the soaring spirit of the birds. Some are of one family and others of many. That is how the Ancestors send their talents on, that is the way of Spirit.'

The Water People have a free ranging spirit. Water knows no bounds and accepts few barriers.

The Bird People move with great vision and a soaring spirit. That is the virtue of flight.

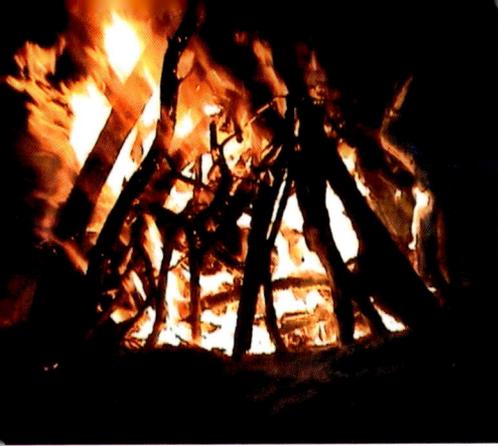

We are the Ancestors

'Precious is a newborn babe. Its journey is of now and yesterday, for when its life begins in the womb it carries into the ever-dividing cells of its creation, the codes that shape it, the "ancient memories" that Doctor Mountain calls chromosomes.

'The mother's blood brings the fruits of the

soil, air, and water to the unborn within the womb. The child knows only the darkness. Then, at a moment of its choosing, it moves to the call of the birthing tides, breaks through the waters and struggles into the light.

'Although arriving naked in the world the newly born carries with it all it needs for the journey — understandings reaching far beyond the mind, knowledge founded in genetic codes, gifts bequeathed by Ancestors over aeons of time.

'Each child born of this planet receives messages related to their blood and their line. These messages speak of a world of Spirit that takes us far beyond the realms of time.

'We are the sum of all that has ever been. We are supported by Spirit. We are never alone.'

There was much to carry home. Old families to be found in our excitement and our passion, new ways of seeing the world we walk in and the world that walks in us. Once again White Eagle was asked to close the teachings of this night.

 # KARAKIA

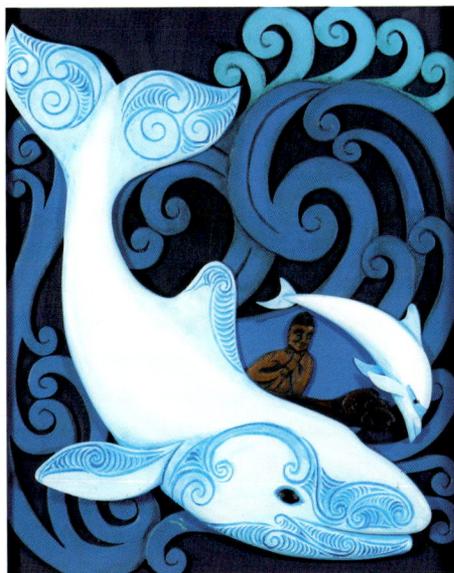

Now grandfather turned to his old companion and smiled. They had made a wonderful journey into the kete of kinship and set the ancient Pouwhenua strongly in the soil of this time. A load was truly lifting from their shoulders. Others stood tall to carry it on. They saw it in the light of their eyes, a commitment that went far beyond the flickering flames of this fire.

The Fire People tend the flame. Fire excites, warms the soul, lifts the mind and frees the artist to dream of worlds unseen.

And what of the Star People who chart their way across the oceans and walk the wild mountain passes? Are they of this planet born, or of others still hidden from our eyes?

The Whale People began their journey on the land, then decided to live within the waters. They know the wisdom of many realms and carry it on the long tides that join the nations.

259

'It will abide!' whispered grandfather in a voice that reached beyond grandmother.

'The promise will not die!' said Hans, who sat on her other side.

'We begin to understand,' offered Day Star. 'Believe me, we do. You do not walk the darkness of these nights in vain.'

Papatuanuku is the nurturing Mother. She gifts all to give birth to the Spirit Child. We speak now of all our sisters and brothers.

The Tree People delved deep within the soils to plant and grow all that brings them joy. They reach for the sky, help gift the breath of life to all and stand tall.

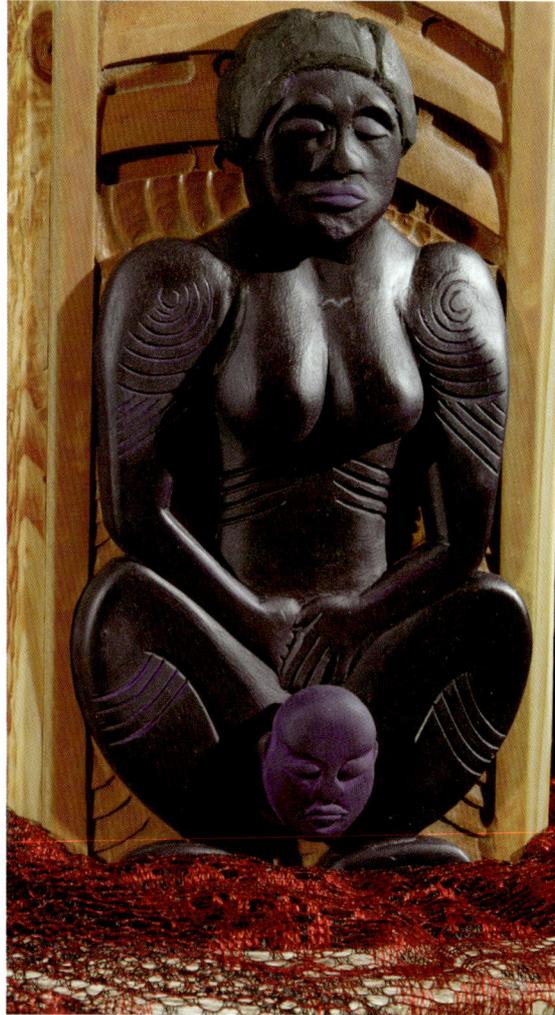

Choose well! It is your life

SONG OF THE LIVING STONES

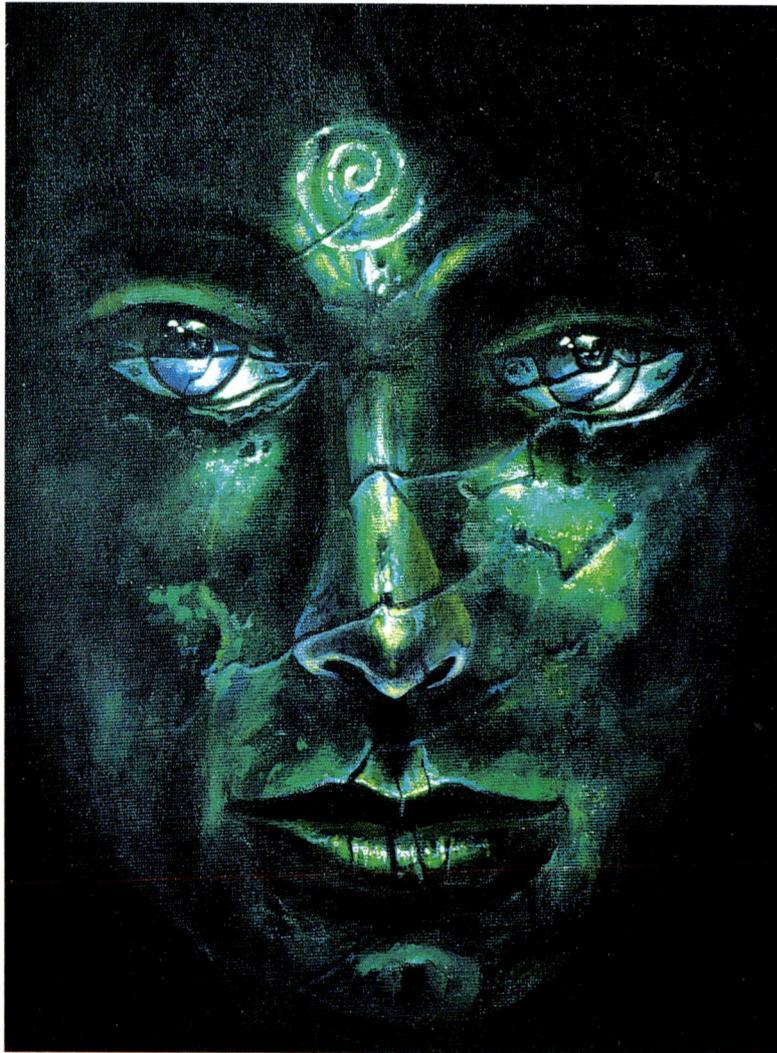

Stone is the First Ancestor,

for all that is begins with Creation,

with the birthing of the stars,

the great fires that still burn to light the night

and bring forth the firmament,

the rock that nurtures life.

Your Mana is everlasting,
untouchable,
the essence that survives,
and the touchstone of your journey.

Honour your truth and bring it
to the Rainbow Mind.
Seek the compassion
of the heart that listens.
Select the wisdom that abides.

Choose well.
Be aware of all you
allow into your life.
And remember the journey is
the destination.

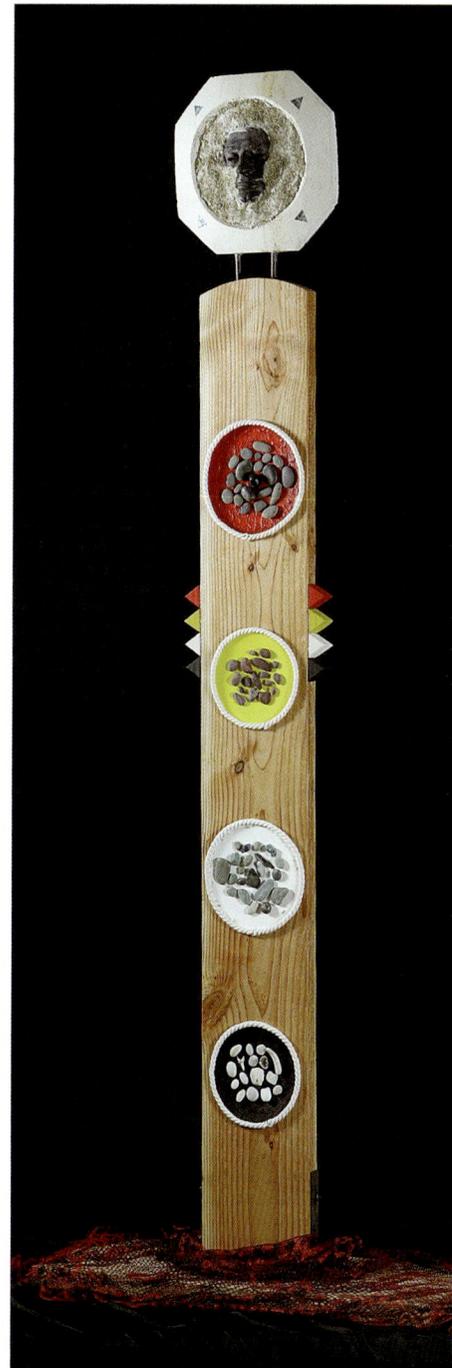

TE HURINGA
The Turning

Grandmother sat with a polished wakahuia, a carved treasure box, beside her. Anaru arrived carrying a flax basket that he carefully set nearby. It was filled with small, round stones that he had gathered, stones added to some the old one chose. Each stone awaited its place in the story of this night.

She knew it was time to begin to close the circle they had created beside the fire, time to bring together, in a different way, some of the markers of their journey. Tonight they travelled to the eleventh Pouwhenua, the place of decision where the people of One Heart meet to be the change.

Each night gathered momentum now, rushed towards an end that many felt was going to arrive too soon. So much that mattered in their lives was being fulfilled and so much that might be achieved for the good gathered close.

Mountain was pleased with Koro's health. Hans and Day Star saw to the old ones' every comfort. At sunrise this morning he said to them…

'When the birds begin to sing again, seeds planted long ago come to harvest.'

Grandfather was content, and determined to bring this waka safely to the other side.

Rewi rarely sounded the conch now; it fell to Echo to welcome the circle to the fire. She had found her own song and grew with its power.

The karakia that was offered by White Eagle was one old Rusty taught him. They met each day now, walked together, shared things that set them apart, were conspirators of a sort in a dream they kept hidden from the team. And with good reason; better to hold some things close until they choose their moment to greet the new dawn.

KARAKIA

Grandmother knew this was to be her session. She had planned it, knew the way it might go, yet remained open to a powerful Wairua that began to flow like a river. The tides that moved here were of the old kind.

Fill the bowl that is your life

Taking the carved wakahuia in her hands, grandmother held it before her.

'Let us pretend you are this beautifully carved wakahuia and we are choosing what to place in it to help us travel through life. We will do this with stones, each standing for a quality for the journey.

'The first four stones I place in this little treasure chest are not new to you. They were yours from the beginning, old companions you may have forgotten but who are forever with you.'

All were silent as grandmother held high a small, smooth white stone.

'The spirit of this stone was gifted to you by a shooting star.
It found you in the darkness of the womb-tides of your mother. It holds the spirit that is the essence of you. It is your Mana.'

Placing the Mana Stone gently in the wakahuia, grandmother then reached for a red stone.

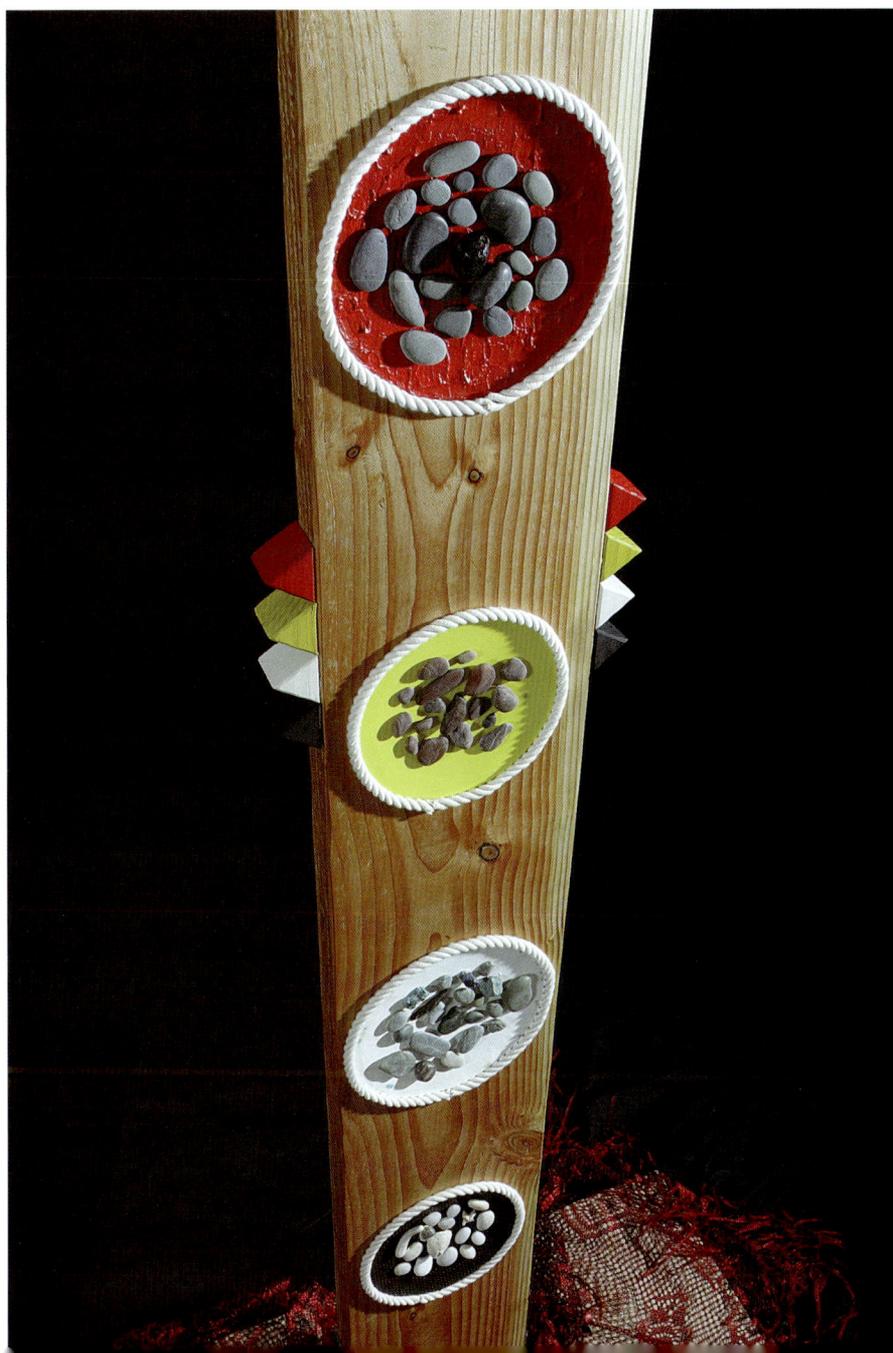

Remember all gifted by Io in Creation, remember your Mana, your Mauri, your Maui and the Wairua that joins you with All. Remember you are Spirit.

'This stone is your Mauri, the energy that moves the Mana to bring forth the wondrous person you are. It is of your uniqueness.'

Now grandmother searched for the third, the one that brought order to the excitement that moves within Creation.

'Ae, it is this black stone, the brave one that stays its hand until Chaos calls it forth to restore the balance. Behold the Maui Stone that seeks harmony in all things.

'And with it comes another, for this yellow Wairua Stone touches everything that is of Spirit.'

With these four stones in the wakahuia grandmother paused and came to a decision. She suddenly saw the need to include everyone in a special way.

'Take your torches to the shore and find four stones to stand for your Mana, Mauri, Maui and Wairua.

'Then choose eight others and bring them to the fire. That's twelve stones in all. And before taking them, remember to ask if they wish to be with you.'

'Kui, how will I know if they say it's okay,' asked little Scree.

'Hold the stone, pause, and you will know if it feels right. Trust that voice within, Scree.

'Return when Echo sounds the conch.'

Wisdom is of your learning

When the circle formed again, it was rimmed with excitement. All had chosen their stones and were quietly arranging them in the light of the fire.

'Set aside the four stones that hold your Mana, Mauri, Maui and Wairua, the gifts that were yours at birth. Their power is of the Creator's Hand.

'Look now to the remaining eight stones and understand their power is born of your choices, your insights and your learning. This is where we have to decide what we truly want to have in our life.

'Tonight I share my choices, the stones I ask you to consider will be the stones that are important in my life. Yet, they might not be important to you at this time. The stones you choose in your own time will be the stones of your story, not mine.

'So I choose my next stone and name it the Truth Stone. I value it greatly because it is the touchstone I use to challenge myself and others. It is the firestone that leads me through the darkest night.'

Dark obsidian, a volcanic stone, stores light within. That's why we say look deeper, see beyond its sharp edge to its core. Obsidian helps us find clarity, for it cuts deep and swiftly to bring us wisdom and direction.

Grandmother showed her Truth Stone to the circle. Then reaching back for a bowl of water fetched by Day Star, she dropped it in and chuckled when it floated.

> 'Everyone thinks stones sink, yet this one doesn't. My Truth Stone asks me to assume nothing, to open my mind to all that might be.'

Those who knew this was pumice stone, born of volcanic fire, smiled. The way the old one saw the world lifted the mind. Ae! Pumice floats, that's why it is found on beaches far from its home.

> 'If any have decided they do not need a Truth Stone for their journey, that is their secret. Remember life is about choices, your choices.'

> 'But, what is truth, Kui?' asked Huia, the teenager who rivalled Torrent with her questions. 'I read things and don't know what to believe. And when the news isn't fooling me, I fool myself by denying things that are right in my face.'

Stones should sink

but if one stone floats

it gives us pause to think.

Gather companion stones

from the beach, sit with them

and call unto yourself the

virtues you seek.

'We all fall short from time to time,' responded grandmother, 'because it's so easy to be swayed by circumstances. We have our frailties, and no one more so than I. That's why I need my Truth Stone to help me remember to listen to my heart, my head and spirit.'

Trust the journey

'Trust is my sixth stone. In times of difficulty it is often hard to find the courage to take the next step. Doubt breeds fear and fear paralyses the will to move forward, makes us smaller and finds reasons to divert us from the truth of our journey. Trust gives us the courage to take the next step, trust allows us to let go of doubt, be free of fear and be true to ourselves.

'Trust is not about certainty. No, trust is about letting go, about accepting that life is a path of learning and knowing whatever the outcome, it will be all right

'I have chosen this beautiful turquoise, gifted from the Americas, to be my Trust Stone. It reminds me no matter how dark the storm clouds that gather, high above them the sun shines and the blue skies reign.

'What do you suggest for my last six stones?'

'Freedom!' announced Scree in a firm voice.

'I love your choice, but Freedom is a mystery, it will find its own way into my wakahuia. We will look for it when we have named all twelve stones.'

Walk with Hope

'Now I choose a wonderful stone that reminds us we are never truly alone. I hold my Hope Stone.'

'Kui, how do we learn to walk in hope?' asked Tamatea. 'Sometimes dark clouds gather and I barely cope.'

'Let others speak of this,' was her response. 'Some who gather here have known illness and loss of the deepest kind, have sat with their child unto its last breath, or were not present when it chose to leave this life. Others have endured illness, known the pain of separation and divorce, or grieved deeply on the death of another.

Barriers often become opportunities when we trust our journey and have the courage to take the next step.

See the sky in the turquoise stone, see the stars that shine bright, see the sacred in the wonder of colours that honour the day and the night.

'They have walked the stark cold places, journeyed into the depths of the soul, and still gone forward to reclaim their life.

'Who is able to share something of this tonight?'

No one spoke. Once again the crackle of the fire and the image of the dancing flames, filled the night. Then came a voice.

'I have been to that dark place you speak of, have retreated into my cave like a wounded creature and left the world for a time. When the Sun eventually shone, I emerged and left a heap of old baggage behind. I suppose that's why I'm here tonight,' confided Day Star.

'What did I learn, what changed for me? I became more real... saw myself... with clearer eyes... saw the rubbish in my life... saw my lies and the illusions and deceptions.'

'How do you see the world now?' asked grandmother.

'I know the world is as I make it... there are no mistakes... no accidents... no coincidences. It's all my stuff... if I wake thinking its going to be a bad day... it will be... and good days come in the same way... it's all about choices... about attitude... about walking in hope.'

'Thank you, Day Star. Koro named you well,' responded grandmother, as she smiled and placed her Hope Stone in the wakahuia.

The pain of loss, deep grief and illness can carry us into the dark recesses of the mind, a cold, stark place of aloneness. Yet, even that place is not beyond the reach of the light.

Respect the old ways

'My next stone may not stand very high in some minds.
I choose the Stone of Respect, one that is often put aside.

'Respect takes many forms. Sometimes it asks us to listen in a
good way, to really hear the voice of the child, or the pain of
an aged one. At other times it asks us to put aside our own
concerns and be there for others who have greater needs.
Much of this is really about respect for the word, about making
room for others to be heard.

'Words have the power to help or destroy, to maim the mind,
to wound a child for life, or make it whole. Words carry their
power long after we come to silence. Some say they echo
forever through the realms of space and time.

'The Ancestors revered the word. There are no swearing words
in our language, no profanity with which to curse others.
That's because our language honours the sacred, for the Word
carried the light into the Nothingness to set aside the Darkness.

'So I take up the Respect Stone to teach me to listen and to
be careful with my words.'

Sometimes we survive by retreating from the world into special places that nourish spirit. There we meet the land in all its ancientness and walk old trails that lift us beyond time. There we go within to find the truth of our journey and emerge to once again begin.

Be humble to be free

'Suggest my next stone,' said grandmother.

'A power stone,' offerd Rain, who was very down-to-earth unlike his twin sister, Mist, who was wonderfully ethereal.

'Tell me about this power stone, what could you do with it?'

'Make things happen… control things…win games easily… defeat the enemy… get rich… be the boss of everything.!'

'That's a mighty stone,' responded grandmother. 'But not one I would like to carry.'

'It's a dangerous stone.' declared Emma, who was known for her independence. 'It could destroy the other stones. How can Truth, Trust and Respect survive the misuse of Power? And even if it was used in a good way, who would decide what was good for each one of us?'

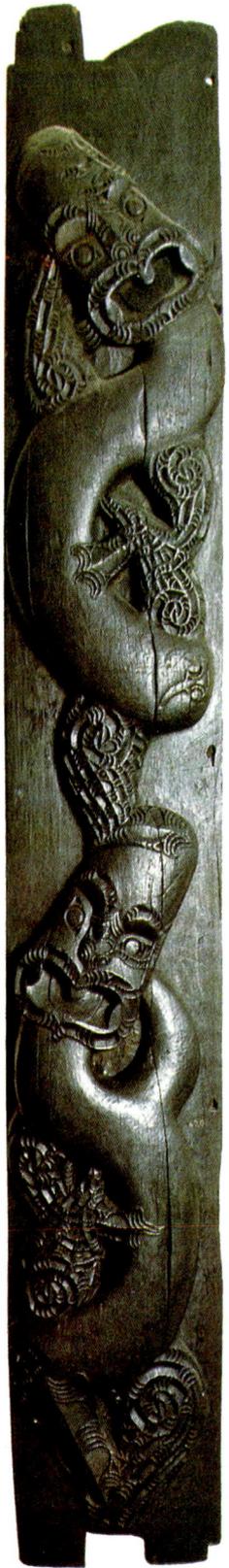

'While you think about the Power Stone, I am going to choose a Humility Stone,' announced grandmother. 'I want that stone because I love to be free. Some might think the Power Stone would allow me to be free of want and doubt, and fear and disappointment. Yet, I think the Humility Stone will give me the freedom I seek.'

'Why, Kui?' asked Rain, who felt a stone of Humility sounded pretty weak.

'Humility is a very strong stone,' replied the old one. 'It allows us to admit our mistakes, to be free of the mind that always has to be right. It allows us to acknowledge we are no better than others, that we all have virtues and talents, and that life is not a contest but a journey. It allows us to live without pretence, to simply be ourselves. It is the cornerstone of real freedom.'

Forgive to live

We are but a brief moment in the turning of the stars and the journey of the mountains. Yet, our moment is born of the Eternal.

The unforgiving chain their spirit, imprison themselves in the pain of the past and send it forward into tomorrow's world.

'I seek three more stones to complete my twelve. Humility opens the door but, to walk in a good way I need to learn more.'

'We need to learn to forgive!' came a response from the circle.

'Very true!' exclaimed grandmother. 'The unforgiving nurture their pain and allow it to grow and in the growing give it the power to chain the spirit. That bitter path I know.

'So I choose a Forgiveness Stone. It has great power for it breaks the chains of rage, sets aside envy, lifts away jealousy, thrusts off bitterness, shifts aside pain and heals the deepest hurts.

Pounamu carries the spirit of Aroha. It is a very powerful stone. Aroha, the love that embraces all, is the greatest force in the Universe.

'Forgiveness frees us of the shadow that shrouds the spirit.'

With a sweep of her arm she put a white Forgiveness Stone with the others to bring the total to ten.

Love conquers all

'Offer me another stone,' suggested grandmother.

'One stone should carry the spirit of love,' suggested White Eagle. 'The loving heart, the heart that walks with compassion to help others without conditions or hidden agendas, is worthy of a stone. I offer the Aroha Stone.'

'Ae, it is the lock-stone of this land, for Aroha is the spirit that is Aotearoa. I accept the Aroha Stone. But tell me, how will it help me on my journey?'

'I am not sure if this helps,' began Emma, 'but I used to find loving some people was a big ask. Then my grandad told me I didn't have to like people to love them, and after that it became easier. Perhaps I stopped judging them, saw the fears they tried to hide, I'm not sure. Anyway, accepting them and loving them even if I didn't like them helped me a lot.'

'Thank you, Emma, you have walked further than you know.'

Grandmother held high the Pounamu she had placed beside the fired white stone at the beginning of this journey. It settled well within the wakahuia. Now only one stone remained to be named.

Be of the gentleness

'Name for me my last stone,' suggested the old one as she held aloft the white, fire-baked stone she had carried from night to night.

'Is it the Peace Stone?' asked a voice from the other side of the fire.

'Ae, our thoughts join. To bring the Peace Stone into this circle reminds us the Ancestors found their greatest power in the paths of gentleness.

'Some see the peaceful way as weakness, say the gentle way is but a frothy tide that other currents easily push aside. But the gentle way is the way of paradox, for its strength is not in the power of the arm, but in the power of the mind, the heart and the spirit.

'The peaceful way is the strong way because it works to resolve conflict by listening with humility, by righting injustice, by seeking truth, by moving only with fairness. It does not impose, does not try to mend hurts by inflicting greater hurts and does not make a virtue out of death.

'The peaceful way is the lasting way, because it deals in completeness. It rejects the view that might is right, does not believe that the just and true are those who hold the most guns. It knows lasting solutions are founded in compassion.

This is a Mauri Stone, shaped from soft clay and marked with a caring hand to hold the spirit of the journey. Touched by the power of the flame, it carries the message of change into another day. It is the Peace Stone, a symbol of the fire within, the dream that lights the way to another age.

273

'It is easy to take a life with a single blow, but harder to withhold that blow and resolve anger, harder to walk the path that heals and honours life.

'Peace is born of the willingness to listen to others, to see virtue in diversity, to respect the many children of this land, and to remember that the old lore teaches that all are kin, all created to reflect Spirit.'

Beware of grit and sand that buries a life

Now that the choosing was done, many thought the old one had finished. However, her time had a longer course to run. Now she beckoned the youngsters closer and gathered them around the wakahuia.

'Can you see freedom?'

'No!' cried Scree and Smoke, and Mist and Rain. 'We only see the twelve stones.'

'I think you are tricking us, Kui!' said Kea, who was learning to look behind the veil of life.

'Perhaps, little one, for freedom is there!' exclaimed the old one. 'Let's leave it awhile and see if it appears. But tell me, is the treasure chest full?'

'Yes!' they all replied. 'It's full.'

Grandmother smiled as she pulled a bag of small pebbles to her side. Taking handful after handful she dribbled them into the spaces between the stones, until there was room for no more.

'Once again I ask you, is it full?'

Doubt grew and few responded. Now the old one took up another bag and dribbled fine sand into the spaces between the little pebbles.

'Now is it full?' she asked with a smile.

No one answered. They needed time to think. Then into the silence grandmother sent another challenge.

'Where is freedom? It was there even though you did not see it. Freedom was the space between the stones. Freedom was born to move between. Now it is gone.'

'You have buried freedom!' exclaimed Scree, who was very concerned.

'Yes,' agreed grandmother. 'And freedom is not all that is lost. What else is buried?'

'Our Mana! Our Truth! Our Trust! Everything that really matters,' cried Torrent, who began to see where this might go.

'Why did you do it, Kui?' accused Scree, who was utterly bereft.

'To show you how easy it is to smother what truly matters under rubbish. It's for you to decide what comes into your life.'

How easy it is to let dust gather, let sand and debris obscure our vision and bury the dreams we hold deep inside. Yet, it is never too late to reclaim our life.

Looking around, grandmother saw that not only Scree was unhappy to see the wakahuia choked with pebbles and sand.

'What is the "rubbish" that buries who we truly are?' challenged grandmother.

No answer came and that did not surprise her, for we are often slow to see the things that mess up our lives. Then the words tumbled out of many mouths to stand before the fire.

'Thinking I am my work… always having to be in control… trying so hard to be perfect… feeling guilty… carrying bad memories… fear… gambling… drugs and drink… reliving past failures over and over again… lacking confidence… worrying all the time… putting money first… forgetting family…'

The old one put her hand up as if to say, 'I hear your anguish; you have shared enough.'

It's so easy to be overwhelmed by the busy life, to think we are our work and set all else aside. It's very easy to be buried alive by guilt and addiction, and grief and pain too deep to assuage. Yet, we know the true way. And the Creator offers the rainbow light of the paua shell to help us discover it again.

The journey is the destination

'The hurt ends when we reclaim our lives and have the courage to dream the dream again. And we come to that in Moenga, "the Dreaming", the calm place that gifts wisdom, for there we recognise, once more, our Mana. It is where we meet the truth of who we are.

'Into the Dreaming we bring Aranga, "the Awakening" that carries us to understanding. You know this Awakening, the awareness that you are but part of a greater world, that you are unique and accepted.

'Look to the stones you hold and all they mean. Be of the simple things, the things that really matter.

'The Ancestors taught us that the real world is the world of Spirit. Yet, today we are told to believe that what really matters is mortgages, bills, and taxes, and earning lots of money. That material world, that world of things temporal, is worshiped as the real world.

'But the elders taught us that truth is paradox. That the so-called "real world" is

not real, it is illusion, a distortion that has the power to choke our lives with sand and pebbles if we choose to let it.

'In medieval times to walk in spirit usually meant going apart from everyday life and entering the cloistered world of the nun or the monk. The challenge now is not to be apart from the world so that we might live in spirit, but to be in the world, living in spirit. It is time to be the change we want to see, time to reclaim our lives.

'Remember the journey is everything – it is the destination.'

Grandmother was fascinated to see that everyone, including the children, was handling a stone and looking closely at it. She hoped they were beginning to find twelve virtues and wondered what they might be.

Koro looked to White Eagle and nodded. Once again the younger generation was being asked to step up. This time White Eagle's prayer asked for courage. Some dreams demand much of us, but they cannot be denied if we wish to truly stay alive.

What is illusion?

What is the 'real world', what 'truth' decides the shape of our day? Is it the material world or the realm of spirit that speaks to us of the good way?

KARAKIA

Just one more Pouwhenua called to be set in place, one further marker to carry the promise forward. One more night would see the circle close.

Grandmother was sitting quietly when the voice of little Scree broke into her mind.

'Can I tip up the treasure chest, Kui?' asked the young one.

'Of course, dear one, but why would you do that?'

'To clean the rubbish out… to see the stones…' said Scree, who could not quite finish his thought.

'What a lovely idea! Let me help you!'

So they sat together on the ground and slowly tipped the wakahuia over. Then with the cloth that had covered the stones, they wiped the inside until it shone and polished each stone in turn as they placed it. It was a satisfying way to end the night. When all was done the little one exclaimed…

'I've found it! I've found freedom!'

'So you have,' laughed the old one, 'and so have I in this time with you. Now off you go to your Mum.'

The little one hugged her, then disappeared at a run. It was a night to remember, for her and everyone.

Is all we bring into our bowl of life truly of our Journey? Only we can decide.

We live in an amazing age of opportunity

CHAPTER TWELVE
SONG OF THE FLAME OF HOPE

Nature reflects all that we are. The beauty of the land is our beauty,

for we are of it. The sound of the waterfall is our sound,

for we are in it. The power of the storm is our power, for we feel it.

The light of the stars is our light, for we embrace it.

There is no separation except in the mind that sets itself apart.

We are the sum of all that has ever been.

We live in an amazing age.
We cross the thresholds of Creation to
explore the genetic codes that shape the
body and the mind.

We come to a time when the prophecies
of hope might be fulfilled,
when the One Hearted People stand
tall to walk the good red road of Spirit.

We move in the power of Te Wai Pounamu,
the ultimate stream of awareness that leads
us to the Rainbow Mind.

We acknowledge Spirit in everything.

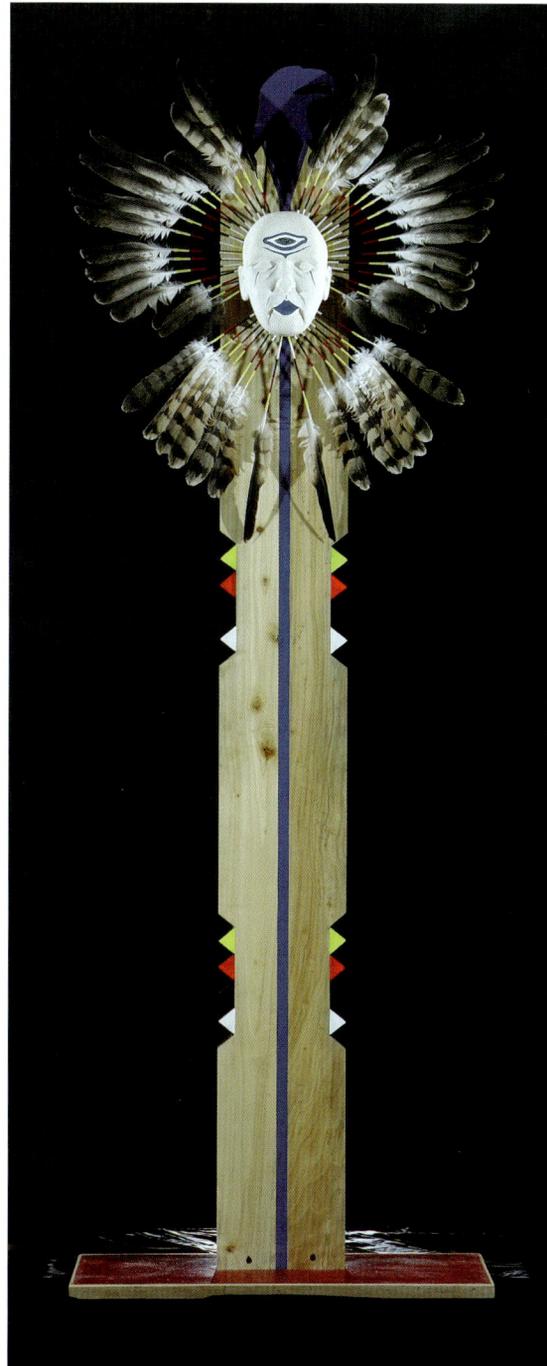

TE HOKIANGA
The Returning

The old ones spoke quietly to each other. None could hear their words, but all felt the joy they shared. They would soon come to the end of this circle, yet they knew the ripples that went out from it would travel far. The seeds sown had fallen on good ground.

The cry of the conch echoed, and sounded and echoed again. Its keeper was revelling in this last opportunity to send its message along the shore. The people had gathered to its call, more and more each night. And they did again.

When all settled, Koro offered his opening prayer to the last light that caressed the top of the cliffs behind.

KARAKIA

Grandfather sat strongly, summoning all his strength to bring them through. To be complete, the beginning and the end had to meet. Only then would the journey to the twelfth Pouwhenua honour all the nations, the many peoples who on this Earth reside, but are of one Mother tied. Only then would the flame of hope rise to circle this spacecraft voyaging through the stars.

This wondrous age was foretold

Grandfather's opening words took us far from these shores, and spoke of prophecies that were new to many who had come to this tide.

> 'When the Wairua moves, time shifts to align; then nothing is impossible.'

Once again the old one had opened with a saying from another age. It was his way to shift the focus to help them see with different eyes.

'Prophecies written long ago predicted this age, this time of opportunity, this turning within the Old Tides.'

'How could that happen, Koro?' asked Emma. 'How can anyone see into tomorrow?'

'I don't know for sure, but have some thoughts on this,' confided the old one. 'I think it goes back to the altered state that carried the wise ones into the ultimate stream of consciousness we called Te Wai Pounamu.'

'So it goes back to the power of the higher mind,' said Rata.

'Ae. It's my only explanation for prophecy, for it is of the shamanic mind. Some speculate that the altered state defies the boundaries of Space and Time.'

'Ah!' exclaimed Nova, calling on her knowledge of astrophysics and the paranormal. 'We come again to parallel Universes… to time bending in space… to time folding over time… opening a door into a world centuries away… yes, I know I speculate, but I've no doubt, the Ancestors were into fascinating stuff.' She was very comfortable with the dynamic world of time and space, but on seeing the confused looks on some faces, remembered others were not.

'You're saying, time bends and folds so much the old ones slip through a crack into the future and are part of it today,' offered Torrent.

Grandfather quietly applauded Nova's performance. He enjoyed the thrust of her mind and found it meshed with much that was old while stating it anew. Then he smiled in Torrent's direction for in this youth she had found her perfect student. He knew they often walked the shore together to explore the tides beyond the tides.

Be of the One Hearted People

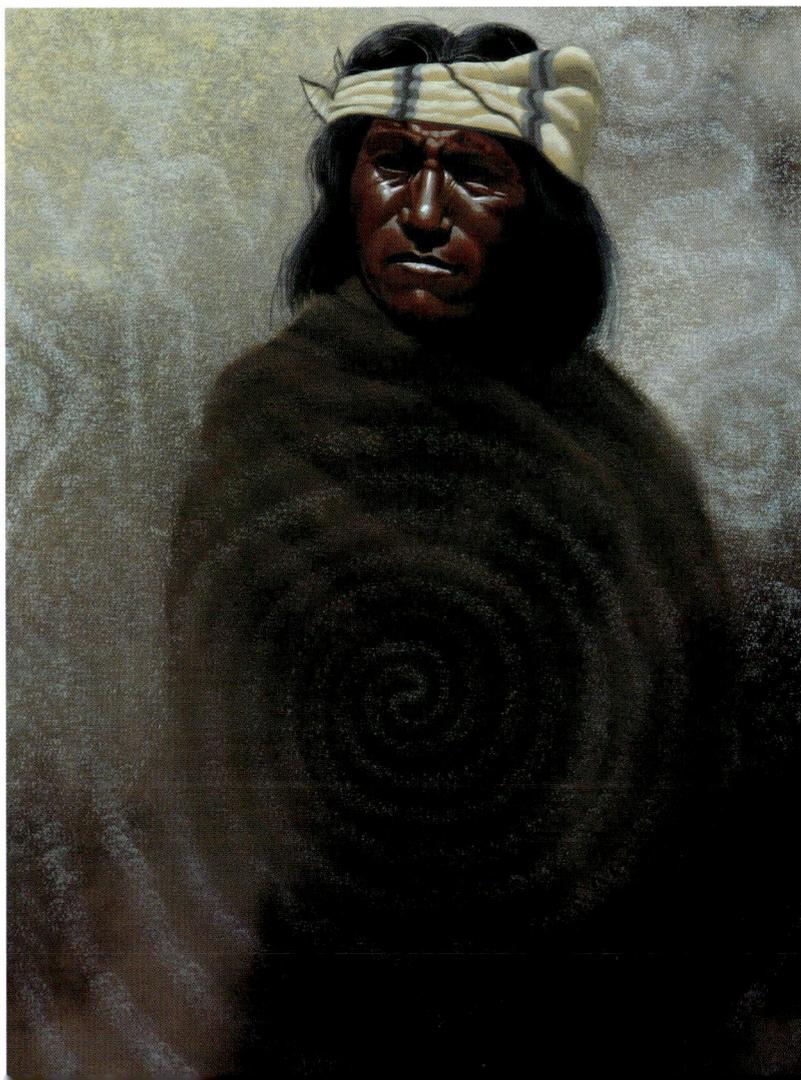

The Hopi of Arizona hold to the old lore and honour the sacred and the ways of peace. They chose to live in the harshest of lands, the hot deserts, because they wanted to walk the margins of life where they must be close to the Great Spirit to survive.
They dance and the rains come to grow the corn, they dance and Great Spirit provides. They aspire to be One Hearted People.

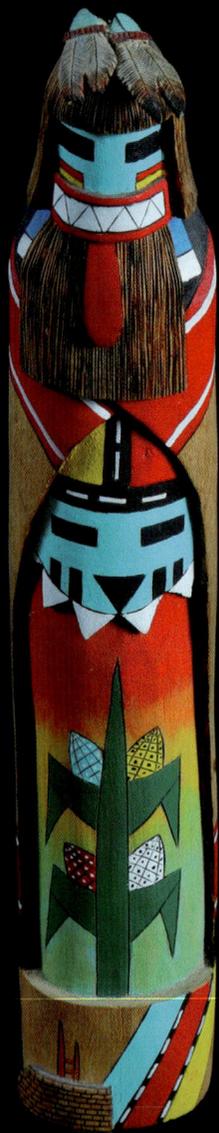

'Whatever the way of it, there is one certainty; many ancient prophecies come to completion in this age,' said grandfather.

'The Hopi people of Arizona, those who have always shunned war, say we have come to the age of the Great Purification, the cornerstone of their most ancient prophecy.

'I stood beneath Prophecy Rock and heard the Hopi elders speak of the prophecies their Ancestors carved in stone thousands of years ago. They marked the arrival of the railway, the wars of the last century and when we shattered the gourd that held the "ashes of death", the first atomic bomb. Then I saw them trace the human story to the end of a line that divides; one fork zigzagging down to the place of pain, the end of all, and the other curving up to reveal the path of the One Hearted People.'

The old one paused to gather his breath. The excitement of this night was almost too much. He would not speak for long. Others would take up the talking stick to share their insights. Even the children would have their moment to put their words before the flame.

'Ae, I remember so well their smiles. They said that we are going to win, that there are enough One Hearted People to save the nations and the planet,' shared grandfather.

'But, who are the One Hearted, Koro?' asked Emma.

'You! And you, and you! All of you!' exclaimed the old one with great joy. 'All who seek truth, who speak their truth, who walk their truth to heal the pain and bring us to Spirit again. You are the One Hearted, for you do not say one thing and do another.

'And there is more. The Hopi confided that while some outsiders interpreted the Great Purification in very dramatic ways, suggesting fire and flood would sweep over us to cleanse the world, they did not see it that way. The Great Purification is an opportunity, a time to choose our path and take responsibility for our journey, a time to bring Great Spirit into our lives. It is a journey within.

'I was inspired and uplifted by the Hopi who say they hold the Spirit of the Turtle in their hands, for they are the guardians of its soul.'

'What is the Turtle, Koro?' asked Torrent.

'North America is the Turtle, or at least the Turtle's Island,' said the old one.

You are your own teacher

'I have sat with the elders of the Asian nations and met those who hold the wisdom of the Tao and learnt of their prophecies. They also see this age turning on a fulcrum of change. And they see a future filled with hope.

'Known world-wide for their wise and far seeing Gurus, they face a momentous shift in their lives. For their prophecies announce the end of the Age of the Guru. From this time hence, those of the Tao are to be their own teachers.

'While we may still learn much from the inspiration and wisdom of others, we are asked to be more than followers. For this is the age of the mind set free, the way of the seeker who takes responsibility for the journey.

'That shift runs the edges of this fire tonight. Every word I share is simply there to be lifted up, examined and put down again by your own hand. I do not try to persuade, for that is not the way, I merely offer words that you can take up or let go. And if you take them up, they should be fashioned in ways that truly make them your own. Walk your truth not mine.'

Great minds have opened the trails of Spirit for all the Nations. Yet, while they remain to inspire, they ask that we become our own teachers, that we take responsibility for our own journey.

Return to the good red road

'I was, by chance, in Wisconsin, in the United States, when the first white buffalo calf was born. This little calf was front-page news, for it fulfilled a prophecy the elders made when the sacred hoop of the peoples of the First Nations was broken.

'Driven onto reservations, deprived of their far ranging hunting life, they saw

the end of their race, saw the great circle of life shattered. Despair and poverty was now the measure of their days. Yet, within their tipi, some elders wove a single strand of hope. In the world of visions they saw better days to come, days that would begin with the birthing of the white calf.'

'What did that mean, Koro?' asked Emma.

'The birthing meant a great opportunity had arrived, an opening in the doorways of time that allowed all the peoples of the planet to walk tall in Spirit. They spoke of this journey as "the good red road".'

'And are we on it, Koro?' was Emma's next question.

'I truly believe so, for I see wherever I go a new awareness, an awakening to spirit. Out of that awakening are born the One Hearted People. They need no religion, no platform outside their lives, no organisation that asks for tithes. They are of all nations, brothers and sisters who acknowledge each other with an open heart. They stand strong in Spirit.

'Yet, others still stand apart, blind to the way that opens. Remember prophecies do not create the future, do not dictate what will happen, they merely bring into our time the wisdom of Ancestors who marked a moment of opportunity. It is for us to decide, to honour the dreams of old or deny.'

May the people of peace walk tall

'Although there are many prophecies that offer hope in this time, I share but two more.

'The first is of our own shores, a vision born of the Tohunga of Waitaha who mark this age of opportunity in the meeting of two stars. Centuries ago, when the Long Night of the Patu brought the Nation of Waitaha to an end, their wisdom keepers foretold a day when two special stars would meet in a unique way. This occurred in 1990 and allowed two things to happen. They could now share their sacred lore with the world and this was gifted to all in "Song of Waitaha". And secondly, they could help others understand that it was time for the people of peace to walk tall.

'The years that follow 1990 mark a great watershed in the history of humankind. We see the end of Apartheid in South Africa; a huge step that says racism has no place in this world. We see the peaceful demolition of Soviet Russia, a monolith of power that was constructed to provide but in the end denied. We see the end of the battle of the Super Powers, the death of the Cold War. So the opportunities are there.

The good, red road opens to all. To mend the sacred hoop of life, to restore the spirit of the broken, we come to a special time. Every day we meet family, people new to us, but clearly of us, who walk in peace.

This age of opportunity was foretold by the Ancestors and charted in the stars. Prophecy does not decide, it merely opens the doors to another side. There is much to ponder in the journey of a comet.

It is up to us to decide the shape of the days to come. Prophecy tells us when the doors are open, but we decide if we step through.

'Another event of great note is written in stone on an ancient calendar. I speak now of the wondrous work of Mayan minds that calculated the turning of the stars and the tides. They created a calendar with a span of some 4,000 years that was tied into great epochs of human progress. Their calendar turns a new page in 2011 to usher in another 4,000 year cycle, an age that awaits our words, our dreams, our hopes and above all else, our wisdom. It is time to write our story with the power of the Rainbow Mind.'

Change direction

'These ancient prophecies bring us to Te Huringa, "the turning" that takes us to the new direction.

'The pain we feel and the pain we lay upon the planet, ends in the mind just as it began in the mind. It ends when hope steps beyond the illusion of separation and comes to the returning. It ends when we remember the old mind that takes us back to the beginning that is without end. It ends when we know the old mind is the loving mind, the one that knows only compassion.

We are the seed of tomorrow, carriers of amazing potential, the dream makers of the new world. Our journey is with the seed, the hikoi that honours heritage.

'The healing begins when we look within and see we truly need each other to know completeness, need all the peoples of the planet, need the essence that is female, the nurturing spirit, and the essence that is male, the protective spirit. Need them in partnership, each standing tall and gifting wisdom with love. Need them joined within us, balanced in harmony, honoured within one body and one mind.'

Nurture new seed in old soil

'Long ago we turned our backs on the old wisdom and set aside the Knowing and favoured another path. We embraced the world of the miraculous mind that gave birth to the age of science and new technologies.

'We sent that mind to the Moon, sent its mechanical probes out to the edge of the Universe, sent its eyes into our hearts to see its pulse and saw not the death we gifted to our children.

'Nothing of itself is evil. There is great beauty in all created by mind and hand. Modern technology is a wondrous thing born of dedicated, inventive minds which create amazing opportunities and unfathomable hope. But only if that mind moves with reverence for all life and asks what mark it leaves seven generations hence. For that was the old way, the good way.

'If we continue to walk into the wilderness of the mind, a place that accepts separation from the world and its creatures, to arrogantly stand apart, our future is fatally flawed. We are slaves to the ultimate illusion.

It is easier to destroy than to build, easier to kill than to heal. It is a choice.

'If we continue to destroy life around us, continue to pollute the waters, continue to plunder the forests and fill the air with poisons, we abuse the freedoms gifted to us. And all we say we love will one day die.

'It is time to bring into the Universe of the Mind understandings that mesh with the natural lore of creation and renewal. It is time to make the longest journey of all, the one that is but three hand spans across, the journey that brings the head to the heart.

'There is within us a Knowing that is of the beginning, the understanding that the mind alone is not the sole font of wisdom. Heart and head together shift us into the limitless realm of Spirit. In their union we gain the power to realise the promise of the many nations that are our world.

'Ae, I come to the end of my story. But that does not close the circle for we now make a space for everyone who wishes to stand with the talking stick. As it moves around the circle you may hold it and speak, or move it on. This is your time.'

Share your story and the dream you carry forward

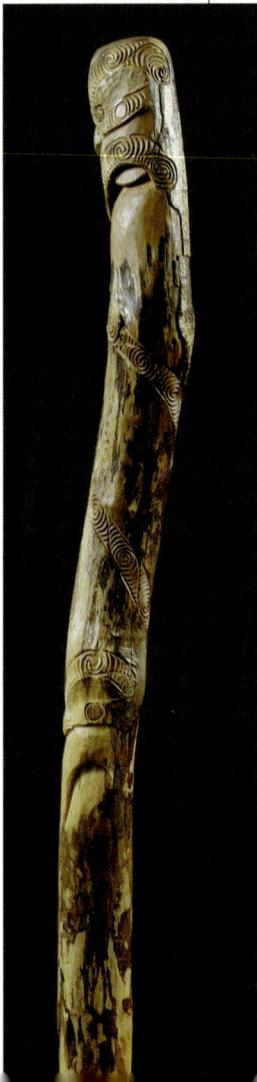

We journey into the unknown to carry our dreams forward. We share the trail with those who have gone before and all who will follow. We are never truly alone.

Mountain was the first to hold the talking stick, the first to halt its progress around the circle and many thought the ideal one to begin.

'Grandmother and Koro, I shed tears even before I begin to speak. Shed them in the joy of all that has happened before this fire. Shed them for you, for the courage of your journey and your determination to be with us night after night. I don't want these amazing evenings to ever stop, but that is the selfish part of me that forgets their cost.

'I live in two worlds and more. The wonderful world of Hirini and his marae and the ever-growing extended family. I am Aunty Doctor to so many children, they could be my total practice. Then there is the western world of medicine with its wonderful science. In the past I straddled those two worlds with some difficulty, but no more. You have given me new eyes, helped me see myself in all my power and given me the tools to begin to use it.

'The power I speak of is not the power to push and shove, to control and dominate, it is of a very different kind. It is the power to heal in the gentle way that both of you display day by day. It is the power that comes from giving value to my story, from appreciation of the wonderful gifts bestowed by my Irish Ancestors. It is the power of family and beyond family, the power of friends and beyond friends, the power of all who strive to be of the good.

'Koro, you have named me Mountain, and, in moments of disagreement, called me "Volcano", and there was humour and love in that. Mountain has set me aright; there is mystery in it and the strength I need to get through difficult nights. It is not easy to sit with the pain of others and see them leave this life. And do this again and again.

'Kui, many know how we conspired together to out manoeuvre the "old one", who always wanted to find his own way around his erratic heart. And we succeeded most of the time and know the wisdom of that. Yet, few know all that you bear, for all we see is the quiet strength you share. I speak for many when I say you have become an anchorage in my life. Whenever my waka hits a storm and needs shelter, I know where to confide.

'To both of you, my heartfelt thanks, for giving me more than you can ever know,' concluded Mountain as she brushed away another tear.

'Oh! And Scree insisted I thank you for the chocolate fish. He can't remember if he did so.'

The talking stick moved on and came to rest with Hans.

'A Maori-Dutch relationship is filled with surprises, Day Star and I encounter them every day. In the beginning they tipped us off balance but we have learned to go beyond that, to be more open to the excitement of entering another's world. So we grew.

'When Day Star suggested I join her for these evenings, I was reluctant to attend. However, if that part of me had won, I'd have missed the most amazing

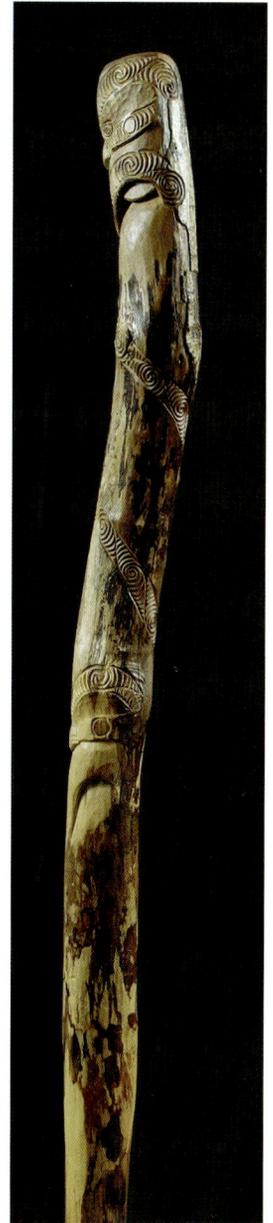

The talking stick takes us back to our hearts, asks us to speak in a way that makes room for others, and opens a space for the truth that heals. It claims our respect and in that claiming opens doors to places we need to go.

time of my life. That's not said lightly. I am used to a forthrightness that sees the truth placed with stern resolve, a clarity that helps us solve differences. I see the same things done here, but in a gentler way and have loved that too, for both have their place. But the difference for me has been in the way Aroha has carried us through each day. Everything shared has been bound in nurture, in caring, in wanting to help the other from not only the head, but from a heart place.

'Humans are made of contrary stuff,' continued Hans, 'we have our moods, our annoying habits, our highs and lows, yet I can't remember a single night, a single moment disrupted by that. Koro and Kui, you took us back to the heart; when we spoke, it was from the core, that inner place that holds the best of us.

'I could say so much more, but end with a final thanks to everyone. The old ones came and we responded and there is great virtue in that. May we meet again to share our journeys.'

Day Star was the next to take up the stick to speak. As she stood, she reached into the neck of her loose dress and pulled at a cord. Many were amazed to see what she wore. The beautiful Hei Tiki, that grandmother had carried every night bar this one, was now hers. Holding that Taonga at the end of its cord she raised her head high and spoke.

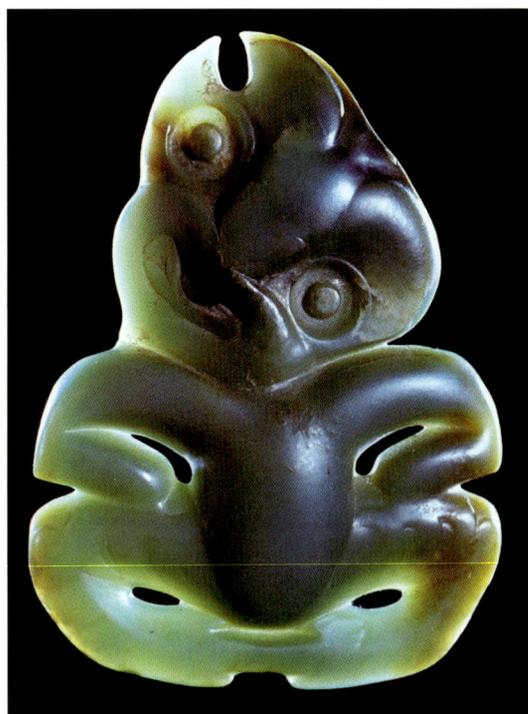

'You see the treasure that I am blessed to wear. A taonga revealed so that I might share its story. It is of the oldest of days, of the time of the families that followed only the peaceful ways. It was cut from a Stone gathered from the Arahura, a river sacred to our peoples, lifted from the waters in answer to a dream and named.

'The first cut, that slow grinding of stone on stone took many month, then this Taonga in the making was set aside for a generation.

'In a later time, another of that family was called to the Stone to make the next cut to free it to its journey. When that was done it was set aside until another child was born who had the hands to shape the first curve for its face. And when that was done, it was set aside again.

'This happened over many generations so that over time, the Taonga was filled with the Mana of all who shaped it and all who cared for it.

'When it was finally completed it came to the women of the family, for they were its guardians. Now it comes to me to travel with our child as it makes its

journey into the world. It will be with me day-by-day and at the breaking of the waters. It will be at the blessing of the one Koro has named Quasar, and when the time is right it will move on again.

'Kui and Koro, my heart goes out to you and carries with it great Aroha.'

As she finished, Day Star returned the Taonga to its warm place. It rested near the little one surrounded by the tides of creation. Then the stick moved to Rata who looked at it for a long time before sharing his thoughts.

'I have few words to add. Those who have spoken have said much that I might offer to my Koro and my Kuia. Koro when you named me Rata, you made me look deep inside. You helped me see that my need to hold everything close smothered that which I cherished. We have fished the afternoon tide together, Silver, Huia and I, sharing more in those moments than in many a year. And there is more, for I revel in the magic of the Rainbow Mind.'

Silver passed the stick on. She had spoken with grandmother before the gathering. They had shared their thoughts on the power of the aloneness to teach and to heal. Her life had turned a corner.

Huia held it close, for she wished to speak. At thirteen years she stood poised on tides that swept aside the childhood years.

'I came to help get firewood. That was fun. I loved the beach and even caught some fish in the river. I met cool people like Torrent, Echo and Tamatea, and hope to see them again. I want to thank you for letting me ask so many questions. That's all.'

Flame was next to speak. She looked at the talking stick for a short while, smiled and moved as if to feed it to the fire. The laughter that echoed off the cliffs was applause for the fire keepers who kept the flame alive through all those days.

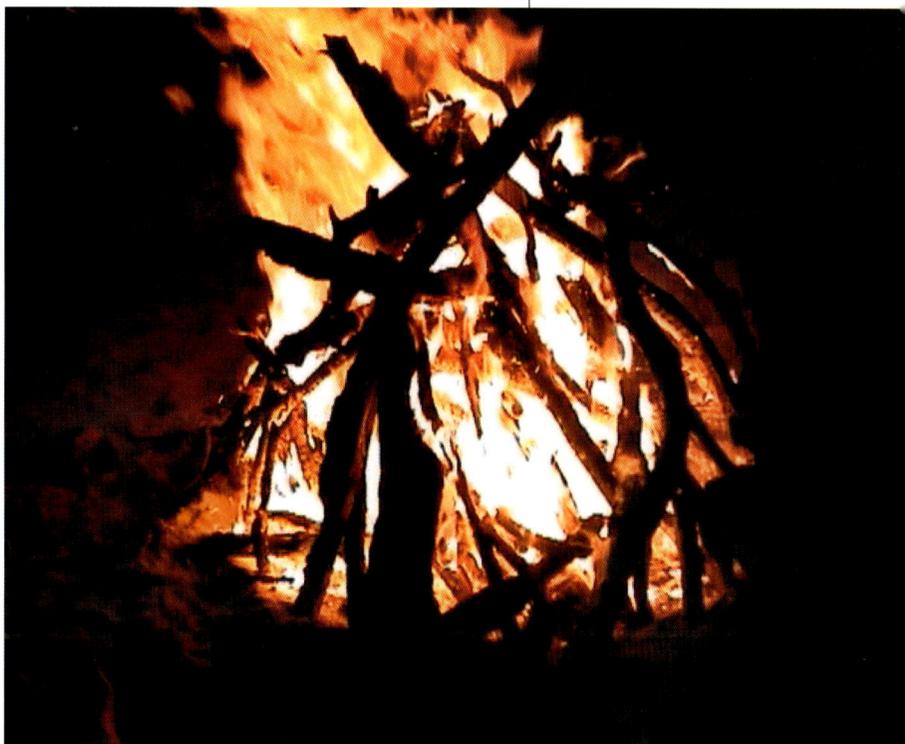

293

'We came as a family, came to have a holiday in the bay at Koro's invitation. We knew he had a bigger plan when he began to give us new names. Smoke is perfect for that little one who drifts so swiftly in and out of our lives. Spark, of course says little, for he ignites the flame, he is the quiet one who starts so much in his own special way and is always there to see it through. He never left this fire. He was so determined it would not die he shifted our tent close by.

'It's been a wonderful time for all of us. We understand we are of the old Fire People, we know the trees that hold the fire children and give life to the flame. We have found ourselves again beneath these cliffs.

'Smoke told me to say he will miss all of you, but wants me to send a special message to Scree, Mist and Rain. He wants all the parents to promise the children can see each other again.'

Before the stick could move on Emma placed her hand on it and set it before her as she gathered her words.

'I came late, I'm sorry for that because I think I missed important stuff. However, I think Echo, Mountain and Nova helped me to catch up. I'd love to do this again and if Anaru and Tamatea walk the Peace Trail I'd like to go too, if that's okay. Loved the conch, Echo. Thanks everyone.'

Kea now received the talking stick. She was determined to speak, because she thought it was great that children could have a say.

'People listen to each other here… they even listen to the children… I think every house should have a fire to sit around… and a talking stick… I'm sorry for White Eagle who had to look after me every day… but I really wanted to stay… I love you all.'

Fran and Mick held the stick together. This close couple had raised a fascinating family. Mist had stolen many hearts with her quiet elusive ways, Torrent had startled some with the reach of his mind and Rain balanced all of them with his hands-on approach to life.

'I came to this circle from a German background, carrying things that are not often spoken of, pain that lingers within a nation,' shared Fran. 'To you I am just another Kiwi and secure in my place. Yet, that is not so. My parents escaped the Russian advance and worked their way to this land. It was not easy for them, but they made it, because my father had a clean slate. They had survived a madness that few outside Germany can imagine and yet they felt the guilt of association with the Third Reich. That was our Long Dark Night.

'My parents found acceptance on the West Coast and that's not easy, unless you are born there. But Dad's engineering skills and his reliability won the day. Mother was a nurse, a good one and that helped. Many in Blackball came to her before they went to the doctor. Especially the women, who had concerns about their children and were too poor to pay. While saving them many a penny, she ensured those in need reached the surgery.

'Meeting Mick, having our kids, creating a home and a family was just great. Yet, there was always a past to be healed, something that got in the way. Kui and Koro, you have changed all that. You took me into the Long Night of the Patu, the Night of the Muskets and Horse Soldiers and revealed to me the depth of my country's pain. You helped me understand that, while I cannot change the past, I can heal it.'

When the talking stick went around once more, Salote held it tight. She had come to the circle as often as possible and while involved was rather shy. Surfing the big waves was her passion.

We come once more to the circle, to an ancient site that honours its power and remember we are of the Beginning that is without end.

'I arrived here by chance, or so I thought in the beginning. And found in my first hour why I came. The sudden death of my darling baby, a girl who had yet to be named, devastated my world.

'But here I have learned to feel my pain, to accept it and hold it close as I might a child. I ran away to ride the waves, left family and friends behind, but I return now. What I feel, I know I can heal. I have journeyed through that empty place I tried to fill with the ocean.

'My gift to you is a song that I have carried from the elders in my village.'

Salote's song was a lament for those lost forever within the tides. It was her farewell to the sadness that had overwhelmed her life. It moved many to tears.

White Eagle was the last to speak this night. Great excitement swirled within him, fuelled by dreams that might take months to achieve. He had shared them with Rusty, but only that old one, for the Kaumatua would have it no other way.

'I have experienced the Sun Dance and the Vision Quest and now see them as a stepping-stone to these days. How do I thank you all for the spirit in which we have met? How do I begin to thank my Koro and my Kuia for the knowledge shared? How do I put into words the wonder I feel for the way that was done? I have my path and that stretches before me and will come to completion in its own time. So I leave you with a mystery, knowing Koro will enjoy that, and I leave you with the promise that the mystery will be set aside one day. Peace be with you.'

Eternity walks with us every day

Grandfather sat with his talking stick when it returned. It had travelled the circle and all who wished to speak had done so. There were few words left to say, but it was hard to let go of this night. He looked at the children and felt love surge, they brought so much joy and taught wonderful things without intention. He looked to the others and felt content. It was time to move on.

'We come now to Te Hokianga, "the returning that takes us to the beginning that is without end."

'Our journey is back to the new beginning where we accept time and change, understand the darkness, greet the light, move with the Moon and the stars, honour each other and walk courageously into the future together.

'Then we will know the awakening, the wondrous turning within the circle that is without beginning or end. Then we will truly be the difference that makes the difference. So be it and may it ever be so.'

The Sun rises to a new day, a bird reaches for the distant horizon and the dream shared flies into tomorrow.

Those who sat around the fire knew they finished early, that the new dawn was hours away, yet it would come and its light would touch the hills and reflect off the waves. The dream shared would go forward into tomorrow. Its time had come. It was of the Eternal, of the sacred river that flowed through the Universe and within each of us.

Grandmother felt warmth deep inside and its name was hope; she saw a place for all in this land. Words filled her. They would be her final gift.

'Let us visit once again the Dreaming, the trails the Ancestors walked and the vision they gifted to these isles. As we travel let us remember the Dreaming is anchored in the land and the waters, and in the lives of the people and reaches out to the many realms of Spirit and the Stars. The Dreaming is born of the extraordinary awareness of the awakened mind, the Rainbow Mind that brings

forth the promise. It is time to hold the stone and the star in our hand and walk the truth of our journey.'

Then ever so slowly, grandfather stood to place his last words in the circle. The night had lifted his heart and stilled his deepest fears for his children.

The flame of knowledge was not dimmed; they could stand tall to face tomorrow without him. His karakia, the chant for the opening of the trails, rang out with new courage, great strength and purpose.

KARAKIA

Reach for the light as it passes through the stones, take it in your hand, bring mind and spirit into the space between to walk the trails of wisdom.

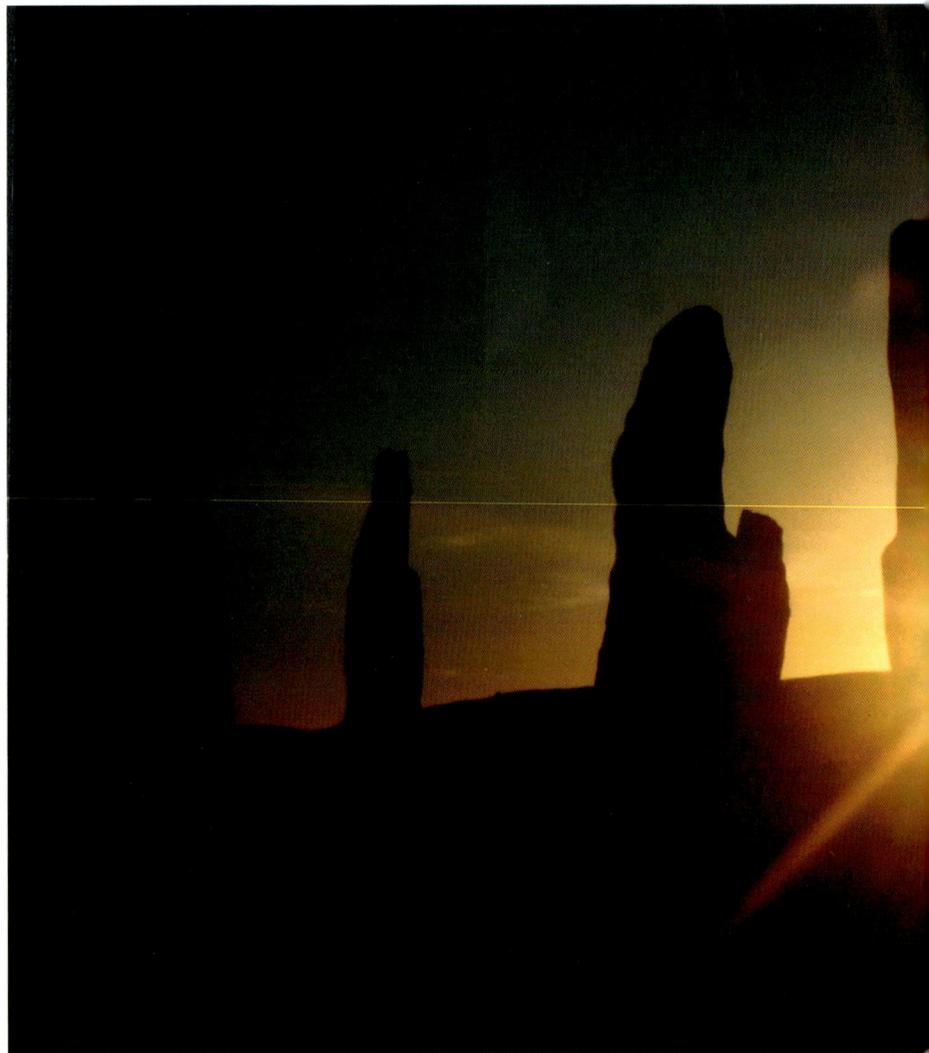

And his words reached into the fire to rise on the smoke to the heavens, spun over the waves to meet the waters and join with the long tides, rode the winds to rustle through the trees, moved on to greet the high cliff top, touched the stones and entered within and found the hearts of the people.

'Remember, if we lose our story we lose the dream
and if we lose the dream the spirit dies.

Be the dream, for the dream is you.
Be both the singer and the song.
Be all you were born to be.

And remember to be gentle with yourself,
for we are all Children of the Universe.

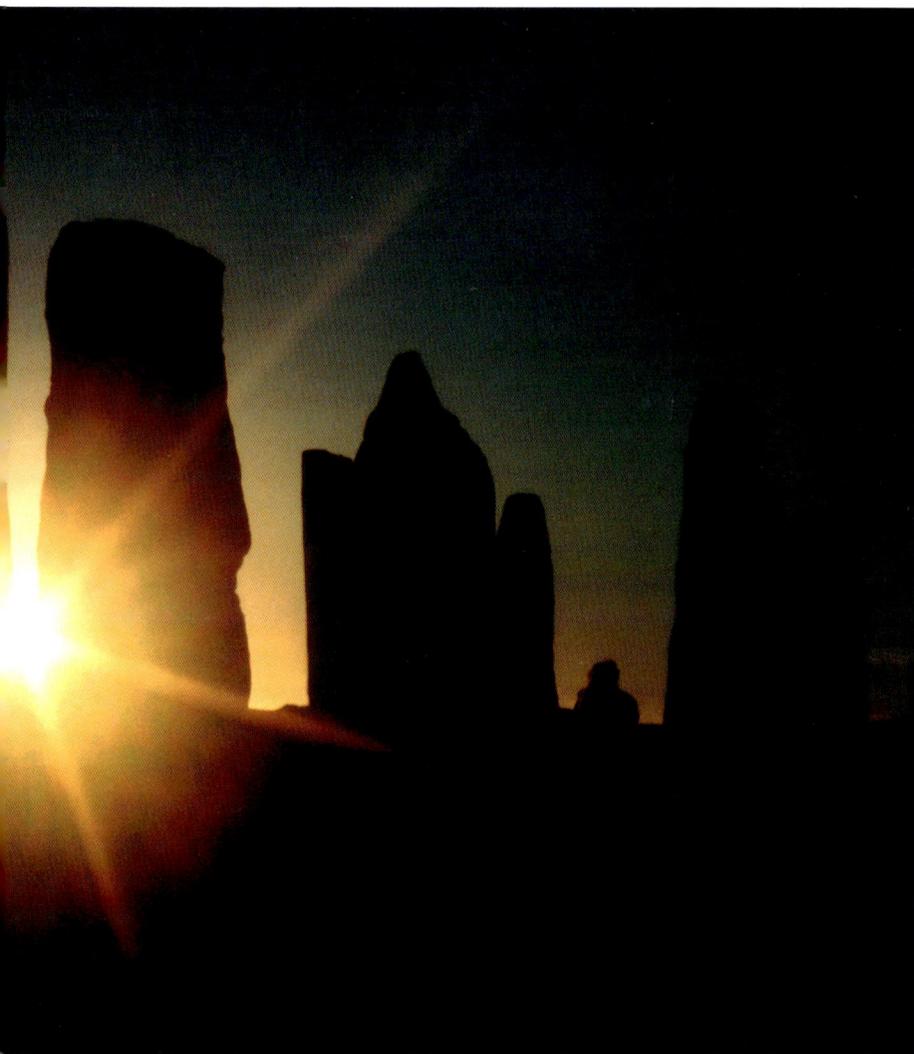

Thus do we come to the end that is of the beginning.'

'In the Beginning…

THE LATER DAYS

A year later, almost to the day, the circle came together. We gathered to be with grandfather in his eighty-sixth year. We came with our hopes and our tears. It was the old one's tangi, the time of weeping.

The piercing call of the karanga drew us into the Meeting House and words of welcome. Many came to farewell the old one. Grandmother held us close, each and every one. Then she took us to him, led us to Koro's resting place in the depths of the House where a single candle lit his lined face. Beside him was the wakahuia, the treasure box still filled with grandmother's living stones.

We formed a circle around that tiny flame and wondered how to say goodbye to such a special spirit. Yet, as we offered our gratitude and tears, we knew he was still with us, in remembered laughter, in insights shared and teachings that grew deeper year by year. Also, we carried into the house names he laid upon us, names like Flame, Spark and Smoke, Mist and Mountain, Day Star, Torrent and White Eagle, names we held close. And little Quasar of course, who took his first steps on the marae lawn.

There was no escaping the reach of Koro's gentle hand or the touch of his heart. Goodbye had no place and farewell no meaning, when all we are and might be, was joined in this circle.

"Journey well," were the words he so often left with us. "Journey well, Koro," were the words we now gave in return.

The children came with gifts to leave with Koro. Smoke gave him a whistle he made out of a piece of bamboo. Scree had the little piece of Pounamu he found on the beach at Arahura. Mist left a poem about the day they all used water to cleanse the blood off the Patu. Rain had etched three words into a smooth beach stone. It simply said, "Love you Koro." Kea was last of all because she had to retrieve her gift from outside the door. It was the wonderful little waka carved by her Poua. All these gifts stayed, but for one.

When all had taken their moment to quietly offer the old one their few words, grandmother signalled to Hans to switch on the lights. The stunned silence that followed would have rocked grandfather with laughter and delight. A circle stood outside their circle, a circle hidden by the darkness that defied the candle's light, a circle of Pouwhenua standing tall, twelve in all.

No word was spoken; just a turning of heads, a silent appraisal, a growing understanding and finally, the realisation that it was all here. Every night of learning, all the old ones shared, was captured in the artist's vision, captured in powerful shapes that honoured the spirit of the words.

Grandmother walked over to White Eagle, embraced him and in thanking him with whispered words, confirmed that the Pouwhenua were his work.

Then she said…

'In the beginning we felt inadequate, too old and too out of touch to be of use. Yet we did our best and hoped it might be enough. In return you did your best. Our best and your best challenged us to stretch and grow. Ae, perhaps it was enough. Koro would love to think so.

'Koro blessed these beautiful Pouwhenua. We slept beneath them before he left,' said grandmother, in a voice that held a strength that leapt far beyond her words. 'We knew long before the Pouwhenua came, that the seeds sown in the night had taken root and flourished. We heard it in your letters, the phone calls, and the family visits to the bay.

'Out of the darkness surrounding our fire on that first night, we have created a pool of rainbow light. And if we need to be reminded of our journey, need to see how far we have travelled together, the twelve Pouwhenua stand tall to mark the trails we followed.'

As grandfather was carried to his last resting place, grandmother carried Kea's waka and when the last words were said and the last chants sung, she gave it back to the little one with these words.

'Koro wants you to look after this for him. He told me it is a waka of dreams and that it is for you to carry into tomorrow. Do that for us, little one.'

They said that in the end his heart gave out. But his heart didn't fail; it simply wore itself out from so much giving. Koro was Aroha and gentleness, laughter and wisdom, and the promise of things to come. So his work really begins with his passing.

The circle is even stronger now and grows day-by-day. And grandmother still holds the centre where the fire is brightest, and we hold her and pass the promise on.

Light the fire, tend the flame, journey in peace

Ahi Kaa…Bright Fires

'E muramura ahi kaa ki uta
E muramura ahi kaa ki tai
Kia korakoragia muramura o ahi kaa

May our fires burn brightly inland
May they burn along our coast
May the sparks of our bright fires
Be seen by all'

With these words from the sacred
fire ritual of a very old world,
we open the way for your journey.

Tend well the Fires of Hope!

Kia Kaha!

Have courage,

walk your truth!

Journey well!

'TE AO HURIHURI...
THE WORLD TURNS'

We are space travellers,
Life givers, truth seekers,
Bearers of gifts sent down though time.
We are more than we ever see and know.
We are spirit sublime.

THE TWELVE POUWHENUA

Pouwhenua are a part of our past. Tall standing posts were used to make a statement, to announce to the world that something special was in place. So it was no surprise Maaka Tipa chose this shape when he decided to bring the nation's story to the fore.

The Pouwhenua hold the Wairua for each chapter of the book. They capture the stories in ways that bring old wisdoms into today. In living with the words Maaka came to understandings that transformed them into totems that stand tall. They bring a startling edge to the stories, lift them out of the mists of the past and make them relevant to this time and the coming days.

While the uniqueness of these pieces sets them apart from other Maori art, they retain the essence of the old ways. Traditions bound in truths that abide are forever at their side.

TE WHANAU
The Family

When we step into the world of the Ancestors and travel into the depths of the past, so much is asked of us that the journey cannot be accomplished alone.

The lines that draw us there are paths of courage and insight, for we travel to discover the old ways anew, to explore the wisdoms of life and reach into the Trails of Spirit. So we go deep within ourselves and walk paths that cross the barriers of Time and Space and learn that in the end it is family that holds us in place.

The weave that shelters us grows stronger day-by-day. It is founded in family honouring family to nurture those who walk the margins where truth holds sway.

MAAKA TIPA

My journey with the Pouwhenua

From the outset I felt the pouwhenua needed to speak to the world in the materials of today. I wanted to bring the wisdom of the past, the teachings of my ancestors, into our lives in a very contemporary way. I wanted to say their voice still has a place by going beyond the traditional carved forms into something very different. So I used the old concept of the post imbedded in the ground as a marker, the wooden pouwhenua, and added natural fibres, paint, worked stone, iron rods, steel bolts, fired clay and resins. That's how I chose to acknowledge the past and the present and give hope for the future.

Creating the pouwhenua was like coming home. I set out on that journey feeling like an adopted child who did not understand how it fitted into the world. My behaviours, my mannerisms, my dreams and visions were born of ancestors lost in the mists of time. Yet, as I worked on the pouwhenua, the veils between lifted, the mystery dissipated and I began to recognise who I was. I gained a sense of turangawaewae, a standing place, a belonging and discovered a voice for my song.

That understanding was deepened by my participation in the Sundance of the Lakota Nation. There I learnt to connect with all the families, to treasure those who saw within me the ability to manifest the pouwhenua, and to accept the support that was offered by those who gathered to the work. This created the space for me to be open to the old ones who wanted to come into the now, it allowed the love of the peaceful peoples to flow into the pouwhenua. It allowed me to find my old Waitaha roots.

That connection helps me place before Uenuku, my marae at Moeraki, and all who hear this voice, my love of the old lore. I strive in my work to honour a heritage born of many iwi, a spirit founded in the sacred that defies time and goes beyond ownership.

So I have stepped beyond. And in that journey I have discovered the Ancestors and looked deeper into myself.

Chapter 1. 'Song of the Spirit of Creation'

Depicting the Unseen One, the Creator we know as Io Mata Ngaro, took me on a journey that remains unresolved, for who can begin to understand the meaning of Te Kore, the Nothingness, or truly express the power of the Beginning of All that is.

I brought together two symbols in my quest to express the Spirit of Creation — the circle, which seems to be a universal expression of completeness, to stand for the Creator — the koru, the unfolding fern frond that signifies the promise of growth. That's why the aspects of Io that Io sent into the Void to seed Creation, are found within four circles of light. And why the frame that supports the circles reflects the unfolding of life symbolised in the fern frond.

Through these symbols I am bringing Io, who knew everything but couldn't experience Itself through Itself, into the Nothingness to seed the Beginning of All.

The Mana: I saw the Mana, the essence of Spirit, the everlasting seed as being transparent and devoid of pattern. Yet, the heat generated as the resin cooled made it opaque and created interwoven strands. I felt this "accident" left me with a circle of enlightenment shaped by hands that reached far beyond my own. In those strands I see connection, the lines that join everything to the moment of Creation and the miracle of life itself.

The Mauri: The creation of the Mauri that gave movement to the Mana led me to form two embryonic fern fronds in the mould. This time, to my surprise, the disc remained bright and crystal clear and retained the images I moulded for it. I love the sparkling clarity of this disc because it expresses the explosive, creative excitement that is the mark of the Mauri.

The Maui: The third circle has a clearly defined koru, the unfolding of the promise in the cycle of death and life. Yet, in reshaping the Mauri, in bringing design and form to the excitement, in harnessing the gigantic forces unleashed, the Maui has to give of itself to contain the Mauri and save it from destroying itself. Thus the outer edge of the Maui circle is broken to show its loss. That irregularity says everything is constantly changing, reforming, and renewing. Everything is of the Becoming.

The Wairua: Two spiralling streams of water meet within this circle.
They represent our body that is of this world and remains when our life on Earth is done, and our spirit, which is eternal and moves on. This is about aroha, the coming together and the love that is the first lore of the universe.

The Fishing Ties: The fishing line that holds the four discs in place stands for the ties that bind us to our forebears. In the past my ancestors were bound to the Earth and its rhythms, and through that knowledge they survived. I am bound by invisible threads to my ancestors who lived that I might be. I am the sum of all that has ever been. I am tied to the past by blood and heart and mind, tied to family. I am not an island. So these invisible lines affirm that my life is anchored in the past.

The Base: The base that supports the Pouwhenua is the foundation upon which we build our life. It asks me to think of my ancestors, to remember the vision they carried forward and to dream my dreams and walk them into tomorrow.

The steel brackets that support the pouwhenua make me face the present. While I can learn from the past I do not want to become lost in it. The steel bolts bind the past and the present together and ask me to build on a base that is wisely founded.

Chapter 2. 'Song of the Fire of Life'

This Pou tells the story of the creation of life on our world. It brings to the fore the strength of Tane, the great one sent by Io to clothe Earth with trees. That's why he stands tall like a tree.

Tane came with the power of Spirit to create a physical being, a female, from clay. He did not make a man first, for he needed to bring her out of the Earth Mother, from 'Papatuanuku', a human form that would provide the nourishment needed to sustain body, mind and spirit.

In his strength, Tane embodied the male essence that was gifted to protect the nurturing spirit of women. Tane reminds us to honour the balance, to acknowledge that ability is of many kinds.

My people taught me the lore of balance through the fish we know as flounder, or Patiki. I would like to share that teaching with you because it flows into much of this work.

The Patiki: The flounder's shape was used by my teachers to explain the relationship of men and women.

The role of man: The maihi is the sheltering arms, the strength the male offers and the skill to hunt and provide. The **raho** is the penis, a symbol of power born of the open mind and the willingness to seek and learn. When we bring the **maihi** and the **raho** together in balance we create the roof of the house.

The role of woman: The **u** is the breast, the nurturing mother, the nourishing of body, mind and spirit. The **Tara** is the vagina, the containment of life, the nurture of knowledge.

Losing the balance: When the **raho** of the man pushes for more power, it rises, and as it rises it distorts the shape of the Patiki. The roof grows steeper and the base narrows to leave the women and children unprotected. However, If the **u** of the woman is withheld the family is weakened.

The Patiki teaches me that every action has consequences. So it was constantly in my mind as I worked on this piece.

The Patiki

The maihi
the sheltering
arms

The raho

The u
the nurturing
breast

The tara

Tane's tattooed thighs remind me the world strives for balance in the clash of the ocean and land, and in the meeting of the rivers and the mountains. And we seek it too, for the male raho only finds completion in the seed tides of women. Together we assure the continuance.

The Giant Eagle and lizard-like Tuatara in the tattoo are my signature pieces, for they are the wisdom keepers of my people.

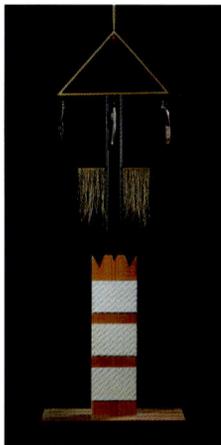

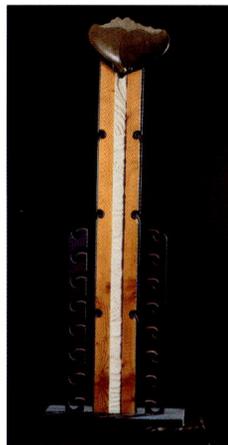

Chapter 3. **'Song of the Ancient Lore'**

This Pou is about the acquisition of knowledge and the choices we face in life.

The story tells us that Tane Raki o Nui chose the ways of peace and his brother Whiro chose the trails of anger and war. However, in my mind they are one person. I have Tane and Whiro within me, and strive to bring out my Tane and heal my Whiro. In the choosing I chart my journey.

The Arrow
I see the great arrow reaching for the stars of knowledge as the path of the truth seeker who strives for peace. It also stands for the sacred lore that flies the mind to free the spirit. When I ask the elders, "Who am I?" they say we are born of the stars and return to the stars. So I am much more than I know and more than you see.

The fibre strands that flow from the arrow speak of flight, of the dream that soars and the need to aspire. That's very important to me as an artist.

The Three White Baskets
The baskets bring into our lives the knowledge of the ancestors; for they are created of rock formed by shells, bone dust and fossils that tell the story of life on Earth over the last 45 million years. Here I acknowledge the wonder of all the ancestors and thank them for their journey. Their gifts allow me to aspire to gain knowledge, understanding and wisdom.

The Feathers and Beads
I used the larger feathers to catch the four winds to remind me it is important to keep the sacred pure and the small breast feathers of the hawk to seek the protection of prayer. The beads that hold them in place come from India and North America. They remind me that the truth we seek is universal, that it is bound within archetypes that defy the limits of race and culture.

The Jagged Edge
Above the three white stone baskets, the timber ends in a jagged saw-tooth edge. This is a sharp wake-up call, a reminder that it is easy to lose our way, easy to forget the old lore.

And it says more, for I see in its form the up-thrust branches of the giant Kauri Tree, the greatest one of all. My heart delights in this wake-up call — what was, still is, and with our nurture may continue to grow.

Chapter 4. **'Song of the Waters and the Land'**

This story is about the great oceans and the land, which shift and shape with a power that speaks of Gaia, the living planet.

Change
Change carried me into this Pou, for change is the constant in my life. When I look at the ocean pounding the shore I see change in every wave and the stirring of the sands. I carved the central column of whitestone to depict the land from the shore to the mountains. Near the base are the pebbles and sands of the beach, and above them the coastal dunes, the plains that rise to the foothills and the mountains.

The Land was once a Whale
At the peak of the Pou we come to the flashing fluke that reminds us the old ones say the land was once a Whale and that everything changed when it went deep and stayed beneath the tides. When I was about to cut away the excess sandstone above the Whale's tail a voice within whispered, "Leave it". A little later I saw that extra stone was waiting to become the mountains.

The Waka of the Gods
When the Whale disappeared beneath the surface the land was formed out of the Waka of the Gods, a mighty double-hulled canoe, depicted in the long timbers of the Pou.

It happened this way. The Waka of the Gods sailed the oceans for many generations. Then came the day when the Great Deluge struck, shattered one hull and left the crew of the other in so much pain, lo turned it into the southern island. The mountains covered in snow are the crew. Their strength and courage is there to see at the dawning of each day.

The Old Tides
The Waka of the Gods is flanked by the Old Tides, the two great oceans of the world that meet on our eastern and western shores. They stand very tall because they are the tapu and noa waters, the waters of the gods and the waters of the people and their meeting creates something very special.

The Fish
Of course this story ends with Maui catching the Fish that became the northern island. Now the Whale's fluke becomes the Sting Ray that our ancestor hauled to the surface.

For me this Pou speaks of travelling into the beyond, about leaving familiar surroundings to look back through different eyes. The elders describe this as "flying the mind", for it asks us to see our world through a different lens.

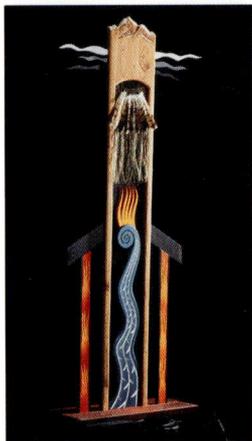

Chapter 5. **'Song of the Sacred Promise'**

Although this story is about the exploration of our land and its settlement, for me it also carried the message of loss.

Loss of Fire
In the Maui story the great navigator stayed so long in this new land that his people ran out of fire sticks. So the first loss was warmth as the winter snows covered the mountains. When Maui went to Mahuika, the Keeper of Fire, and asked for a Fire Child to nurture, he accidentally dropped it in the river. The amazing tumult of steam it produced and the rainbow colours that drifted in the wind excited him so much he deliberately threw the next Fire Child there as well. This event is shown in the blue fountain rising up from the base of the pou.

Scorched Feathers
Maui had dishonoured Mahuika's gift by giving her Fire Children to the river. Angered by this betrayal she pursued him into the forest where she attacked him with tongues of fire. In desperation he called for help and was heard by his grandmother who turned him into a hawk, but as he climbed aloft the flames reached out and scorched dark bands across his tail. Hawks carry these marks to this very day.

The Rains Came
The fibres below the Hawk's tail feathers are the heavy rains Tawhiri Matea, the Keeper of the Winds, sent to help Maui. However, the dark clouds gathered so low and the storm was so great that it threatened to destroy all the Fire Children and leave the world without their comfort. Five brave trees saved Fire. They opened their arms to the Fire Children, gave them shelter from the rain and hold them in trust even today. So only five precious tongues of fire remain.

Looking Deeper
Of course the story of Maui and Fire has a deeper meaning. Maui stayed here a long time, stayed not out of foolishness but out of need, for there was much to be done if he was to honour his promise to open this land for his people. When he saw their fire sticks were running low he went into the forest to discover which trees held Fire Children. He didn't take fire away he gifted it to the people.
On my journey I have been told many things and not all of them are correct. I have learnt to seek my own understanding within the stories and carry only those things that ring true for me. If I just accept all that is set before me I lose a bit of myself, lose my truth and become the instrument of my own confusion. When I follow my truth I rise above all that is happening in the whirlpool of life. I suppose that's why I find inspiration in the eagle's soaring flight.

The House
The sheltering roof of the house is the maihi that we met in the shape of the flounder. Maui came to build a new world for his people, a new house in a new land. In this part of the Pou we are told to build well, to remember what might be lost and to remember actions have consequences. When fire and water mix we create a strong reaction, the powerful third aspect of their meeting. The three fingers carved into the end of the barge boards of the house remind us to seek knowledge with an open mind, to be ready for the unexpected and to explore all the dimensions of the heart and spirit. The house brings us back to the need for balance. The fiery colouring of the base and the fire that runs through the walls, remind us to build on a good base and tend the walls well, or the house we create can consume itself.

The Tree
I also see this Pou as a tree that provides food and shelter for the birds, holds the Fire Children safely in its arms and allows a river of sap to run its length. The tree honours many tides.

The Mountains
The snow-covered peaks affirm the lore of the ancestors who said, "All who sleep beneath the mountains of this land are of this land."

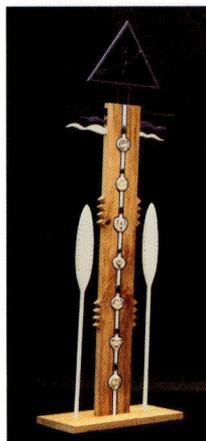

Chapter 6. **'Song of the Trail Makers'**

The Trail Makers were the great leaders who followed in Maui's footsteps to build a strong house for the people. This Pou is about commitment, for it depicts the brave ancestors who honoured Maui's promise to care for the land and live in peace. So it made me reflect on the task I had undertaken, on my journey with the Pou and where they were going. I knew I had to honour my words, and move with belief in myself to complete the challenge I had accepted.

Land, People and Spirit
As I approached this Pou I discovered I was working to integrate the land, the people, and spirit. The main section is the Waka of the Gods, the southern island, which is the focus of this story. The seven ancestors identified by their facial tattoo are the Trail Makers. The white line, bordered with purple, that runs down the centre of the Waka is spirit moving as the ancestors walked the Mana through the land.

The Shamanic Mind
The Greenstone third eye placed for each ancestor reminds us that the ancestors were trained in the power of Te Wai Pounamu, the mysteries of the stream of ultimate awareness. They moved with shamanic power, with the Rainbow Mind to join the mountains and rivers to the stars. The threads of light that touch the stars are the karakia used to accomplish this work. They create a subtle koru, a fern frond image, an unfolding that heralds promise and growth.

Within the star triangle, fashioned by the power of three to honour old lore, is the Southern Cross, the anchor for the six Tuahu, the stones placed to hold the Line of Life and keep the Waka of the Gods safe. It is bordered by purple to hold the sacred. The black, purple and white wave symbols beneath the star triangle speak of the layers of the mind and of its great power when aligned with heart and spirit.

Reaching Beyond Ourselves
This Pou is about reaching beyond. The great arrow calls for us to reach for the stars, to ascend, to explore the power of mind and spirit. The two paddles urge us to go forward. One paddle stands for journeys made and the other for journeys still to come. Commitment and achievement, challenges met and overcome with wisdom and courage, are the message of this work. It honours brave ancestors and inspires us to take up the promise they carried through the land — the promise to nurture it and walk in peace.

The four arrowheads that carry the eye outside the waka stand for the power of the open mind that looks outwards, the mystery of the four directions, the acknowledgement of the many peoples of this land and the family of nations of the Earth.

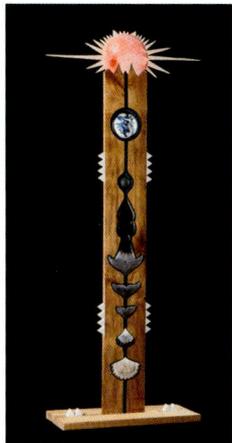

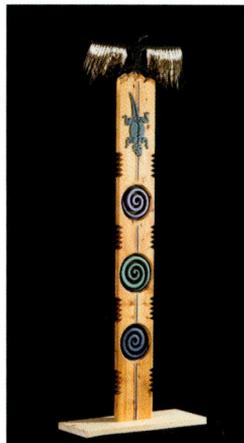

Chapter 7. **'Song of the Eternal Tides'**

I love this story because it explores the invisible threads that tie us to the universe. As I progressed further and further into the Pou, I found again and again one word gave me the starting point. However, this one asked for two, "connection and oneness".

Kinship
This Pou acknowledges that all are kin, that we are no more than the fish, the birds, the trees, or the stones and are connected to them by great tides that are vital to our lives. I saw Earth as a space capsule that moved around the Sun and was joined in that journey by the Moon. So the turquoise, star colour that vibrates through the Pou, expresses our connection with the universe and the creatures on Earth.

The Sun
We are bound within the solar system so the Sun stands above all, for it gives us life. In creating the Sun I stretched two of its powerful rays out either side to make a horizon. That image asks us to step beyond the near horizon, to seek the greater story and explore the power of the light. I cut the wood at the top of the Pou to form mountains that suggest the Sun is rising or setting behind them. This early and late Sun, bathes the land with a gentle, diffused light that evokes the thought that the Sun and Earth are one. The energy of deep space and powerful solar winds, penetrate our bodies every day. So I ask myself, "As this energy passes through, does it leave something in us, and as it leaves does it carry part of us with it? Is part of me already voyaging to the stars?"

The Moon
While the Pou is a masculine shape, at the core of it is a woman who is joined closely to the Moon. Here, I wanted to remember we are all influenced by the Tides of the Moon, for its pull extends beyond the oceans to reach deep into our bodies. My ancestors worked to the Tides of the Moon, sailed the oceans in their power, carried the precious Pounamu over the mountains to its cry, fished and planted according to its lore, and thrived. To catch the essence of this relationship, I acknowledge the blood tides of the seed that flow through woman at the call of the Moon. That wondrous tide brings the gift of life.

Whale Flukes and Bird Feathers
The oceans' creatures and the birds also move to the pull of celestial tides.

White Light
The white arrowheads that project from the sides of the Pou and sit upon its base honour the four directions, ask us to seek pure knowledge, clear understanding and symbolise the joining of all the nations within the oneness of life

The Future
This Pou challenges us to step beyond ourselves, to create a future built on the wisdom of the past, the best of today and the understanding that we are children of the universe, not a race apart.

Chapter 8. **'Song of the Rainbow Mind'**

This story is about special dimensions of the mind, about the power of altered states used by the ancestors. I saw this as the shamanic mind.

Trust
Trust was the word that called me to this Pou. It was about allowing myself to be pulled into scary places, being open to new things, sitting on the edge of the void and letting go.

That kind of trust meant listening to my intuition, to a knowing that allowed me to be closer to the world of the ancestors. My journey into trust began with a vision quest before a Lakota Sundance. During that time of fasting I experienced an altered state and saw that Poakai, the giant eagle, was my guardian spirit.

The Birdman and Tuatara
So I called the Birdman to hold the summit. It is like a Phoenix rising out of the ashes, for it echoes the images created by my people on cave walls long ago. It speaks to me of the courage that flies the mind where others fear to go. The great eagle opened the way for Tuatara, the ancient one who we must pass on the way to the storehouse of the sacred knowledge. Walking with Tuatara meant entering a world inhabited by a powerful guardian who sees things we cannot begin to know or imagine.

Three Koru
Trusting the old one I allowed my mind to listen to my heart, found inspiration in the journey and saw the need for arrowheads that turned inwards to pierce the Pou. That allowed me to be pierced by the knowledge, allowed it to become part of me.

Now I saw three koru sitting upon a circle of black that spoke of space and infinity. The upper koru unfolded in purple, the colour of spirit, the middle one became green for the Earth and the last, blue for the sea and the sky. Then the rainbow colours travelled up the centre of the Pou to connect all three as one. Now I saw them joined as family — three generations moving as one — grandmother, mother, daughter — grandfather, father, son. And that was not the end of all that unfolded, for now the past, the present and the future became one.

The Wisdom Keepers
Those who journey into the old lore have travelled this path for a long time. They know the trails that defy Time and Space, know the power of the stillness and the beauty of the ultimate awareness that we call the Rainbow Mind. They are tohunga, the keepers of the lore that is sacred and they walk with the shamanic mind.

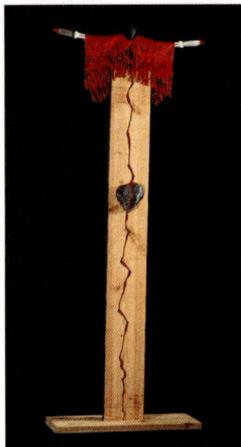

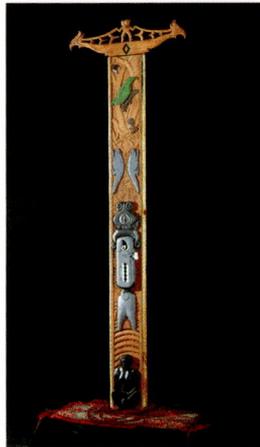

Chapter 9. 'Song of the Nights of Chaos'

The history of this land is like many others. There were times of peace and times of war and each in turn left its mark. Here we face the hurt of the past, face the blood left upon the stone and realise that while the past cannot be changed it can be healed.

Shades of Fear

This Pou is about fear. It is about Whiro who chose to walk the paths of anger and sowed the seeds of war. But deep down it is about me and about you, about all of us. When I was younger and threw myself into a martial art, I was thrilled to feel the wiwi, the wawa and wana, the raw feeling of power that flowed when adrenaline surged through me. That rush threw me to the edge of chaos, forced me to question why I felt that way and asked me to look into the mirror and see the shadows that sat at my side.

The Empty One

So I began this Pou by taking a naked flame and burning the dark side into the edge of the wood. Then I saw Whiro as a skeleton, an empty being consumed by anger and strife, so I built him of bones and gave him sharp steel blades for hands. He had lost the ability to reach out and hold. I cloaked him in blood and let it flow in a narrow stream down the walls of the past until it reached the most sacred of stones that is shaped like a heart, the precious Pounamu.

This brought me to a place of tears where I remembered the death of my people, the death of the peaceful ones who refused to take up weapons when the warriors came. And I think of the power of their last words, "How we live is more important than how we die."

The killing did not end there, for the blood flowed on through the long nights of revenge when warrior stood against warrior, through the long nights of the musket when the regiments came to seize the land and diseases unknown to these shores carried off the people.

Healing the Past

Blood spilt in the past rides the tides on memory to leave its stain on today. This Pou says this is our story, this is the legacy of centuries long gone and while we cannot change what happened it is time to heal it.

Perhaps the outstretched arms of Whiro are saying enough is enough, we cannot continue to feed our anger this way.

Chapter 10. 'Song of the Spirit Guardians'

I see in this story the ancestors in all their wonderful forms. Here I acknowledge all the creatures of the Earth as my cousins.

We Are Never Alone

In the Chaos we lost our way. All of us, and it is time to step beyond blame. This Pou reminds me we are never alone, that the kaitiaki, the guardians who served our ancestors remain.

When I created the woman birthing a spirit child I saw her as Papatuanuku, the Earth Mother, the one who gifts life to all. I return to her now for she is my hope, my renewal, my new beginning after the long nights of Chaos. She is my home and my hearth, and the fire that fuels my life.

Seeking Direction

Above the Mother's head is the star pattern carved into the waka to guide the ancestors over the ocean. When we come again to the Mother we step out again, seek the new path, the better way. That journey sometimes takes us away from the familiar into challenging places, far from the shore. Yet, even there help comes for this is the domain of the whales, the keepers of the sea trails. For when we meet the Octopus that lives within the whirlpool at the meeting of the tides, we are confronted by the whirlpool of the mind.

The Place of Light

So this is a time of choosing, for some are tempted to turn aside, yet if we brave the danger and trust the whales, we win through to the gates of knowledge guarded by Tuatara.

In that place we dance in the light, delight in the flight of the Fantail that touches the realms of spirit, revel in the antics of Kea, the child that brings laugher to the day. Yet, the call to awareness, to the need to honour all life is depicted in Huia, a noble bird. Long ago it left on its last flight and is now lost to this world.

Above us, standing tall, is the giant eagle that supports us on our journey. And carved in the centre of this lintel is the diamond shape of Patiki, the flounder that reminds us to hold the balance, with men and women walking as one to serve.

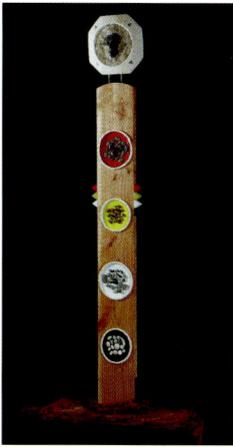

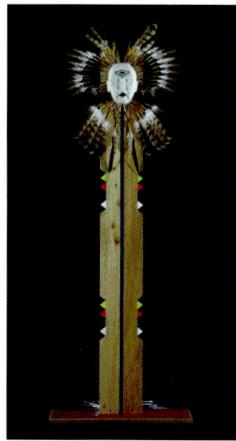

Chapter 11. **'Song of the Living Stones'**

In this story the living stones stand for virtues, for the values we might forge into the fabric of our lives.

"Be careful what you wish for, because you might get exactly what you seek, and more."

This Pou is about choices, about our dreams, about what we choose to be.

Seeking Deeper Answers
We live in dynamic times, face constant change, struggle with expectations manufactured by others and seek values that will see us through to a good life. "Who am I?" In the past I suspect most people found a quick, satisfying answer to that question, but not so now. As confusion fills our lives we seek deeper answers, wish to define ourselves as more than our jobs, our cars, our families and our religions.

This Pou presents four bowls painted in the colours of the four peoples of the world, different cultures with different values, and all facing choices at this time. The stones we choose to hold in our bowl represent our dreams.

Reclaiming Life
The stone-encased face at the top of the Pou is striving to break out. It is almost buried by the pace of modern life, by the shifting sands of pain that obliterate values and dreams. Fear, anger, guilt, envy, greed, work, drugs and other frailties prey upon us to crowd out life.

Yet, all is not lost, for hope beckons in the rainbow colours of the paua shell that mark the four directions. We can reclaim our life.

Chapter 12. **'Song of the Flame of Hope'**

The First was the Last
This last Pou was the first I created. That doesn't mean I saw the end of the trail before I began. Every step of the way has been a lesson.

This Pou came to me with great power. I completed it in trust not knowing its place, or fully understanding its meaning at that time. Looking back I see trusting the process was very important to the outcome. So the first Pou was in a way a test.

It was very contemporary in style and I was excited by the way it came together. It decided the shape of the eleven that followed. It was the frontrunner, the trail maker and in the end the one that brings us to our greatest hope.

One Heart! One Family! One World!
In this Pou the Giant Eagle spreads its wings to mark the end that is but a new beginning, for the journey is everlasting. And the four colours of the peoples of the planet join to honour the dream of One Heart! One Family! One World! And the blue thread of light that has moved from Pou to Pou brings together all that is best in humankind, for it honours spirit.

Ageless wisdom gathers to our side for the Old Tides still abide. New science brings us to a place of great excitement. It is time to put the ways of war aside, time to greet the future with the shining face that honours the power of the third eye and seeks peace for all.

THE ARTISTS

COVER & GATEWAY CARVERS

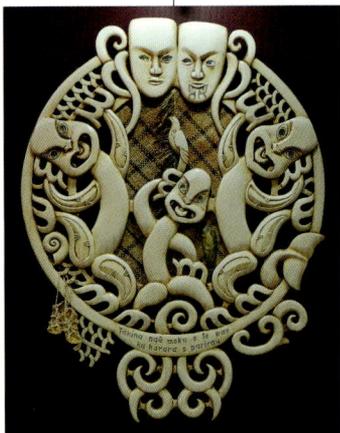

Chisnallwood Intermediate School, Christchurch
The carving used for the cover stands nearly two metres tall and was created by some thirty pupils aged eleven and twelve. Gavin Britt guided their journey into its story. Carved in twelve pieces, skilfully brought together to complete this treasure, this work reminds us our children hold great talents within.

Six key carvers worked on the gateway that opens the way into this book. They were Kieren Dunnill, Daryl Mana Montgomery, Cory Conrad, Carissa Horworth, Sam Payn and Daniel Leigh. The works featured on pages 118 and 259 were also created at Chisnallwood Intermediate School under the guidance of Gavin Britt.

Gavin Britt: Art educator for forty years, inspirer of children in carving, visual arts and performance drama. Craftsman, maker of old Maori musical instruments, teacher of teachers. Works created by children in his programmes are on display in Japan, in New Zealand schools, colleges of education, polytechnics and universities. Gavin acknowledges his European roots while embracing and honouring the place of our indigenous culture. Inspirational leader, educator and trail maker.

STONE, BONE & CLAY SHAPERS: Ian Boustridge, Michael Rarere, Robyn Barclay, Turi Gibbs, Gavin Britt, Maaka Tipa, Brian Flintoff, John Rua, Robin Slow and Mike O'Donnell.

PAINTERS: Victor Tokuafu, 'Hine Nui Te Po', Dxon, 'Koy – Yah – Wa Ma, Hopi Snake Priest', Andrew Forrest, 'Stone Man.'

PHOTOGRAPHERS:
Pouwhenua, artefacts, stills
Rob Tucker: Over 37 years as one of New Zeraland's premier photographers. A former picture editor for the NZ Herald his work has taken him all over the globe. Rob's photographs have appeared on the cover of Time International magazine (twice) and in many of the world's leading magazines. He has covered four America's Cups as Team New Zealand's inhouse photographer and worked privately for the Queen. A master photographer in every sense of the word.

Landscapes, natural history, history
Carl Thompson: Recipient of many photography awards. Known nationally for his detailed studies of flowering plants, insect life and wilderness landscapes. Competition judge, an elder statesman in the photographic world.

Derek Mitchell: Born England. Diploma of Fine Arts; Former senior lecturer in education media at Christchurch College of Education; photographer, print maker and well known as an artist in oils; art director for 'Song of Waitaha'.

Graham Wood: Ranger-Department of Conservation, with responsibilities for wild life; photographer specialising in landscapes, particularly mountains, seascapes and birds. Is published widely.

Dirk Nicasi/Marie Wilson: Dirk: born Belgium, NZ citizen; photographer and wilderness guide in Africa, Australia and NZ; established Rainbow Vision Trust with wife Marie, a 'self-help aid' project for African villages. A photographic skills/computer imaging team.

Kapil Arn: Born Switzerland. Respected for his journalistic photography of people and protest. Sailed with Mururoa Peace Fleet. Covered the Tahitian riots of the time. Artistic action and still life, landscape and people are his life.

Liz Campbell: Born Edinburgh, Scotland, Computer programmer with artistic flair and fine photographic skills. Specialises in botanical and travel subjects. Has comprehensive collections of Easter Island, Hawaii, Australia and NZ.

Gary Cook: Journalist, business leader, health professional, keen researcher of New Zealand's older story and regular magazine contributor. Enthusiastic photographer.

Astro Photography

James Tse: Born Hongkong, NZ citizen; M.Sc (Hons), Canterbury University, in physics & astronomy; teaches at Christchurch Boys High School. Published in Sky and Telescope, USA. Operates a 16-inch telescope from his home with the encouragement of his wife Aliena Cheung.

Philip Barker: Director of West Melton Observatory for the Canterbury Astronomical Society; lecturer in Astronomy in Continuing Education courses at Canterbury University; has published astral images overseas; builder of telescopes and space adventurer with camera and film.

Dr Euan Mason: Associate Professor, School of Forestry, Canterbury University, President of Canterbury Astronomical Society.

Other Photographers

John Ashworth, Kay Baxter, Jan Blythe, Barry Brailsford, Gordon Brailsford, Jonathan Carr, Anthony Clyde, James Dyer, Forest & Rural Fire Research, Canterbury University, Geology Department, Canterbury University, Wendy George, Adrian McKinnon, Hamish Miller & Barbara Russell, Neville Palmer, Craig Potten, Office of Public Works Ireland, Katja Riedel, D. J. Sanderson, Rona Spencer, Sandra Stock, Billie Taylor, Maaka Tipa, Barbara Todd, David Walmsley, Uli Walthert, Lisa Van de Water, Greg & Rose Wood.

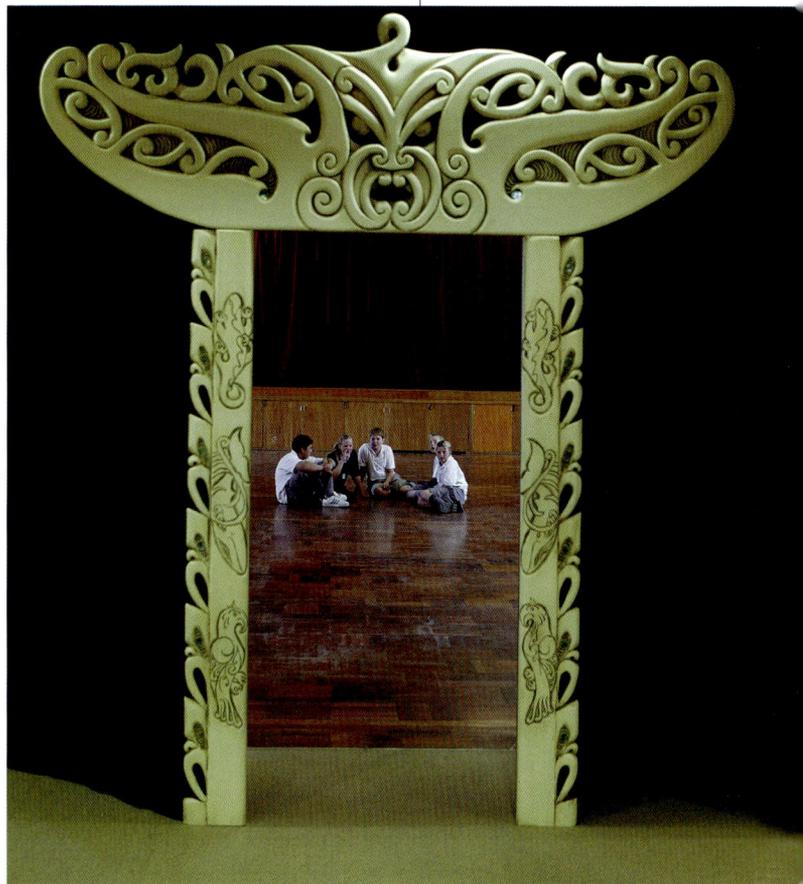

THE VISUALS

To attribute visuals note the page number and track the images from top to bottom.

GLOSSARY

Ae: yes
Aroha: love
Awhi: support
Hikoi: stepping out together
Ira tangata: the first spark of life
Iwi: tribe
Kau: no
Kaumatua: male elder
Kete: basket
Koro: male elder, teacher
Korowai huka: cloak of snow
Kuia or Kui: female elder,
teacher
Kumara: sweet potato
Mana: the indestructible spirit
Marama: the Moon
Mauri: the creative, shaping
principle
Maui: the organising principle
Noa: of the people
Papatuanuku: Earth,
the Mother
Poua: grandfather
Pounamu: greenstone,
nephrite, jade
Pouwhenua: a tall marker post
Ra: the Sun
Ranginui or Rangi: the Sky, the Father
Tangi: the time of tears, mourning
Taniwha: spirit guardian
Taonga: great treasure
Tapu: of the gods
Tohunga: keeper of the lore
Tokotoko: talking stick
Tuahu: sacred site marked by raised stone
Tuatara: reptile, guardian of the lore
Waka: sailing vessel
Wakahuia: carved treasure box
Waiata: song
Wairua: the moving Spirit
Whare: house
Whare Wananga: House of Learning

WE SINCERELY THANK

Te Whanau: Huata Holmes, Wayne Tipa, Donna Te Wahia and Katerena, and Tawhiri Karatai, for standing in the round house for the families to support Maaka and the words.
Long time supporters: 'Song of the Old Tides' is the end of a long trail that was kept open by family and friends, the stone circle members, the trail walkers and the stone carriers. Although too numerous to name you are remembered.
Book and Pouwhenua helpers: Ross Harrington for planning and building the exhibition round house, & Pearl, Ezmic Waller, Andy Amour & Mel Watson, Garrick Ferguson & Midge McLeary for supporting Maaka. John & Linda Ashworth for making the Pouwhenua and graphic design work possible. Elisabeth von Madarasz for a special contribution. Michael & Ann Maclean, Helen Moses, Jan Blythe and Paul Weber for proof reading. Ian Boustridge, Riki Manuel, Rex &Frances Ryman for the loan of artworks, antiques and artefacts. Gavin Britt for his inspiration and the work with Chisnallwood Intermediate School, Richard Paton principal, Kathy Baker teacher, and the pupils. Anthony Clyde & Tamzin Blair, for holding & shaping the work, Ko Ruka, the keeper of the first manuscript and many others, Raffi, who gifted more than a home, Gary & Raywyn Cook, explorers of the universe, David & Jenny, Sam & Madison Dillon, friends from the beginning, David & Mary Bogan, bringers of insight, Michael Fleck, weaver of the net, Ivan & Joan Hall for keeping friendly books, Faye & Peter Coburn for hospitality, Johny Bjorngard, Heike Eckhoff & Yoakim for the journey, Annette Ebbett for her trust, Kerry, Kathryn, Holly, Josh & Amber Grant for their giving, Dr Bill Harrison for his healing, Lisa Van de Water, for saving the waka, Sandy Sims, Charlie & Barbara Campbell, & Rick Schulze, holders of the land and paragons of patience, Greg & Rose Wood, providers of the haven, Amy Blair, manager of the words, Mat Palmer for being there, & Tia, Tuti Aranui, holder of the rainbow, Ruth Tai, keeper of the vision, Claude & Gabrielle Lewenz, dream walkers, Karen & David Walmsley, initiators of the journey, Frank & Miriam Reeves, movers and shapers, Graham & Nicola Densem for landscaping & silk, Szuson Wong for clarity, Mick Collins, master of the stone, Jan Blythe & Brendyn, holders of the space, Helen Sewell for serving, Steve Thompson & Grace Hart, guardians of the old, Anaru Paul, keeper of the ancient one, Lyn & Arthur Knight, children of the earth tides, Hamish & Lyn Monro for the healing touch, Hamish Miller & Barbara Russell, walkers of the energy lines, Effie Protopapas, good friend to all, Sara & Walter Hurni of the good mind, Geoff & Allison Walker for the Rainbow House, Dirk Nicasi & Marie Wilson for the Rainbow Vision Trust, John Scrimgeour of the island retreat, Kathryn Atkinson, loyal friend, Lynda Burdekin for old times, Gerry & Murray Verbowski-Bright for healing, Fayre Cossar for keeping the doors open, Shilo, Lani, Silas & Arla for the gardens, Kay Baxter, Bob Coker, Michael O'Donnell, Annie Boucher and all who gathered for the seed hikoi, Dr Bill Olds for caring, Bill & Renata Findlay for their friendship, Leyton for superb recording, Caitlyn & Sika for their music, Richard Nunns for the sacred sounds, Steve Robinson & Tamara Androsoff & Misha, for their nurture, Jasbindar Singh for her vision, Marie Eiram & Neville Palmer for their images, Eli & Te Whe Weepu for the old ways, Clem Mellish, Ian & Kay Boustridge, Robyn Barclay & Michael Rarere for honouring the stone, Marianne De Cruz & Kyodo Printing for excellence. Kent Ferguson, Wendelin Wagner, and Roger Himovitz, for the School Down Under at Highden, and Barbara Maré, Suchitra Davenport, Warren Brush & Cyndi Harvan, Mark Tollefson & Sharon Buczaczer for their support and their vision for the Twelve Pouwhenua. Thanks to Ken's Cameras for scans.

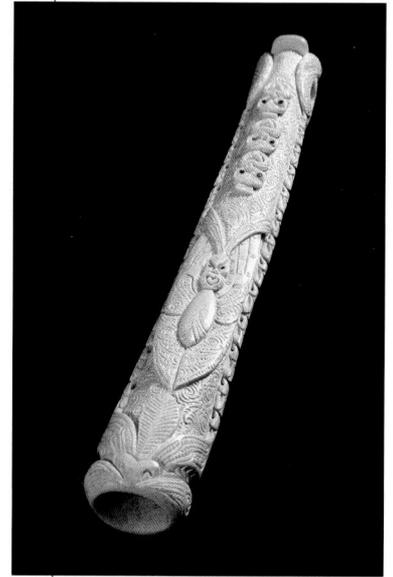

THE BOOK PRODUCTION TEAM

Barry Brailsford: MBE, MA (Hons). Born Greymouth; shaped by the wild lands and the stories that there abound. Author of 'The Tattooed Land,' Greenstone Trails' and 'Song of Waitaha', works that bring new perspectives to the old histories of Aotearoa. Awarded an MBE in 1990 for his contribution to education and Maori scholarship.

Renzie Hanham: A graphic designer/illustrator – judge at the New York Art Director's International Design Awards. Renzie is also a director of a UK based company which specialises in improving performance in sport, education and business. A senior ranked exponent of karate; Song writer, composer and producer of his own CD's. Has lectured at Oxford University by invitation.

Cushla Denton: B Soc Sc. Former social worker, Churchill Fellowship recipient. Founding director of StonePrint Press (1995). Publisher: has wide ranging editorial role, and responsibility for liaison with graphic designers and printers. Caretaker of authors. Mother of three grown-up children.

Amy Blair: Bachelor of Nursing. Manager of StonePrint Press; handles company accounts and distribution. A talented graphic designer, who is very computer wise, and an initiator of great ideas. Enjoys the mountains in good company and is Tia's mum.

PUBLISHING HISTORY

Book Design: Renzie Hanham

Pouwhenua: Maaka Tipa

Tuatara Frontispiece: Tony Schufelberger

Cover Carving and Gateway: Chisnallwood Intermediate School and Gavin Britt.

Printer: Kyodo Printing (Singapore) Ltd

Publisher: StonePrint Press Ltd
PO Box 30098, Christchurch, NZ
Email: info@stoneprint.co.nz
Website: www.stoneprint.co.nz

Books by Barry Brailsford available from StonePrint Press
The Tattooed Land
Greenstone Trails
Song of the Stone
The Chronicles of the Stone
 Song of the Circle
 Song of the Whale
 Song of the Eagle
 Song of the Silence
 Song of the Sacred Wind
Wisdom of the Four Winds
Also by Barry Brailsford
Song of Waitaha
Enquiries to song@mcbrearty.co.nz